AFTER A FASHION

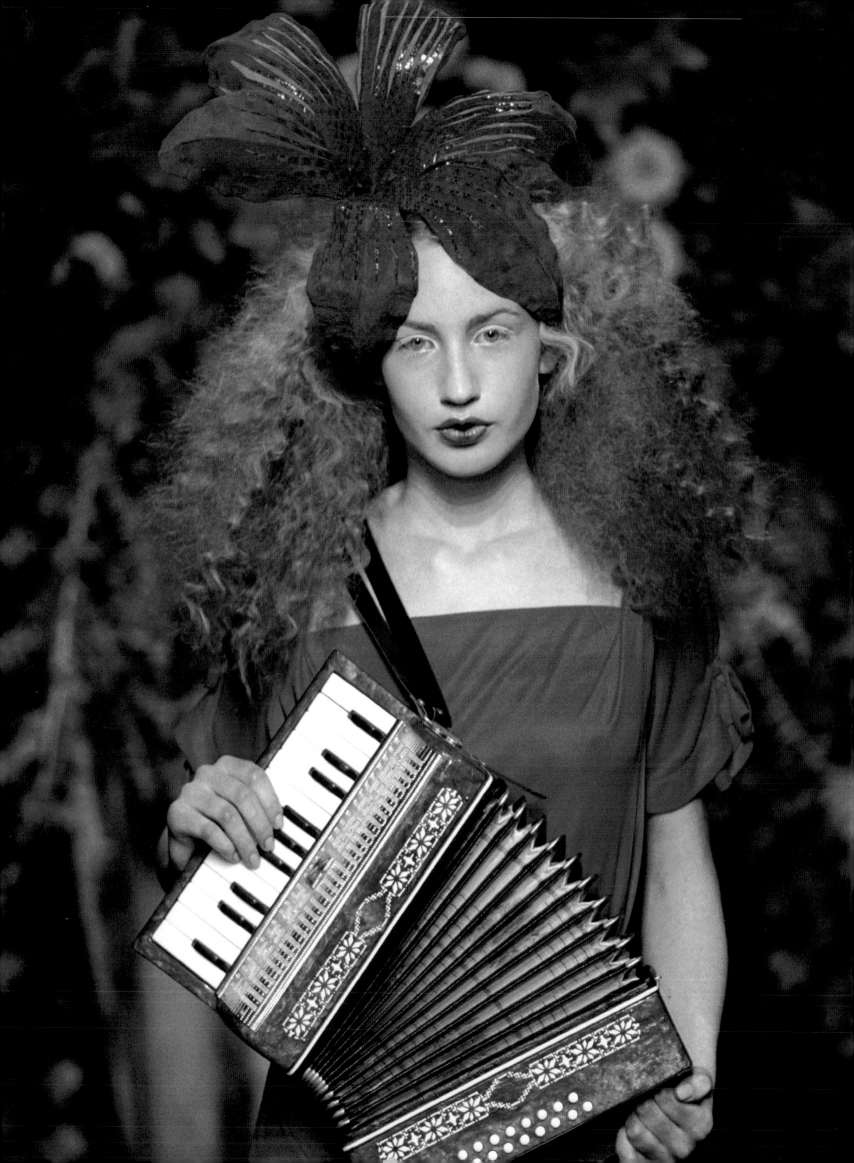

AFTER A FASHION

WHAT WE WORE: 1947 TO THE PRESENT

AMMONITE
PRESS

PRESS
ASSOCIATION
Images

ELIZABETH ROBERTS

First Published 2009 by
Ammonite Press
an imprint of AE Publications Ltd,
166 High Street, Lewes, East Sussex BN7 1XU

ISBN 978-1-906672-38-6

British Cataloguing in Publication Data. A catalogue
record of this book is available from the British Library.

Editor: Elizabeth Roberts
Picture research: Press Association Images
Design: Gravemaker + Scott

Colour reproduction by GMC Reprographics
Printed by Kyodo Nation Printing, Thailand

PAGE 2: ELIZABETH JAGGER
MODELLING AT THE VIVIENNE
WESTWOOD RED LABEL SHOW
AT LONDON FASHION WEEK
1998

PAGE 5: AUDREY HEPBURN
1961

PAGE 7: A YOUNG COUPLE
IN NOTTING HILL GATE
1958

PAGE 8: PAUL SMITH DESIGN
AT LONDON FASHION WEEK
2008

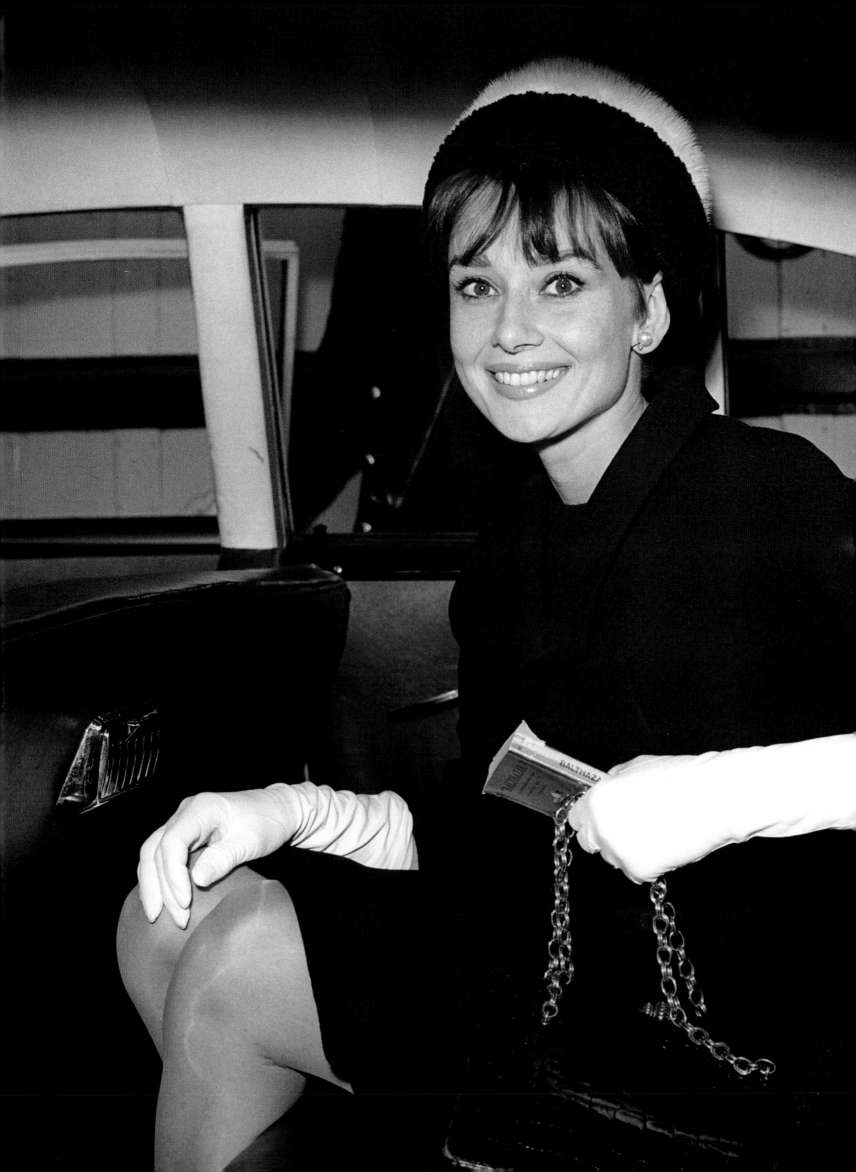

WITH THANKS TO
THE PRESS ASSOCIATION
IMAGES RESEARCH TEAM
FOR ALL THEIR HELP

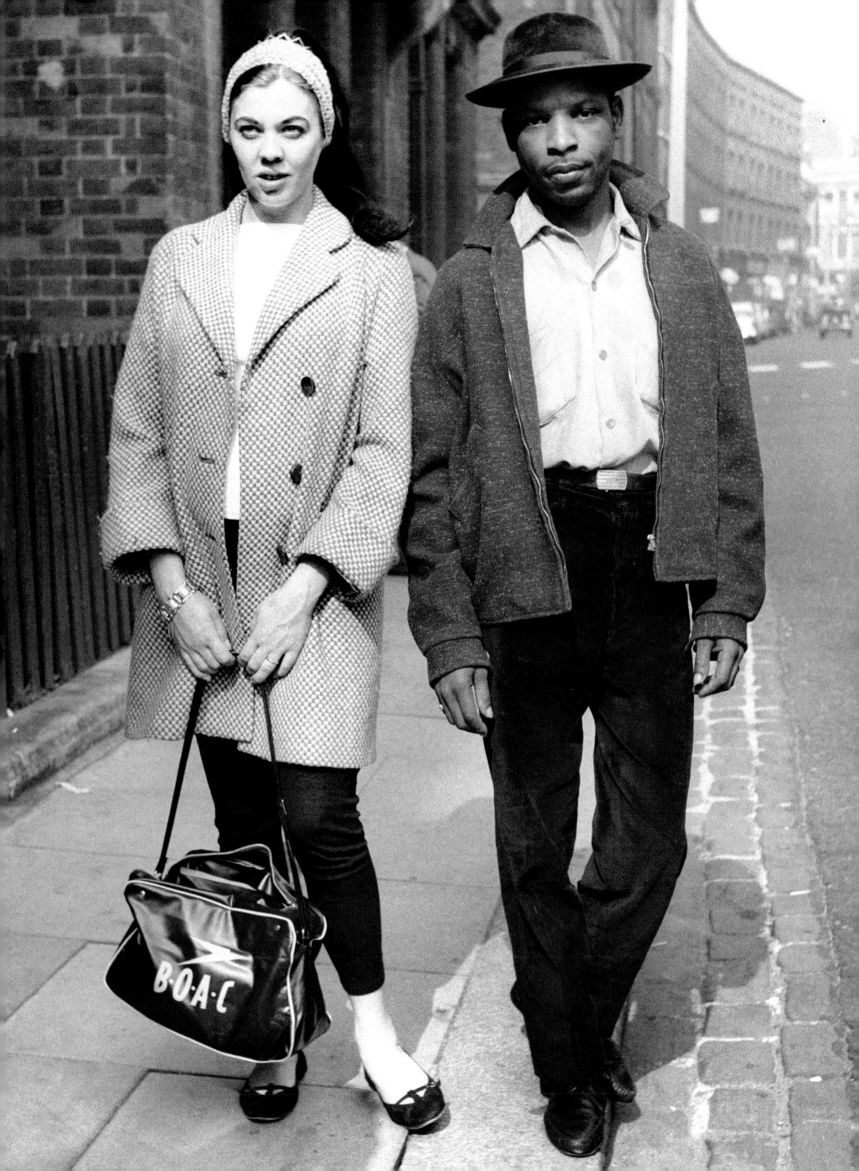

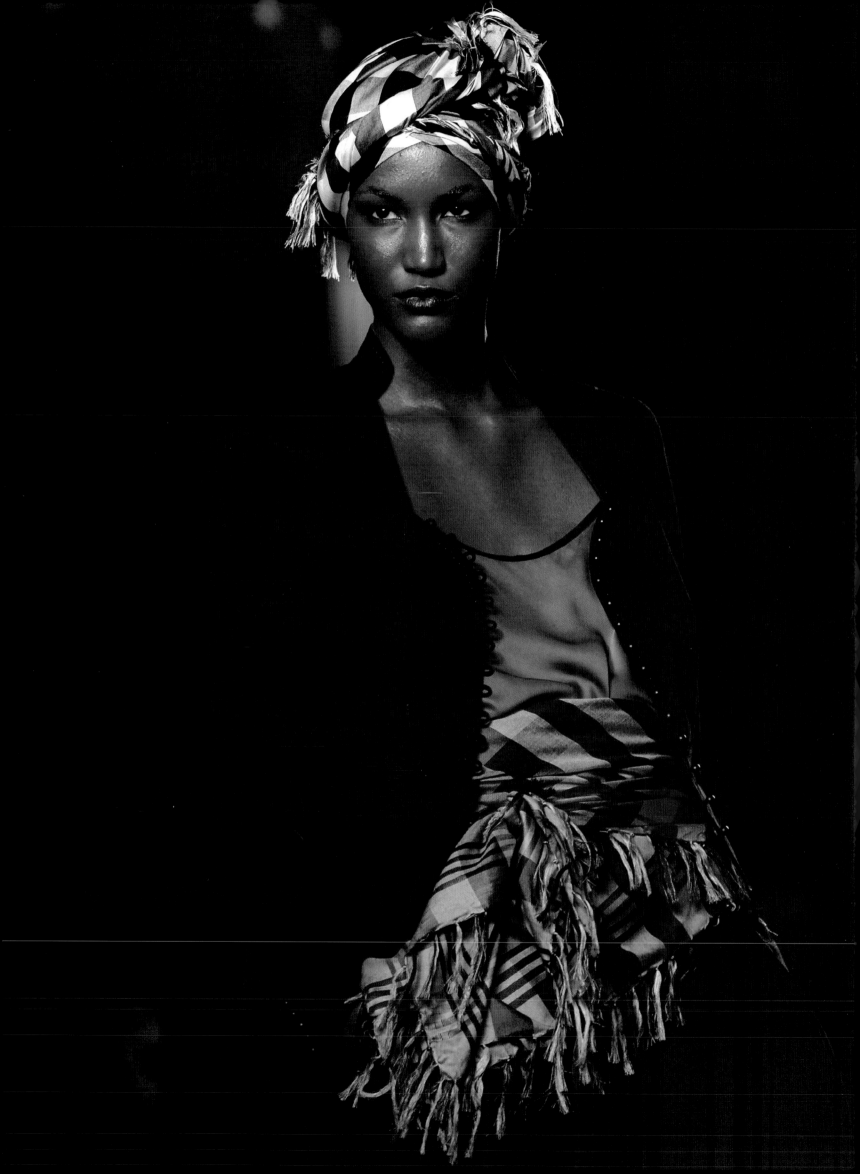

C ONTENTS

WHEN WE THINK OF THE WORD 'fashion' we tend to think of high-street shops and catwalks, but if we look at the meaning of the word in its looser sense – how we present ourselves to the world – it becomes more interesting. What we wear does, in fact, say a lot about us – our attitudes and aspirations, our interests and values are discreetly coded in the way we dress. It's a way of attracting like-minded people and repelling our adversaries, of joining in a particular group or category; it's a cipher that we all understand.

But, however original or conservative we are in our dress, we are influenced by the values that society holds in general and, of course, these change with the decades. What we believed and revered in the 1950s is very different to that of today – and is reflected in our clothes, whether we are conscious of it or not.

When I first started working with the Press Association Archive I began to realise that it was, unwittingly, an extraordinary historical record of fashion. Here were press pictures that covered every conceivable event from a royal wedding to a murder trial to politics and local affairs; people, from every walk of life, were pictured within their contemporary context. The more I saw, the more interesting it became. What people wore said a great deal about the times they were living through; the nipped-in waists and full skirts of the 1950s spoke of femininity, while the revolutionary mini skirt of the '60s spoke of emancipation – and yet both were ambiguous in their way. The designer label and high-street fashion now compete alongside one another for the first time, and celebrities produce their own ranges for us to, literally, dress like them. The clothes speak more of fantasy than they do of reality.

This book does not aim to be a history of fashion of the past century, it is more an exploration of these ideas; a teasing out of the undercurrent of fashion, both playful and revealing. It is also a celebration of the work of the Press Association. Its vast archive of photographic documentation has long discarded its original purpose – that of disseminating news – and become a visual history of how we became who we are today.

Elizabeth Roberts

CHAPTER

1

FILM STARS,
FULL SKIRTS
AND FUR:
POST-WAR
GLAMOUR

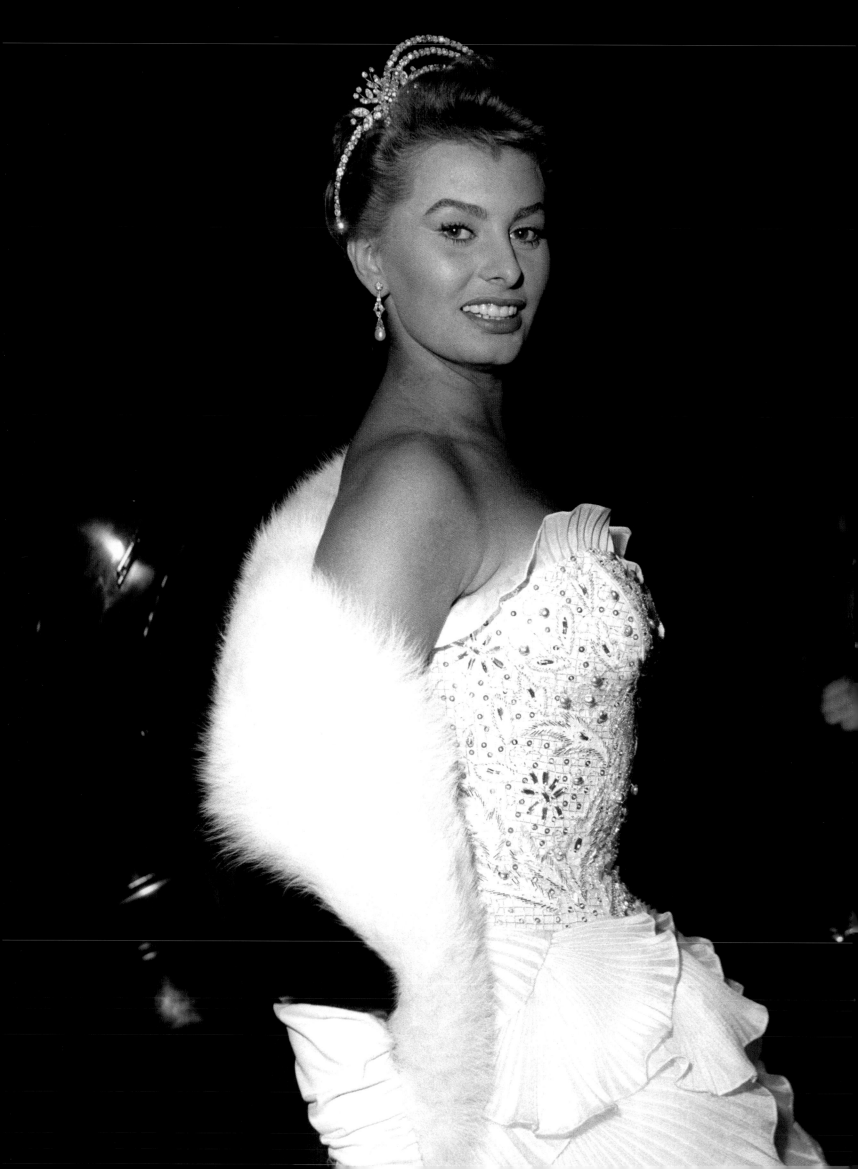

A LOT HAS BEEN WRITTEN about post-war austerity, the frugality of make-do and mend and the respectability of a life without debt. After years of rationing it was hard to break the habit of thrift, embedded as it was with moral connotations. The ending of war had brought with it a period of hope for humanity, a vision of a new world in which horror and bloodshed were things of the past. The old order could never be re-established, but a new one could. The class system had all but broken down and equality and democracy were the new standards.

However, like most things in life, it was not straightforward. Women had experienced a degree of freedom that was unprecedented in our society. Instead of being wife and mother, queen of the home, they had taken up full time work – in the fields, in hospitals, in offices, in factories – women drove trucks, flew planes, broke codes, ploughed fields. Women had, in fact, entered the male world.

But, with thousands of soldiers coming home, women had to move over. It was time to go back into the home and take up their traditional role. For some this was a satisfactory solution, but for others that taste of freedom had been enough to make them reluctant.

Clothes became a manifestation of this struggle. Trousers and overalls gave way to full skirts and high heels. Femininity was given pride of place, with nipped-in waists and full bosoms accentuating womanly attributes. Glamour, whilst not always attainable to the average woman, was held up as the ideal. Those who could afford it – the rich and famous – swathed themselves in fur, the ultimate luxury and symbol of wealth and protection.

Now, at the same time, technology was moving forward. Cinema-going became increasingly popular and television burst upon the scene. Personalities – film stars, actors and actresses and TV presenters became role models to be emulated. However, women in these roles remained womanly – while they might be enjoying independent careers they were still wives and mothers, even if, in the case of Elizabeth Taylor, they had multiple marriages, they still upheld the ideal of marriage and the home.

It was a situation that could not be sustained – the myth had to be broken. It would take a decade before things started to fall apart, but fall apart they would.

PAGE 14: Sofia Loren arriving
at a film festival in London
1954

Television and Radio
Exhibition at Olympia
1947

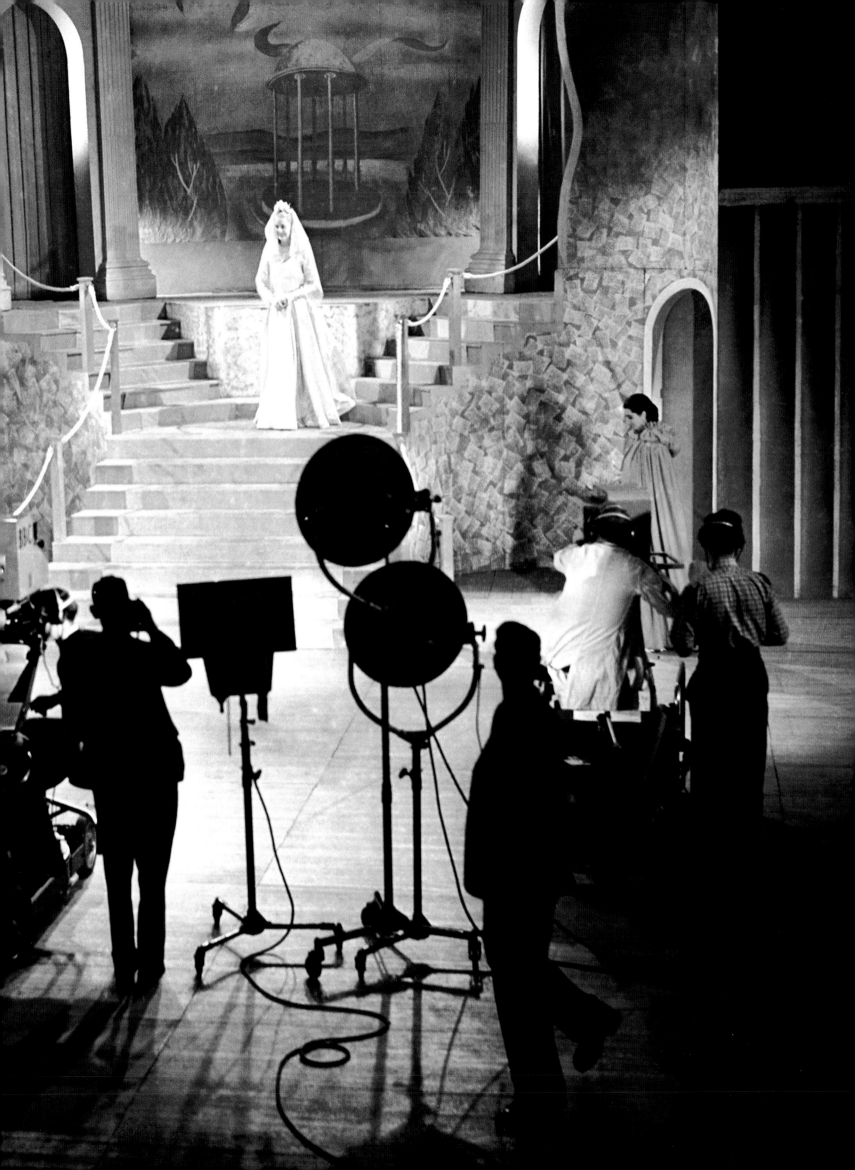

The Viscount and Viscountess
Mountbatten leaving
Britain for India
1947

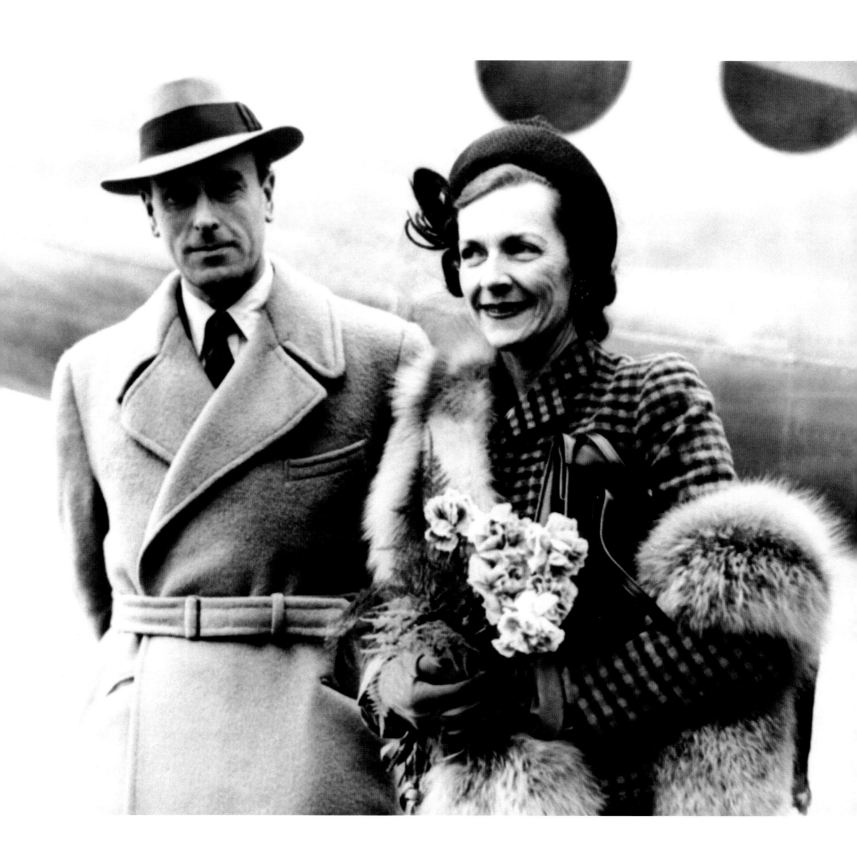

FILM STAR
JANE RUSSELL
1946

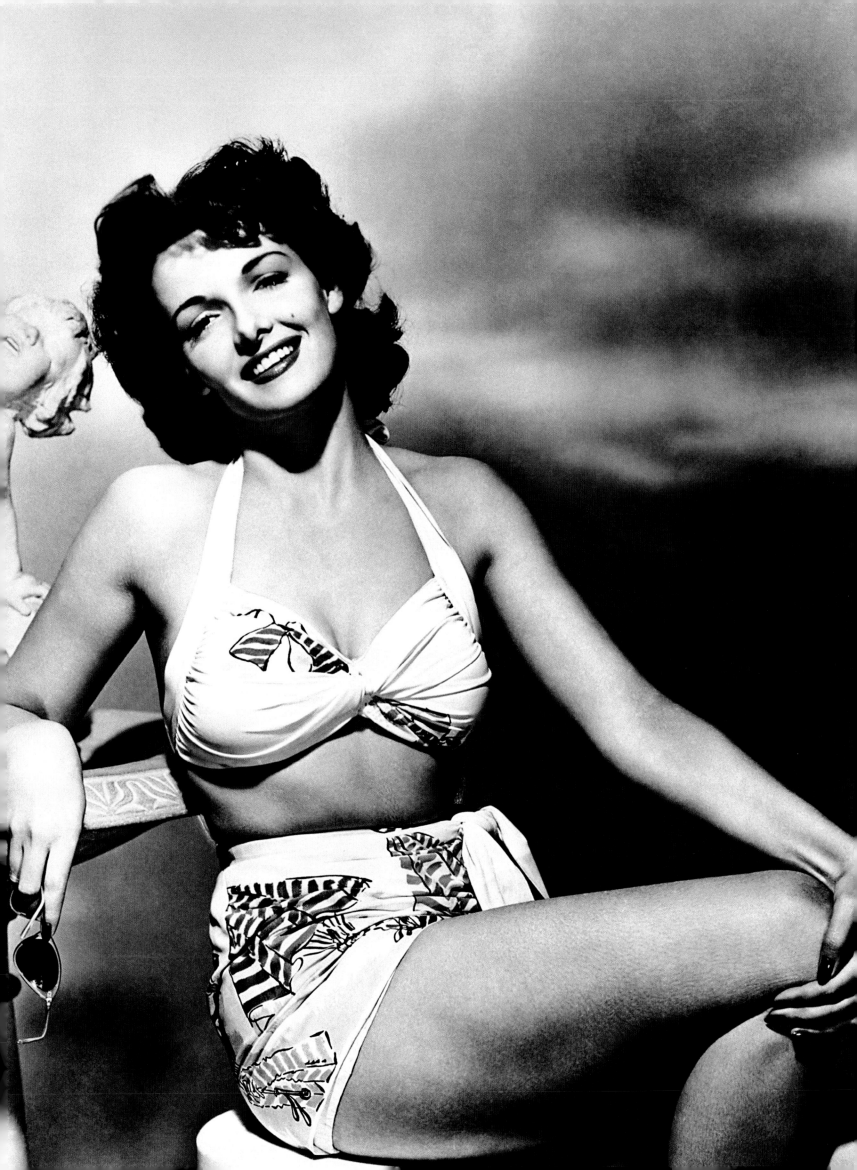

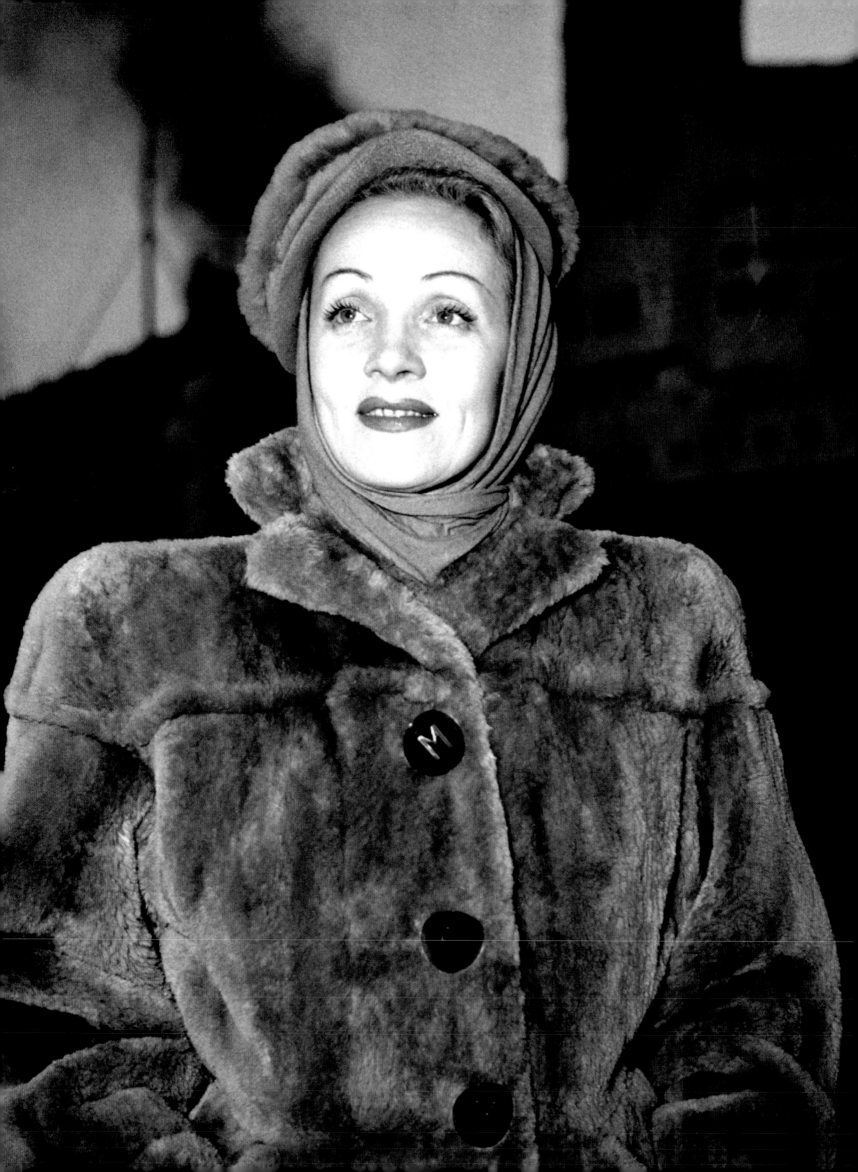

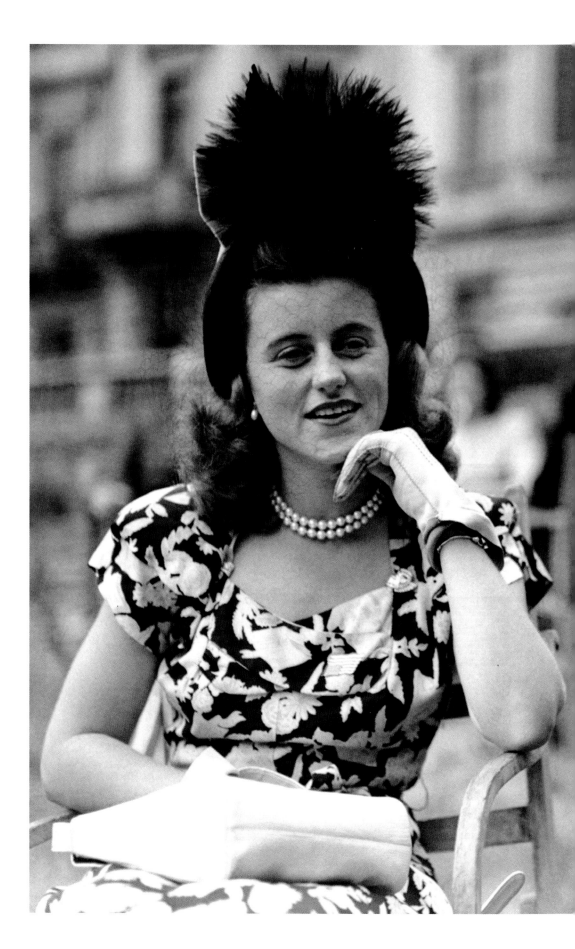

LADY KATHLEEN HARTINGTON

1948

RICHARD ATTENBOROUGH AND HIS WIFE
SHEILA SIM AT A GARDEN PARTY
1948

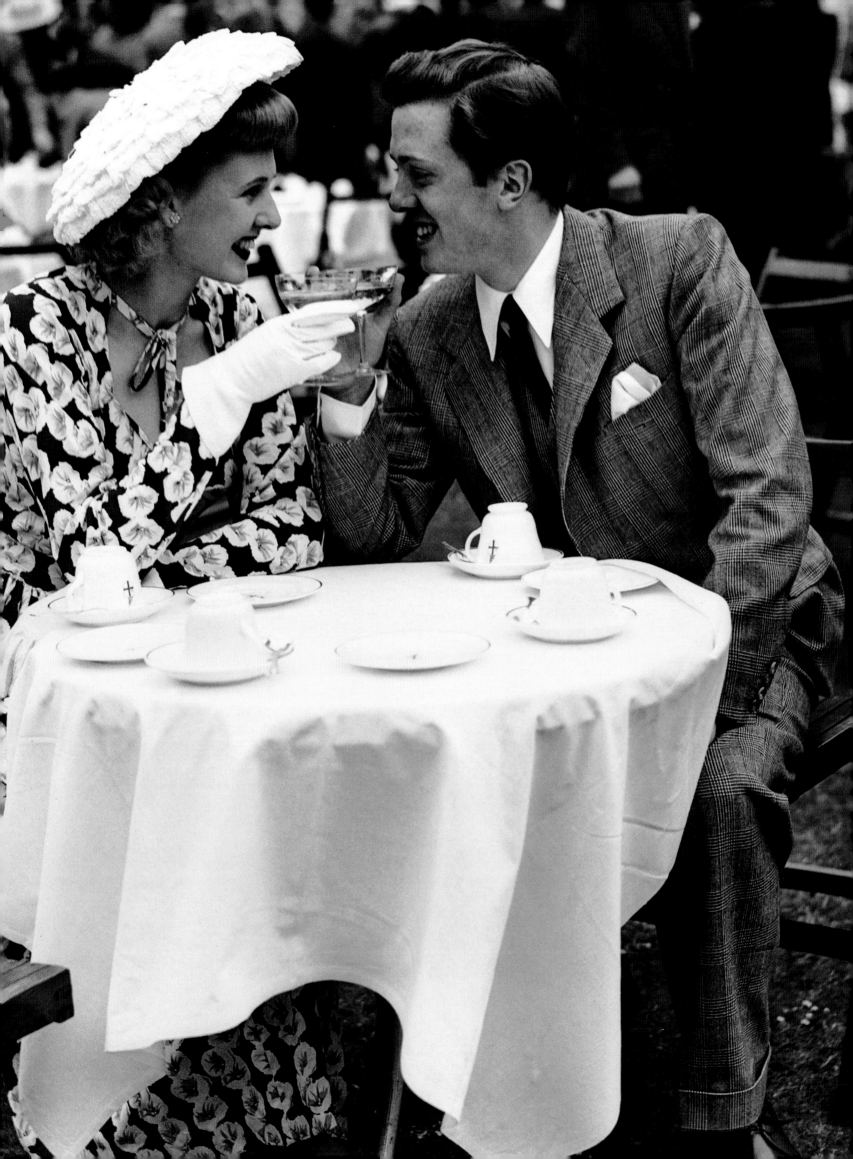

MARGARET LOCKWOOD
IN WHITE FUR
1947

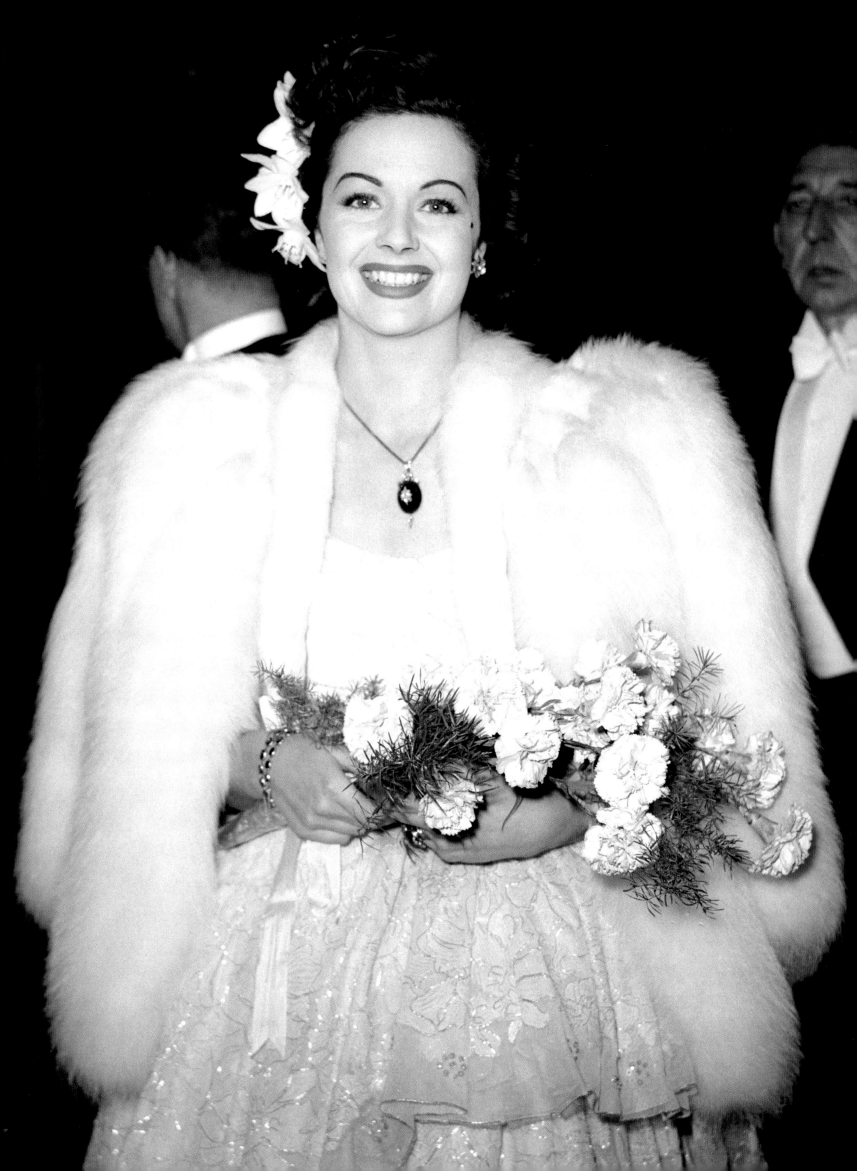

Ingrid Bergman
1948

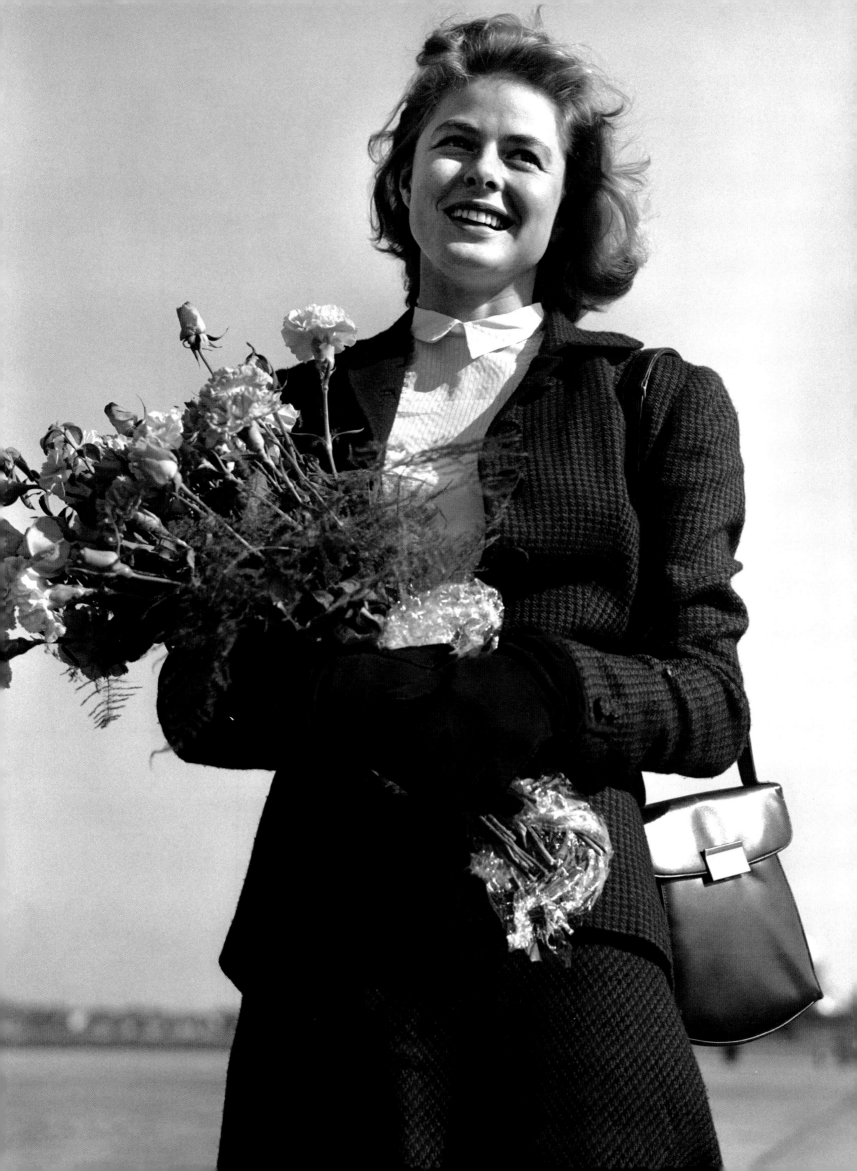

The cast from a Cambridge
Theatre production
(from left) Aud Johannsen,
Nina Tarakanova,
Audrey Hepburn and Marlana
1949

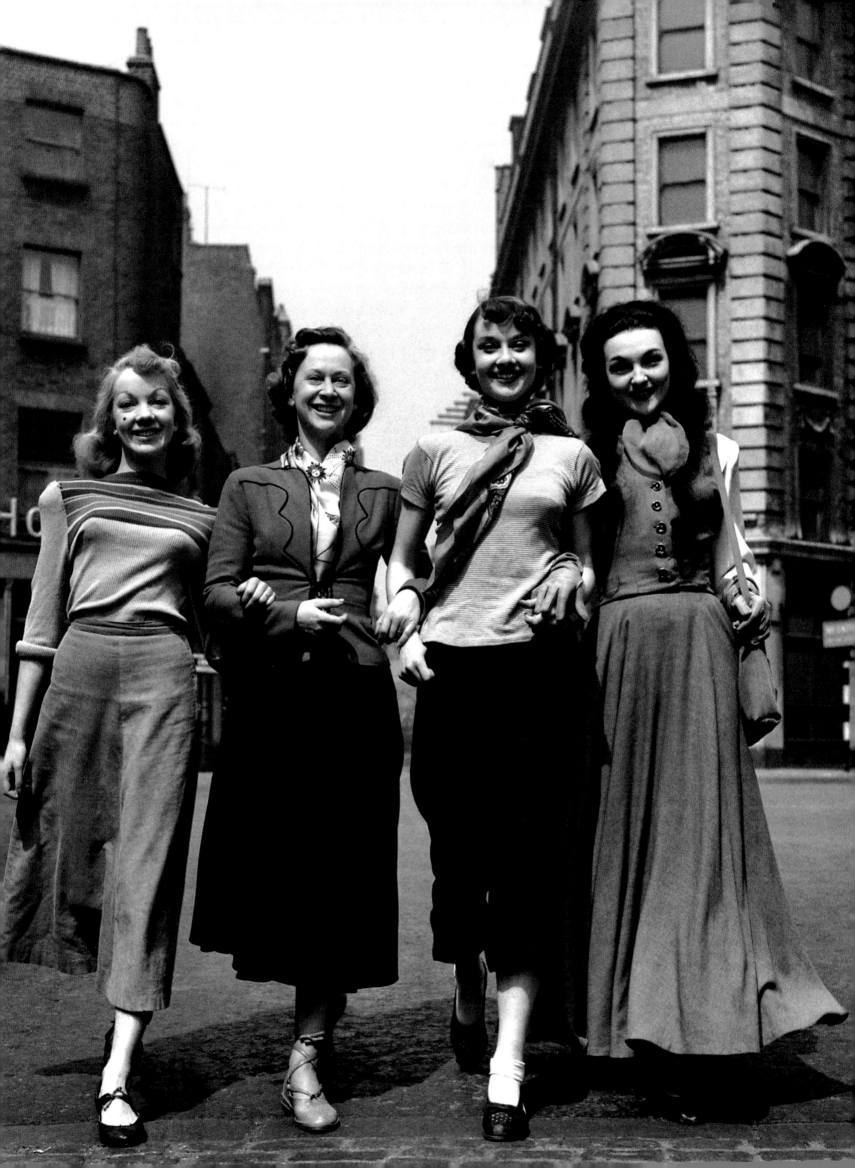

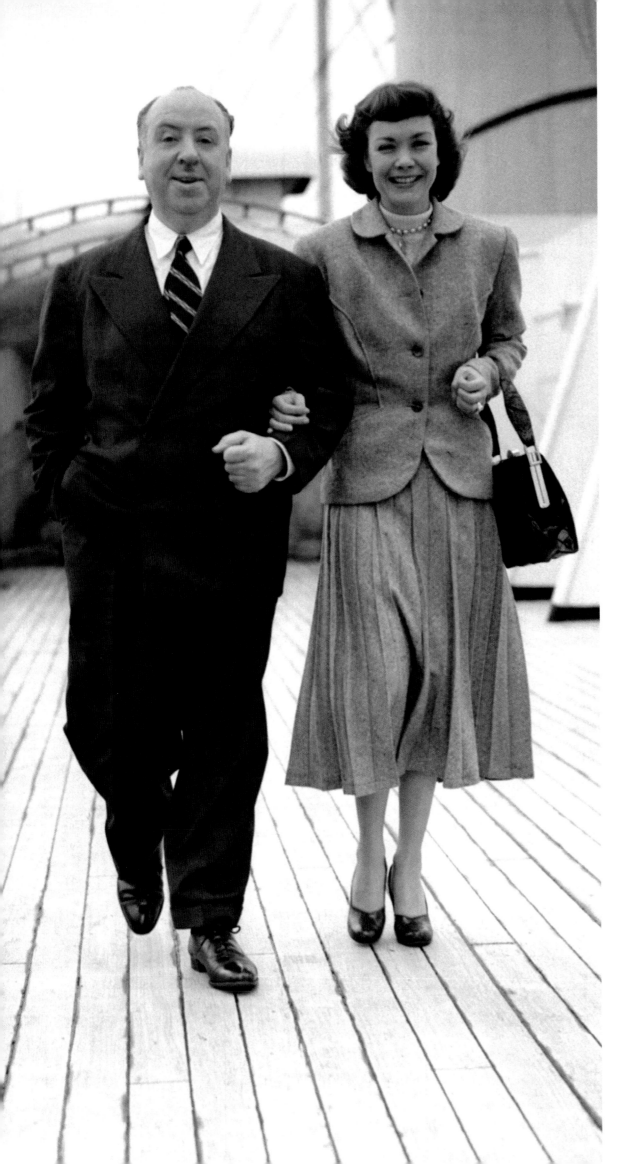

DIRECTOR
ALFRED HITCHCOCK
WITH JANE WYMAN
ABOARD THE CUNARD
LINER QUEEN MARY
1949

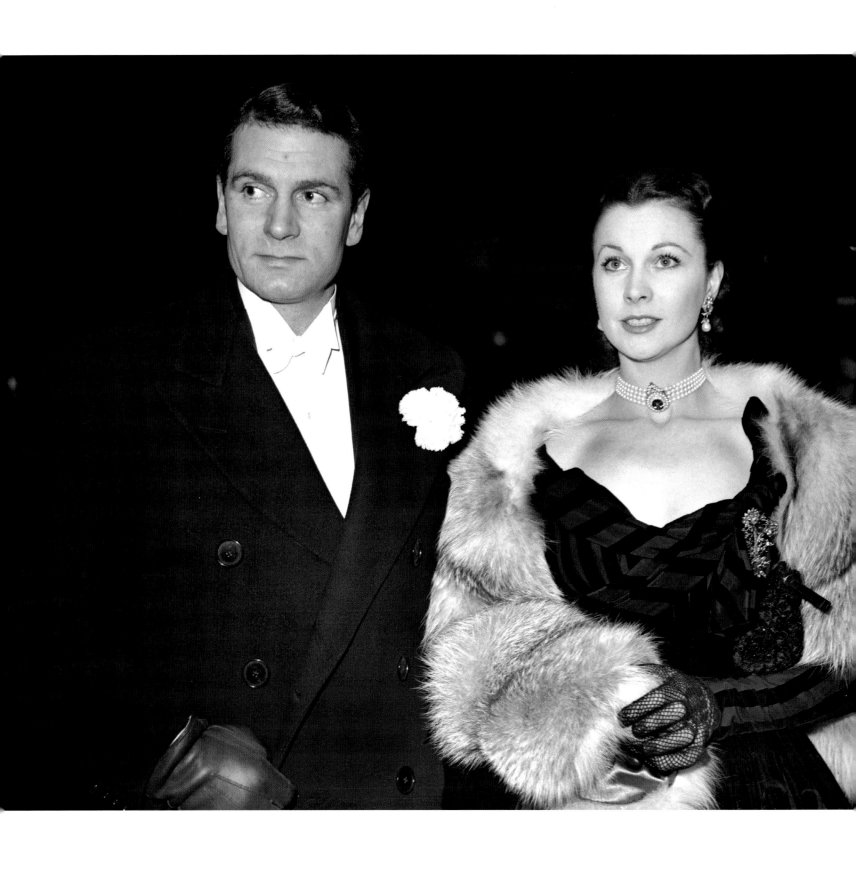

LAURENCE OLIVIER AND VIVIEN LEIGH

1949

THE 18-YEAR-OLD ELIZABETH TAYLOR
AT A HOLLYWOOD CHARITY FUNCTION
1950

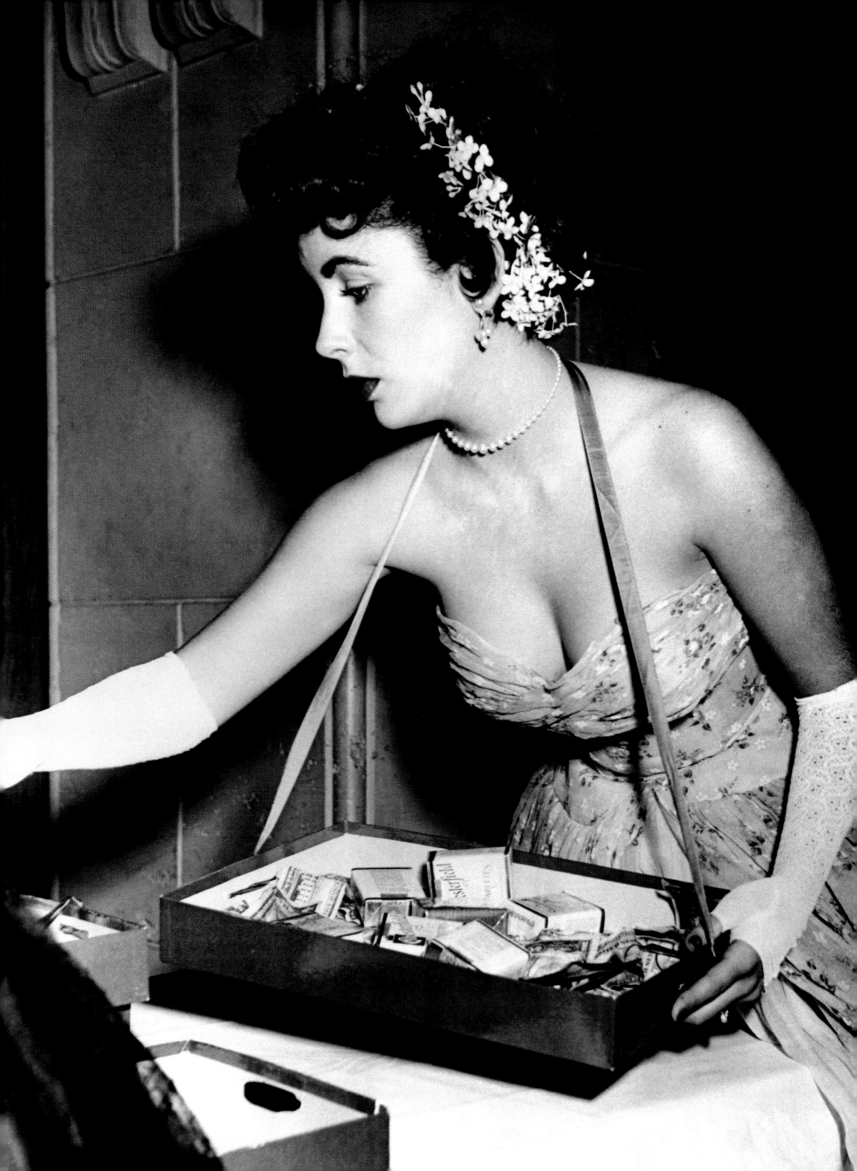

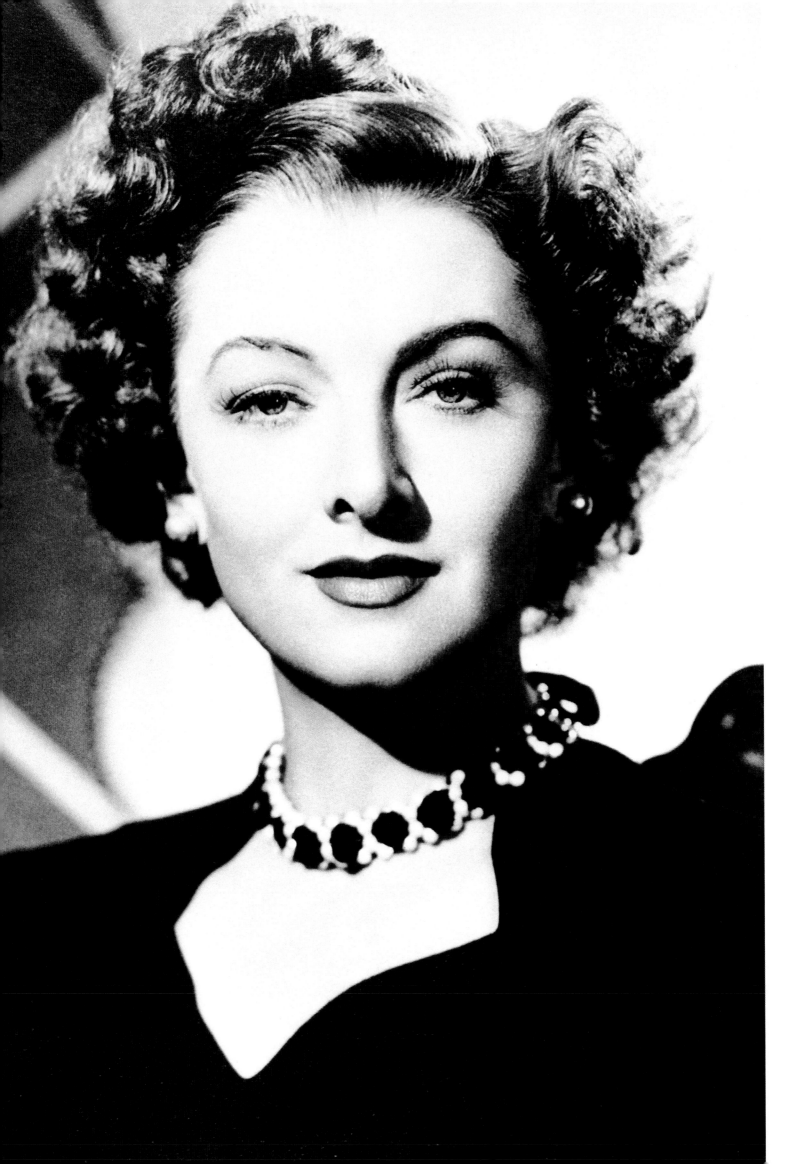

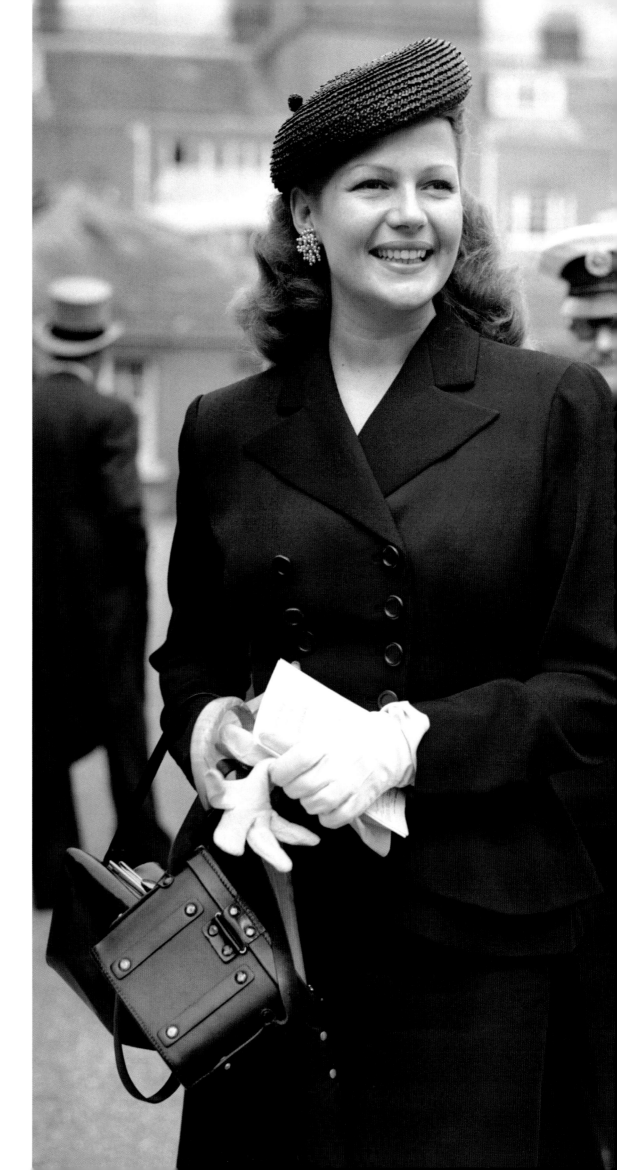

LEFT: MYRNA LOY
1950

RIGHT: ACTRESS
RITA HAYWORTH
1950

BALLERINA
MARGOT FONTEYN
1950

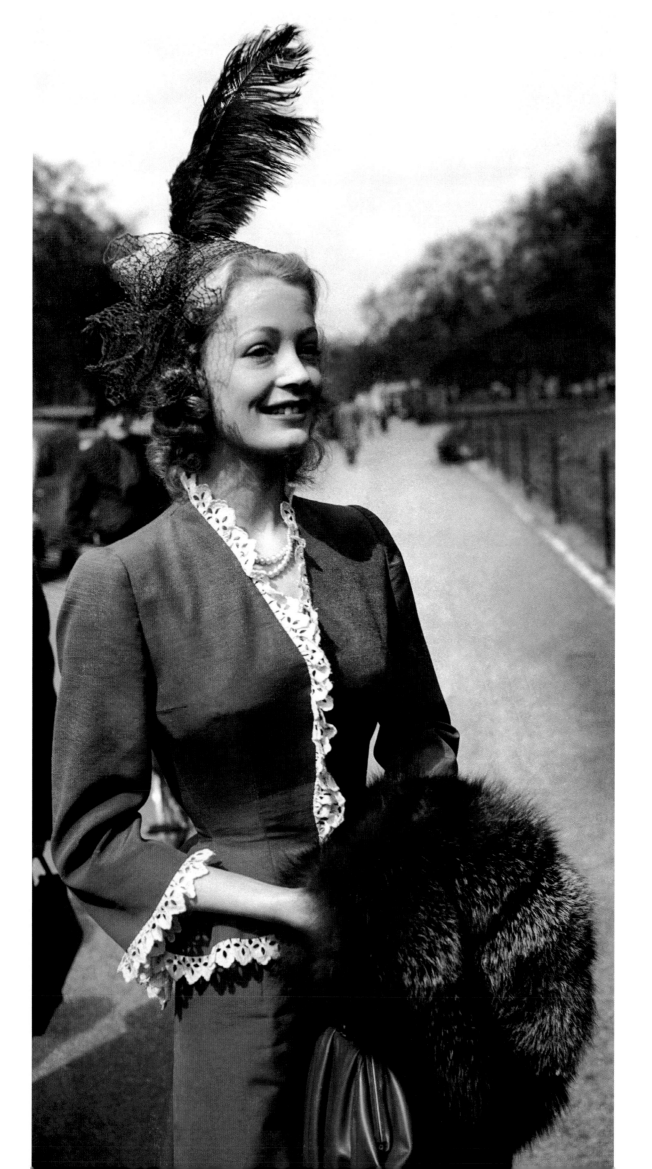

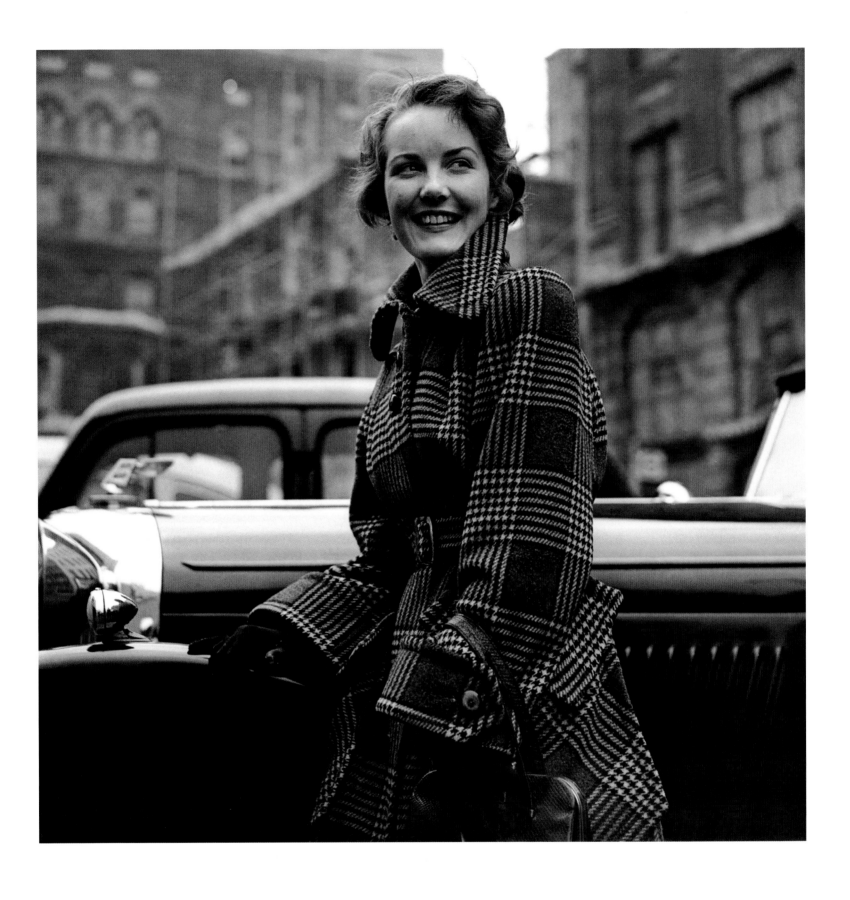

LEFT: ACTRESS PATRICIA DAINTON AT AN EASTER PARADE IN HYDE PARK

1950

ABOVE: PETULA CLARK

1950

JUDY GARLAND

1951

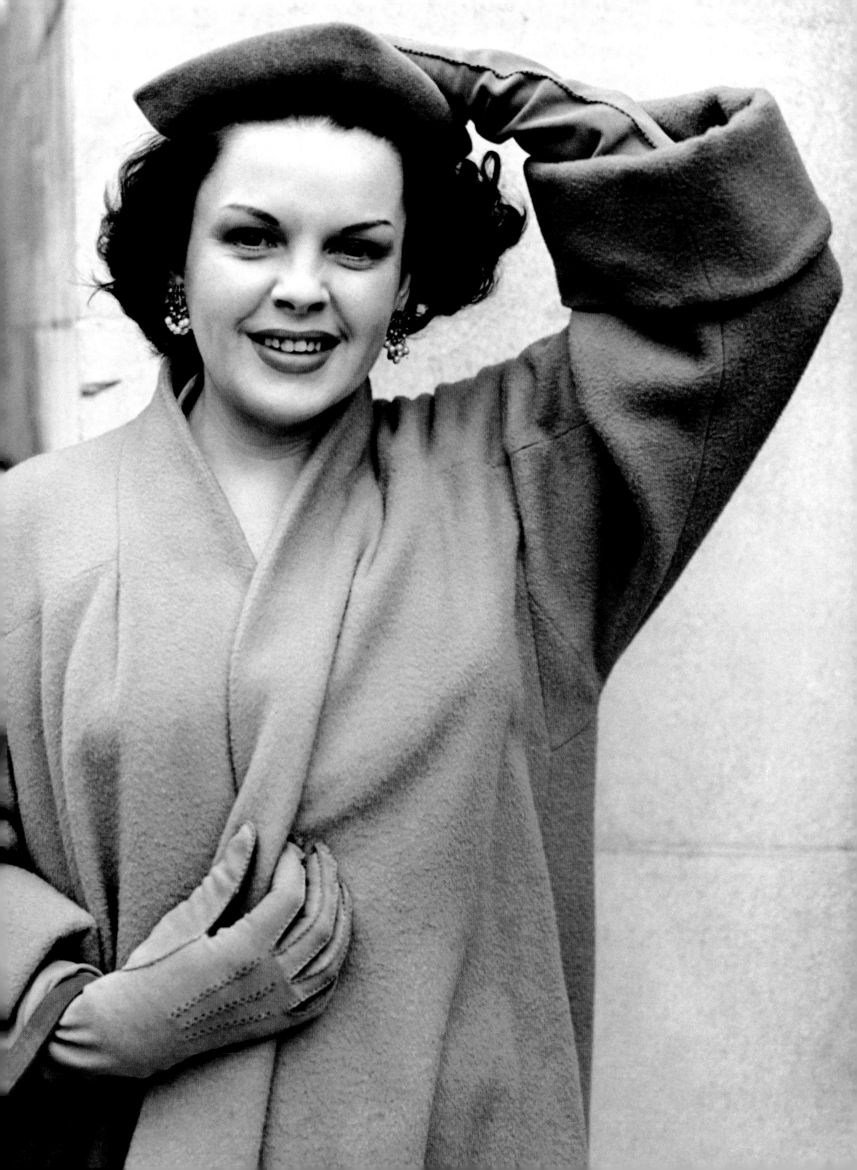

Debutant fashion
by Herbert Sidon
1951

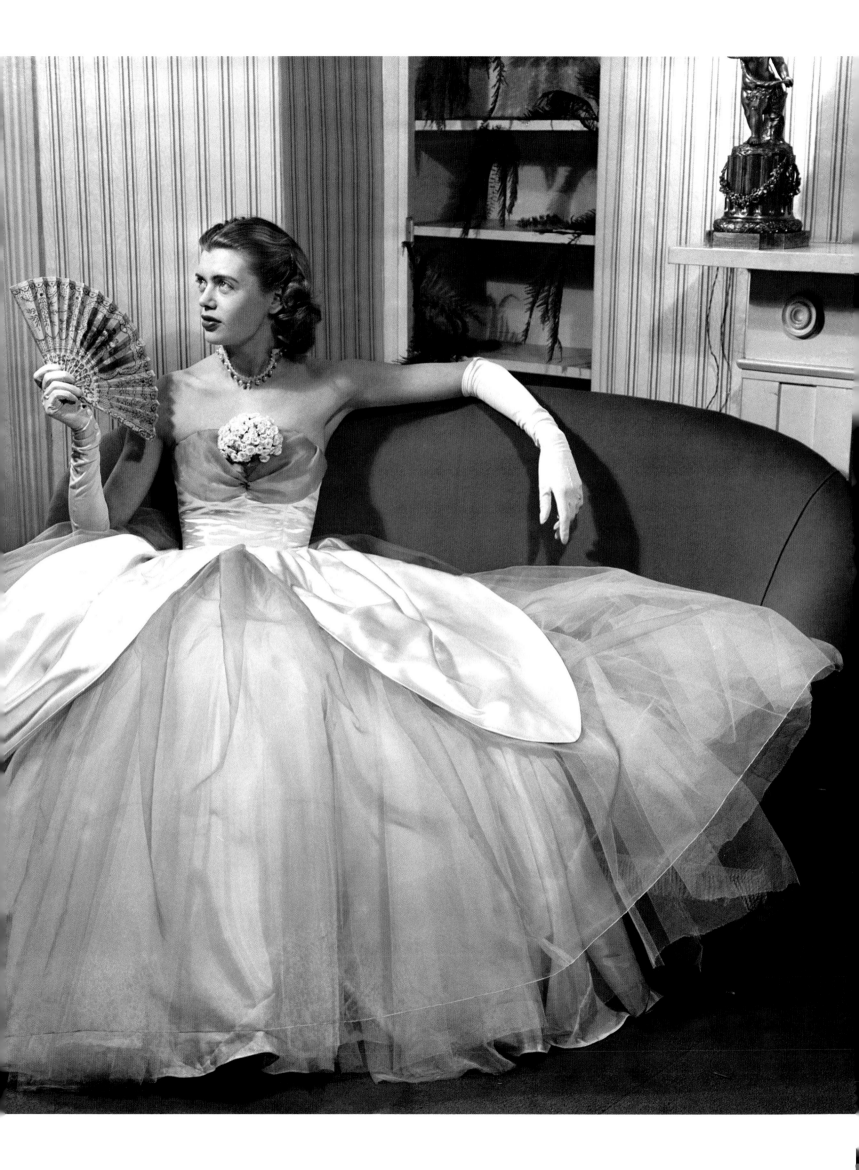

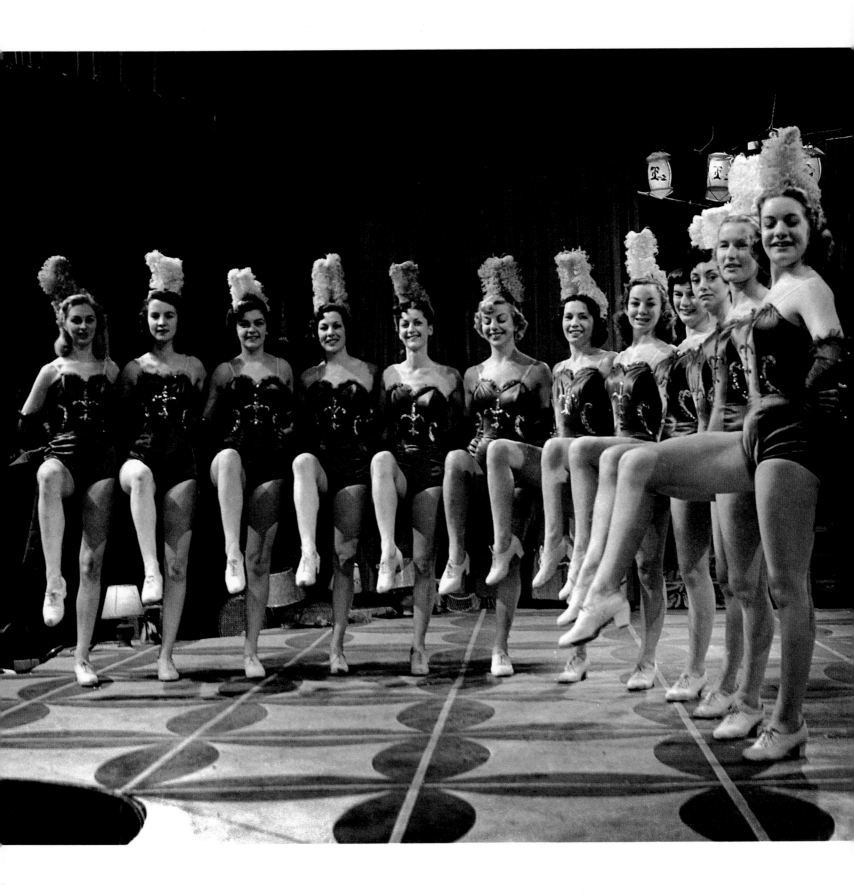

TV chorus girls known as the Twelve Toppers

1951

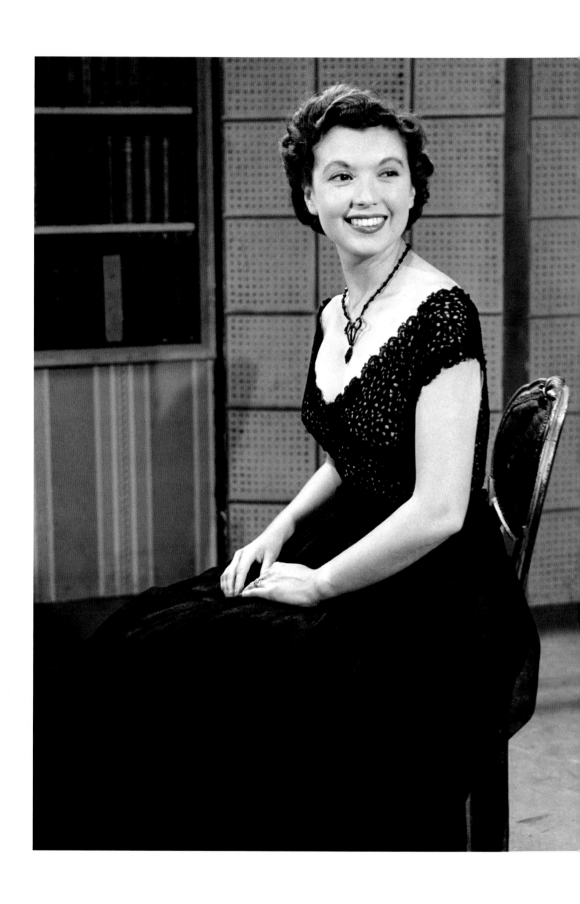

TV PRESENTER SYLVIA PETERS

1952

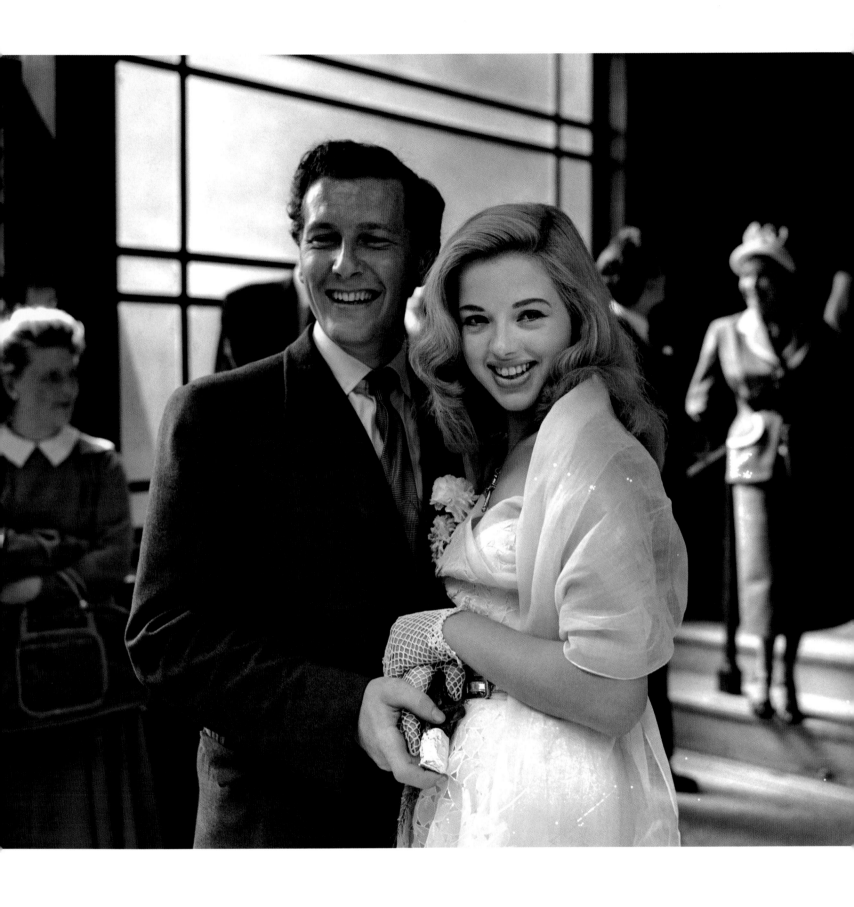

DIANA DORS MARRIES DENNIS HAMILTON

1951

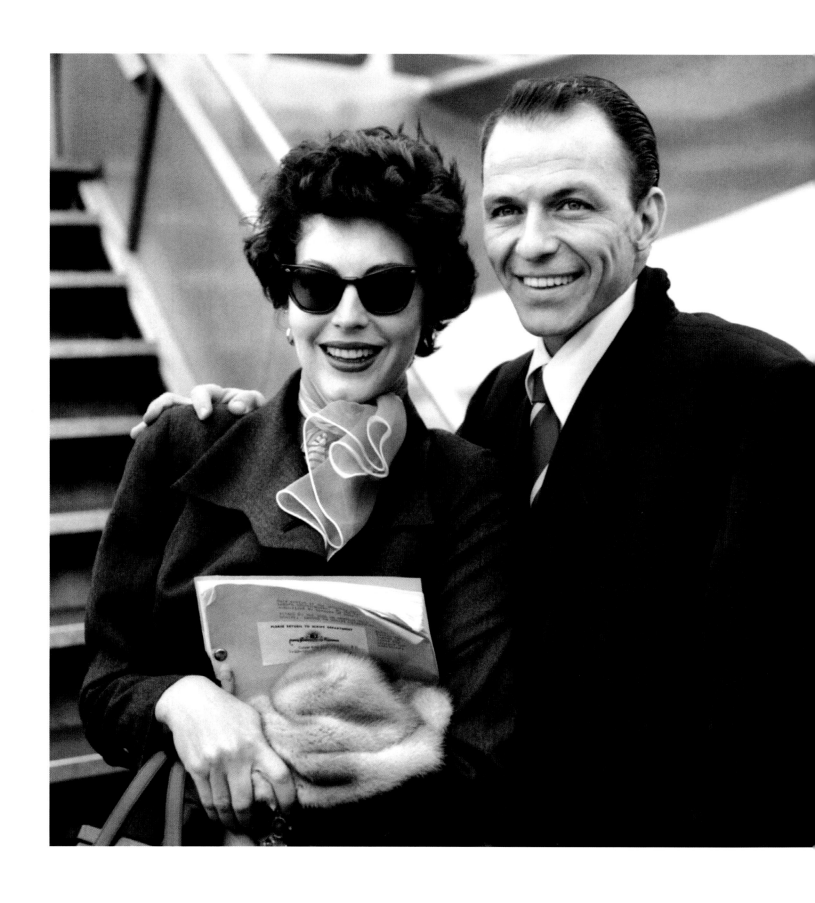

AVA GARDNER AND FRANK SINATRA

1952

AUDREY HEPBURN ARRIVING
AT LONDON AIRPORT
1953

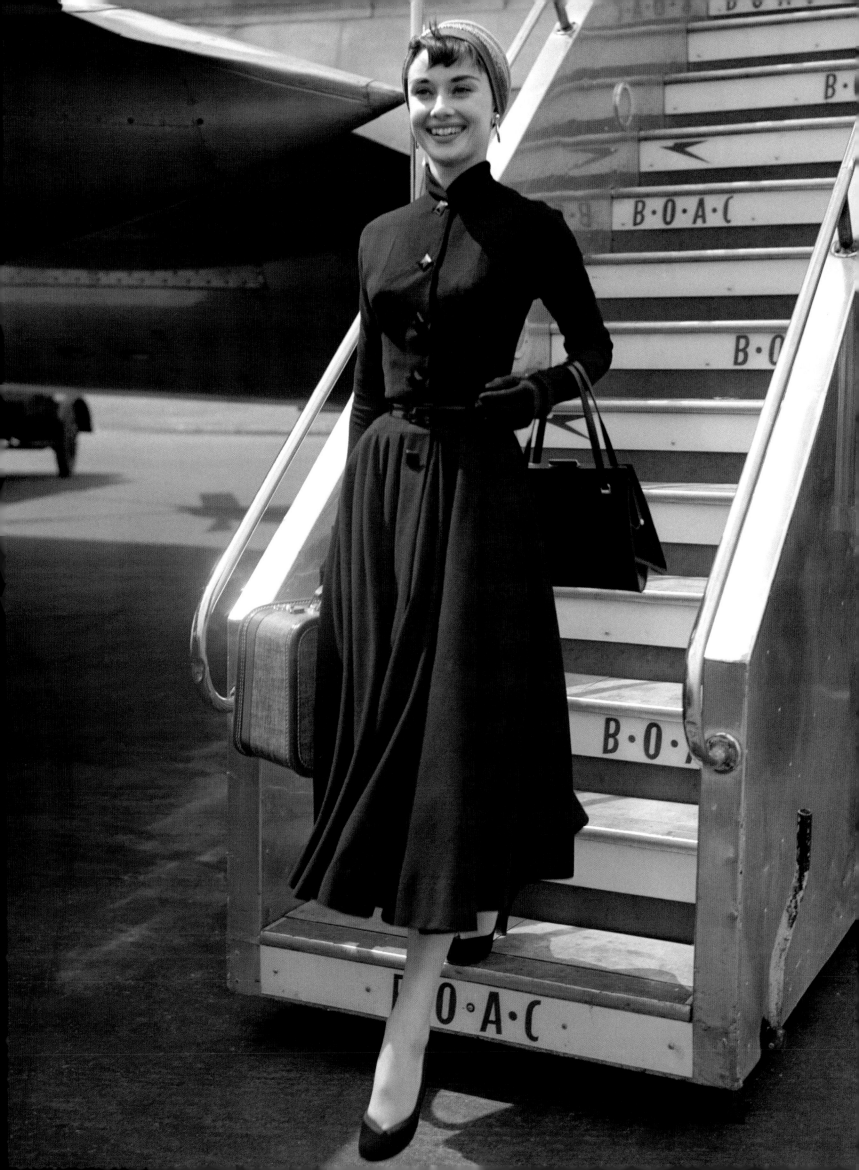

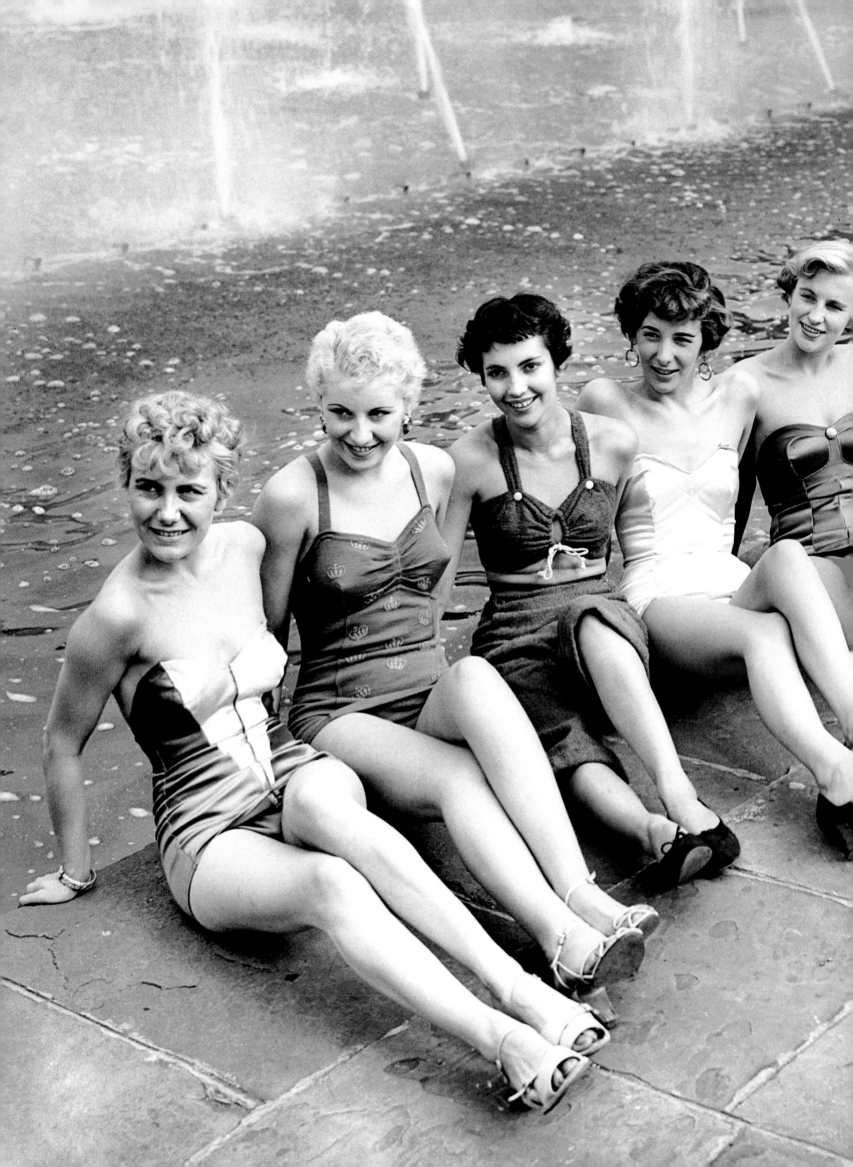

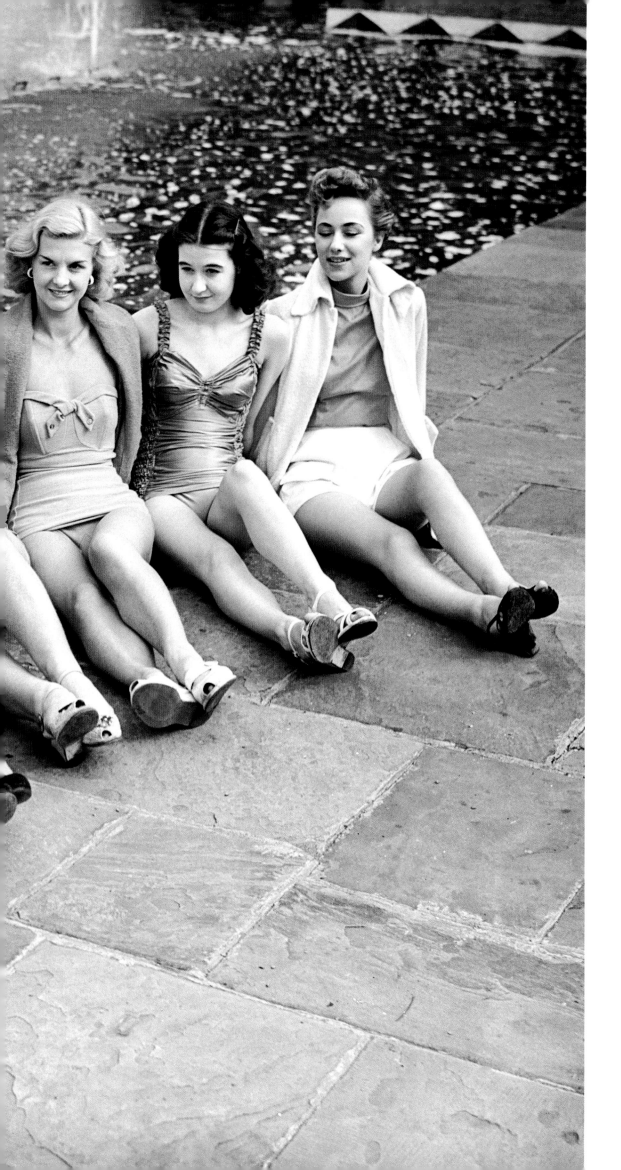

THE LATEST
IN SWIMWEAR
1953

The Duchess
of Gloucester
in the grounds
of Marlborough
House in London
1953

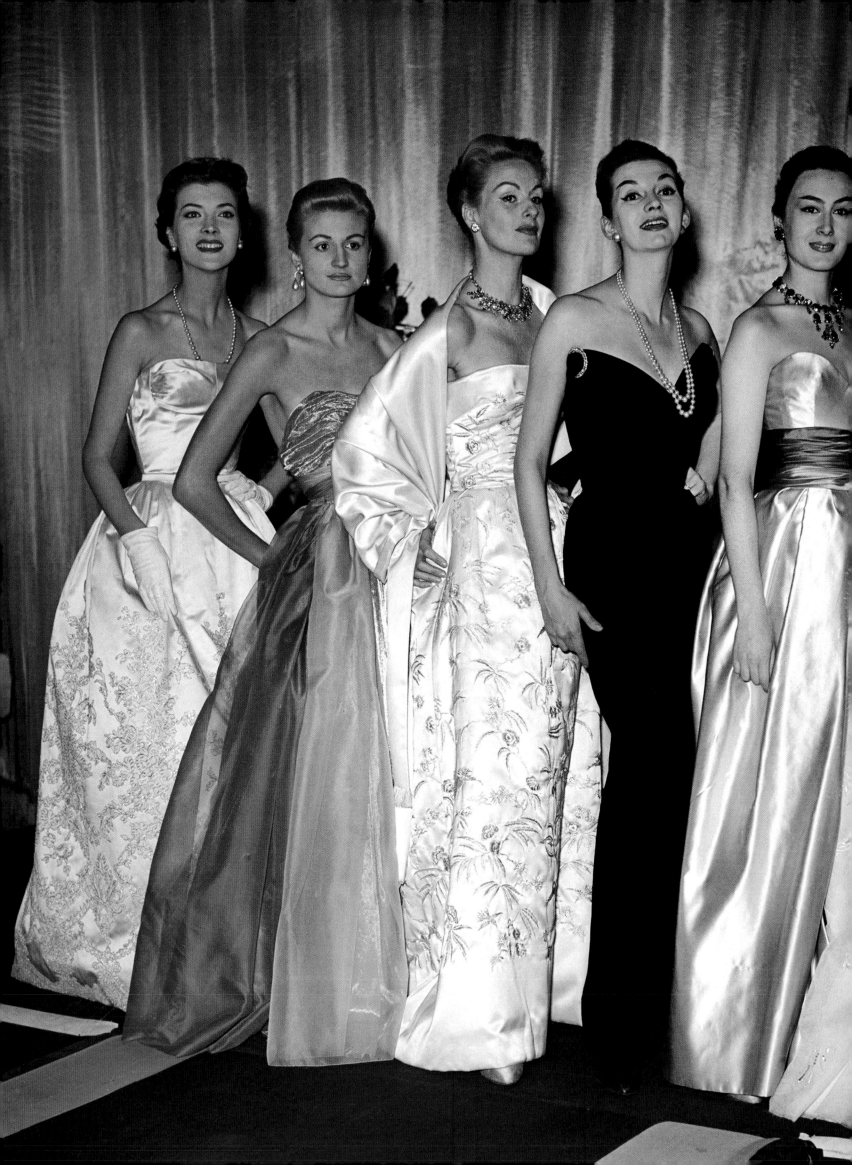

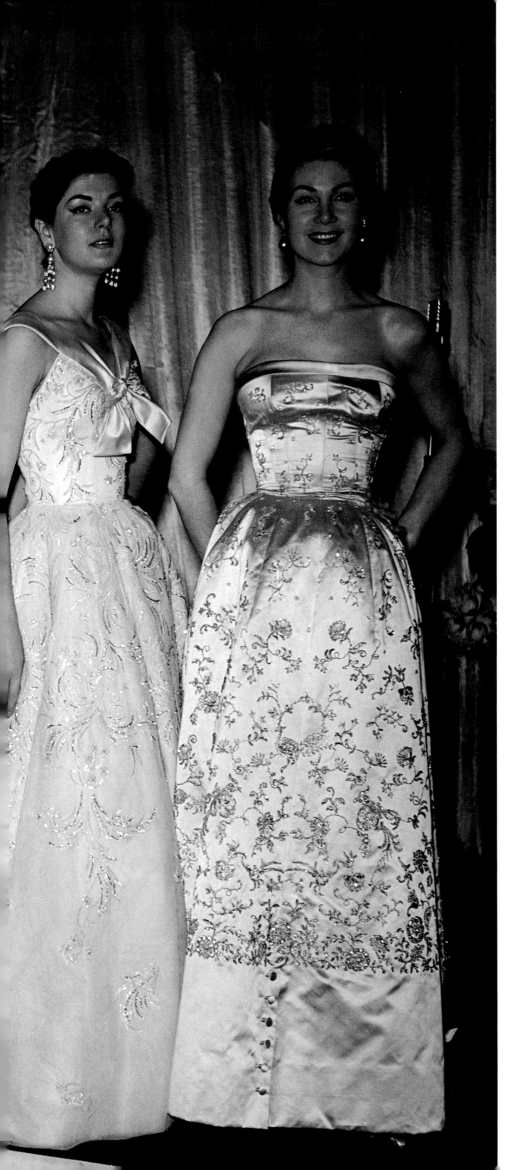

JACQUES FATH EVENING DRESSES
BEING SHOWN IN LONDON
1954

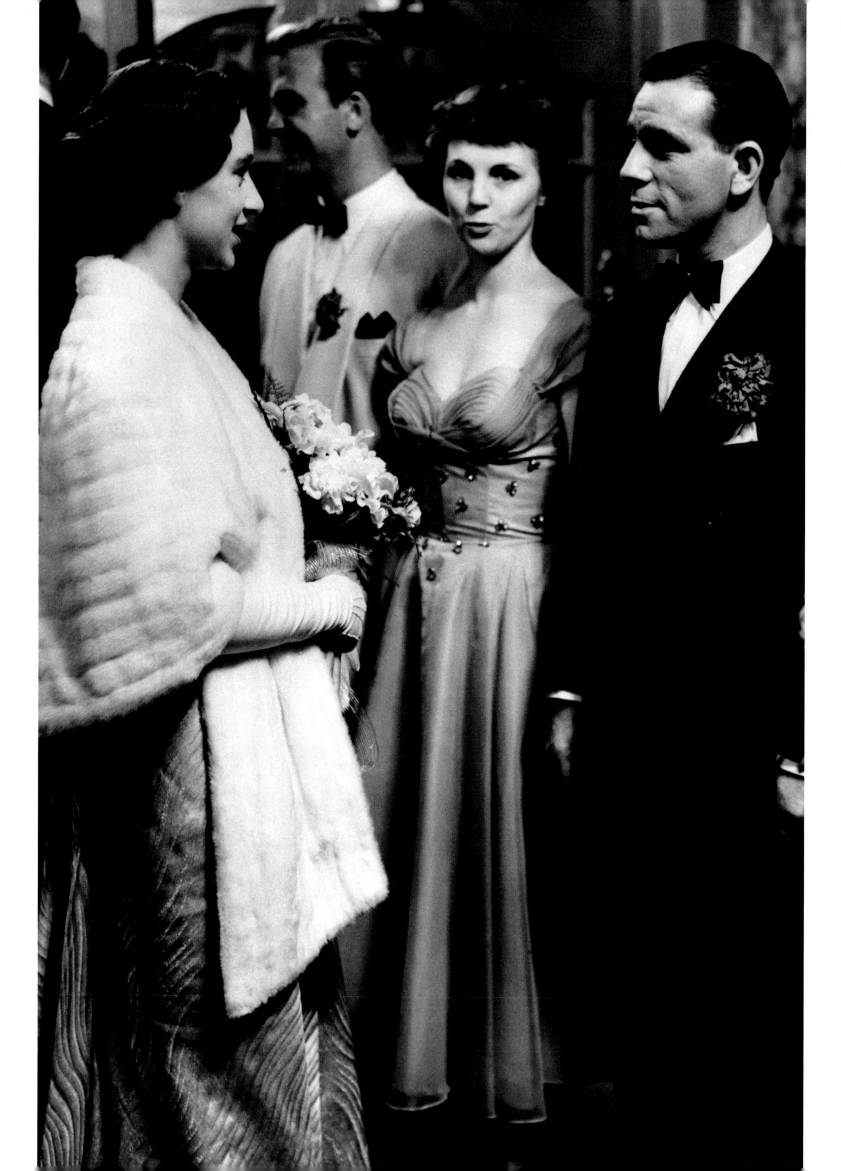

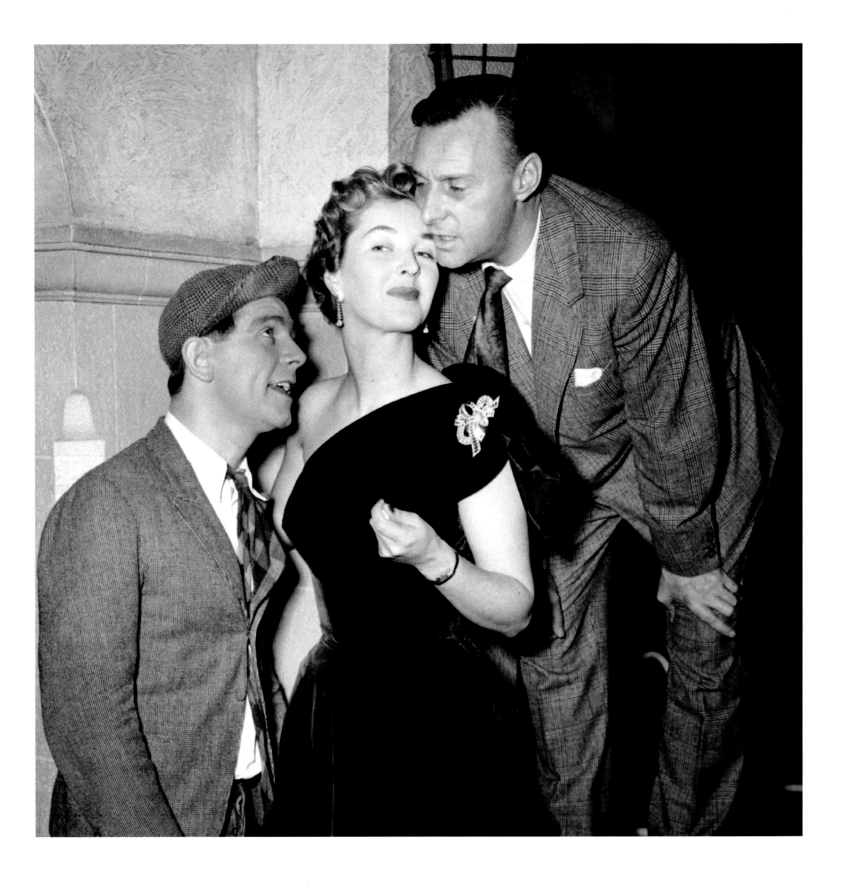

LEFT: Princess Margaret talks to comedian Norman Wisdom and dancer Gillian Moran
at the London Palladium

1954

ABOVE: TV presenter Katie Boyle with comedians Norman Wisdom (left) and Al Read

1954

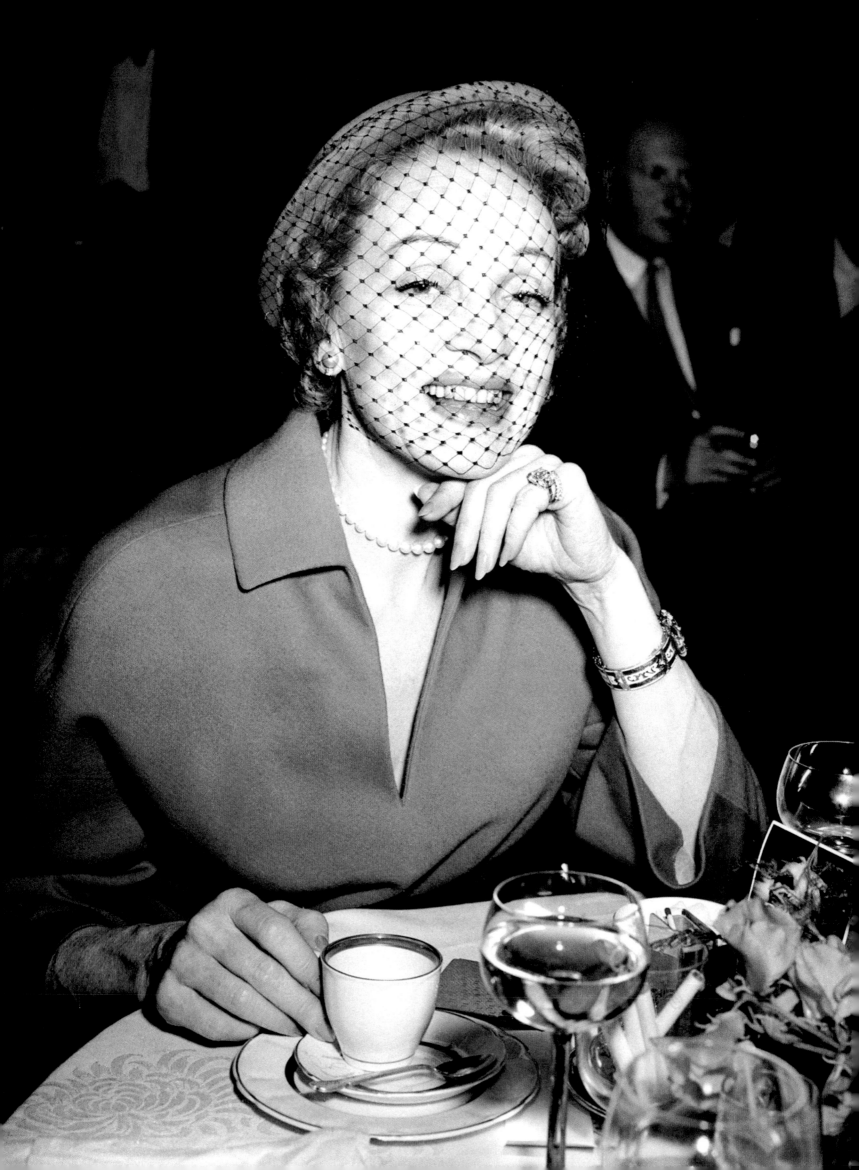

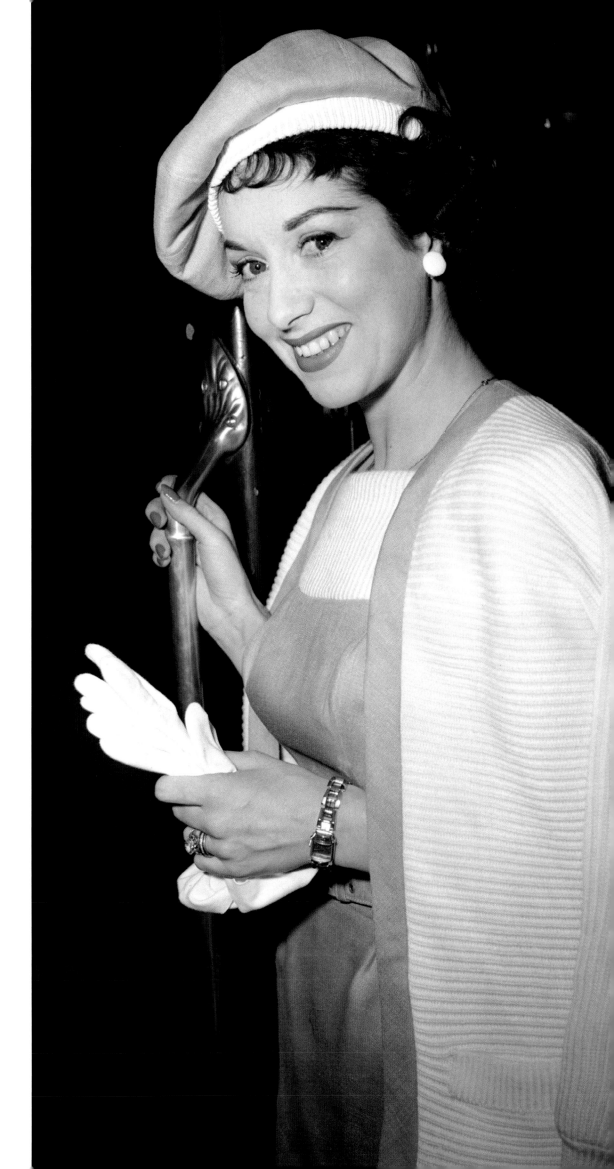

LEFT: MARLENE DIETRICH
IN A CAFÉ IN LONDON
1954

RIGHT: ACTRESS
PAT KIRKWOOD AT
LONDON WATERLOO
STATION BEFORE BOARDING
THE BOAT TRAIN
TO NEW YORK
1954

PETULA CLARK INVESTIGATING
A WATCH TIMER AT THE BRITISH
INDUSTRIES FAIR AT OLYMPIA
1955

SPRING FASHION
BY DIGBY MORTON
1955

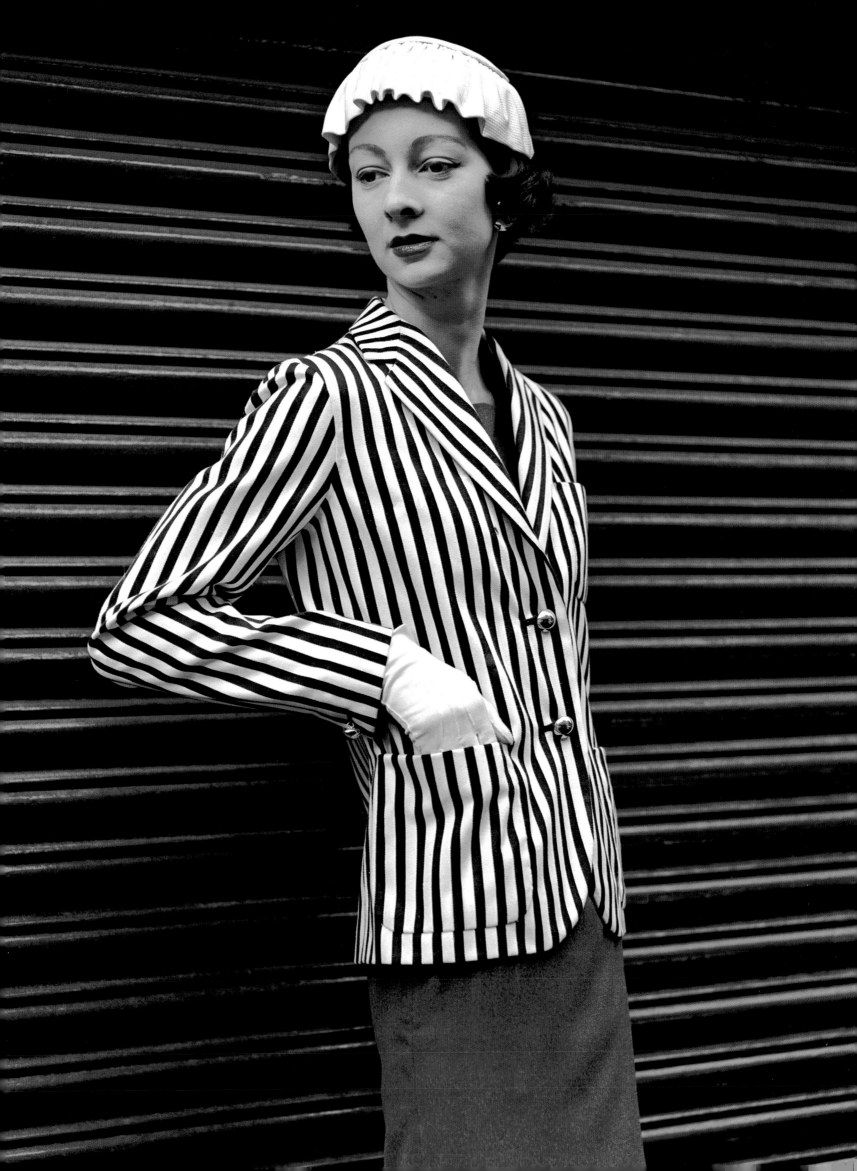

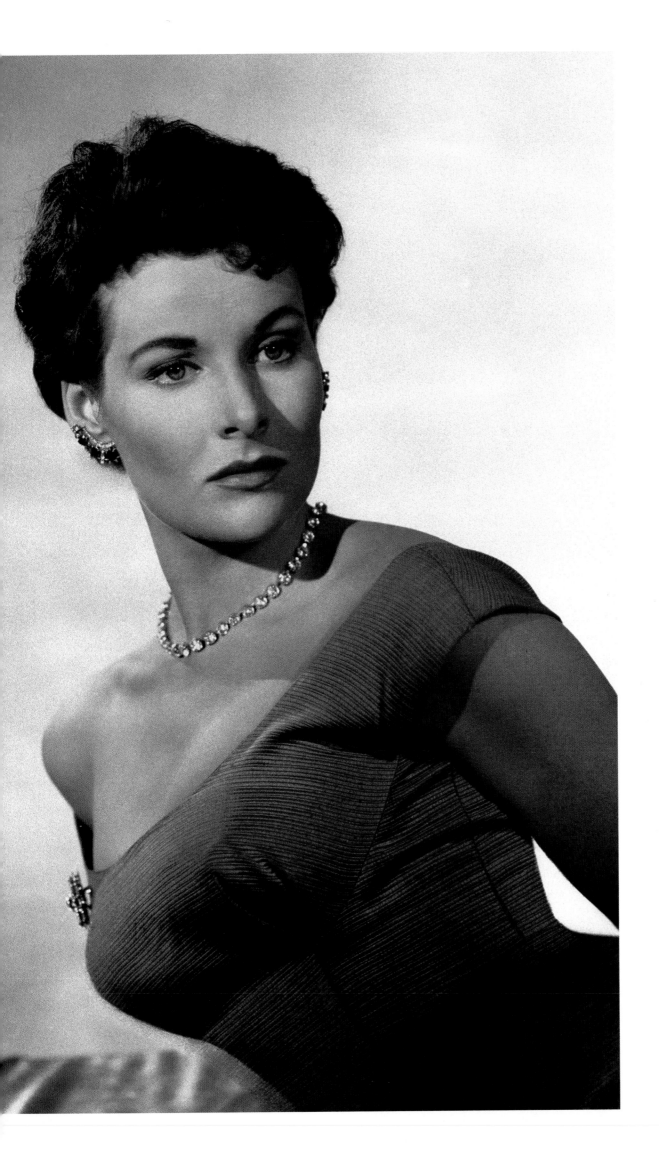

LEFT: FILM STAR
ADRIENNE CORRI
1956

RIGHT: ACTRESS
SYLVIA SYMS
AT HER WEDDING
TO ALAN EDNEY
IN LONDON
1956

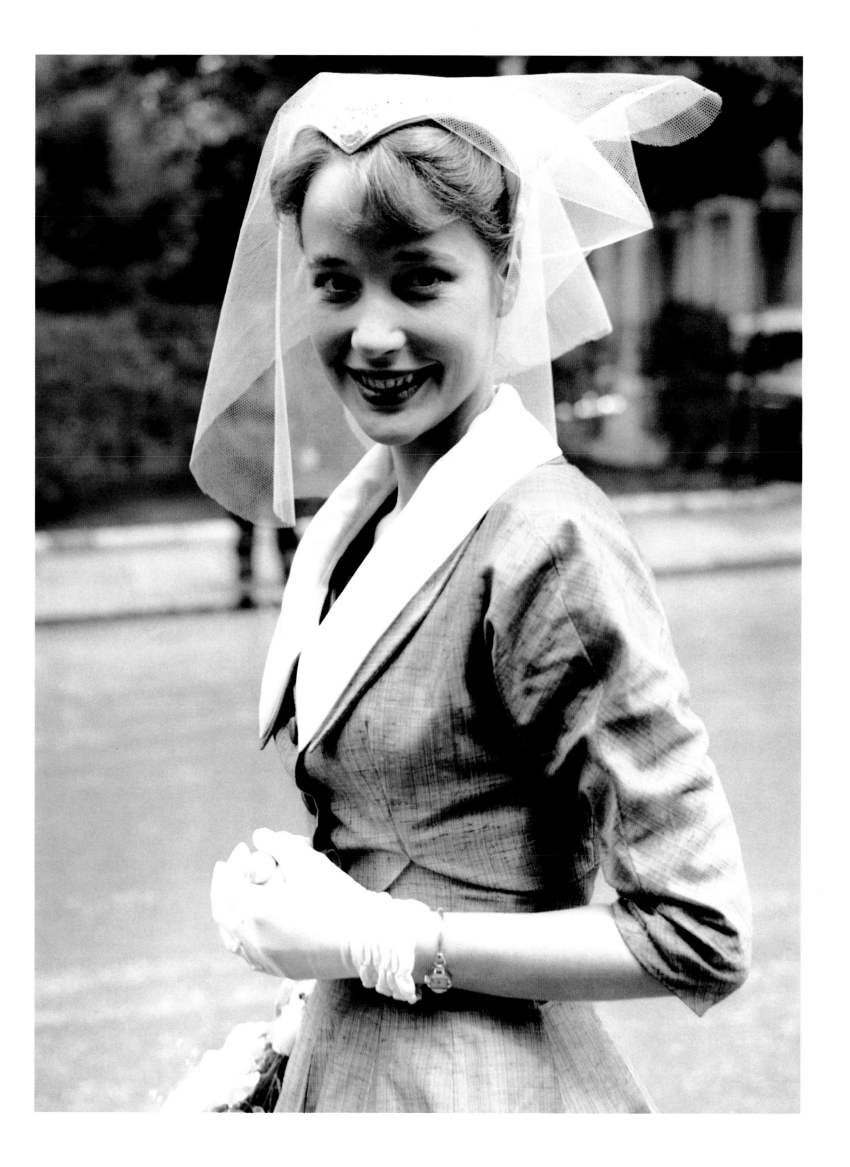

ROMANCE
AND
REVOLUTION:
THE 1960s

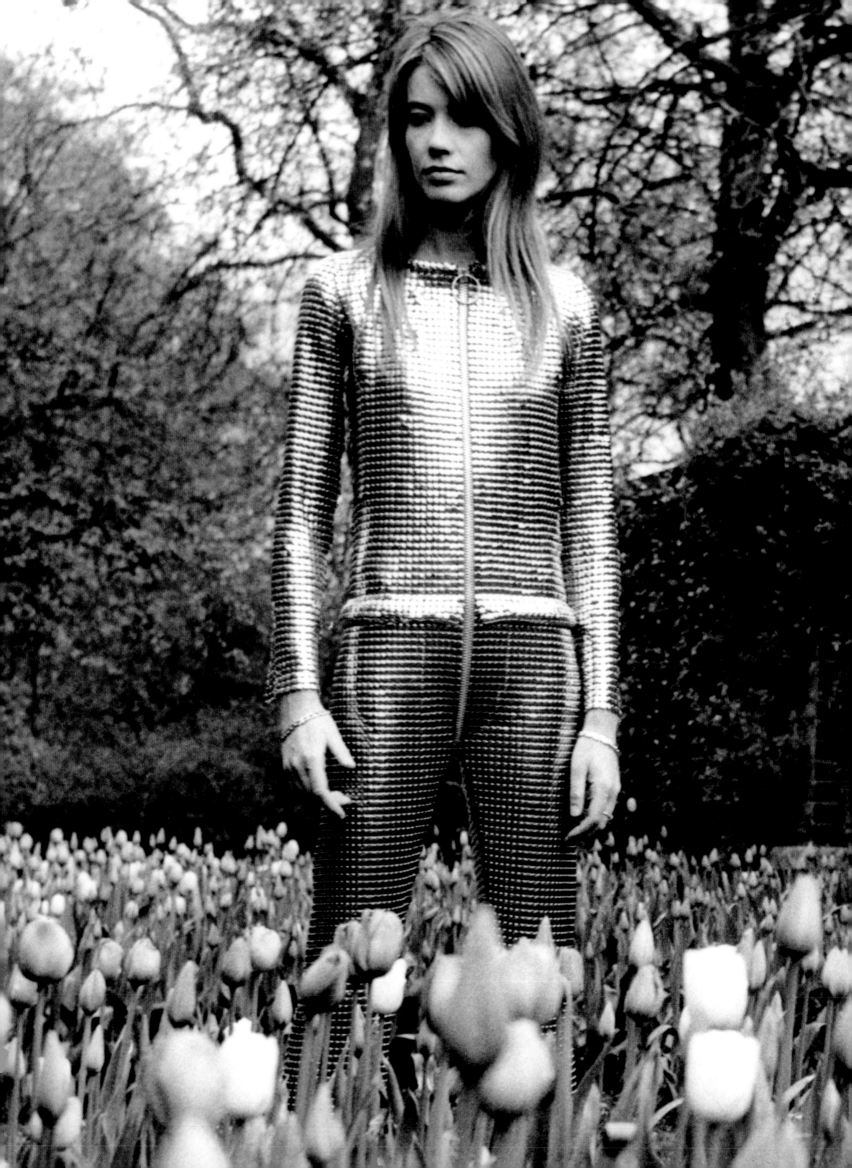

IN THE LAST 100 years there has been no decade quite like the 1960s. It broke all the rules and reinvented the future. And it turned society on its head. It hardly needs to be said that this was reflected in its fashions.

Ostensibly a time of great liberation, it gave birth to a youth culture that was to become all-embracing in the decades that followed. The Beatles, Flower Power, the Vietnam War. The trouser suit, the mini skirt, the maxi dress. The Rolling Stones, free love, Mary Quant. And at the heart of it all was Swinging London.

No longer did young women dress like their mothers. With growing affluence and consumerism, boutiques blossomed everywhere, dedicated to youth. Short skirts got shorter and long hair longer; sexuality grew out of the ashes of the respectable '50s and flaunted itself. Women had found freedom.

Or had they? Dolly birds and bunny girls — as fast as women were shedding their clothes, they were caught in a trap of sexuality. With the availability of The Pill they avoided the unwanted pregnancies of their forebears but found that free love didn't always live up to its promises. They had to reinvent a whole new set of emotional rules.

The decade was, in many ways, a time of deep contradiction. While the young pledged themselves to a life free of the constraints they had seen their parents live under, they were left with an underlying instability that saw the beginning of the breakdown of the family and an increasing drug problem. While the decade adopted aspects of Victoriana, it rejected many of its ideals. So the demurely dressed, long haired Flower Child was expected to have numerous sexual encounters. And the influence of the wafer thin Twiggy set many women on the road to anorexia.

But, however you view the '60s, they were memorable. Out of the floating chiffon, music festivals and Happenings came the beginnings of a new consciousness. Women found themselves no longer bound by the inevitability of childbearing, higher education was more accessible and labour-saving devices in the home meant that an independent career could be on the cards.

The legacy of '60s fashion can be seen all around us today — a pastiche borrowed by the offspring of parents who were once Flower Children themselves.

PAGE 70: FRENCH SINGER
FRANÇOISE HARDY WEARING
AN ALL-METAL TROUSER SUIT,
WHICH HAD 2,000 LINKS
AND TOOK OVER AN HOUR
TO GET INTO
1968

RIGHT: THE CYCLE SHOW
1960

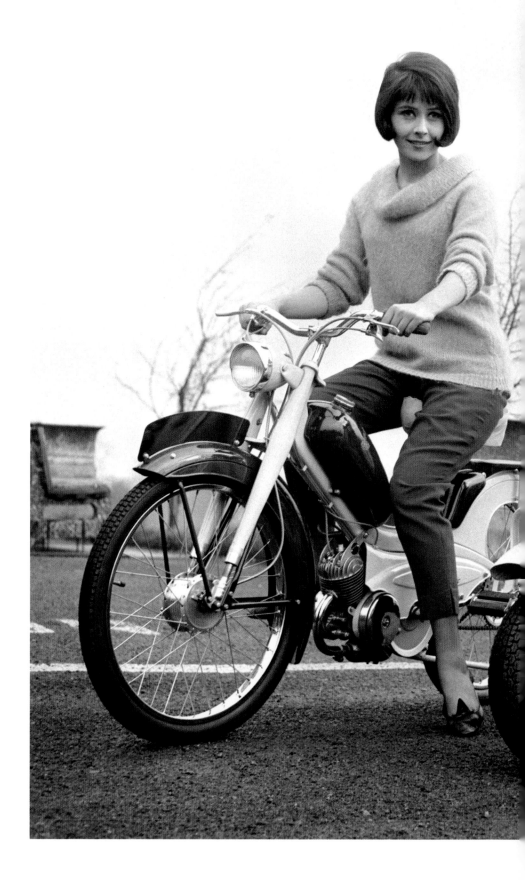

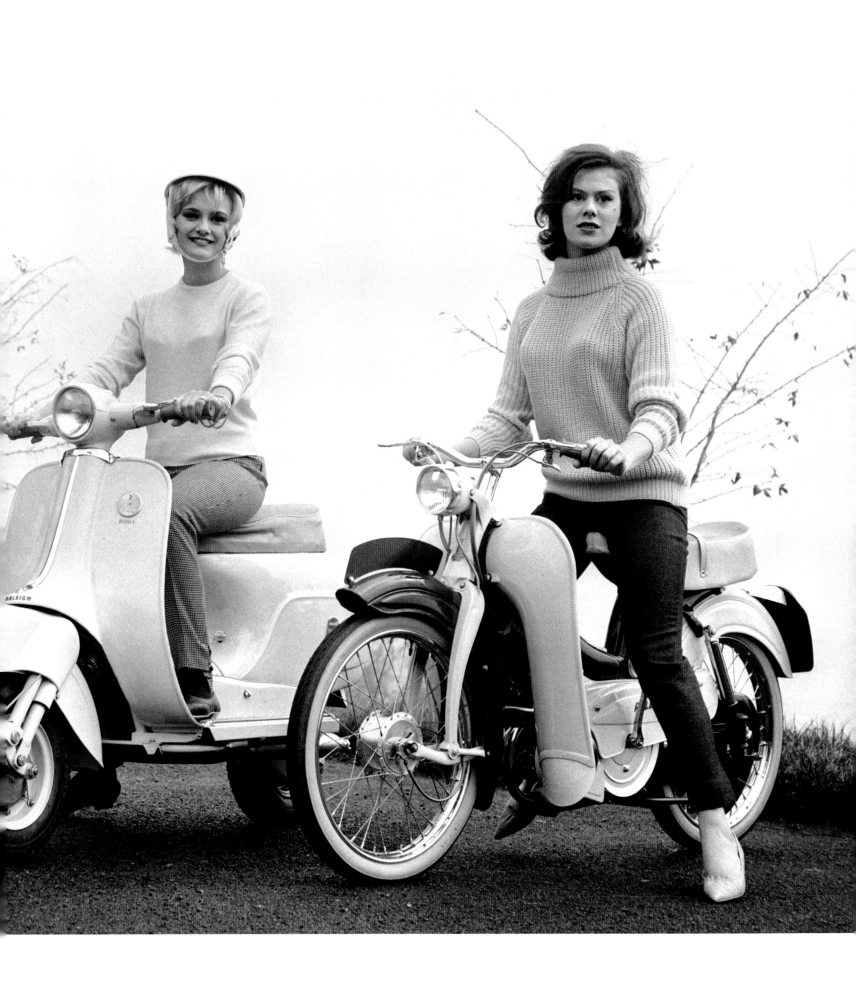

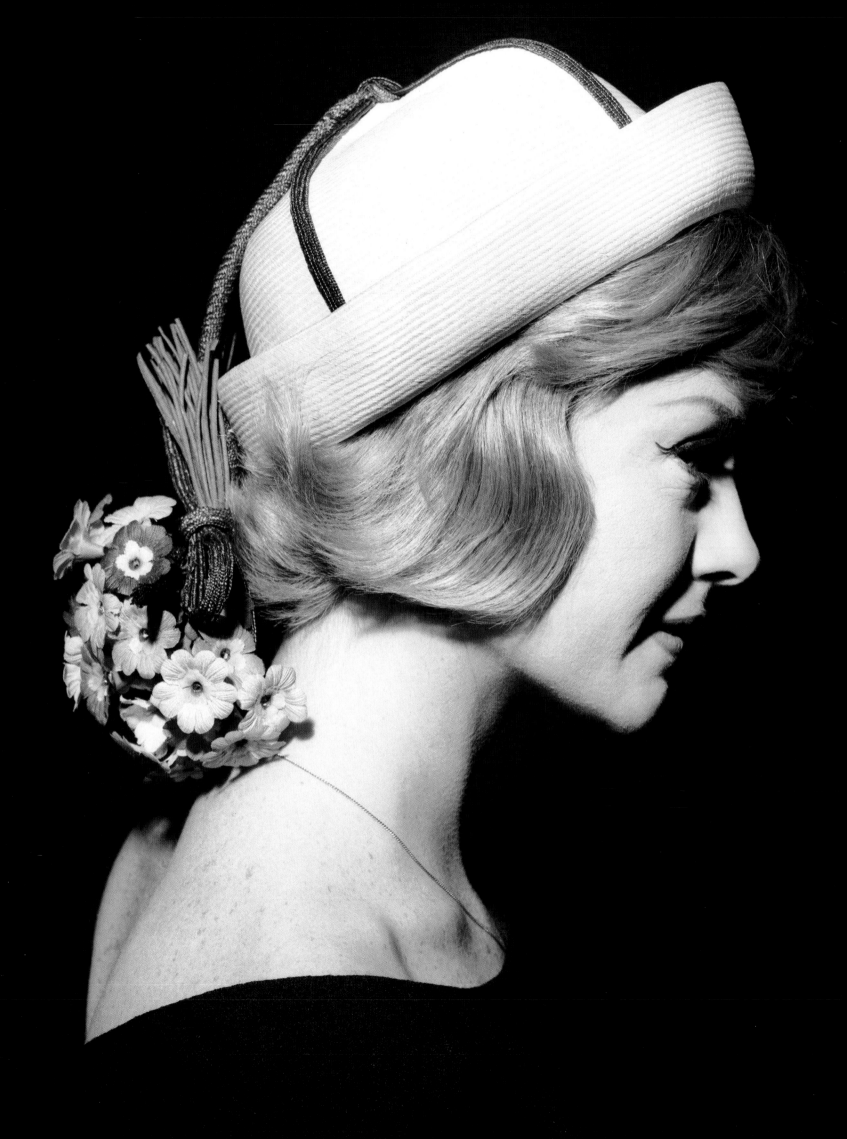

A HAT FROM
THE SPRING COLLECTIONS
1962

CONTEMPORARY FASHION
KNOWN AS WACKYWEAR
1963

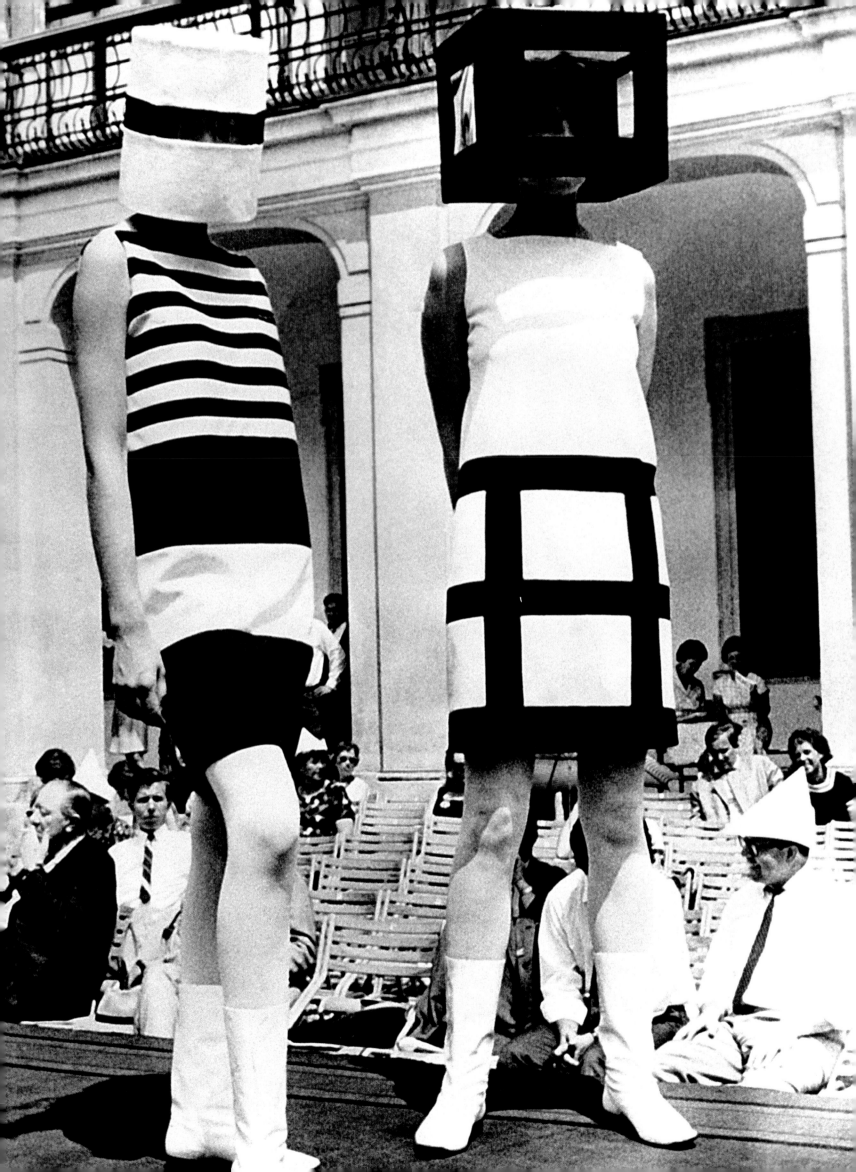

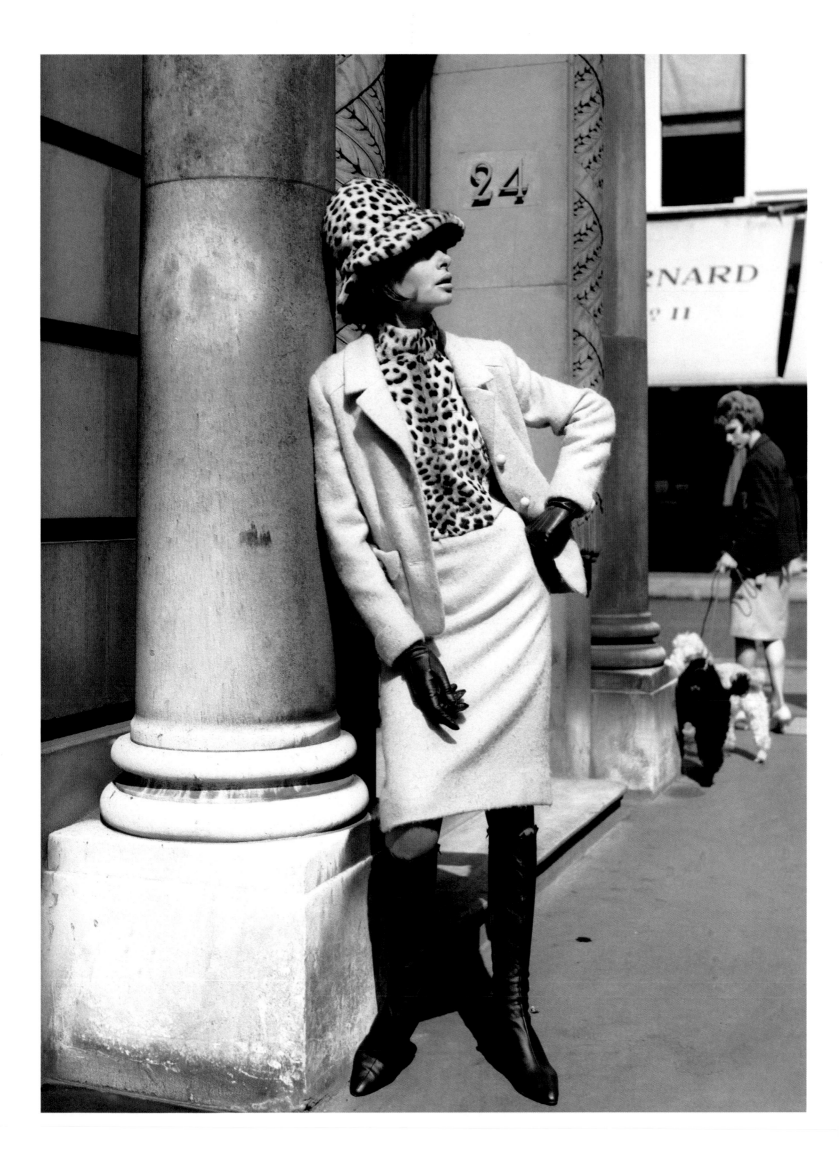

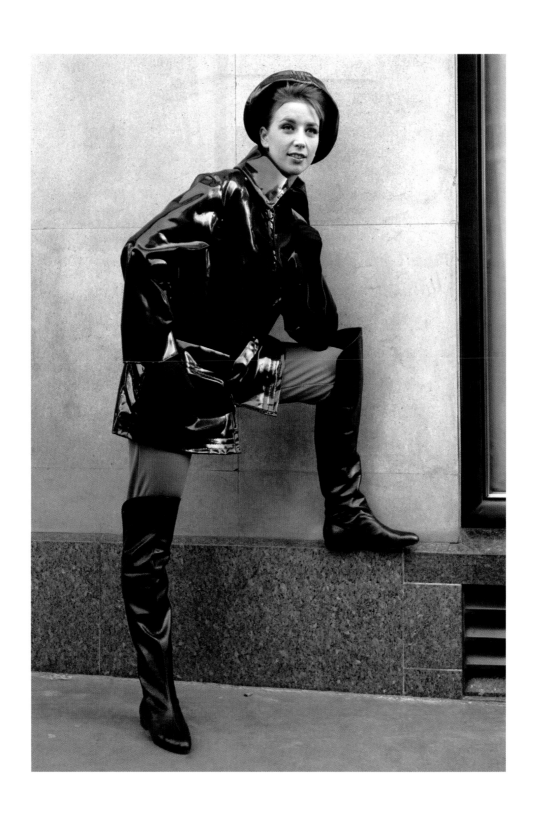

LEFT: SAFARI SUIT

1963

ABOVE: PVC COAT AND THIGH-LENGTH BOOTS

1963

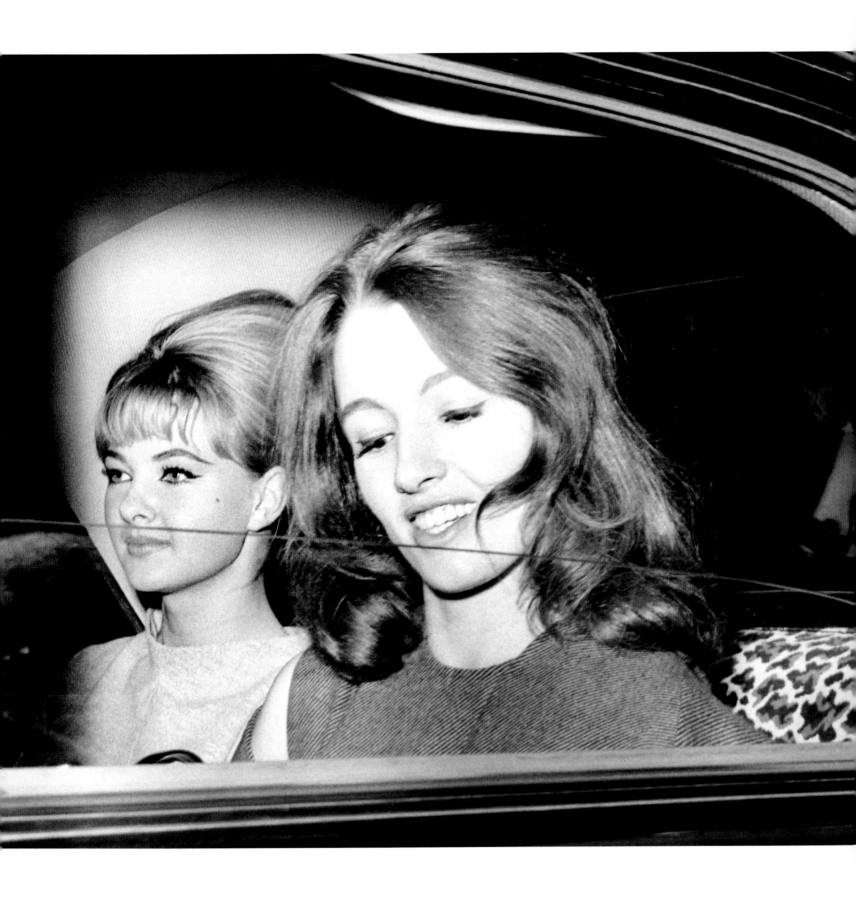

MANDY RICE-DAVIES (LEFT) AND CHRISTINE KEELER
LEAVE THE OLD BAILEY DURING THE TRIAL OF STEPHEN WARD

1963

MANDY RICE-DAVIES

1963

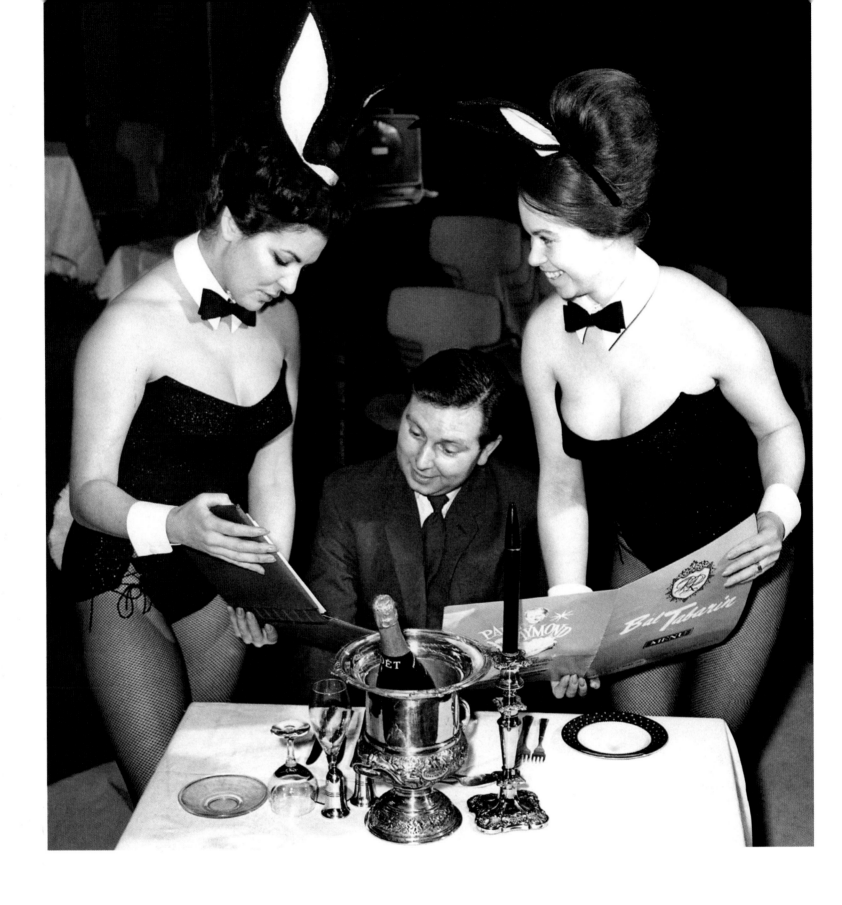

ABOVE: BUNNY GIRLS

1963

RIGHT: A WHITE MINK JACKET WORN OVER A SWIMSUIT

1964

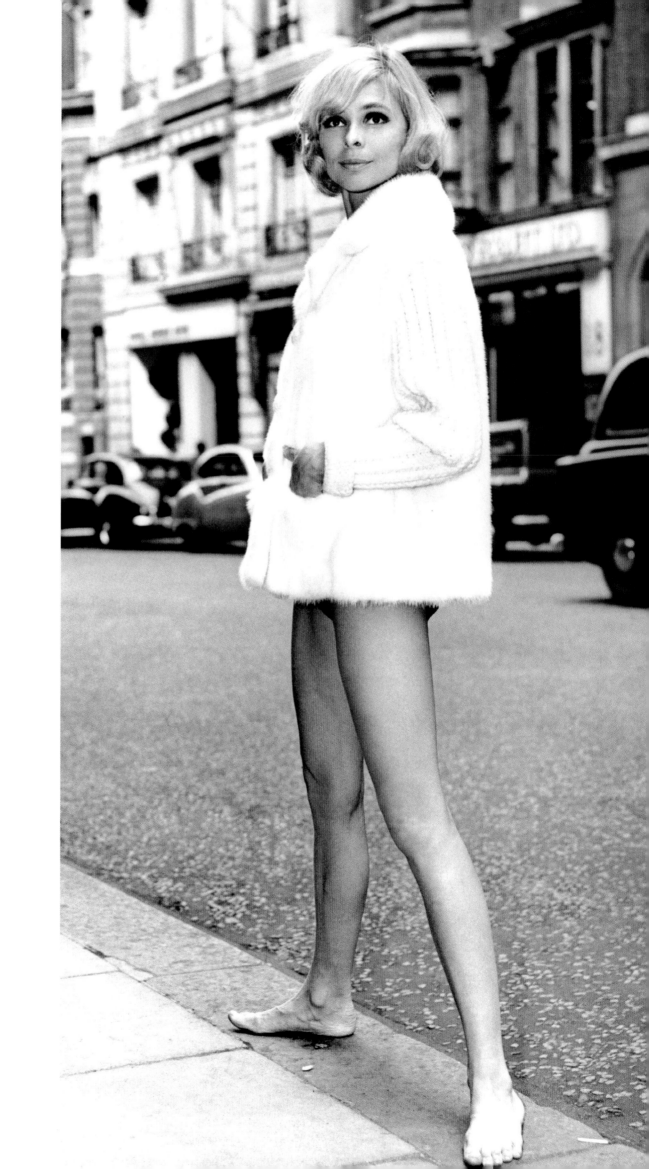

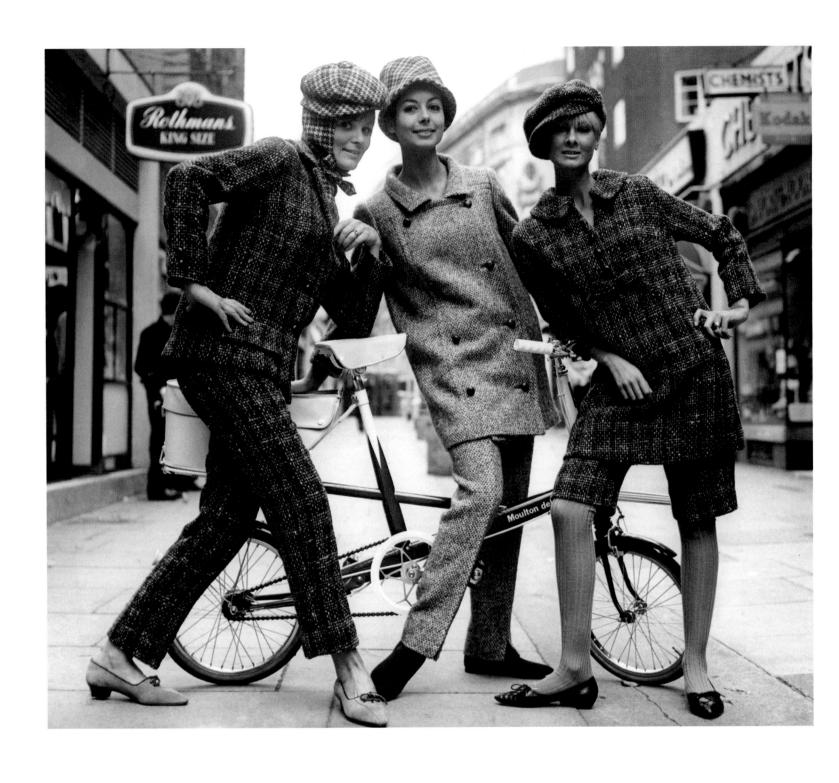

ABOVE: The trouser suit

1964

RIGHT: Fifteen-year-old Scottish singer Lulu

1964

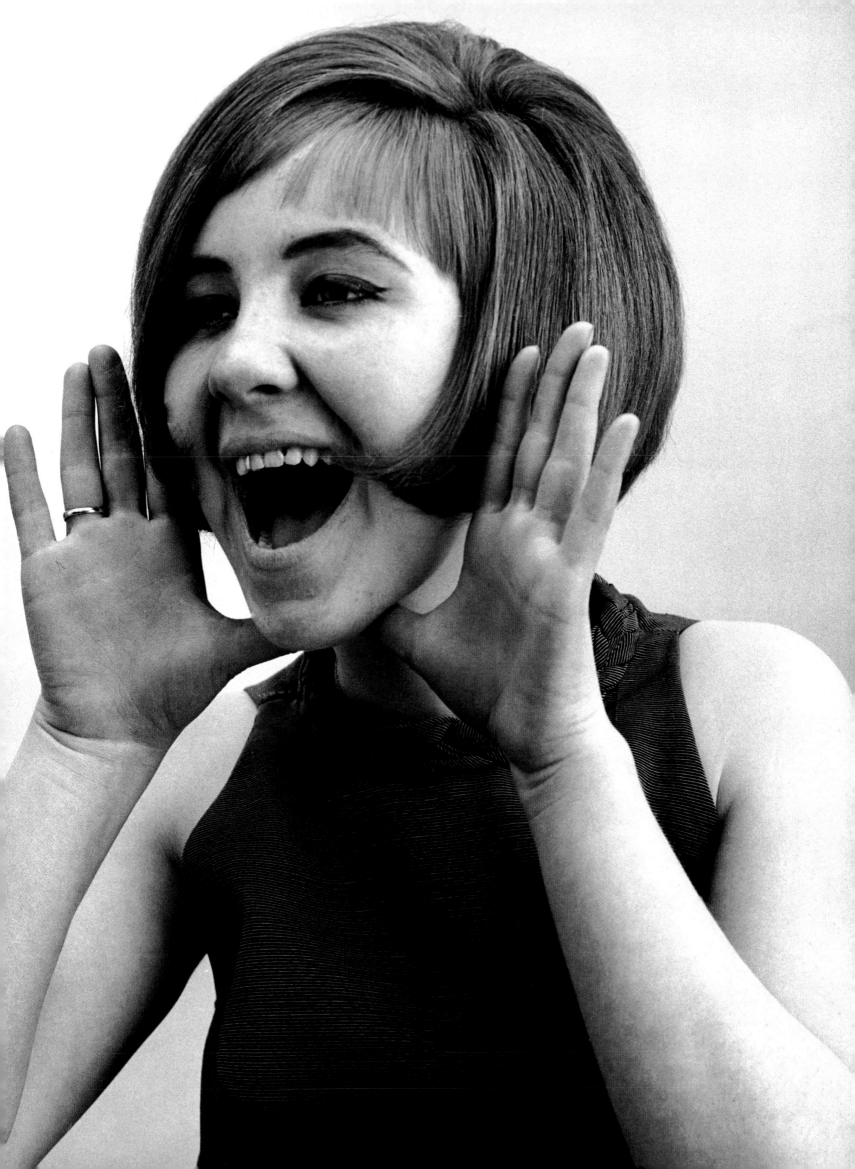

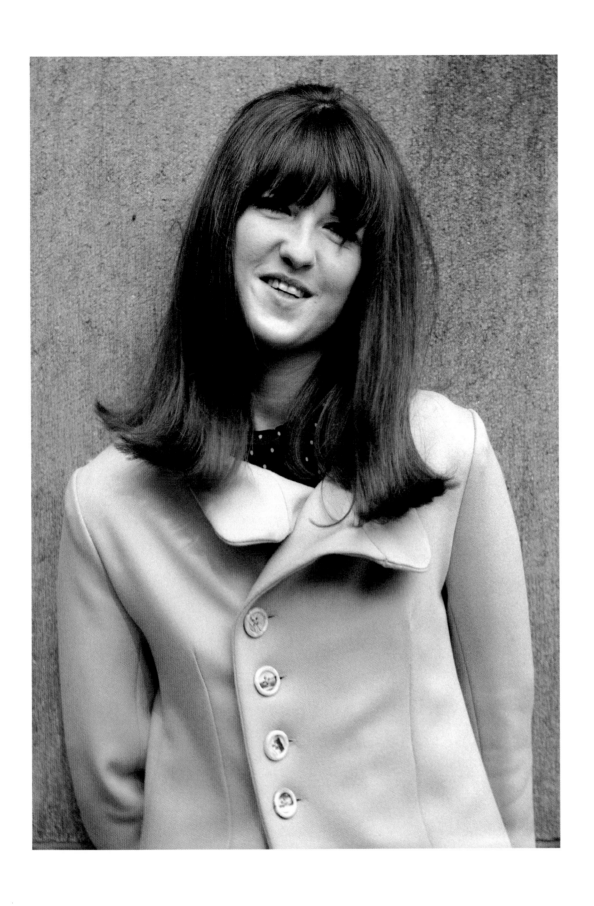

READY STEADY GO PRESENTER CATHY MCGOWAN

1963

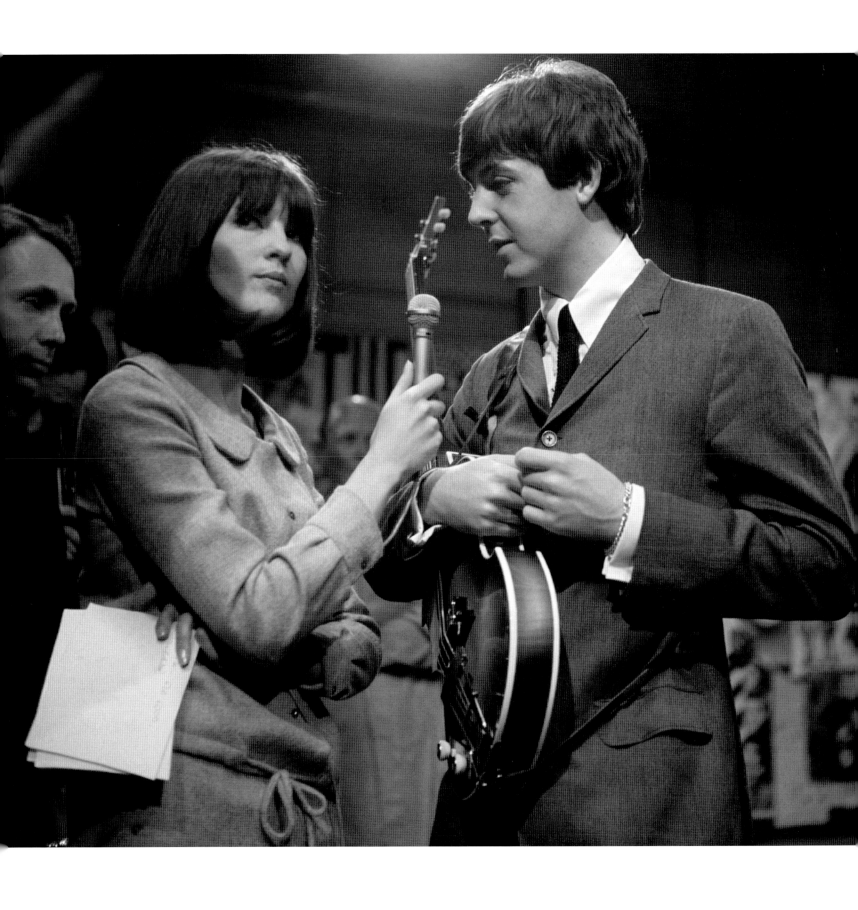

CATHY McGOWAN TALKS TO PAUL McCARTNEY

1964

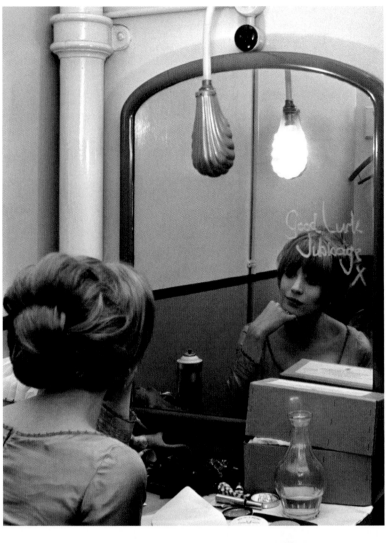

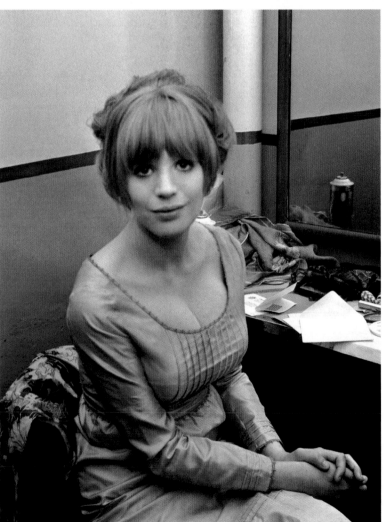

LEFT: Marianne Faithfull

1965

RIGHT: Marianne Faithfull

1966

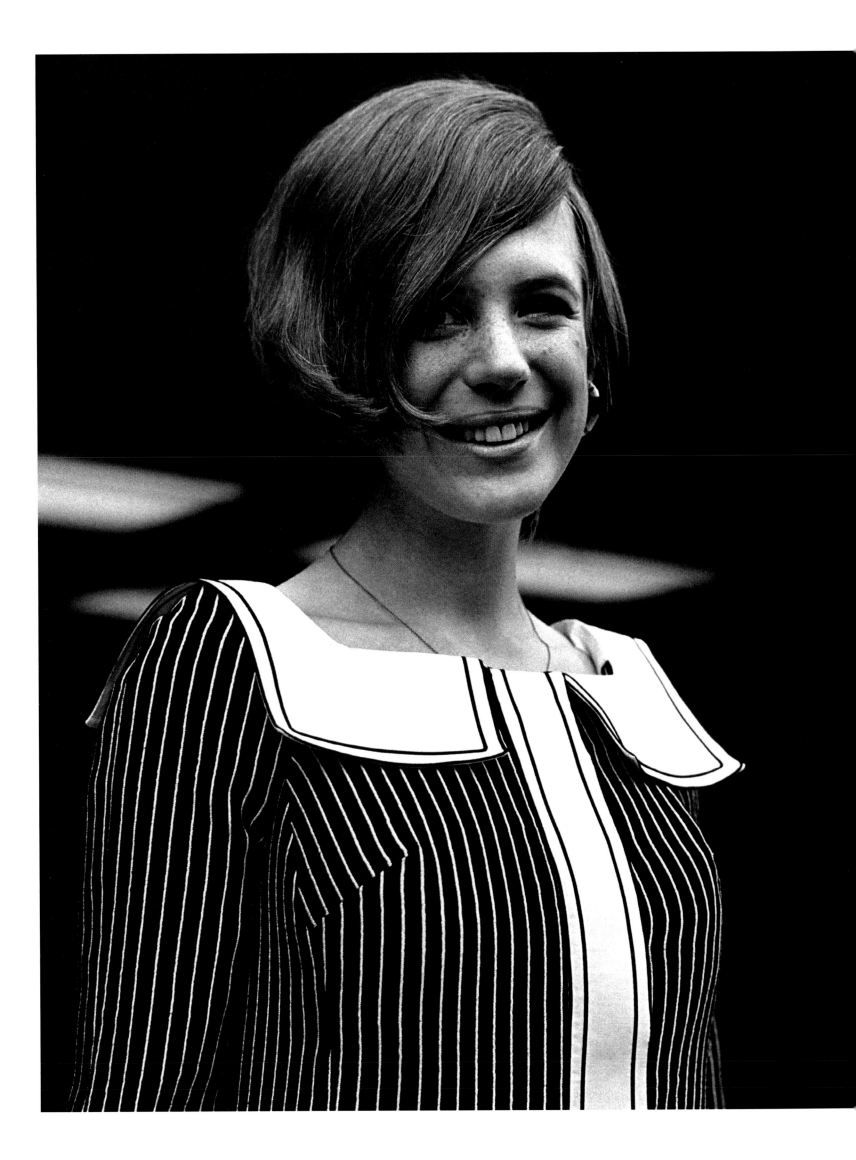

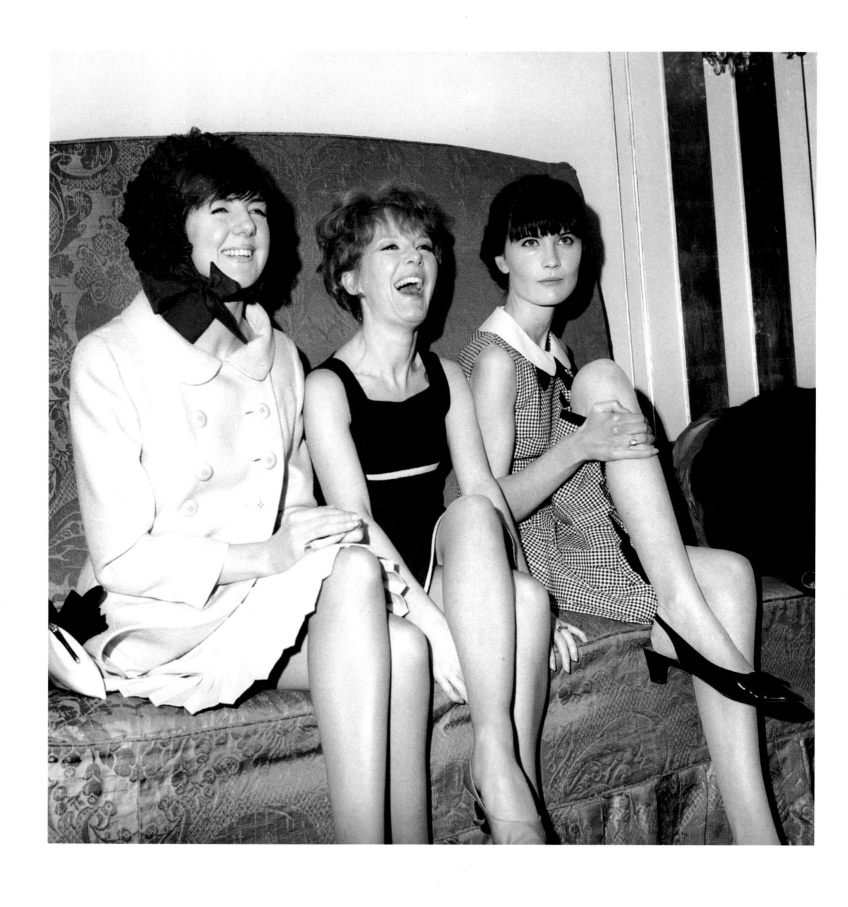

CILLA BLACK, PETULA CLARK AND SANDIE SHAW

1965

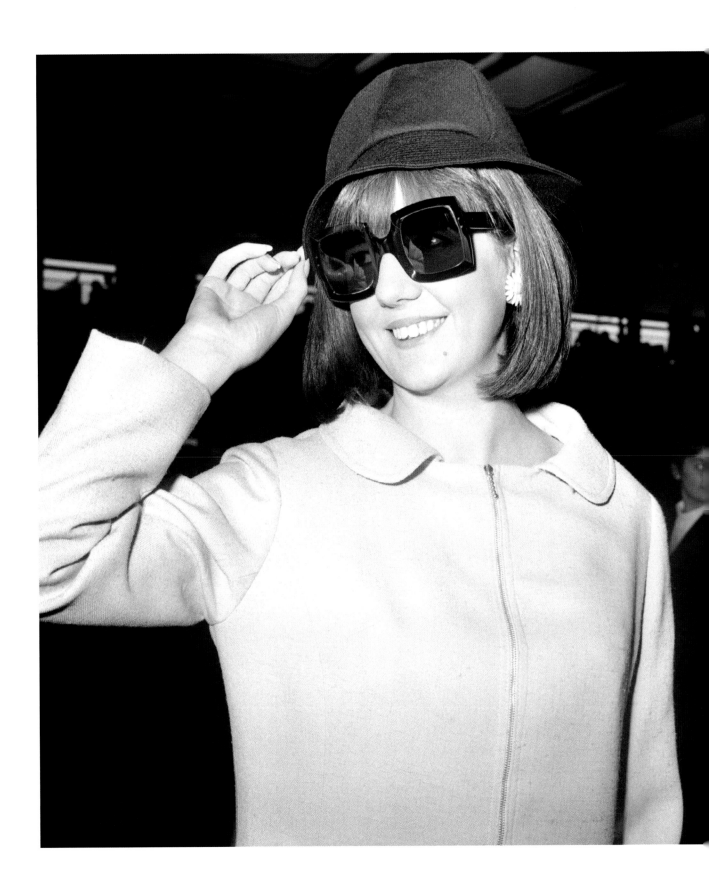

CILLA BLACK
1965

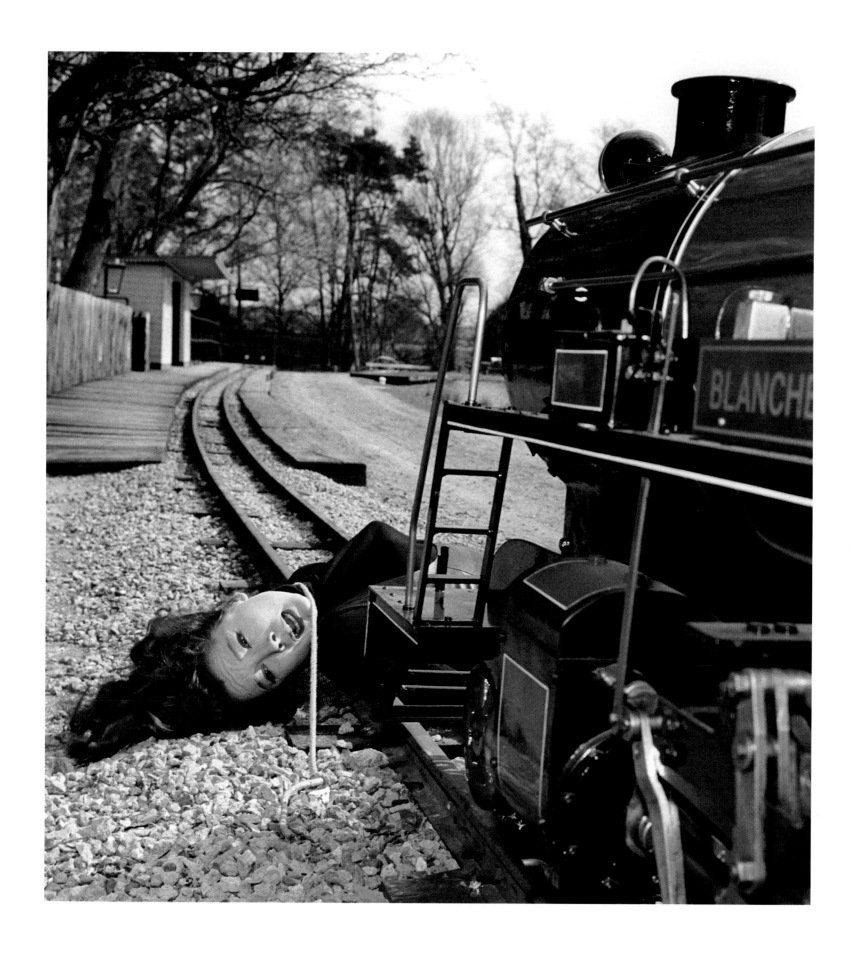

Diana Rigg on a location shoot for the TV series *The Avengers* in which she plays Emma Peel

1965

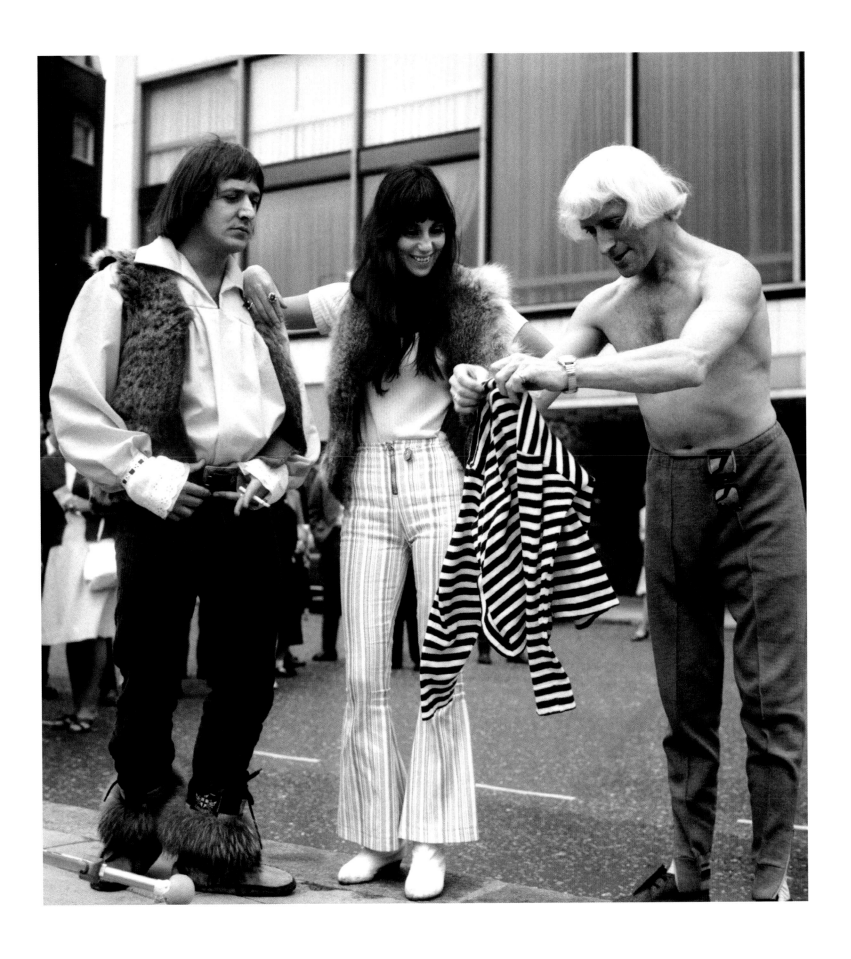

JIMMY SAVILE WITH SONY AND CHER

1965

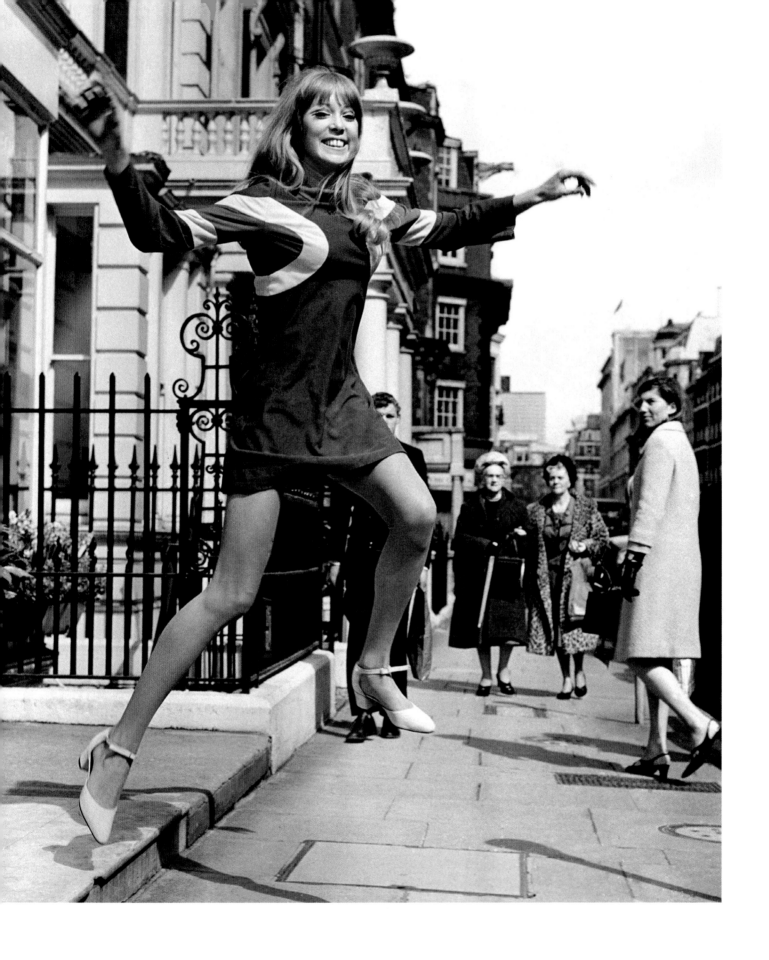

ABOVE: MODEL PATTIE BOYD WEARING OSSIE CLARK
1966

RIGHT: A SCOTTISH KILT LOOK AND A PVC TROUSER SUIT
1966

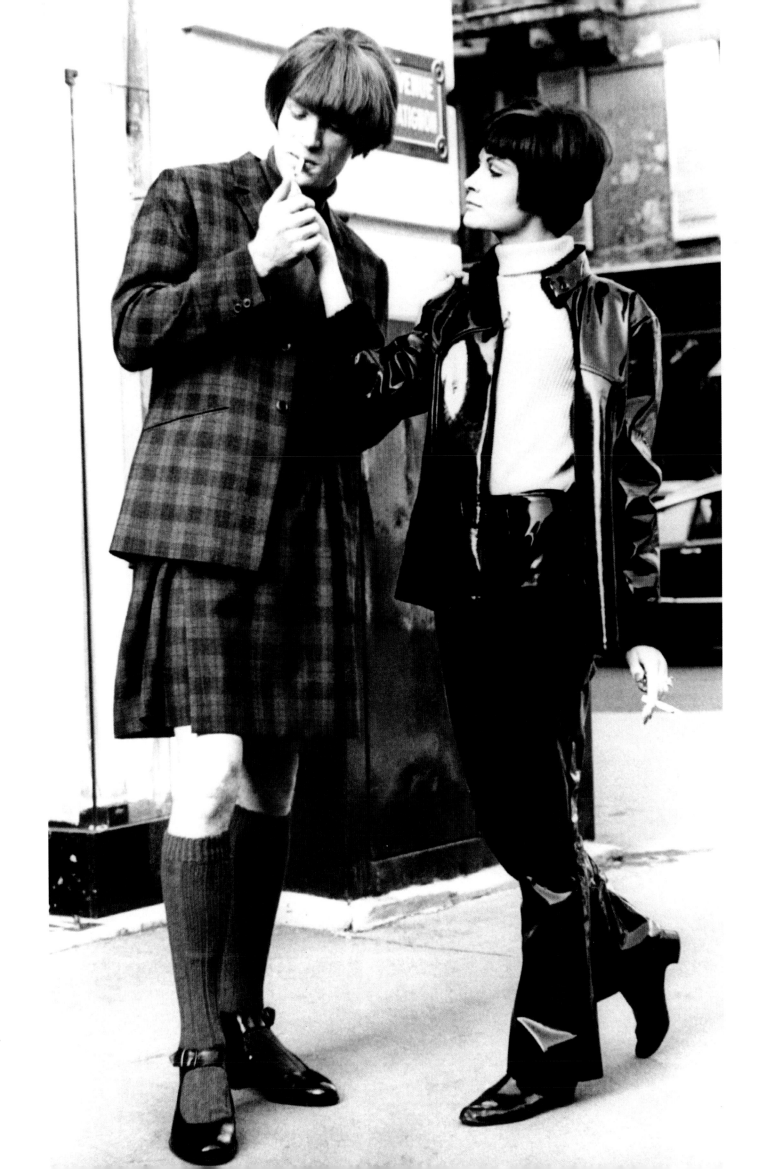

SUPERMODEL JEAN SHRIMPTON
AT HEATHROW AIRPORT
1966

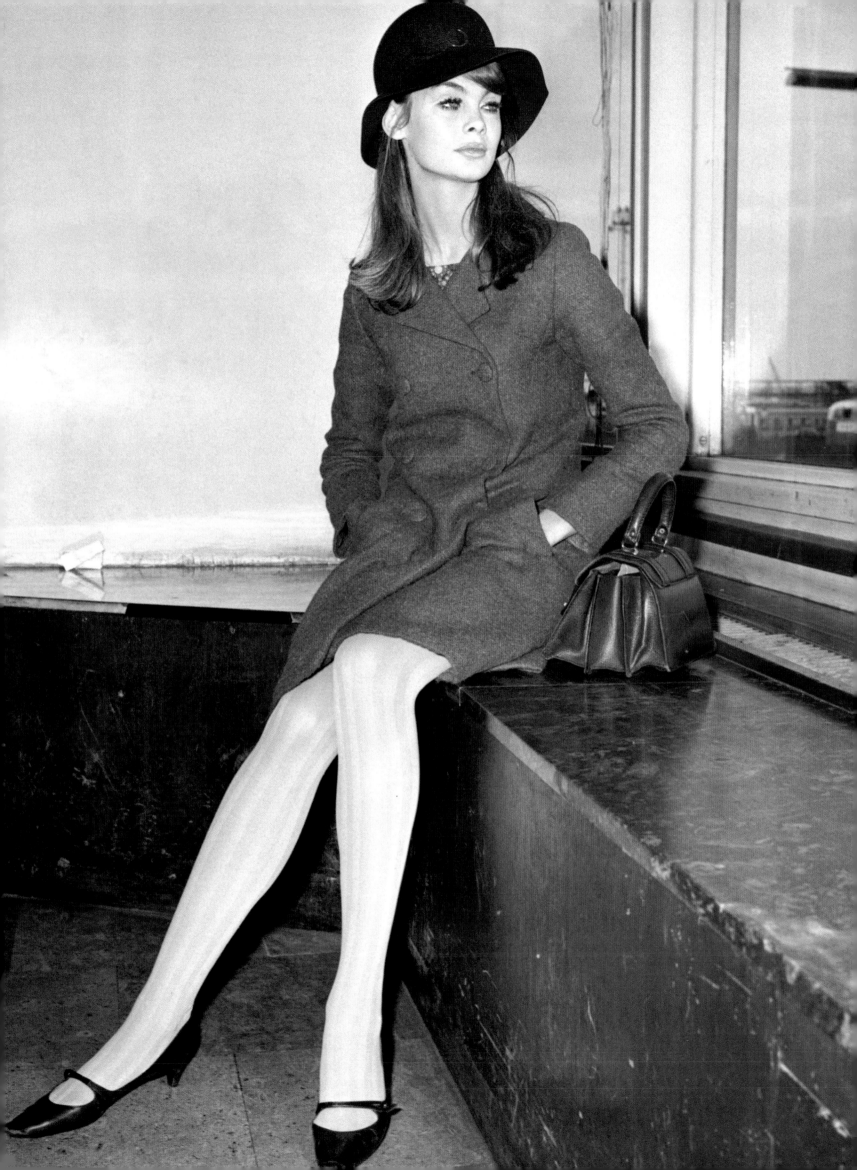

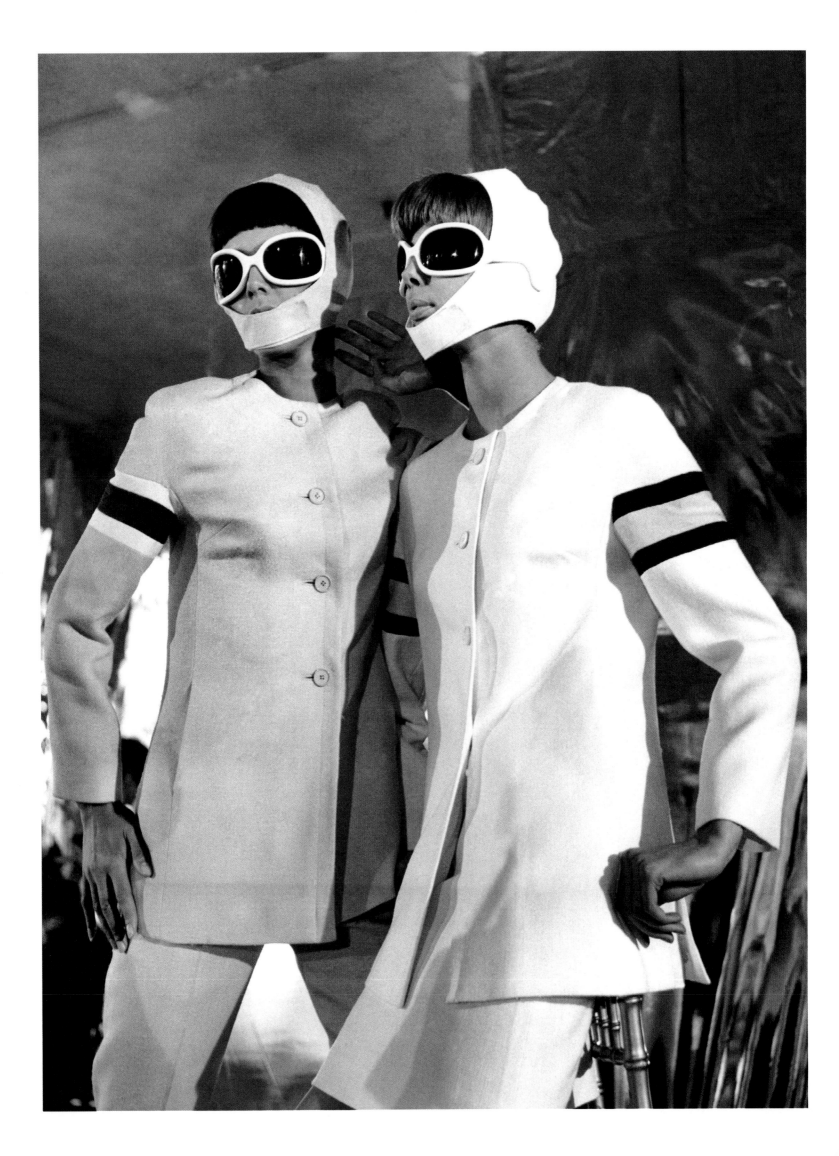

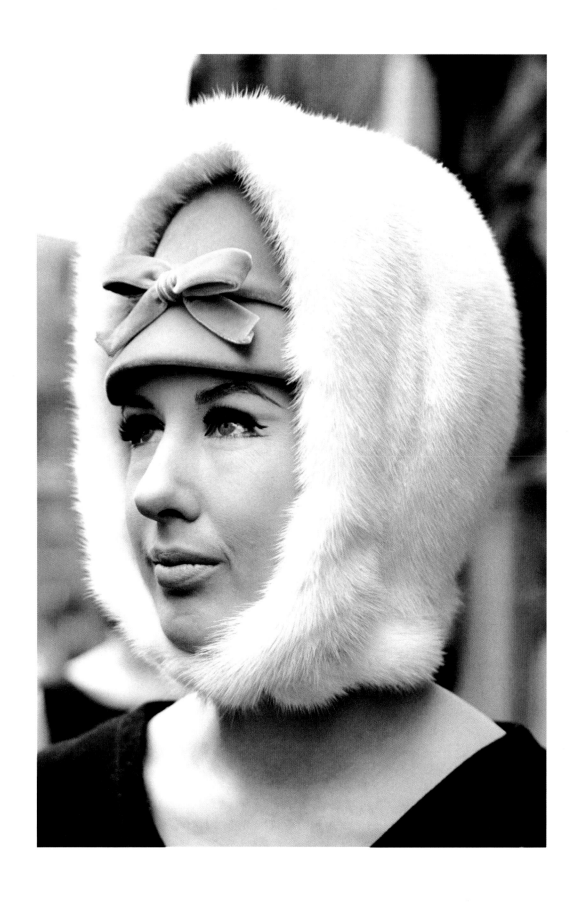

DESIGNS BY THE RELDAN-DIGBY MORTON GROUP

1966

BONNET FROM THE CHRISTIAN DIOR AUTUMN COLLECTION

1966

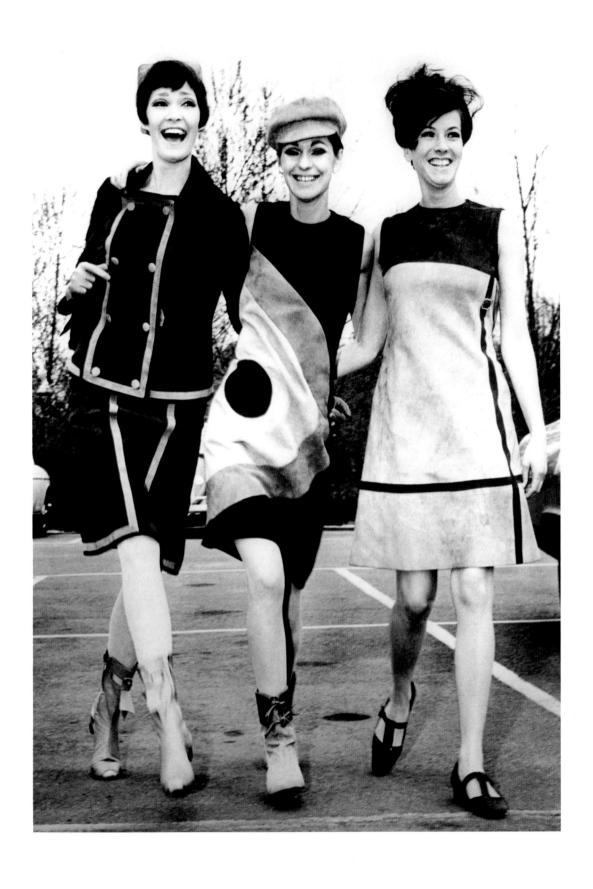

ABOVE: DESIGNS IN LEATHER FOR AUTUMN AND WINTER

1966

RIGHT: TROUSER SUIT

1966

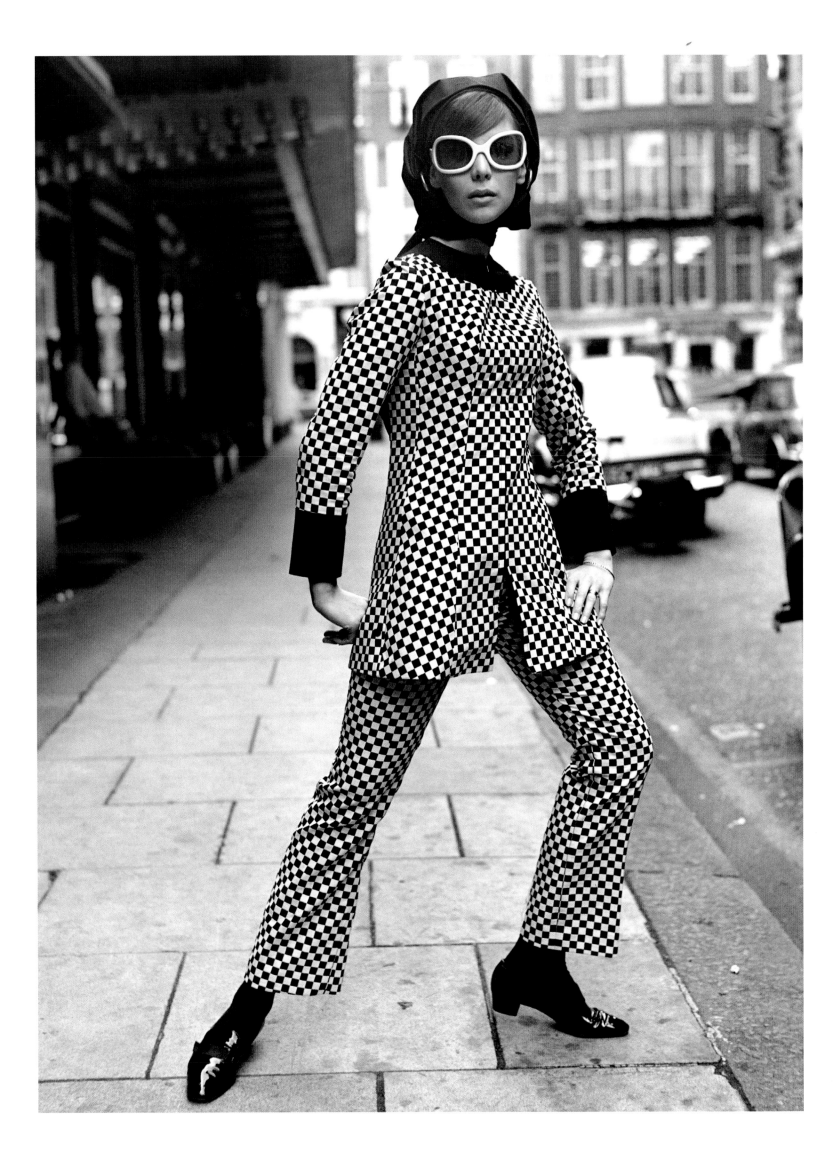

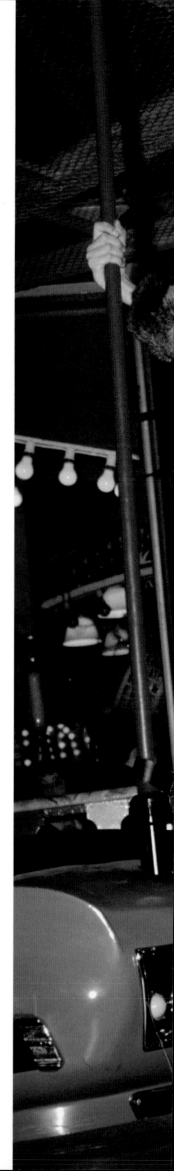

TWIGGY
IN HOT PANTS
1967

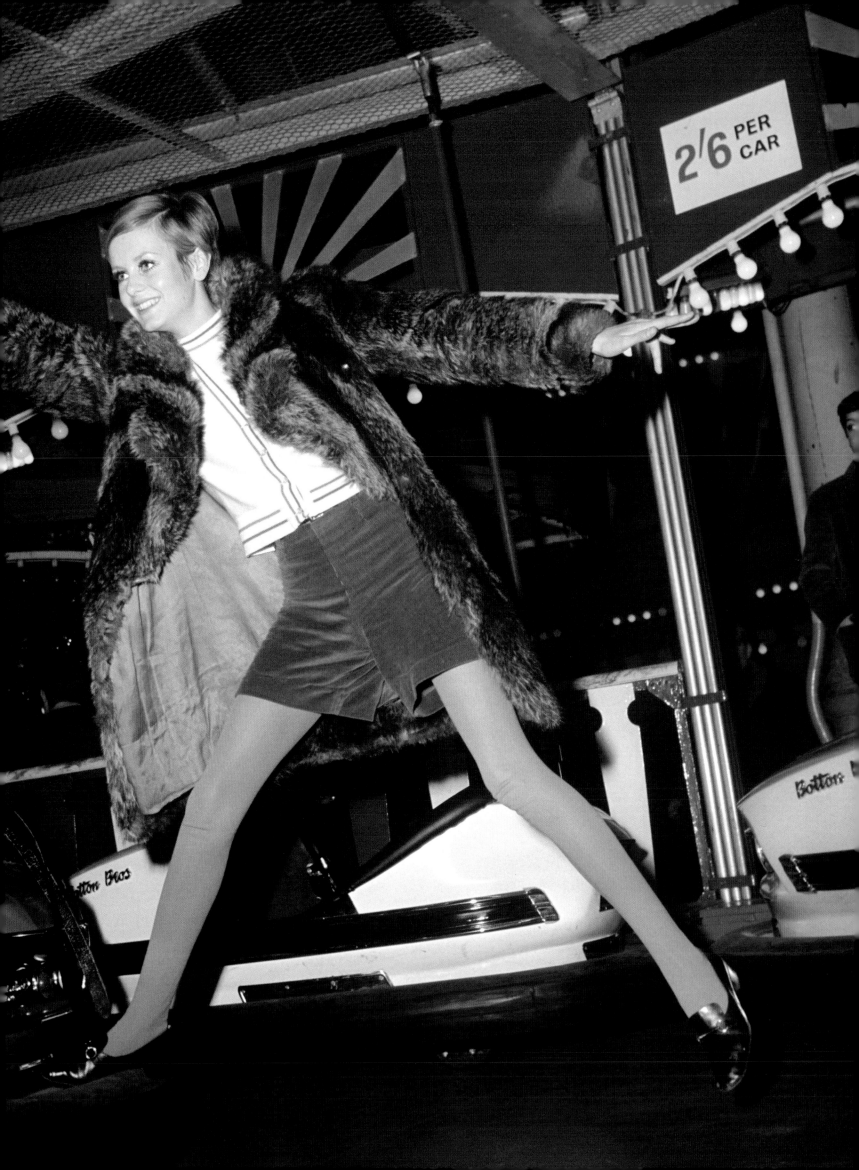

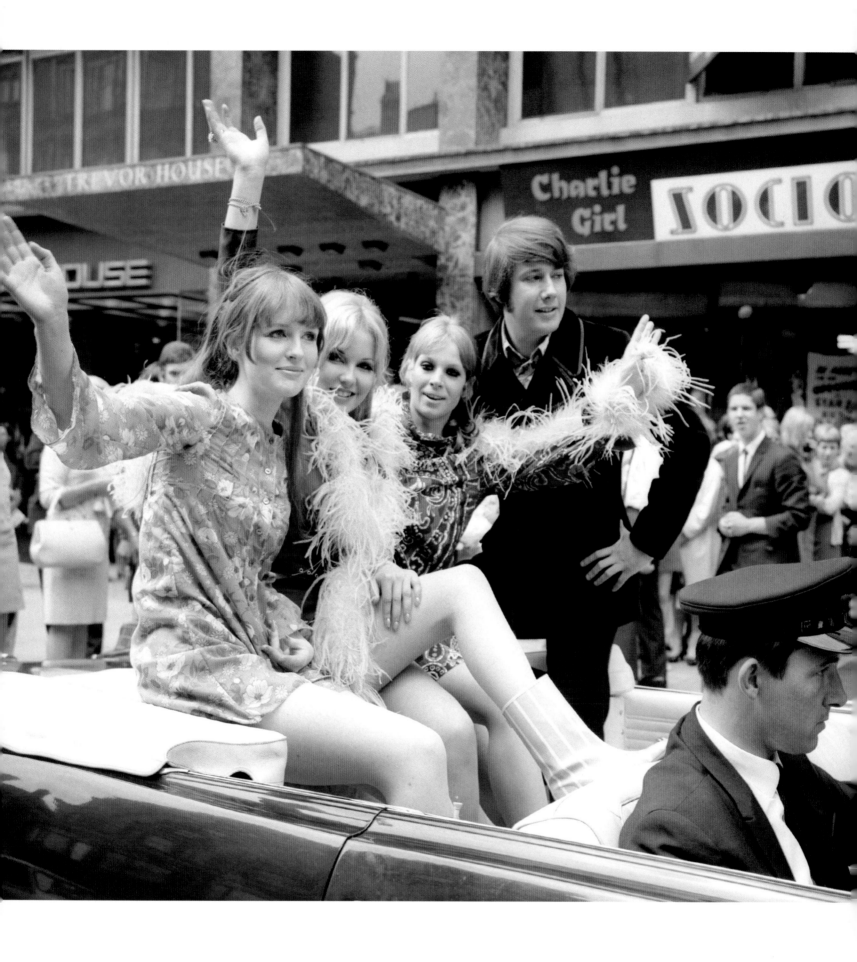

Swinging down the Brompton Road

1967

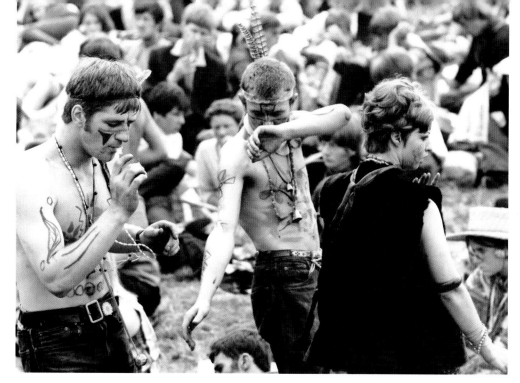

TOP: WOBURN
ABBEY LOVE-IN
1967

MIDDLE AND BOTTOM:
A HAPPENING
IN HYDE PARK
1967

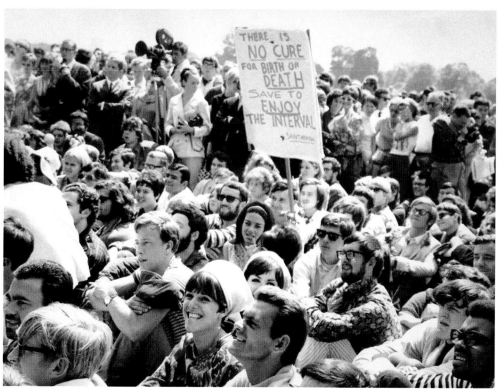

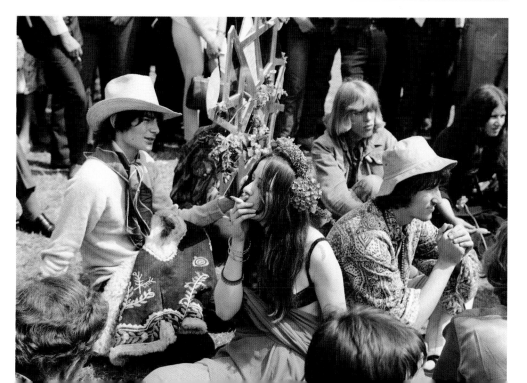

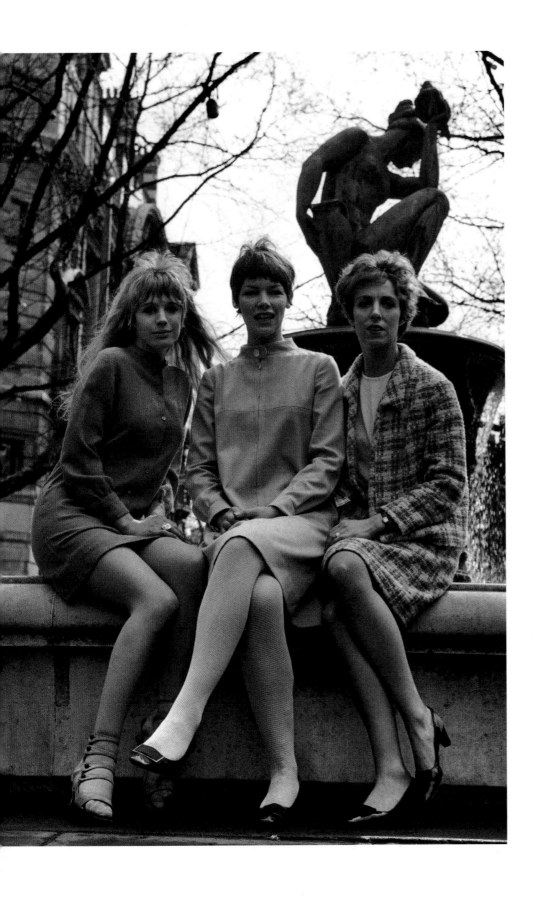

MARIANNE FAITHFULL, GLENDA JACKSON AND AVRIL ELGAR

1967

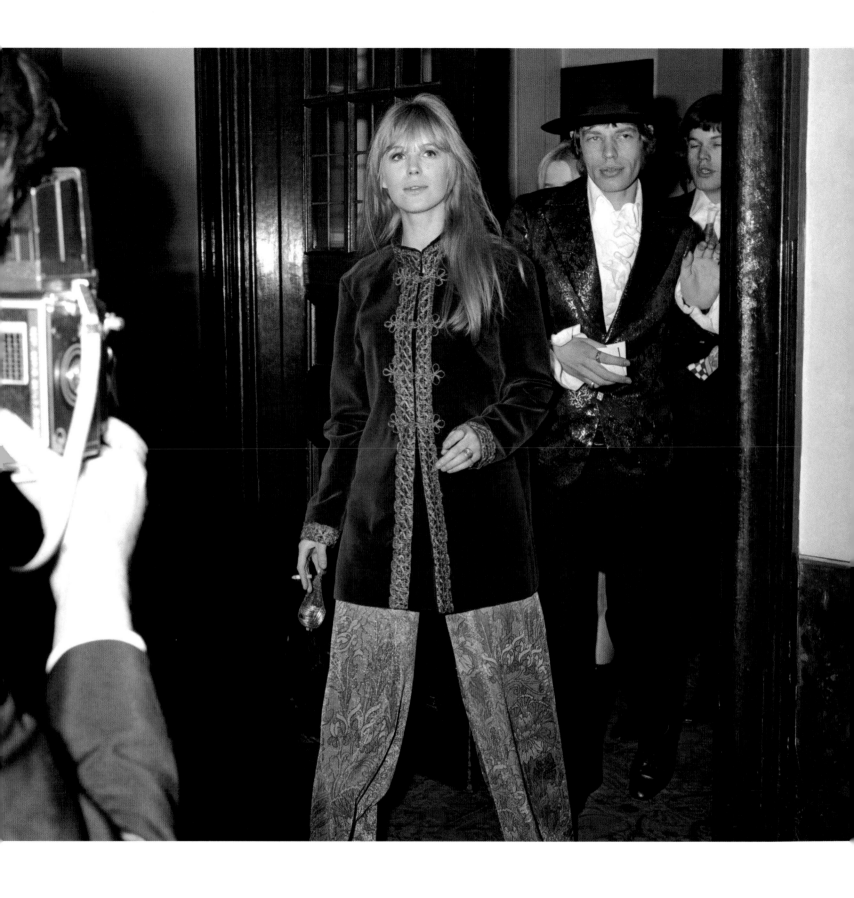

MARIANNE FAITHFULL AND MICK JAGGER AT THE ROYAL OPERA HOUSE IN LONDON

1967

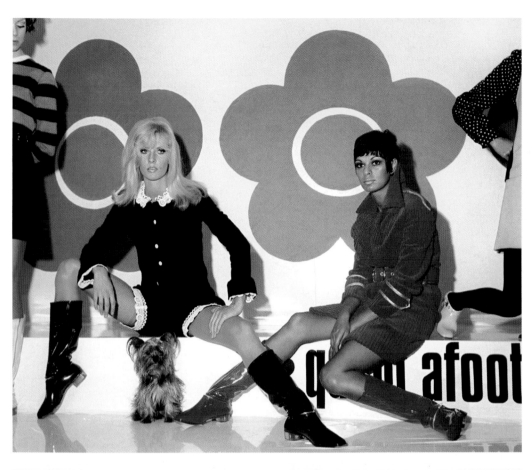

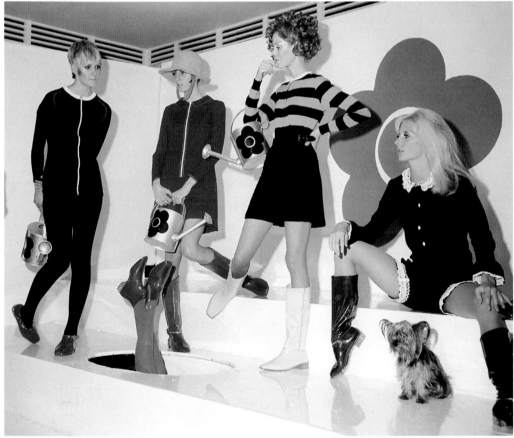

MARY QUANT DESIGNS

1967

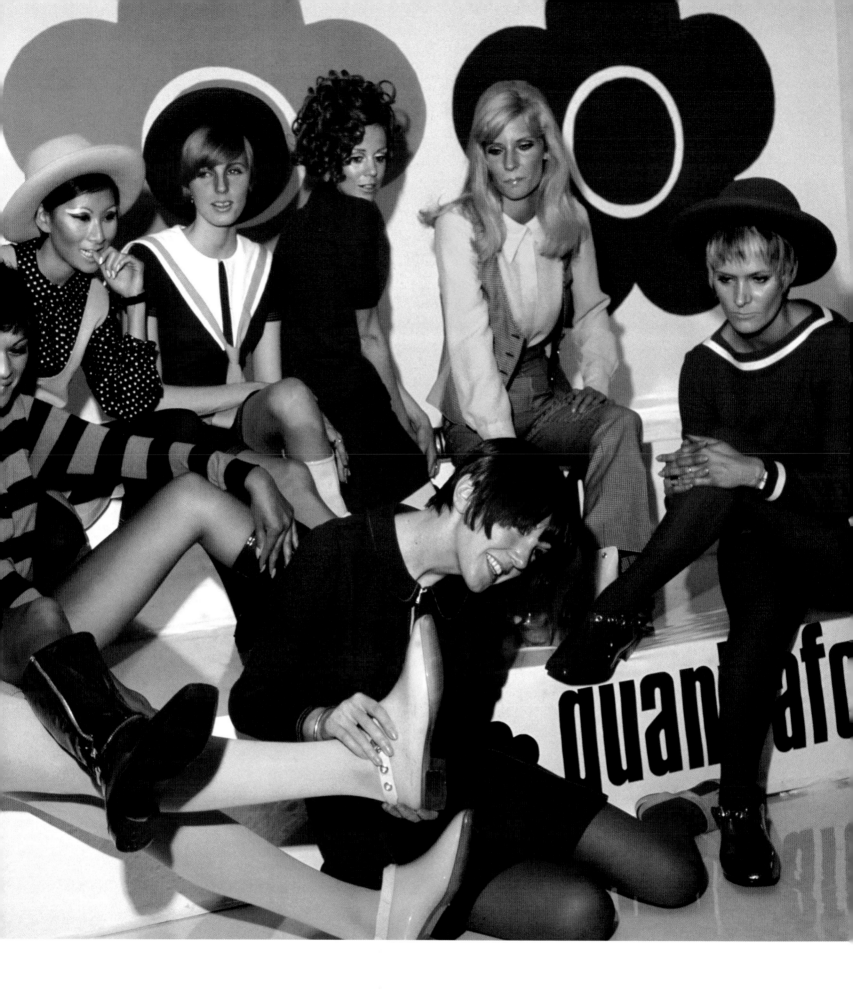

MARY QUANT WITH HER MODELS

1967

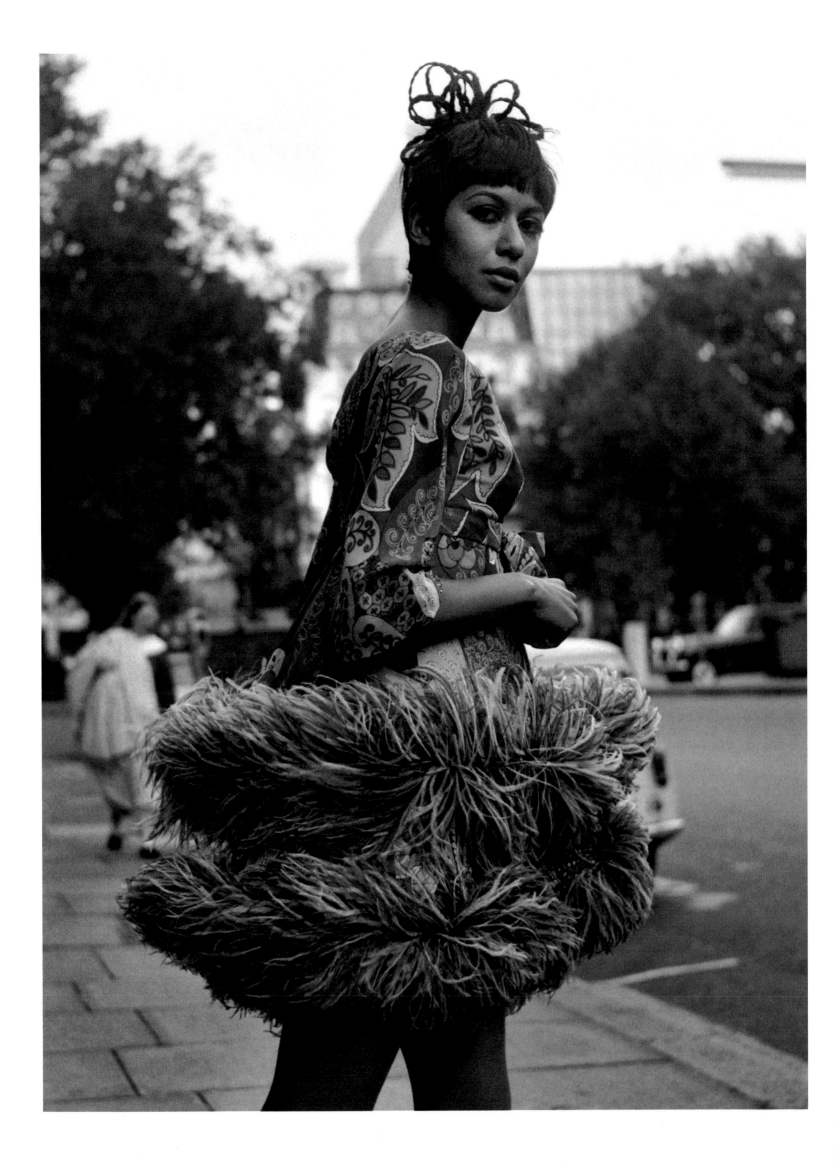

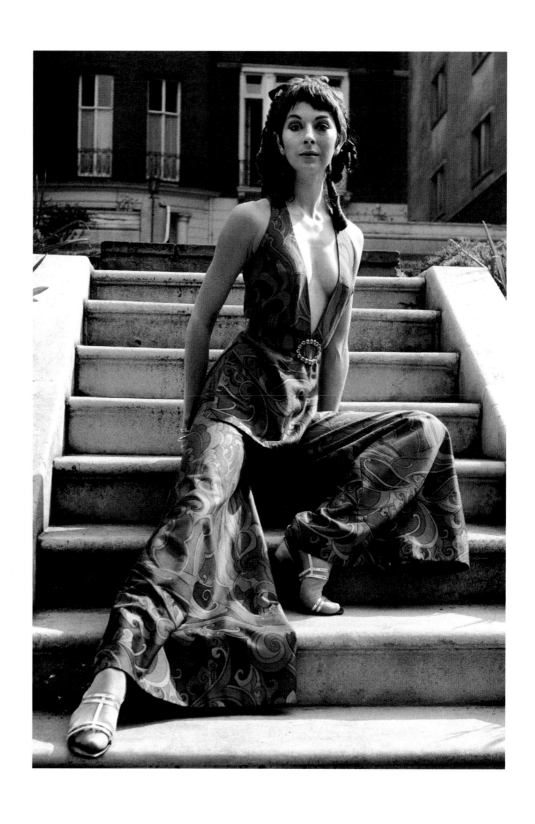

LEFT: PRINTED CHIFFON DRESS WITH OSTRICH FEATHERS

1967

ABOVE: PLAYSUIT

1967

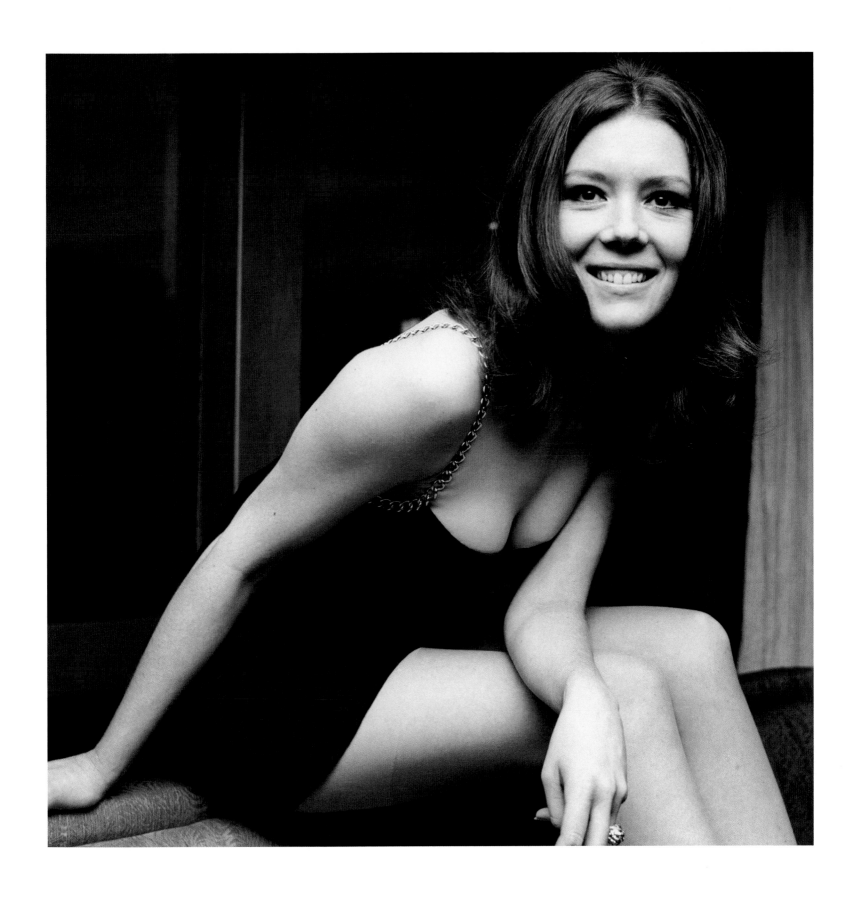

ACTRESS DIANA RIGG

1967

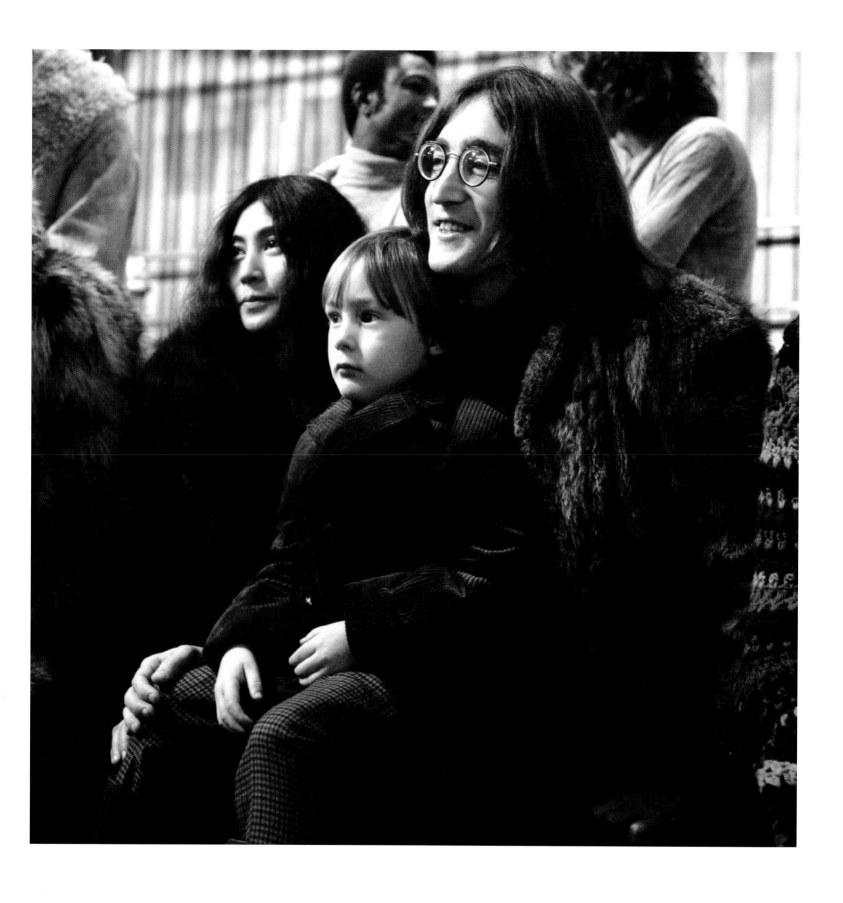

YOKO ONO AND JOHN LENNON WITH JOHN'S SON JULIAN

1968

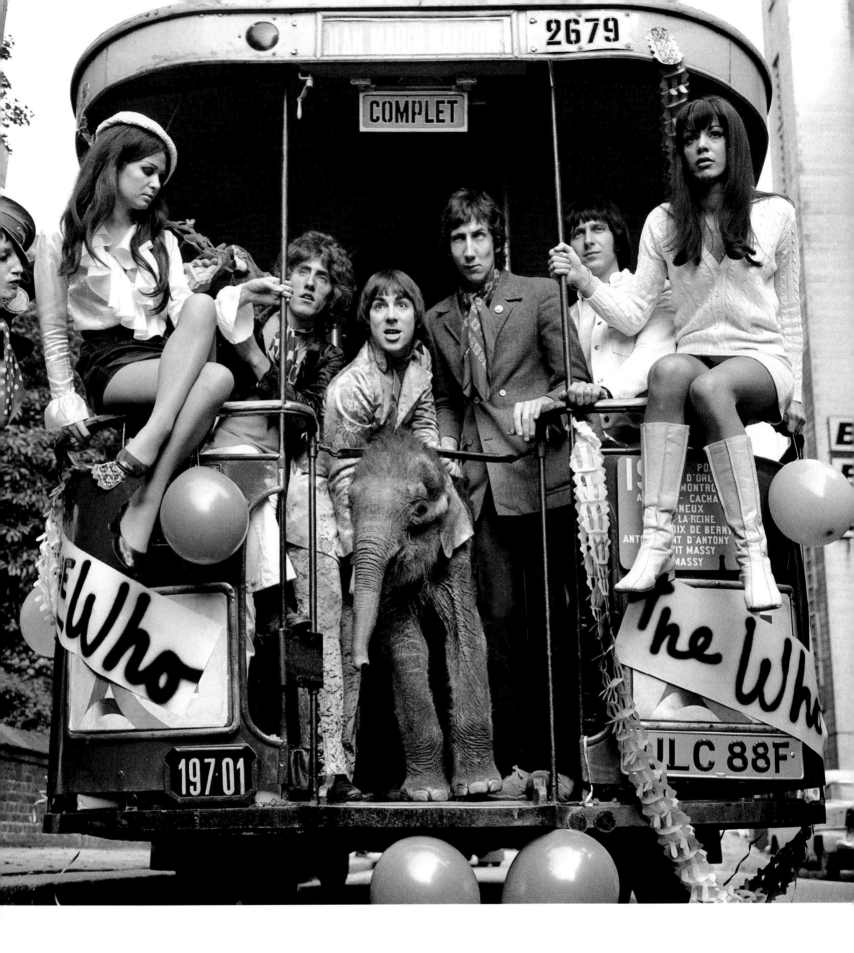

ROCK BAND THE WHO AND ENTOURAGE

1968

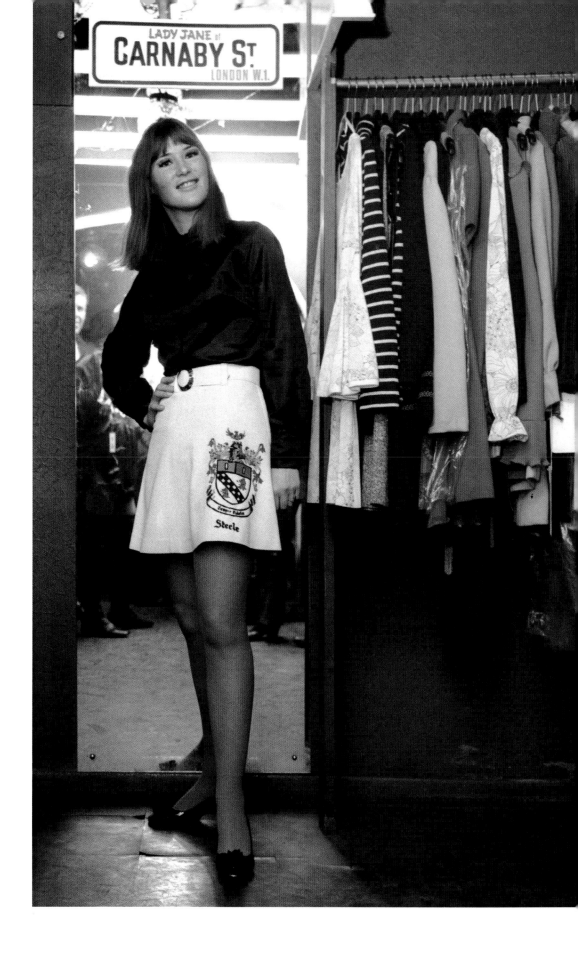

CARNABY STREET BOUTIQUE

1968

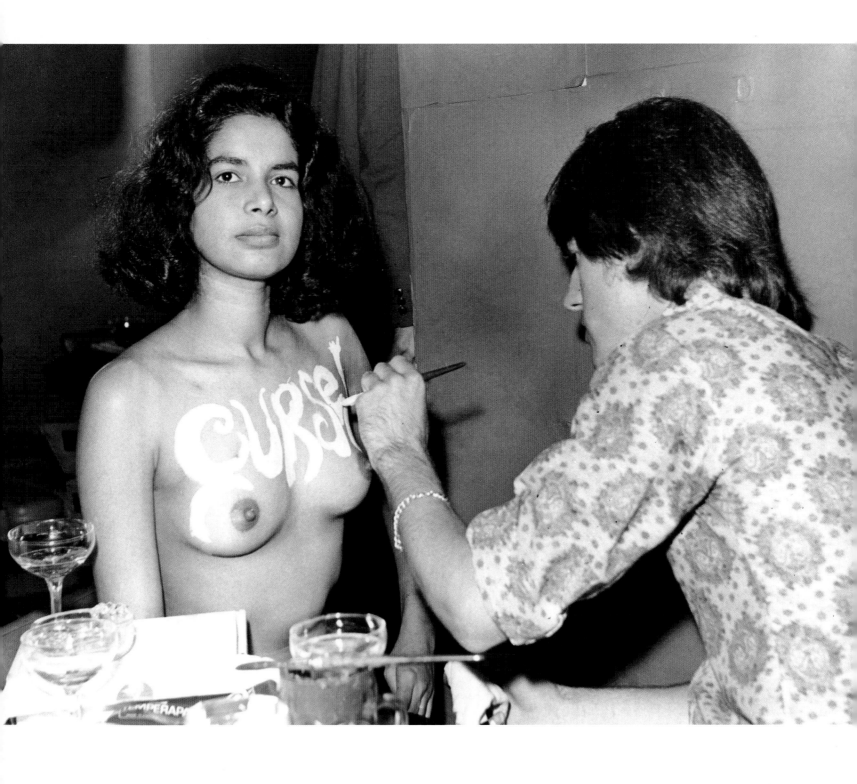

A YOUNG WOMAN IS USED AS A CANVAS FOR PAINTING

1968

SINGING TRIO THE DOLLIES

1968

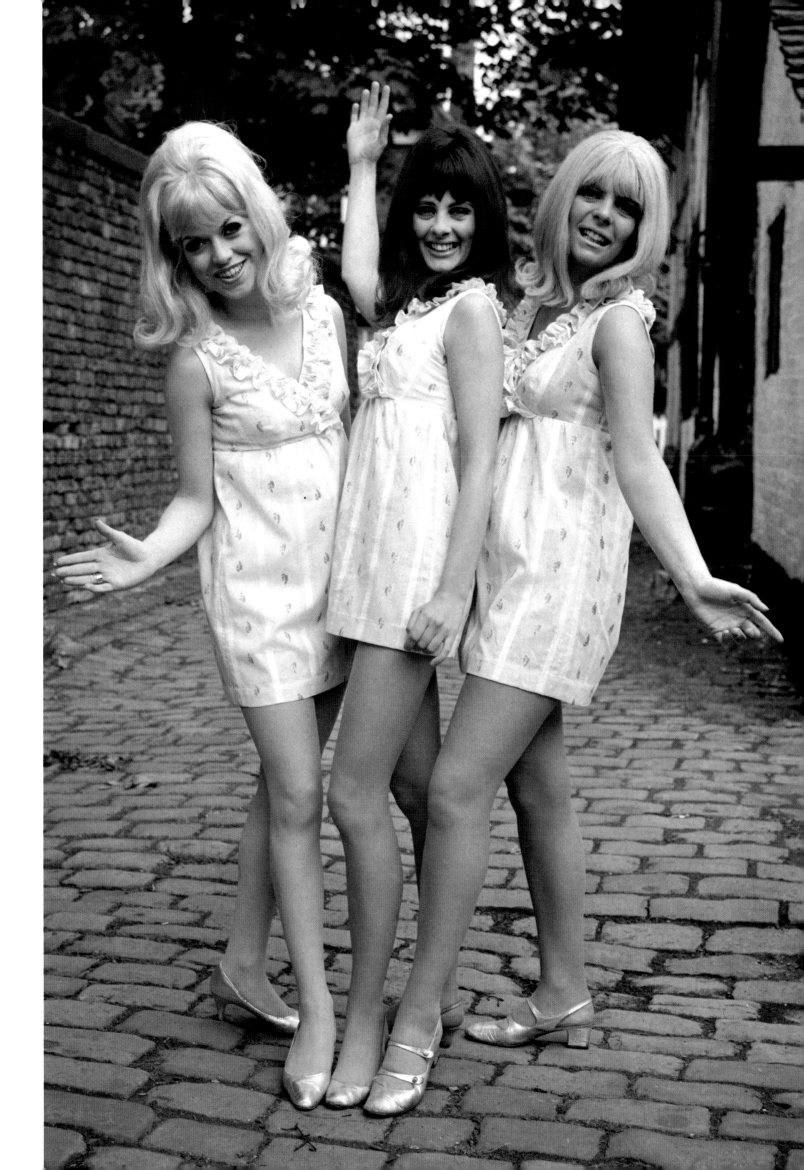

Swim caps
by Kleinet
1969

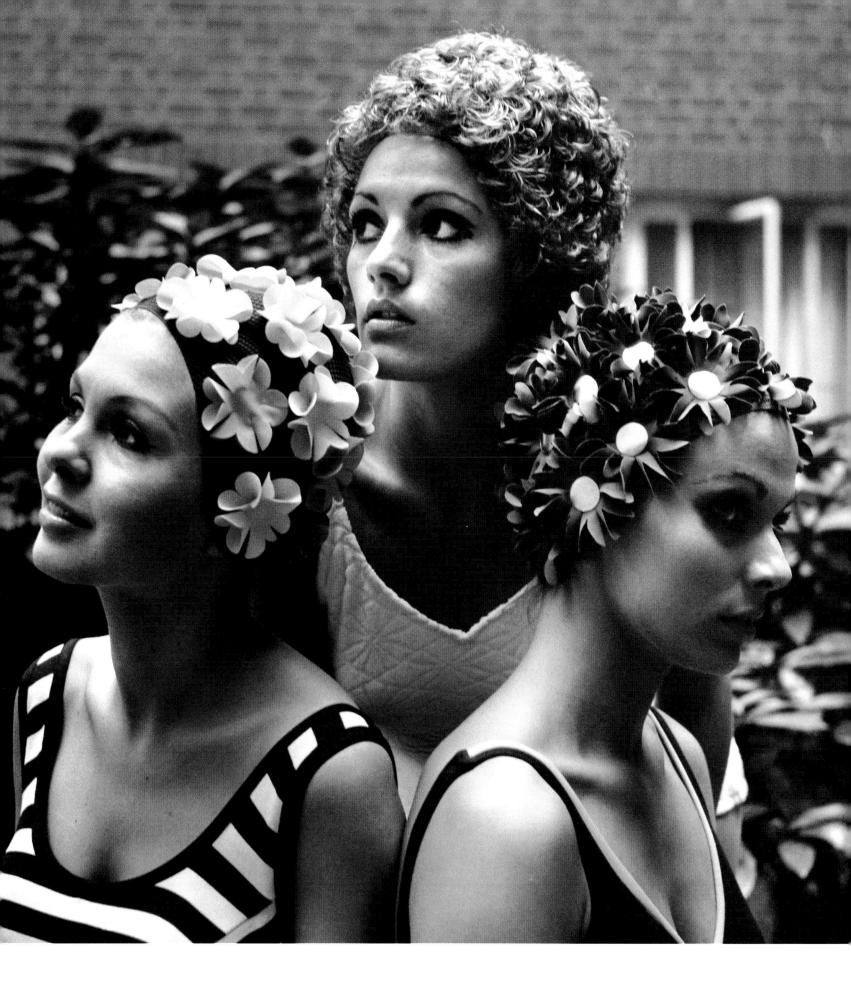

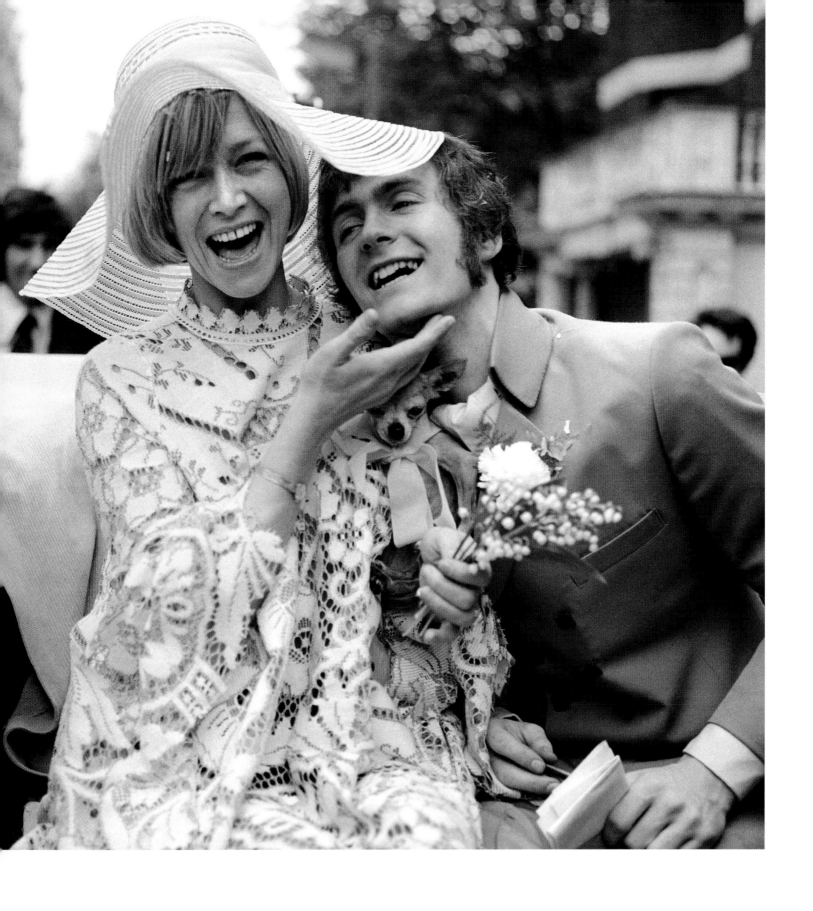

DISC JOCKEY KENNY EVERETT MARRIES SINGER LADY LEE

1969

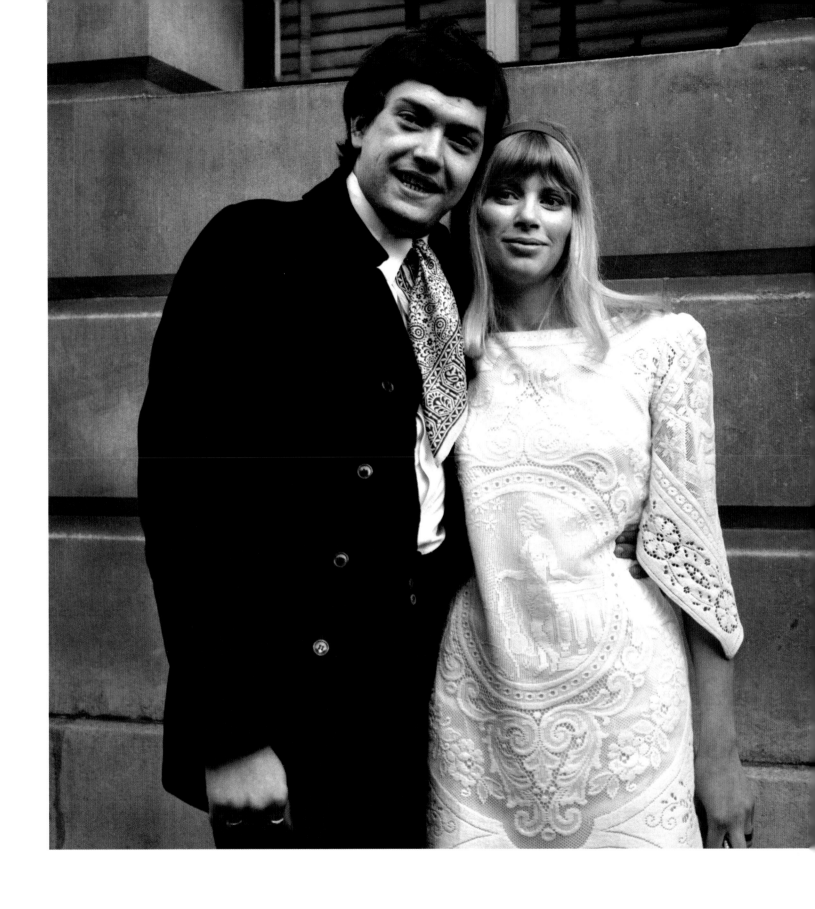

ACTOR MARTIN SHAW AND ACTRESS JILL ALLEN AT THEIR WEDDING

1969

THE MAXI DRESS
1969

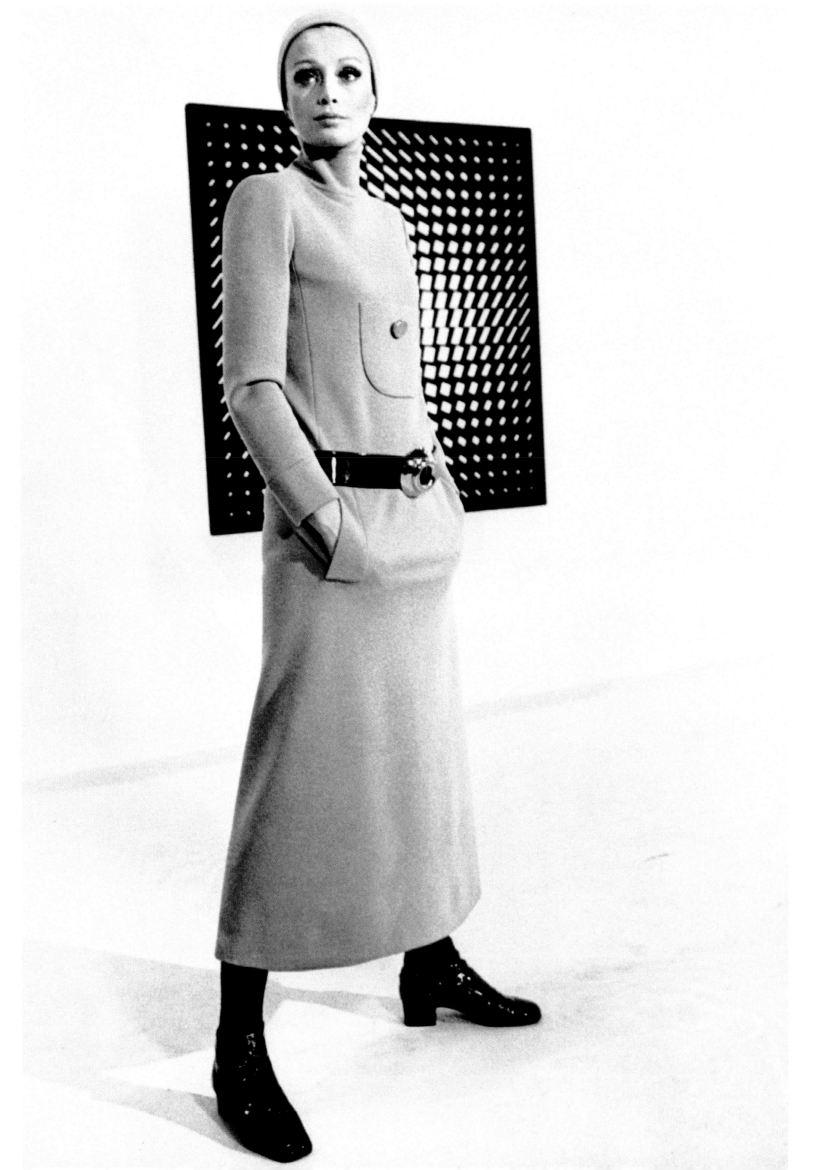

DRESS AND TROUSERS
FROM CHRISTIAN DIOR
1969

RIGHT:
OUTFITS FROM THE
CHRISTIAN DIOR 'LONDON'
COLLECTION
1969

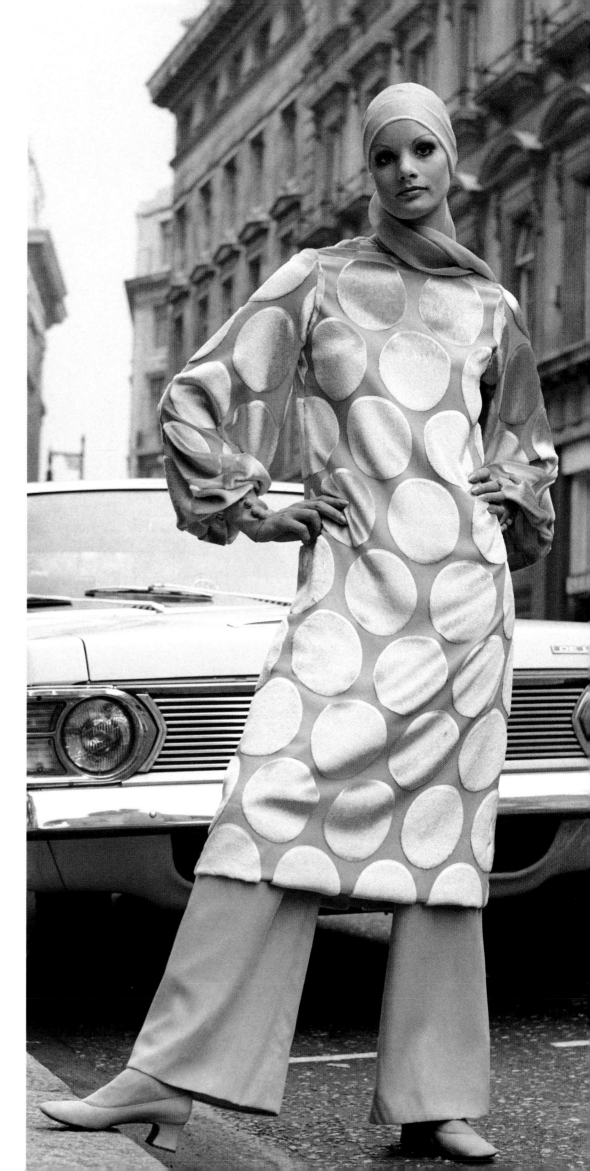

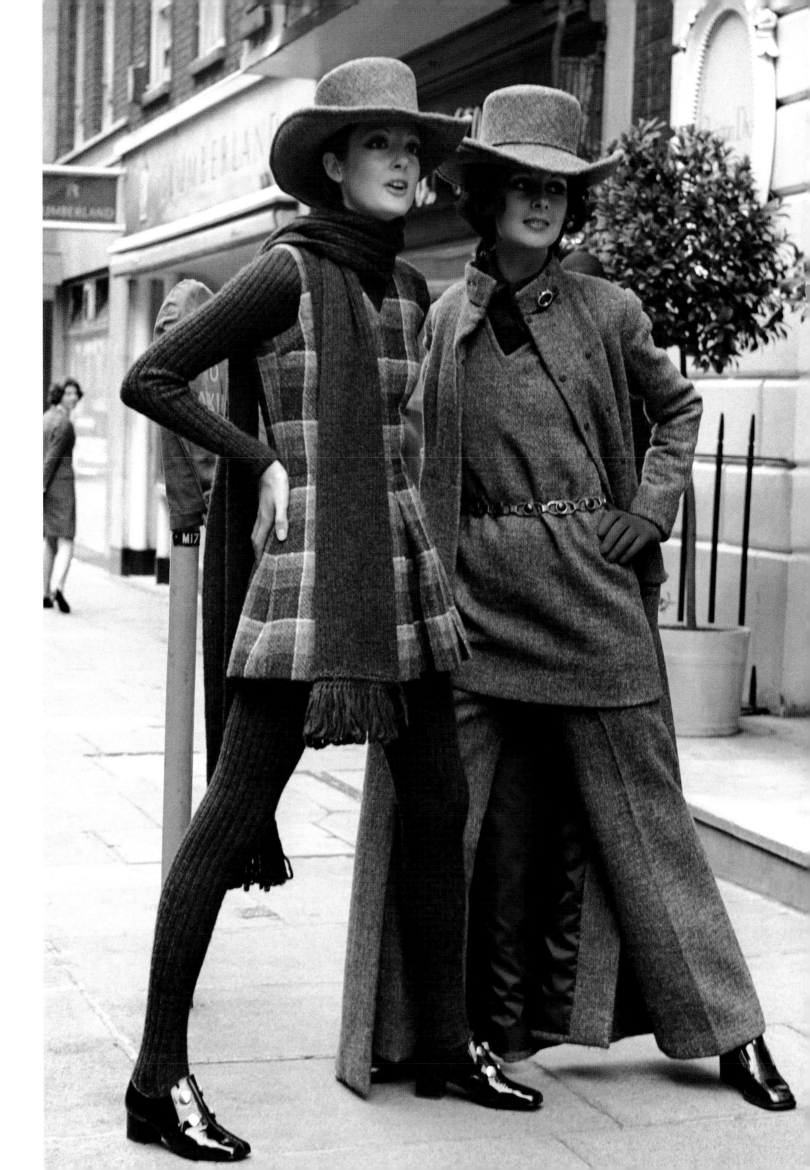

CHAPTER

FROM
THE QUEEN
TO POSH:
FASHION ICONS

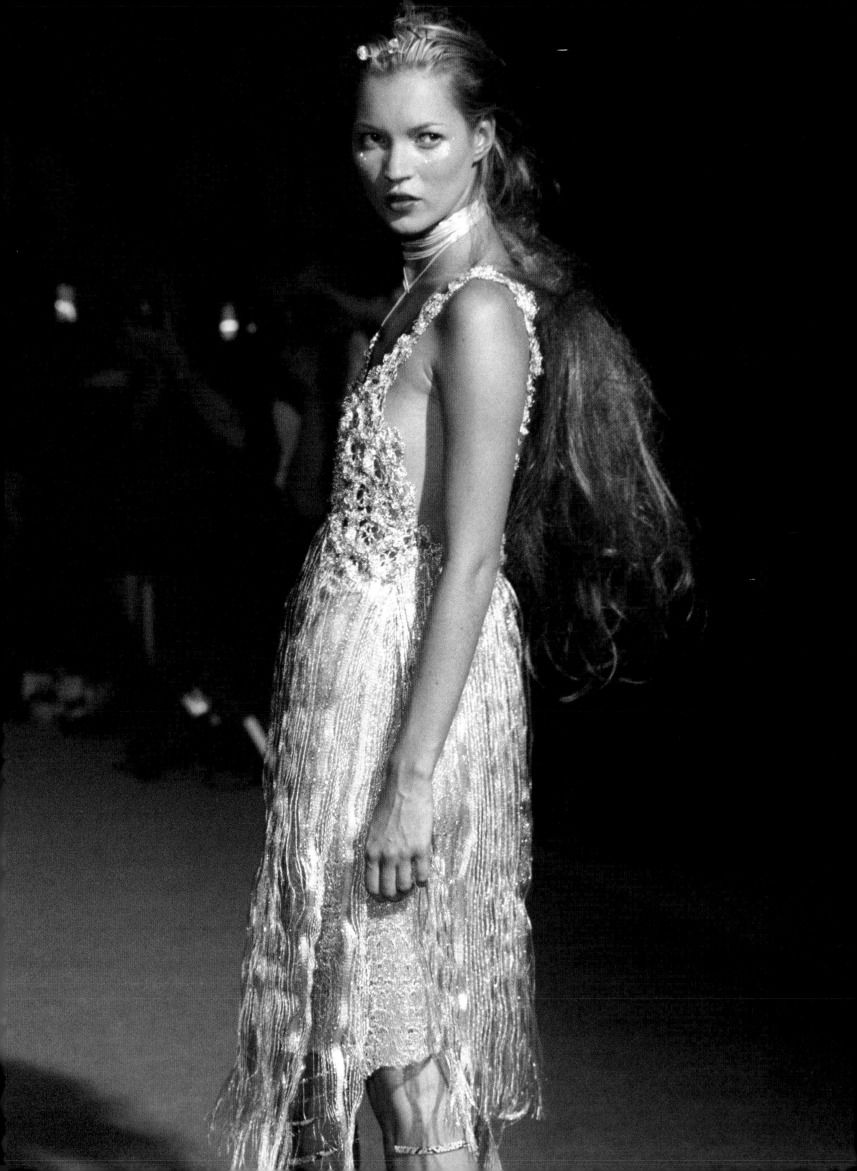

BY ITS NATURE SOCIETY needs heroes (or heroines) to look up to, to admire. We hold them up as an ideal, people we can emulate and strive to be like. Fashion, of course, plays an important part in our hero-worship.

Over time, the nature of our icons changes, as we change. It's interesting then, to look back over the past 50-odd years to see who we have admired and what it says about us.

If we look back to the post-war era we find that royalty – especially the two young princesses – were tailor-made to become fashion icons. Apart from the obvious glamour of being dressed by top couturiers, they were suitably remote, to the point of being unreal. Seen from a distance, they became idealised in a fairy-tale existence that had none of the dirt and trappings of our own everyday lives. Similarly film stars, with their remote but perfect beauty, could fit into this idealised category.

But times change, and when Diana went on television in 1995 to divulge the secrets of her tragic marriage, we were fascinated. Here was an icon become human, someone we could relate to and empathise with. And we adored her. Hungry for more we pursued her everywhere, wanting more intimacy and more access to her life – and her death.

Whether it was the nature of the media, or we as a society – or both – that demanded so much is difficult to say, but the fact remains. We now want our icons to be real, so that Kate Moss's rehab and her unsuitable love affairs become our property – we want to know everything. Victoria Beckham's marriage is played out on a public stage and Amy Winehouse's much publicised decline and fall is all part of our desire for intimacy. We want to live their lives with them, and with many of them producing clothing ranges and perfumes in their name, we feel that we can, literally, step into their shoes – looking and even smelling like them.

It leaves perhaps just one anti-heroine – Vivienne Westwood. Her subversion of the notion of an ideal beauty and her refusal to be phased by her own aging body – while still achieving the status of celebrity – is perhaps a reflection of an emerging change in attitudes. It remains to be seen what influence this will have.

PAGE 128: KATE MOSS
ON THE CATWALK AT
LONDON FASHION WEEK
1997

THE YOUNG PRINCESS
ELIZABETH
1947

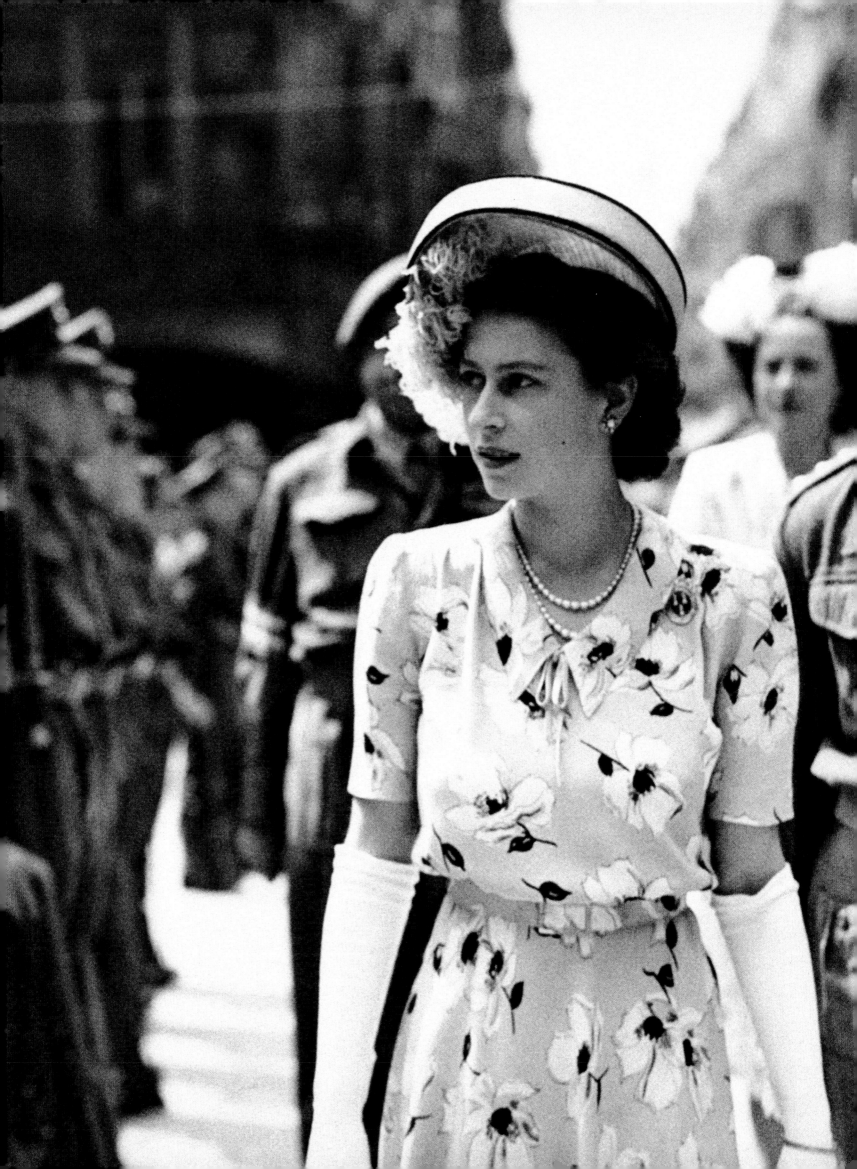

PRINCESS MARGARET

1947

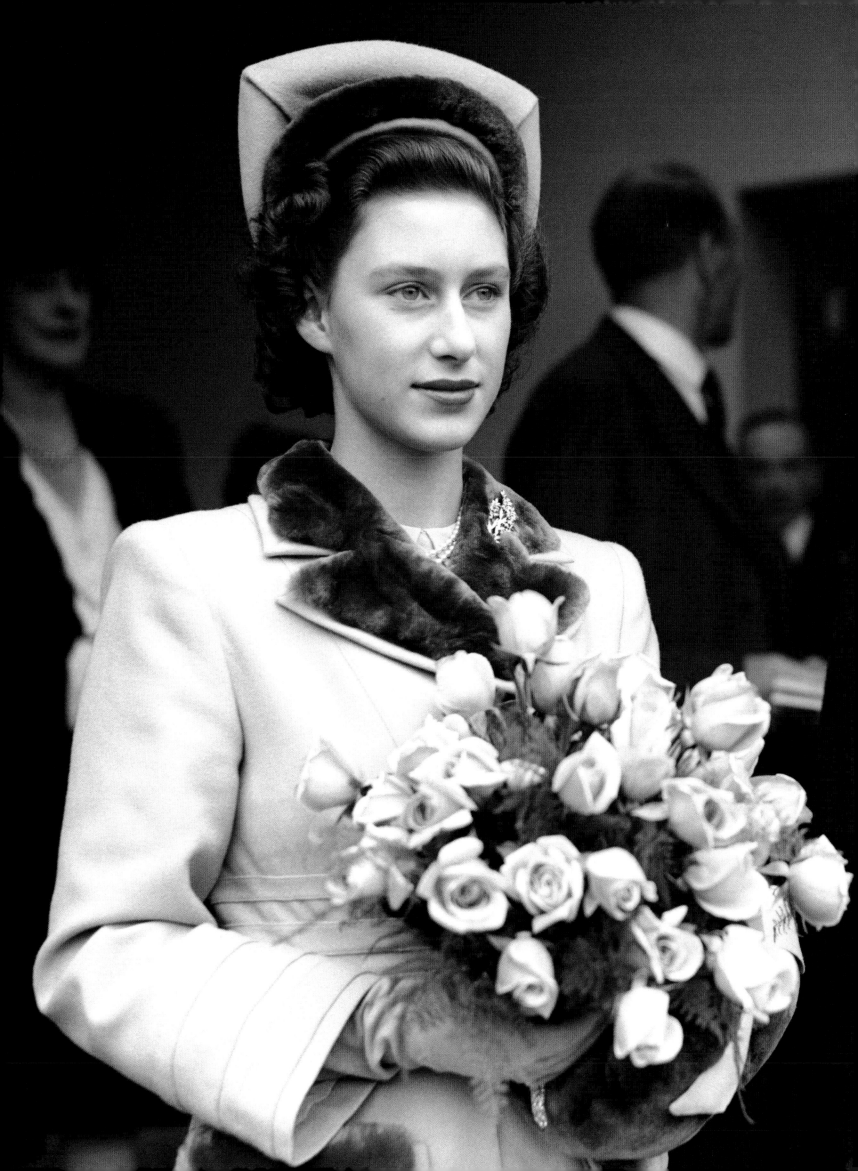

PRINCESS ELIZABETH WEARING
HER DIAMOND-ENCRUSTED BRIDAL GOWN

1947

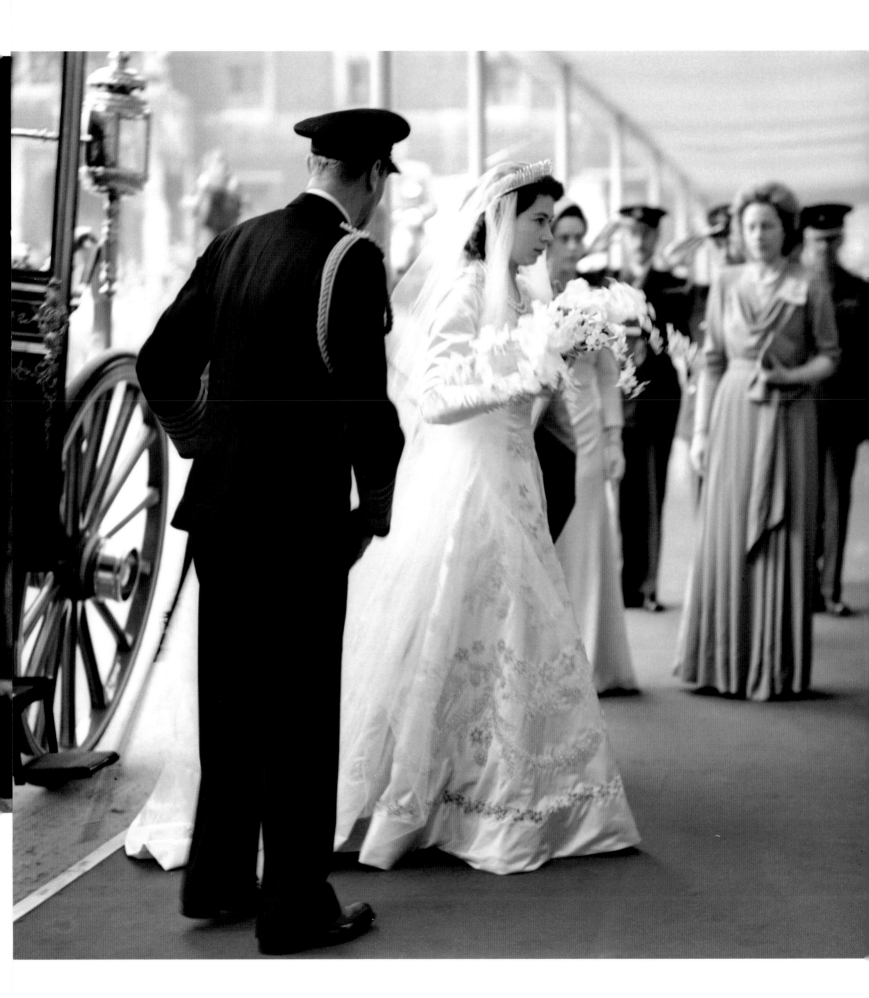

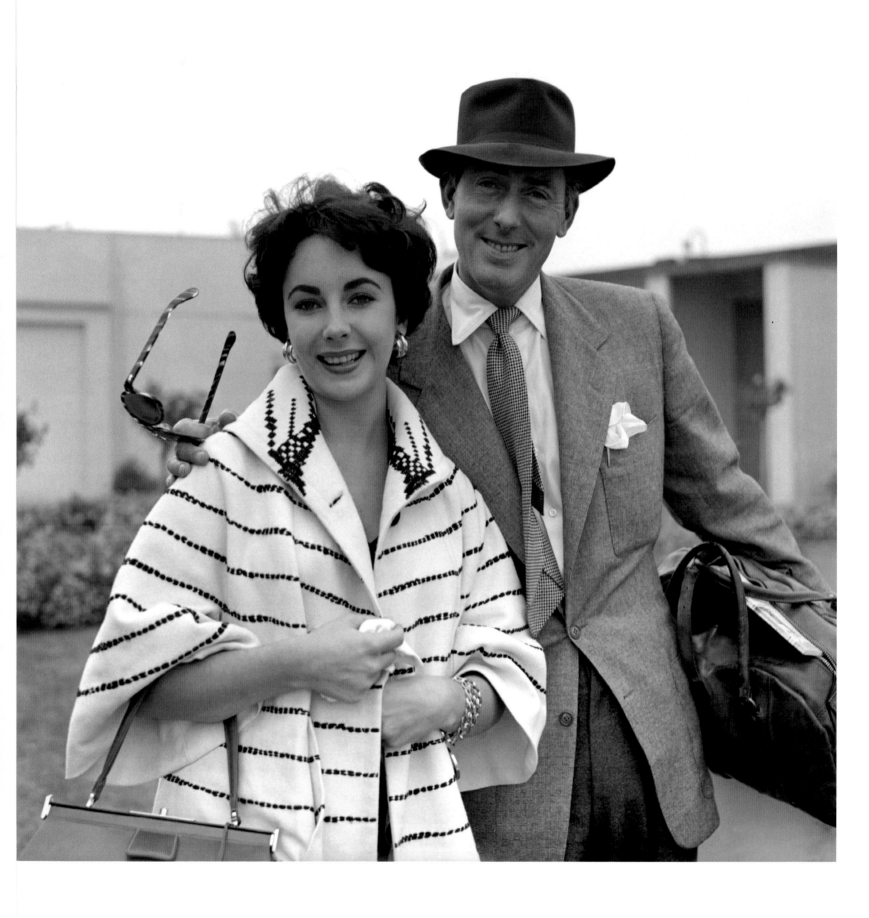

ELIZABETH TAYLOR WITH HUSBAND MICHAEL WILDING...

1953

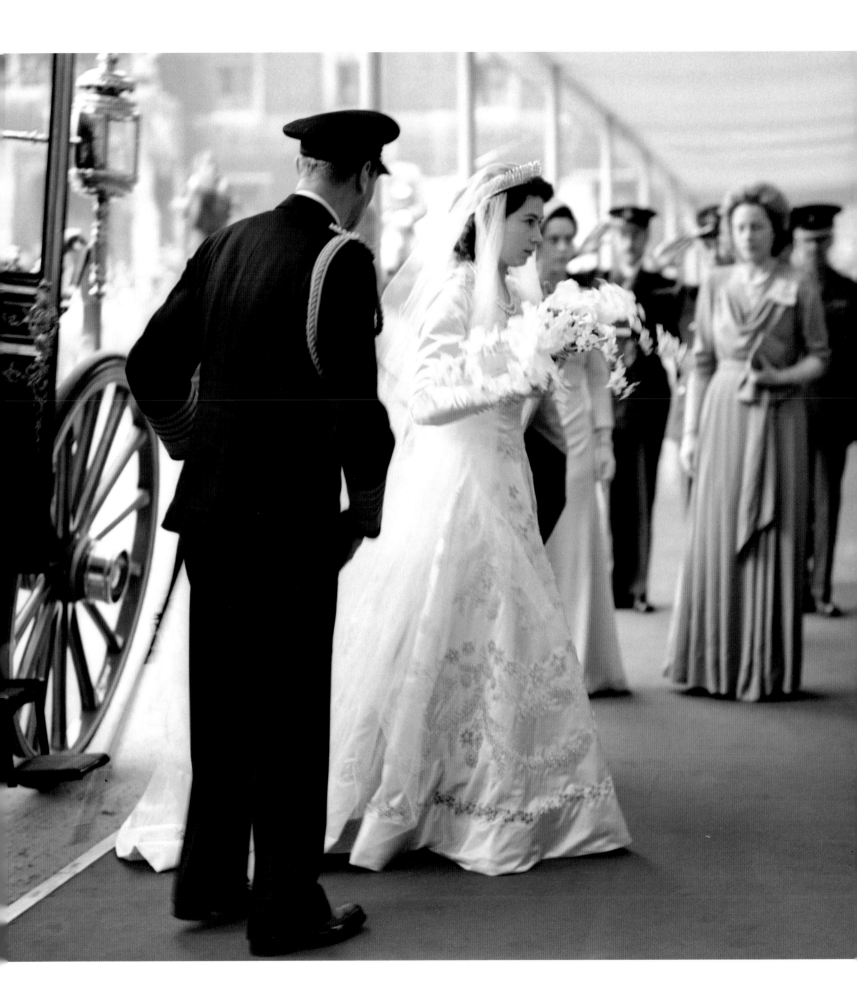

THE TWO SISTERS
AT THE CHRISTENING
OF PRINCESS ANNE
1950

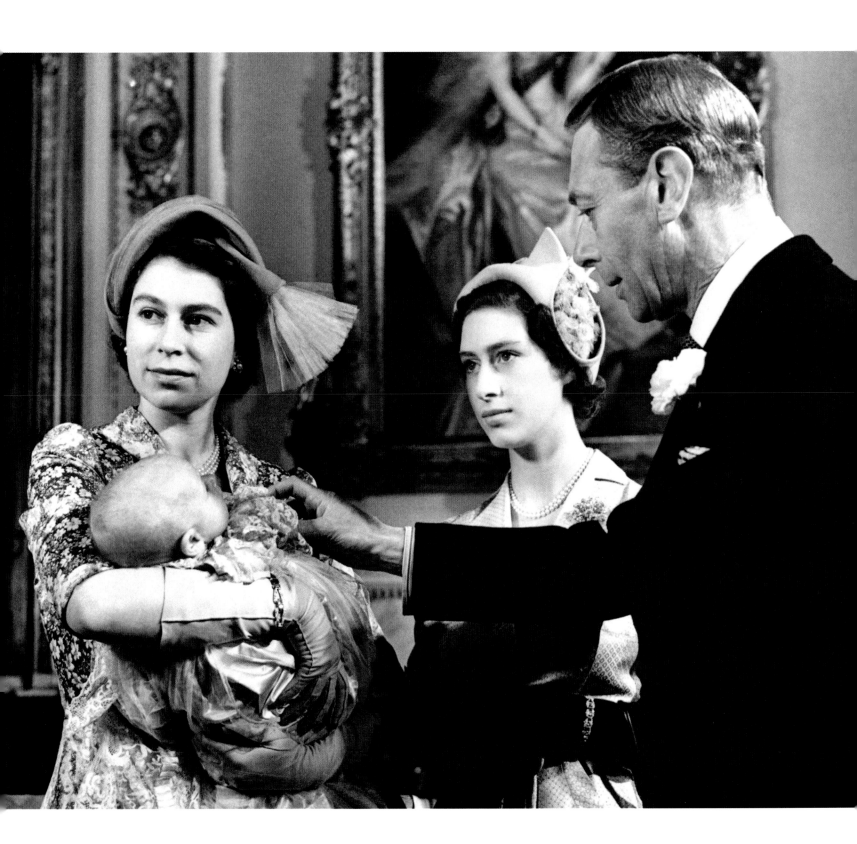

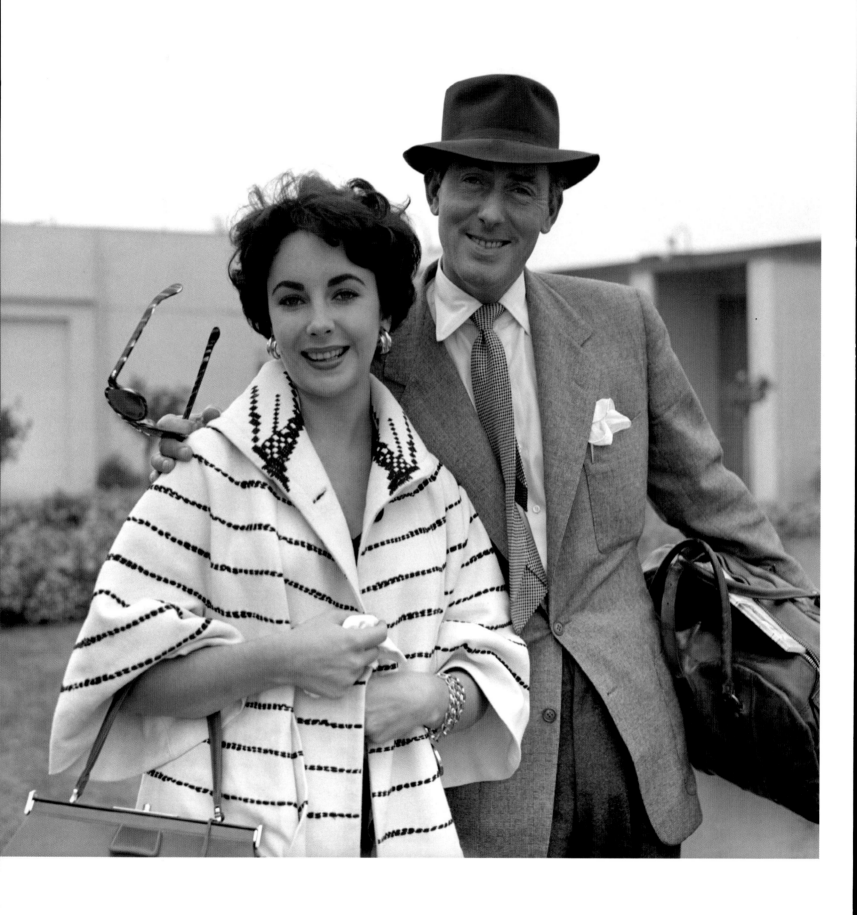

ELIZABETH TAYLOR WITH HUSBAND MICHAEL WILDING...

1953

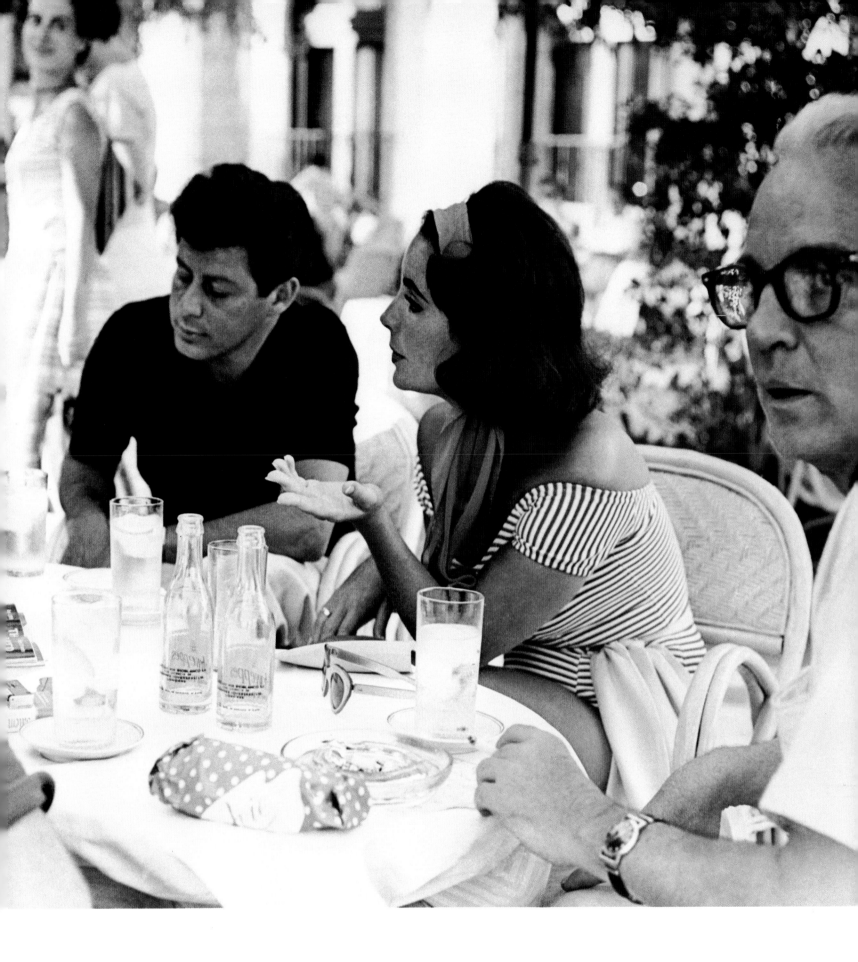

...AND WITH HUSBAND EDDIE FISHER

1959

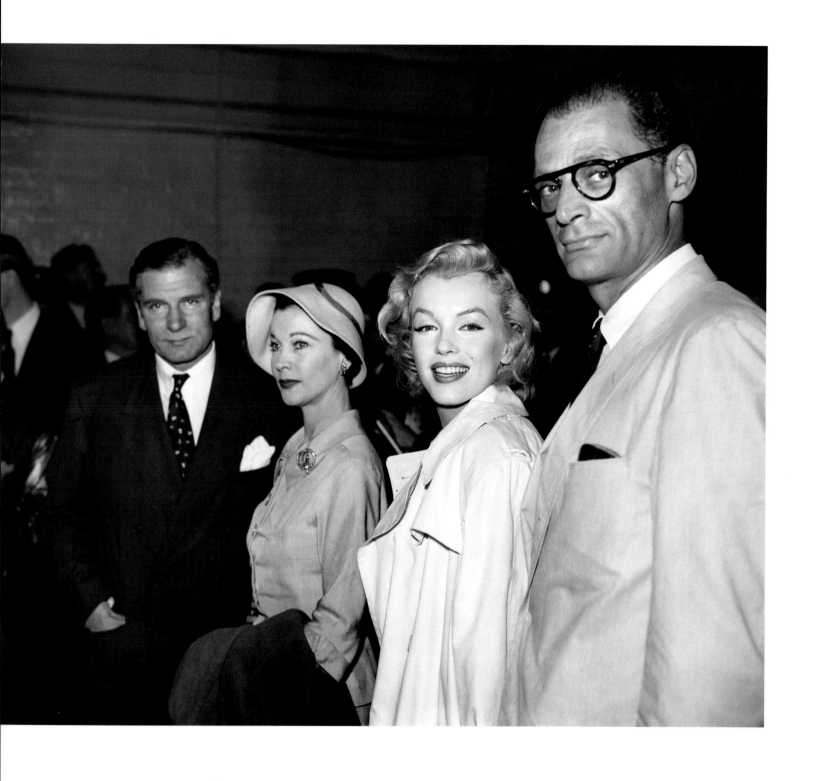

SIR LAURENCE AND LADY OLIVIER MEETING MARILYN MONROE
AND HER HUSBAND ARTHUR MILLER AT LONDON AIRPORT

1956

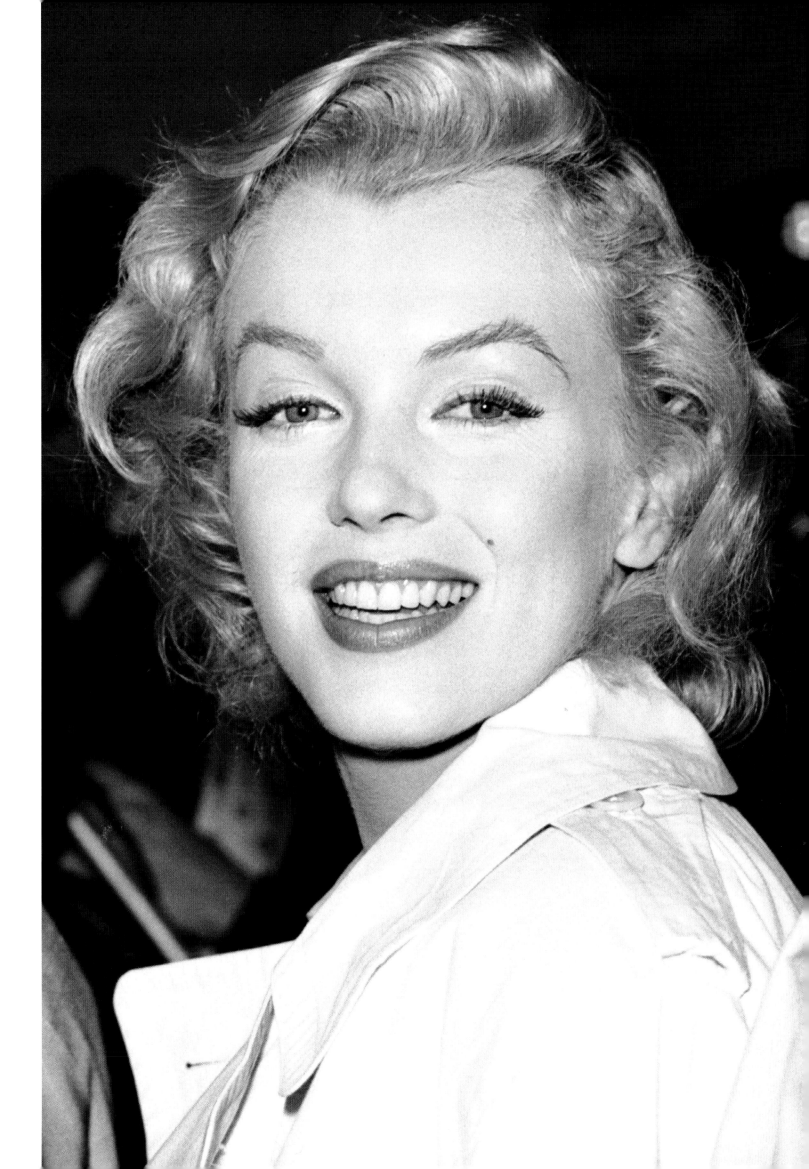

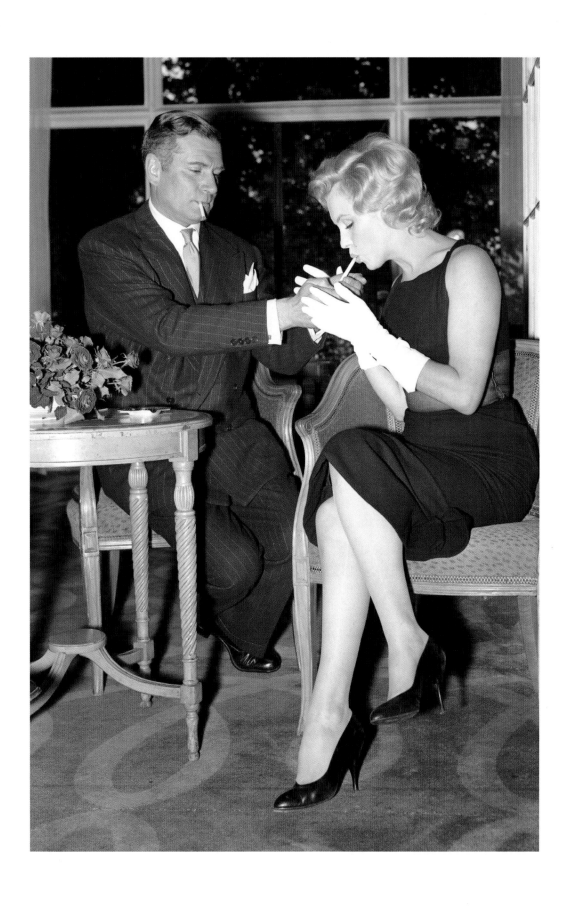

MARILYN (WITH LAURENCE OLIVIER
IN BACKGROUND) AT A PRESS CONFERENCE

1956

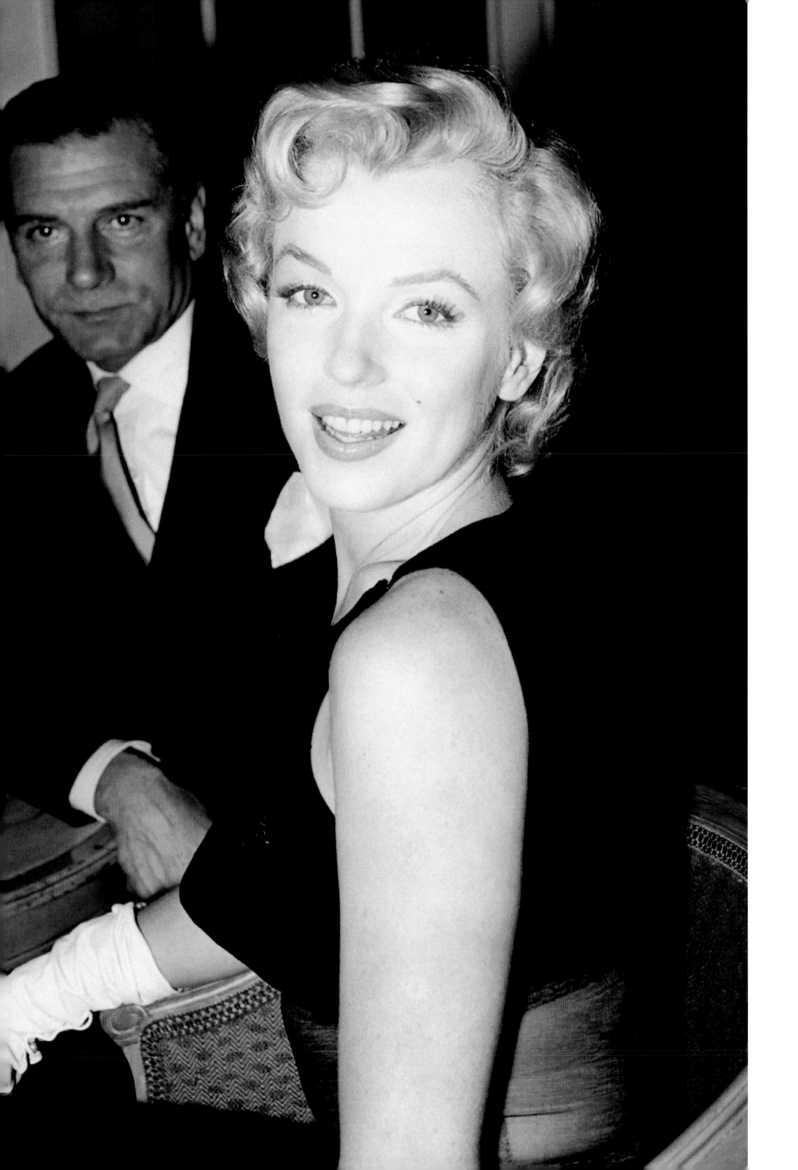

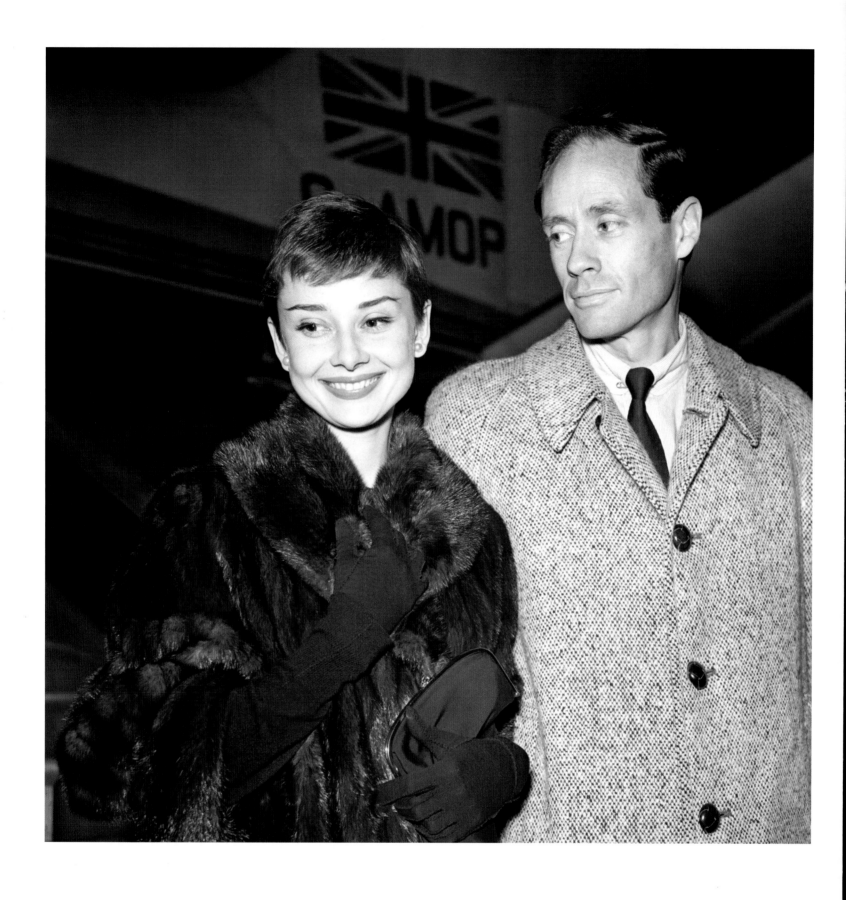

ABOVE: AUDREY HEPBURN ARRIVING IN LONDON WITH HER HUSBAND MEL FERRER

1954

RIGHT: AUDREY HEPBURN AT A FILM PREMIERE IN LONDON...

1955

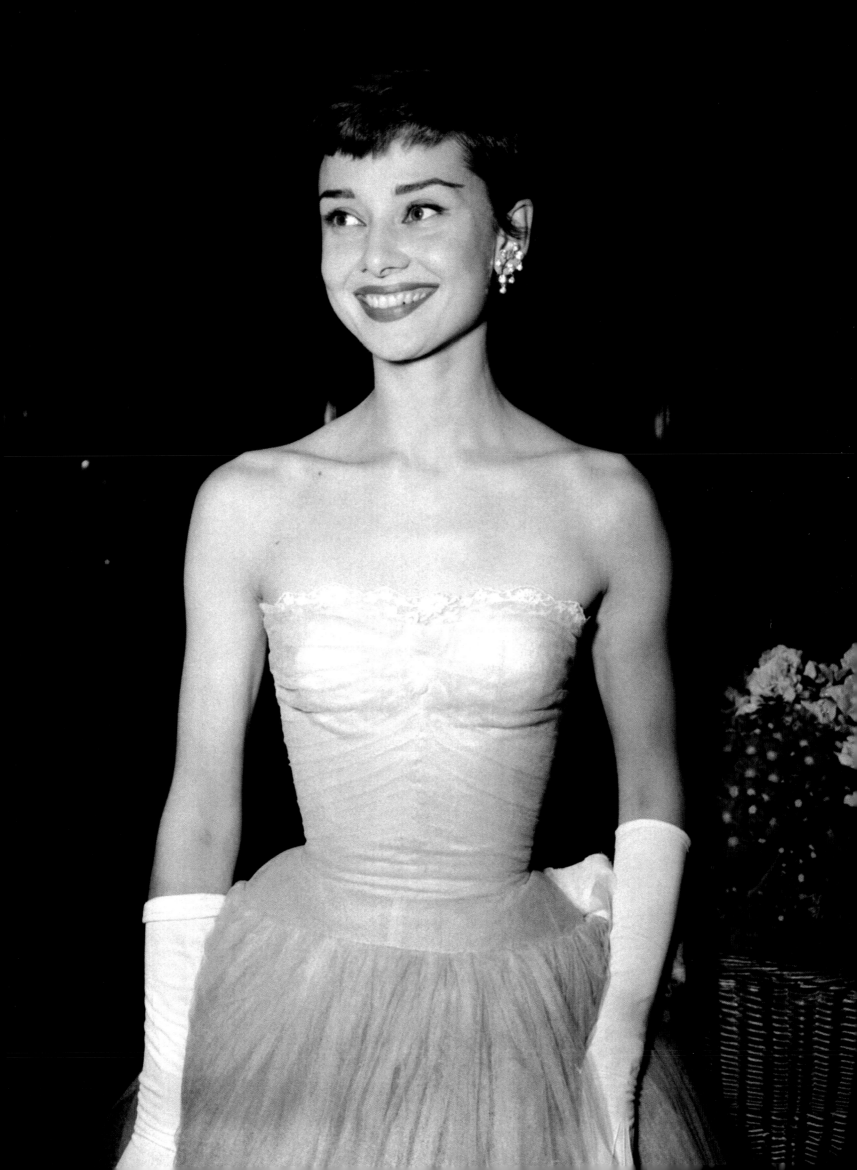

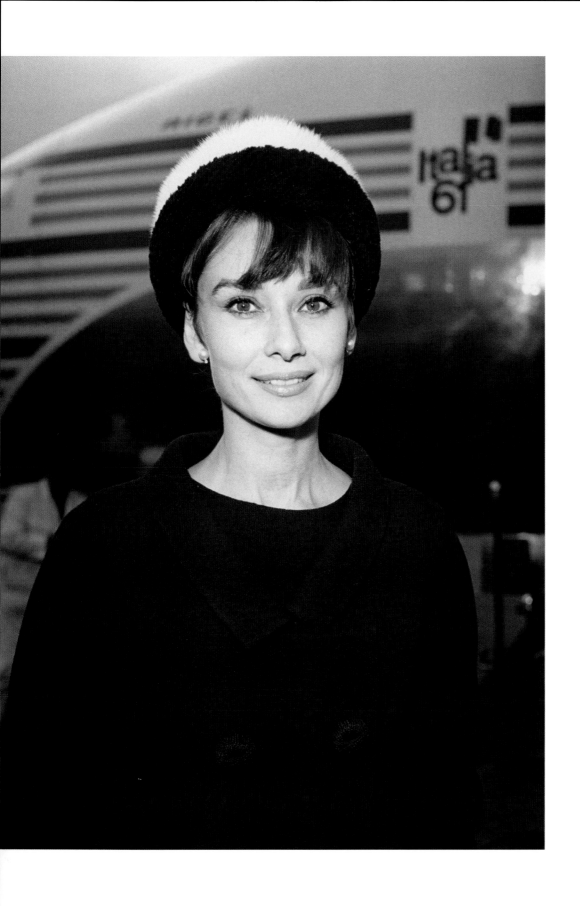

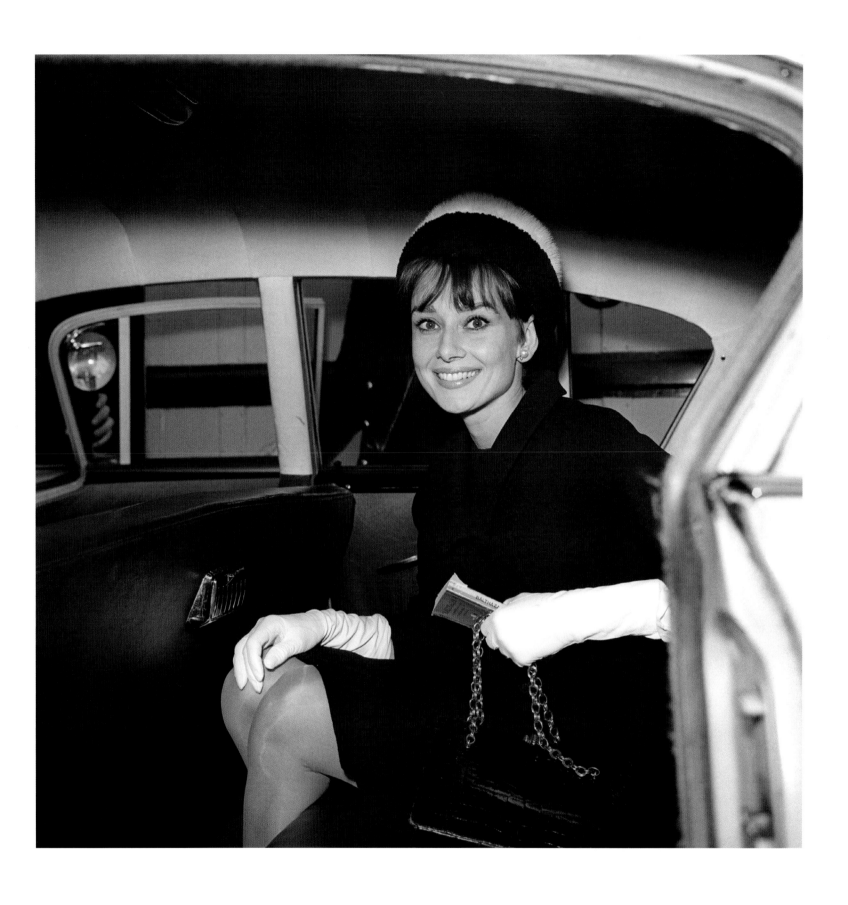

...AND ARRIVING AT HEATHROW AIRPORT TO ATTEND THE EUROPEAN PREMIERE OF *Breakfast at Tiffany's*

1961

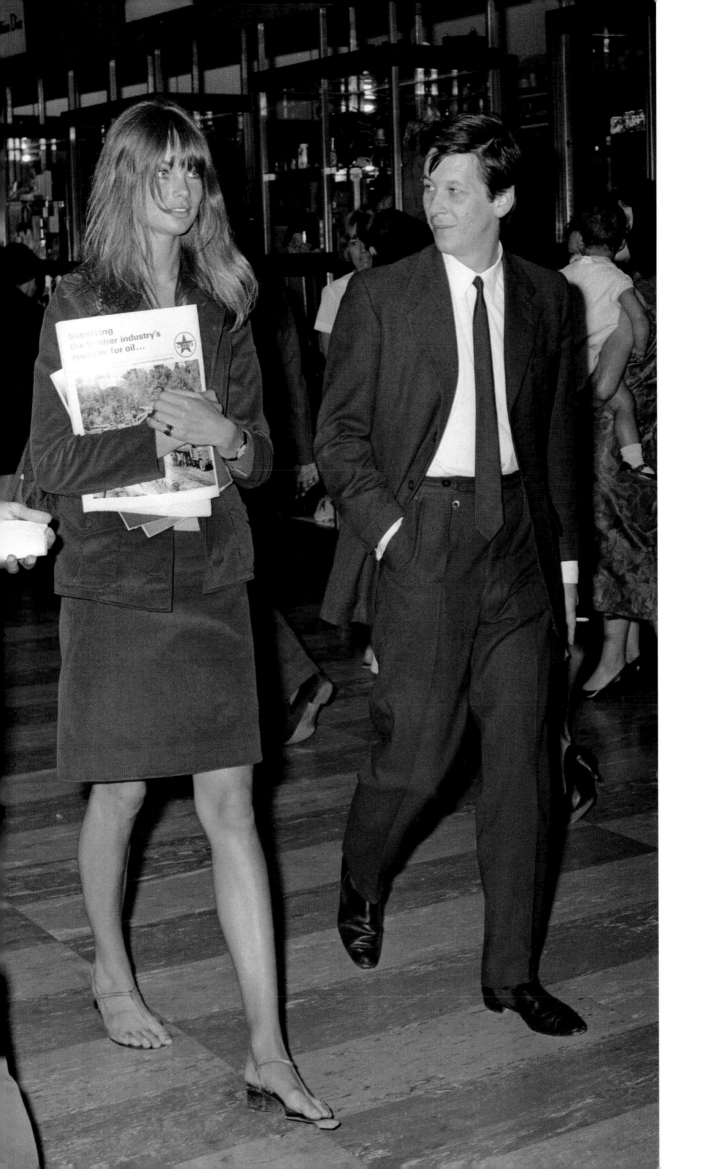

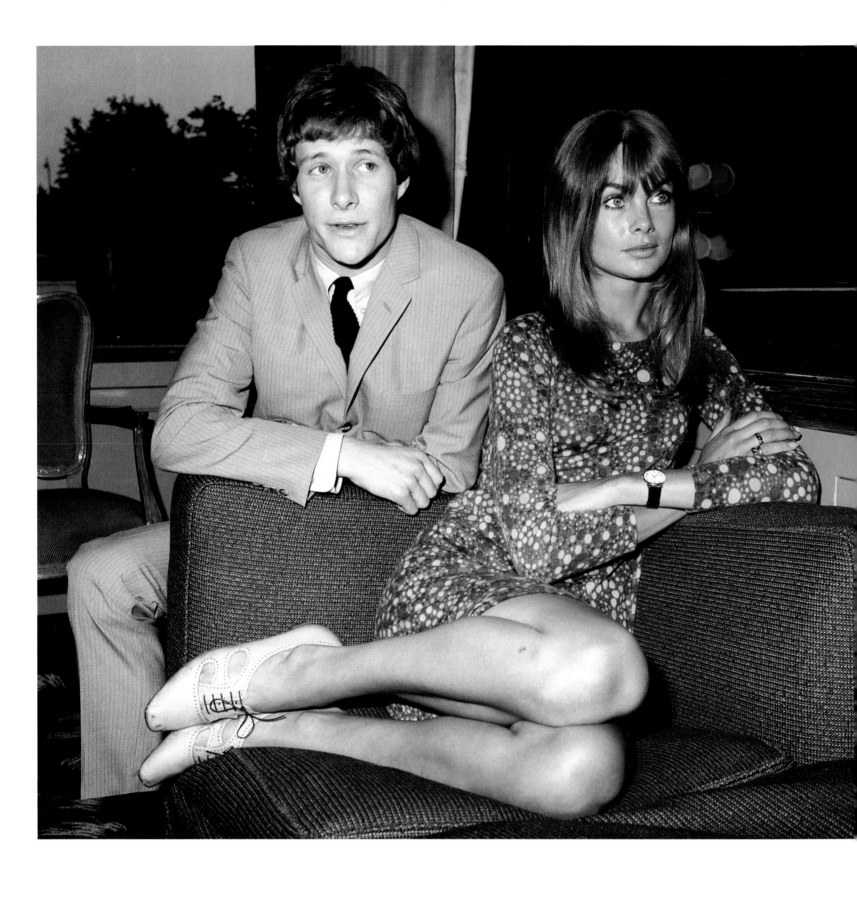

LEFT: ONE OF THE FIRST SUPERMODELS, JEAN SHRIMPTON, AT HEATHROW AIRPORT

1966

ABOVE: JEAN SHRIMPTON WITH POP STAR PAUL JONES

1966

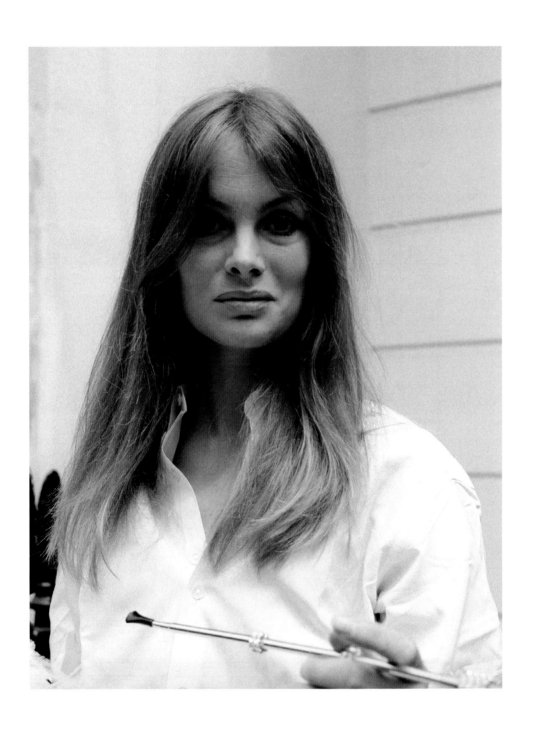

JEAN SHRIMPTON

1970

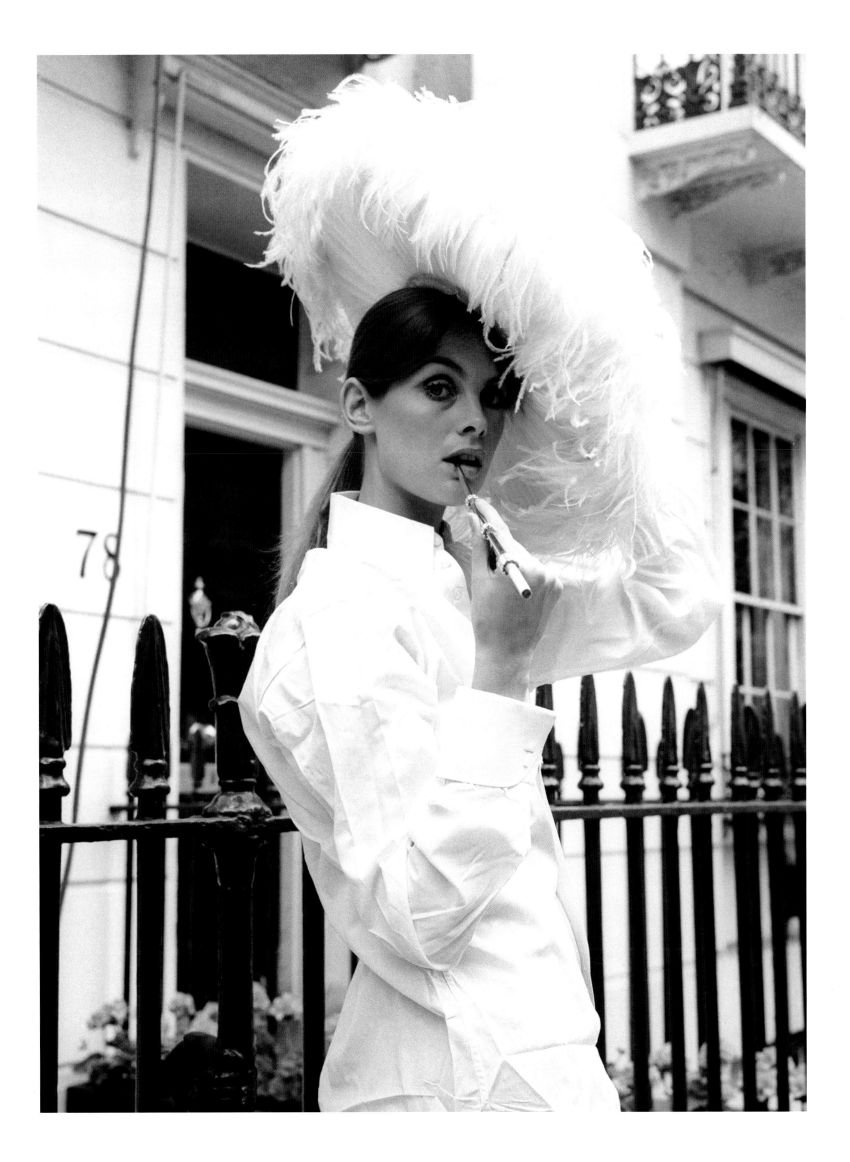

TWIGGY
1966

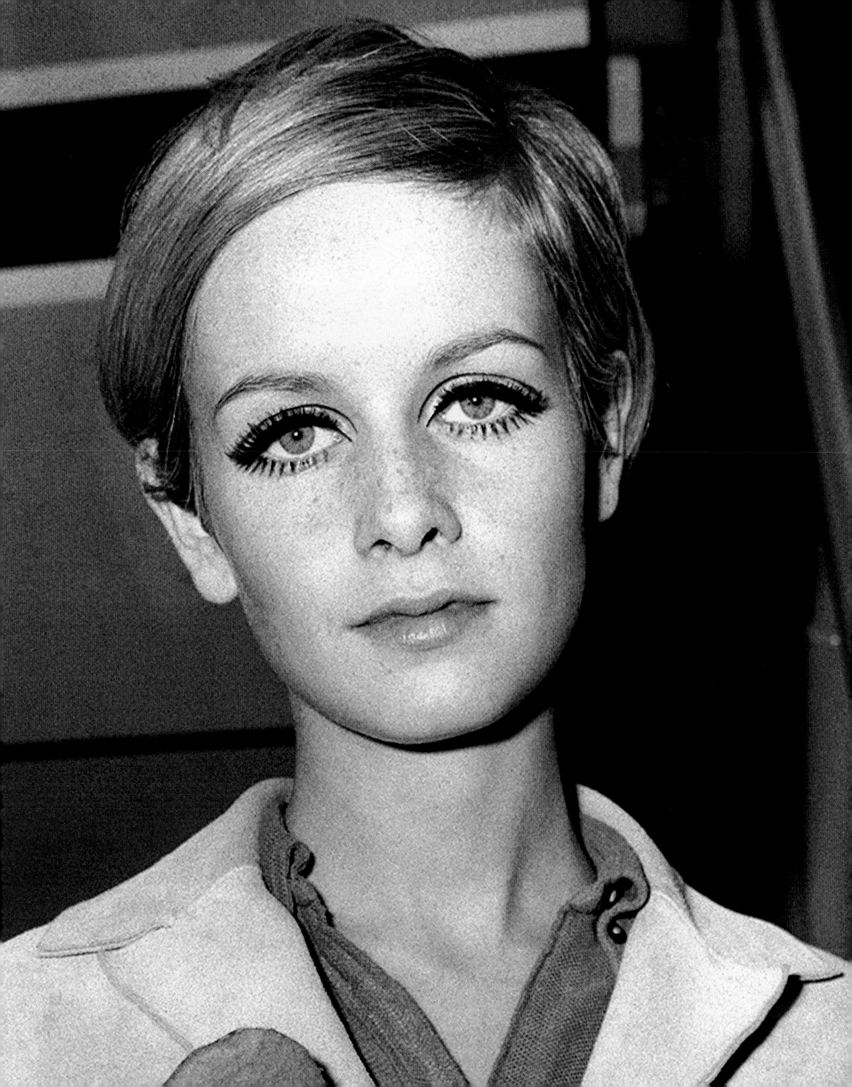

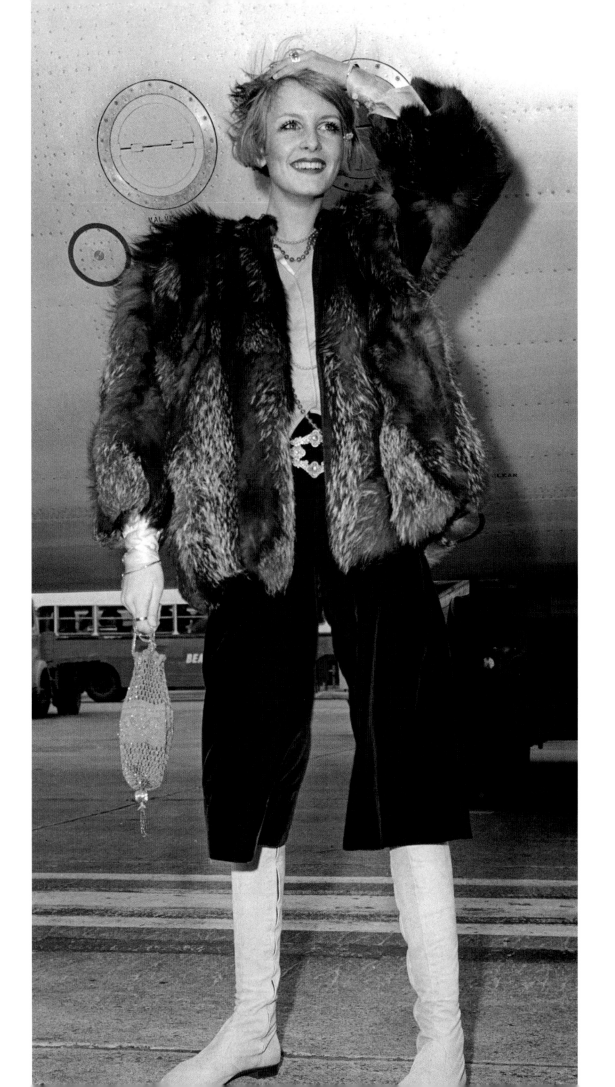

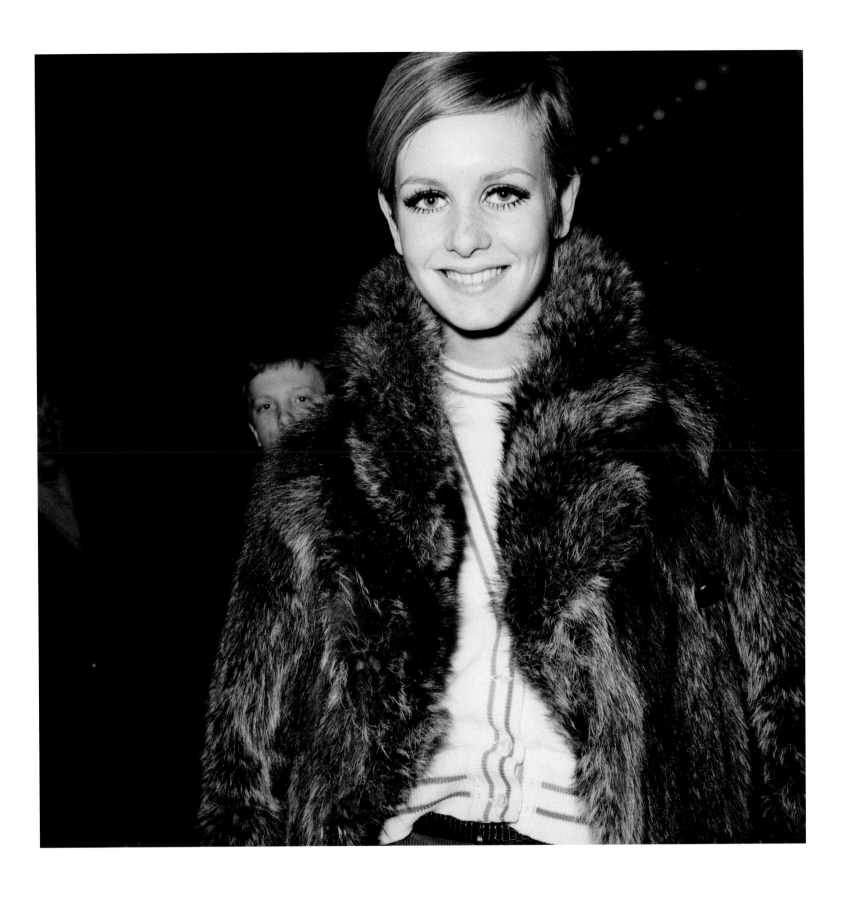

TWIGGY

1967

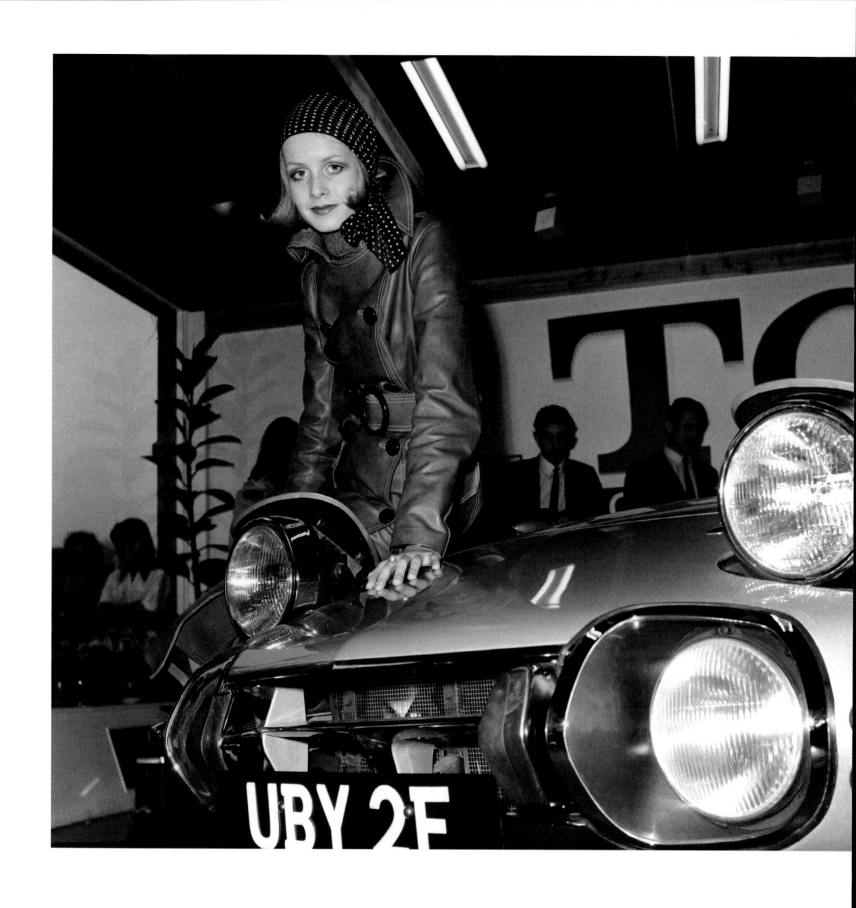

TWIGGY

1968

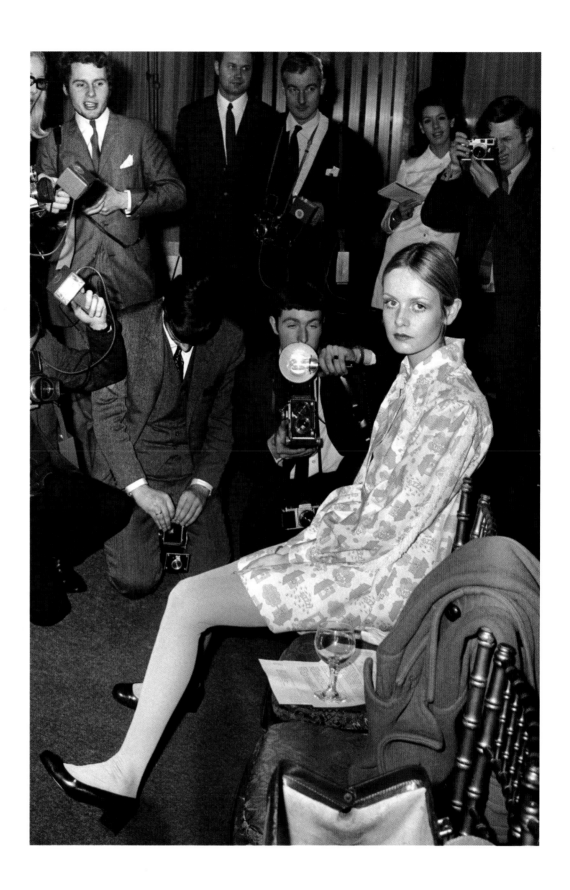

TWIGGY

1968

LADY DIANA SPENCER
1981

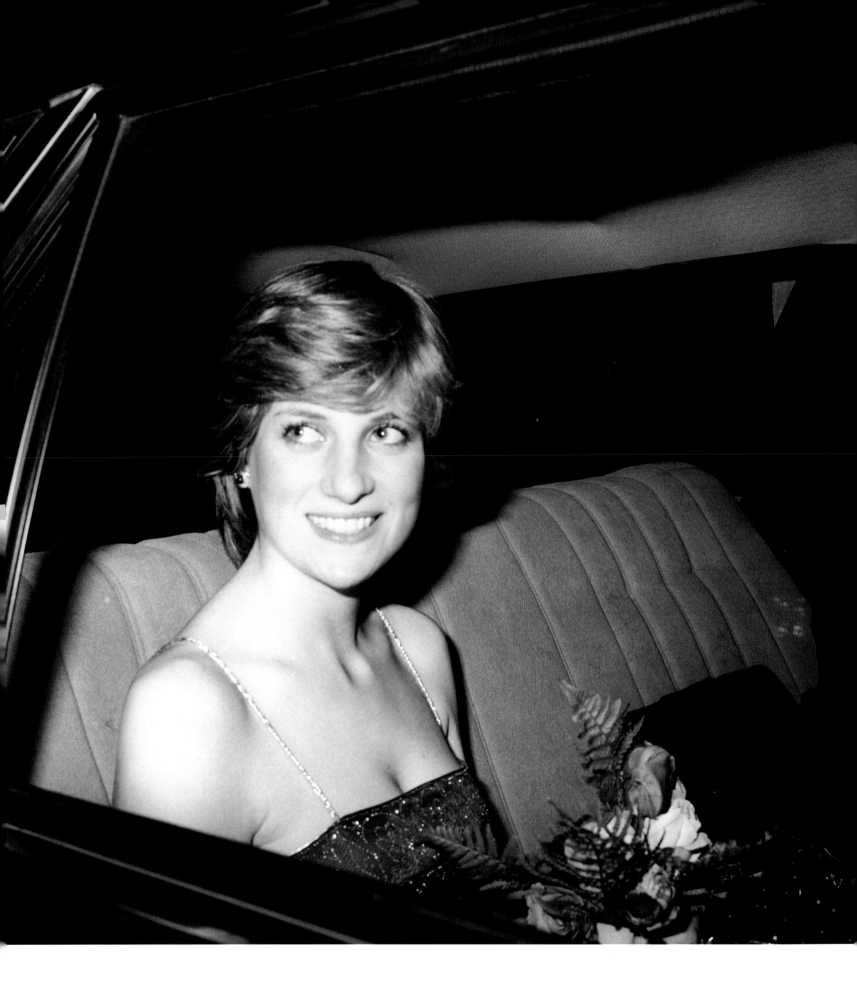

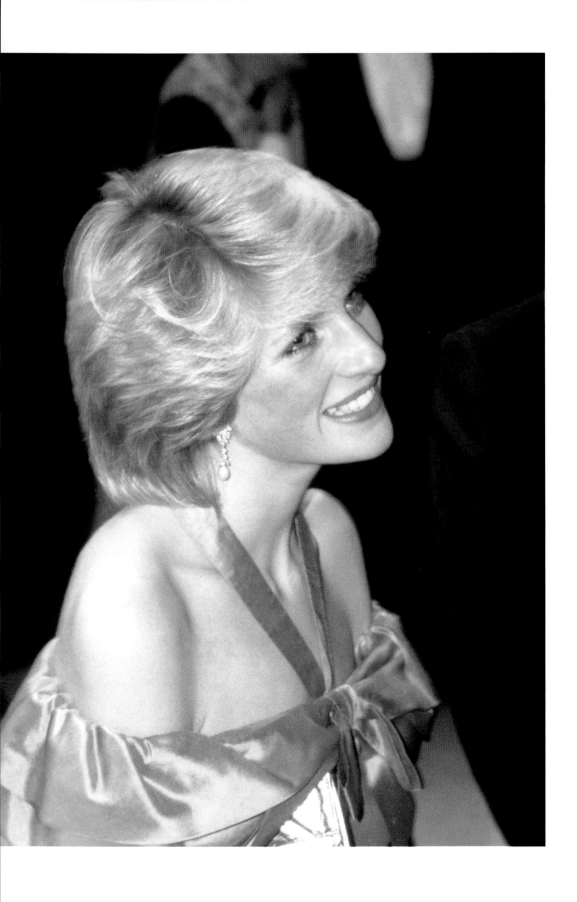

PRINCESS DIANA

1983

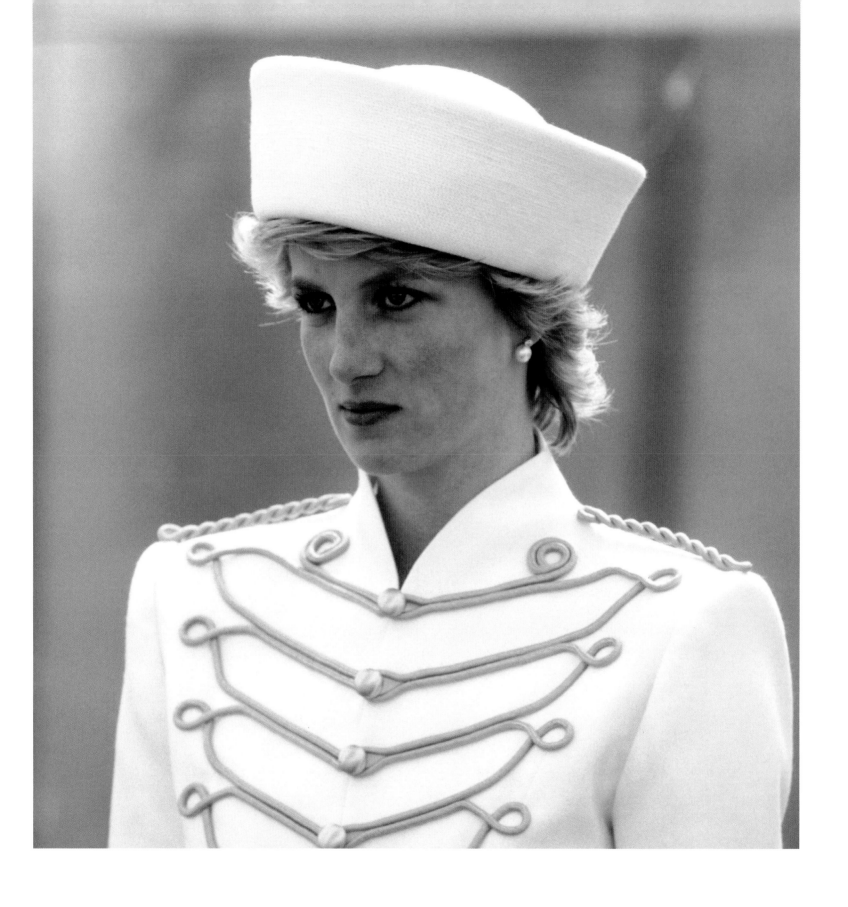

PRINCESS DIANA

1985

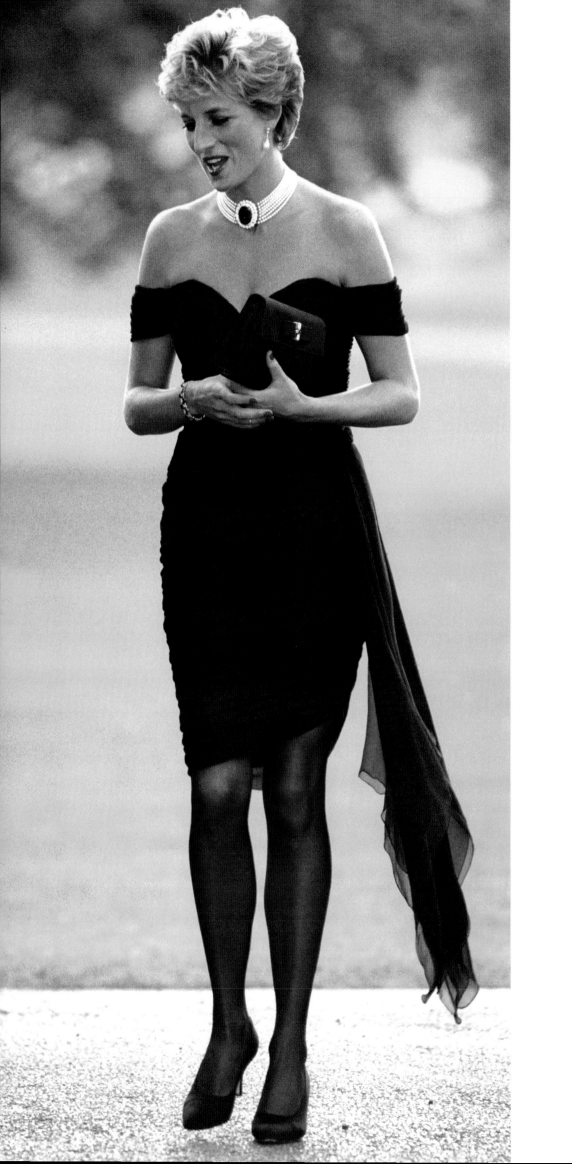

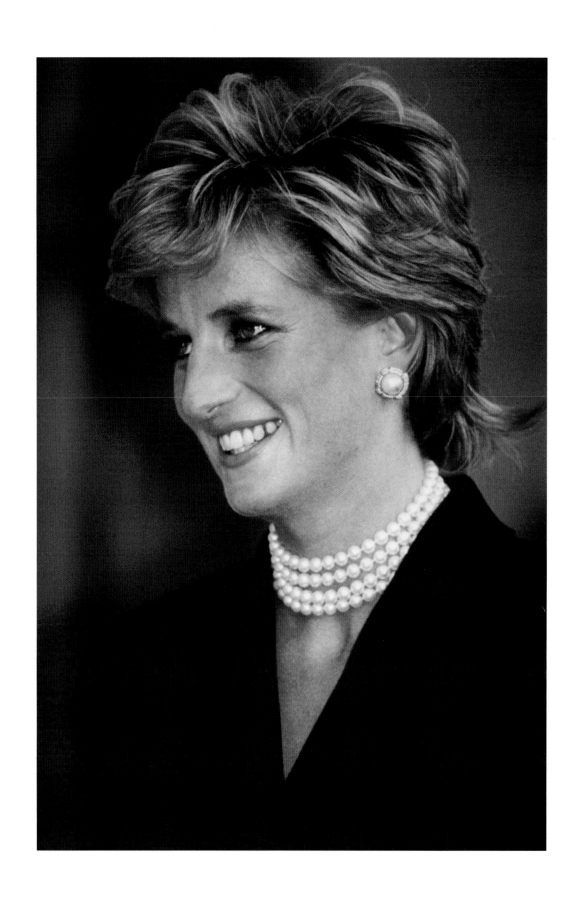

LEFT: DIANA WEARING A DRESS BY CHRISTINA STAMBOULIAN

1994

ABOVE: DIANA IN PARIS

1994

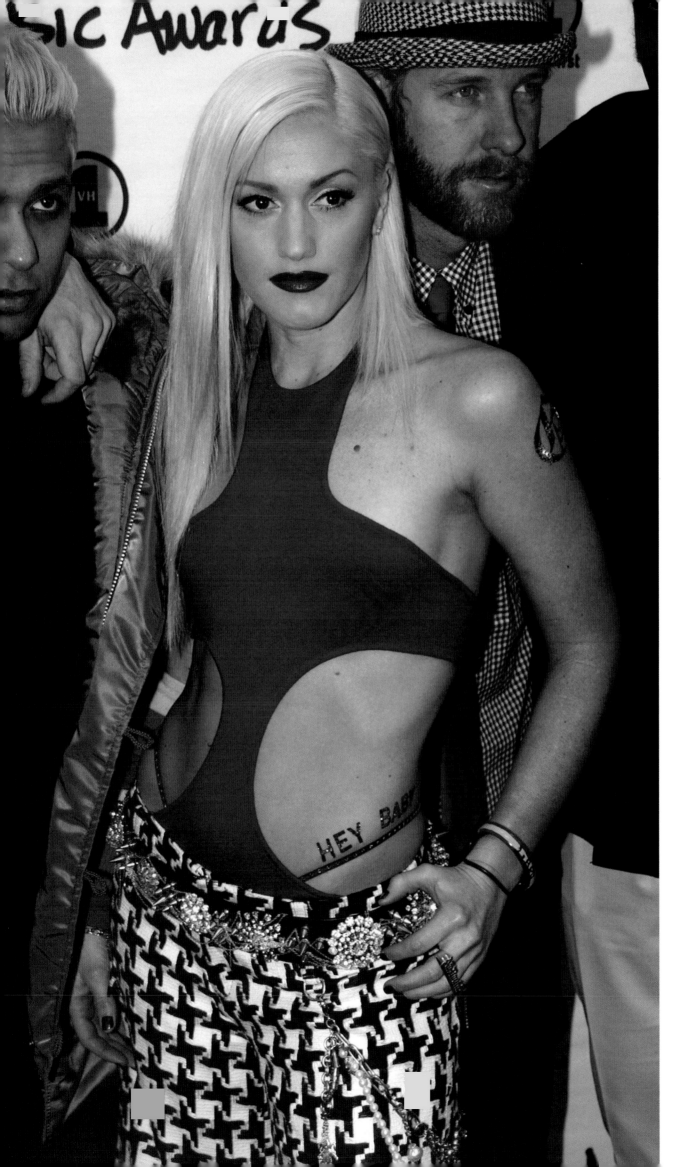

GWEN STEFANI

2001

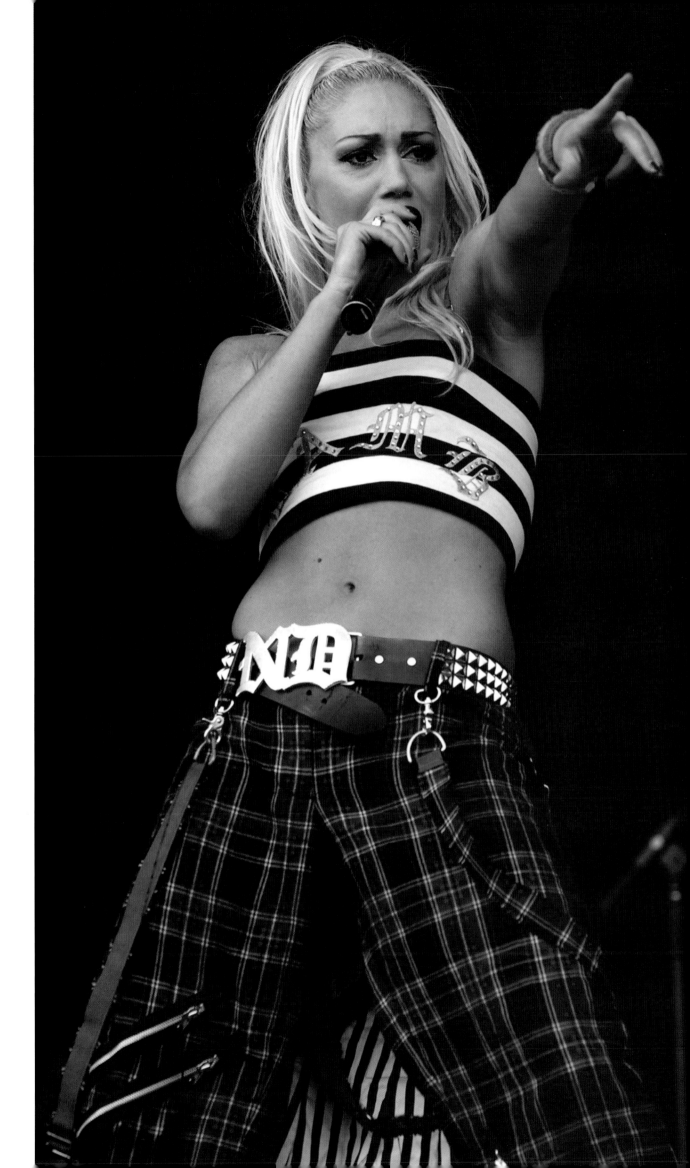

GWEN STEFANI
ON STAGE
2002

MADONNA ON STAGE

1984

MADONNA PERFORMING AT THE WEMBLEY STADIUM

1993

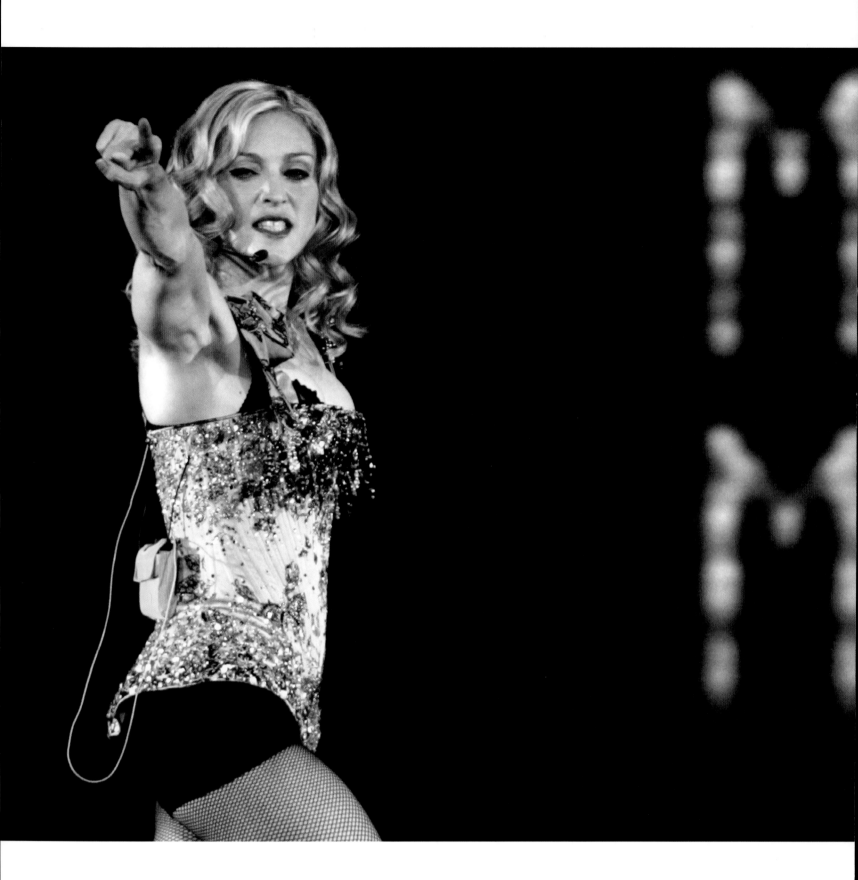

MADONNA

2004

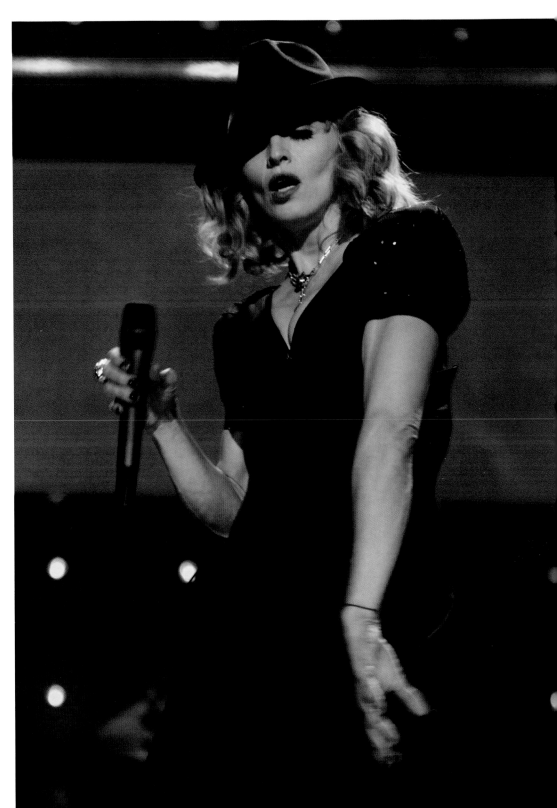

MADONNA PERFORMING AT A CHARITY CONCERT IN LONDON

2007

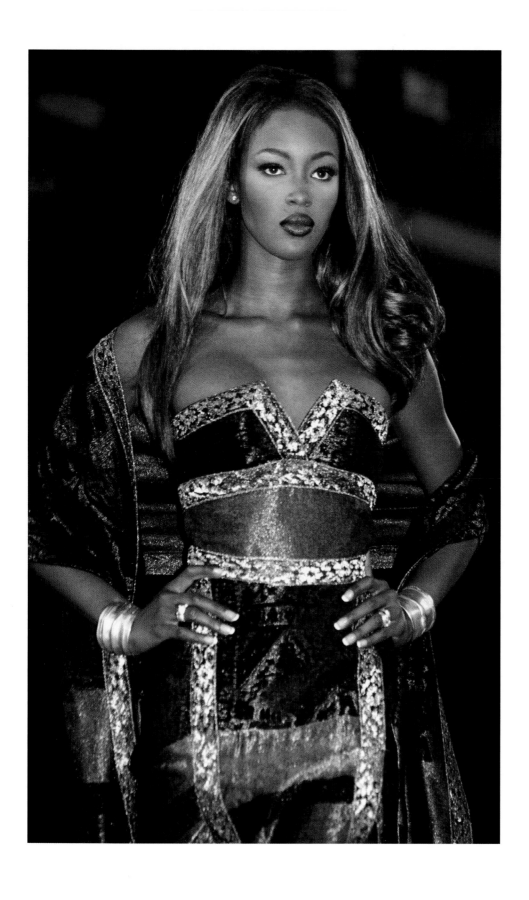

ABOVE: SUPERMODEL NAOMI CAMPBELL

1991

RIGHT: NAOMI CAMPBELL MODELLING A WEDDING DRESS
MADE FROM NEWSPAPERS AND DOLLAR BILLS

1994

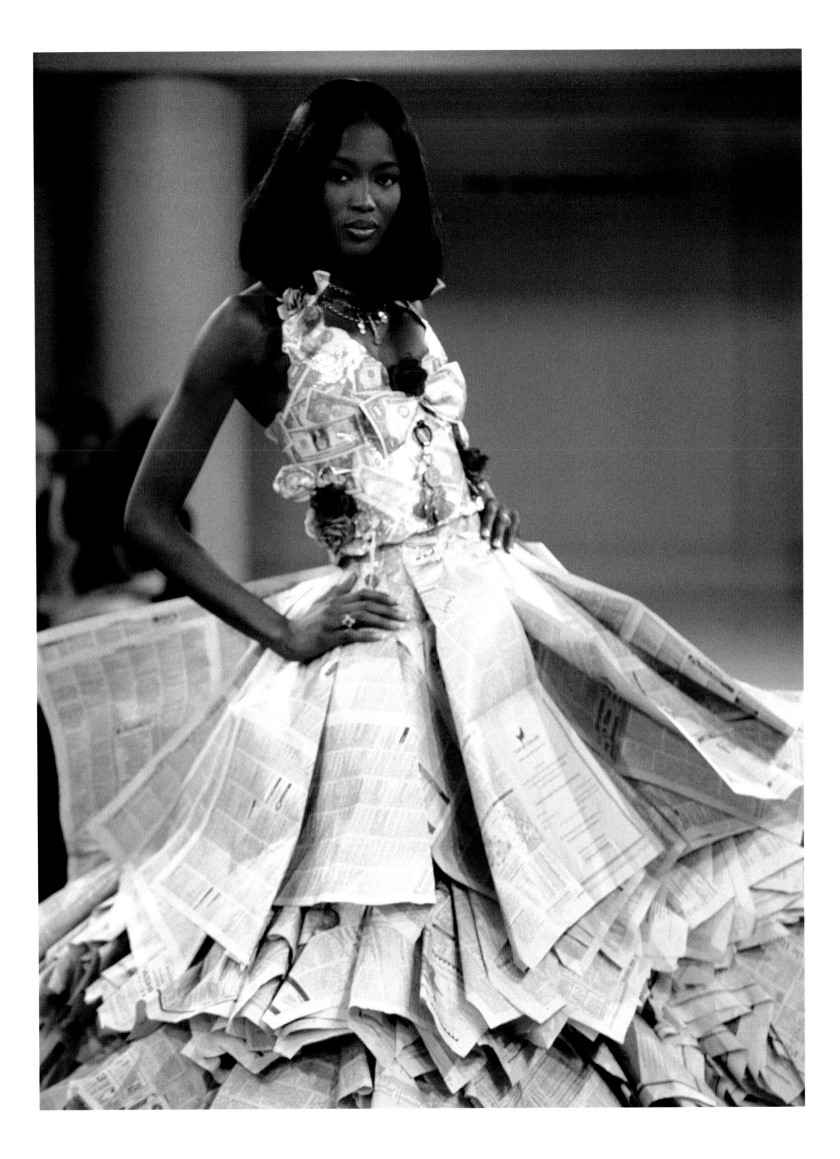

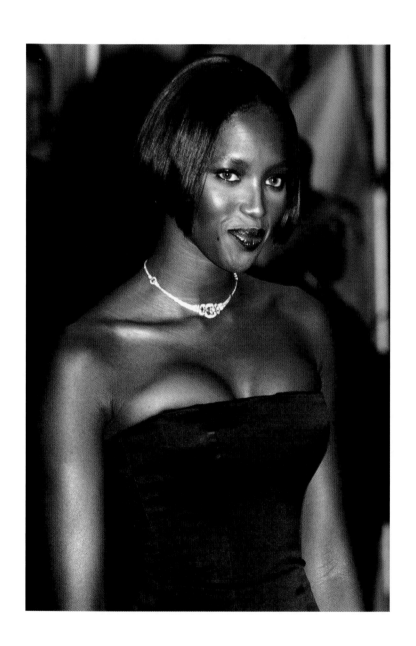

LEFT: NAOMI CAMPBELL
IN WASHINGTON
1996

RIGHT: NAOMI CAMPBELL
2004

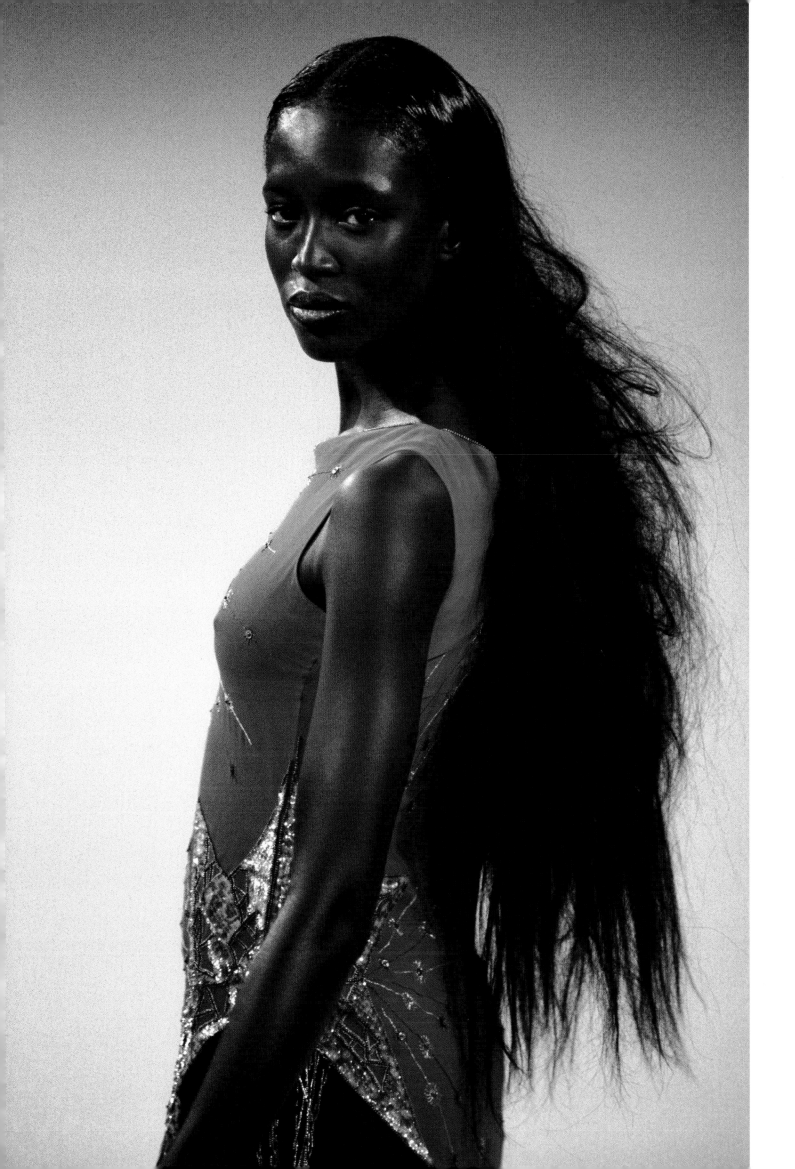

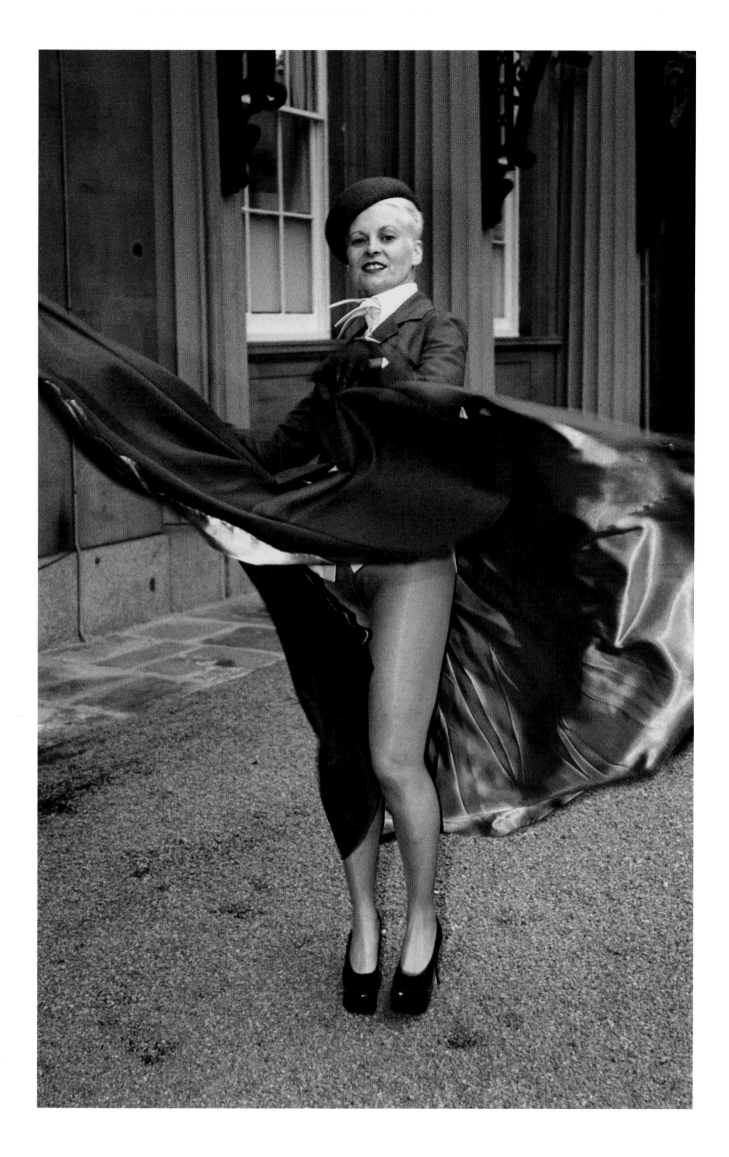

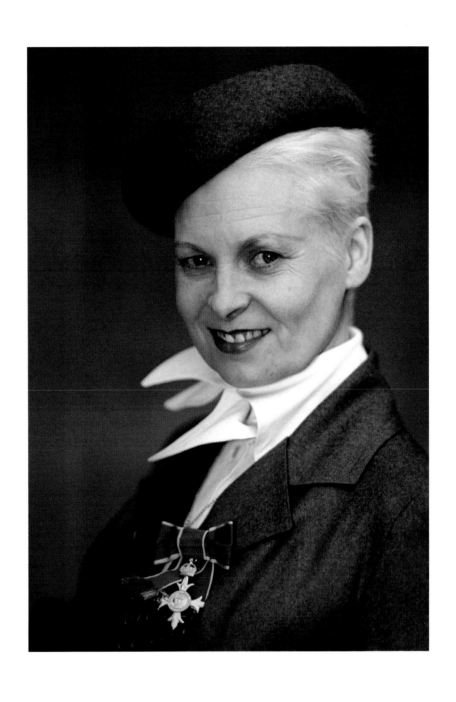

VIVIENNE WESTWOOD AT BUCKINGHAM PALACE
TO COLLECT HER OBE (WEARING NO UNDERWEAR)

1992

VIVIENNE WESTWOOD
AND MODELS AT
LONDON FASHION WEEK
1997

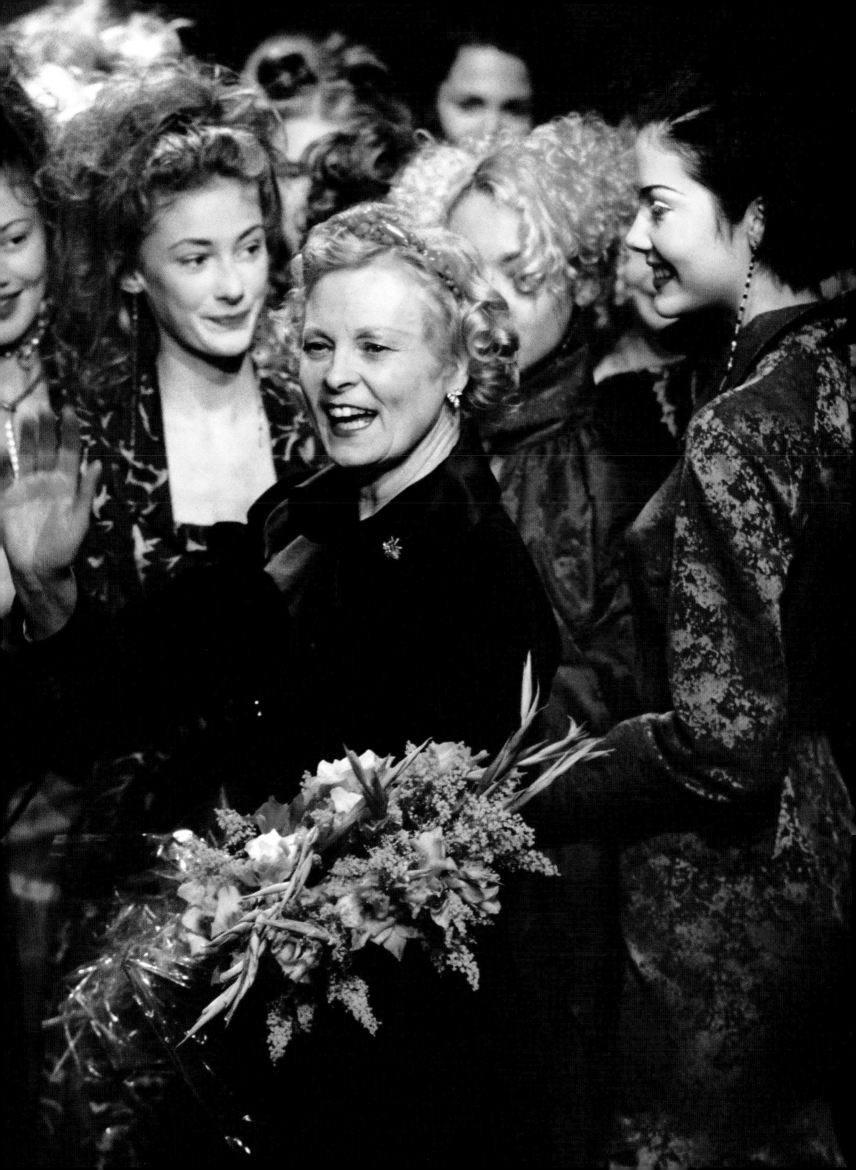

Vivienne Westwood

1999

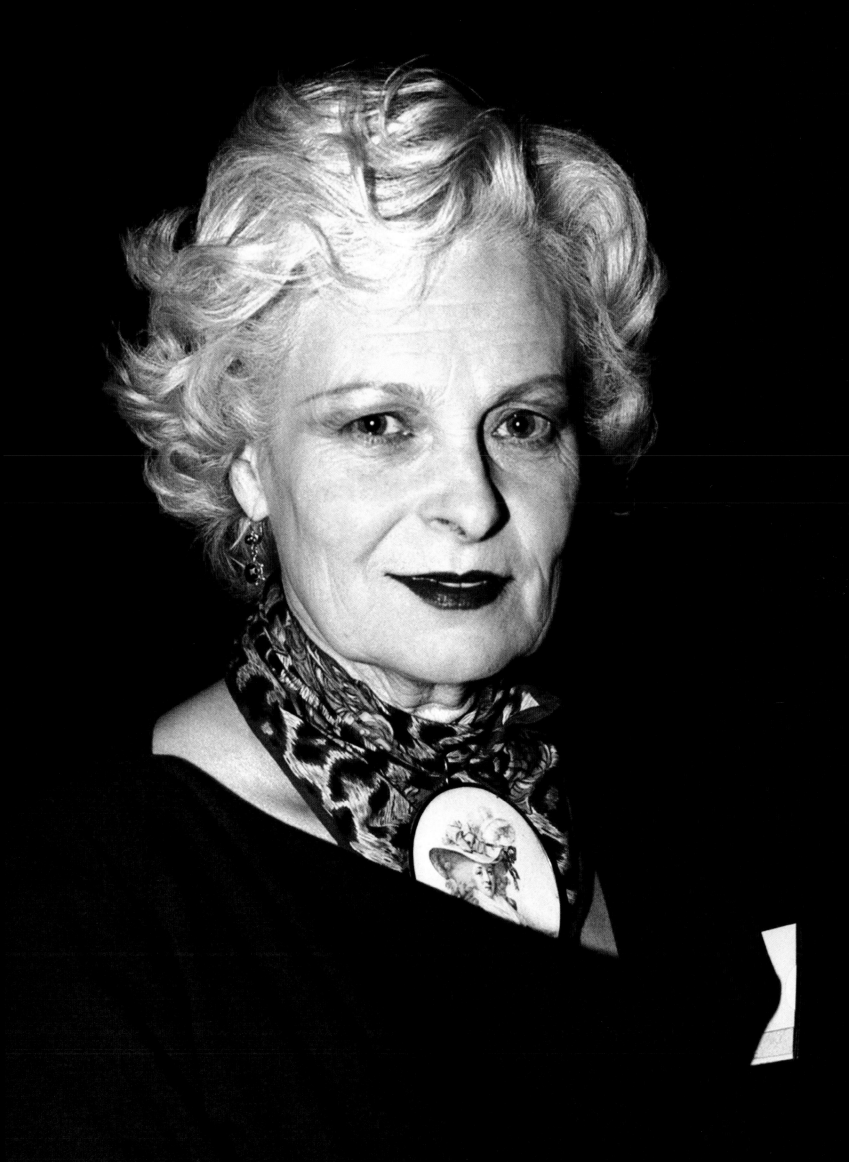

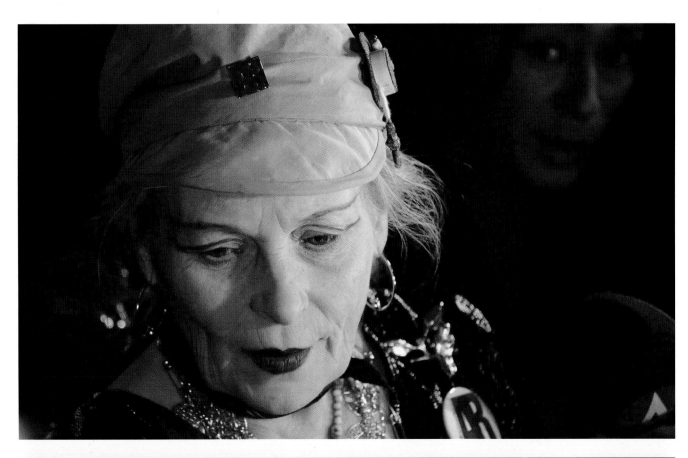

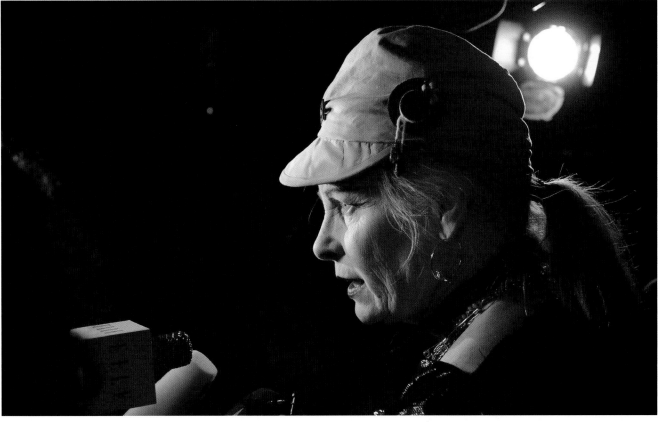

ABOVE: VIVIENNE WESTWOOD TALKS TO THE MEDIA AT HER SHOW IN EARLS COURT, LONDON

2008

RIGHT: VIVIENNE WESTWOOD AT LONDON FASHION WEEK

2008

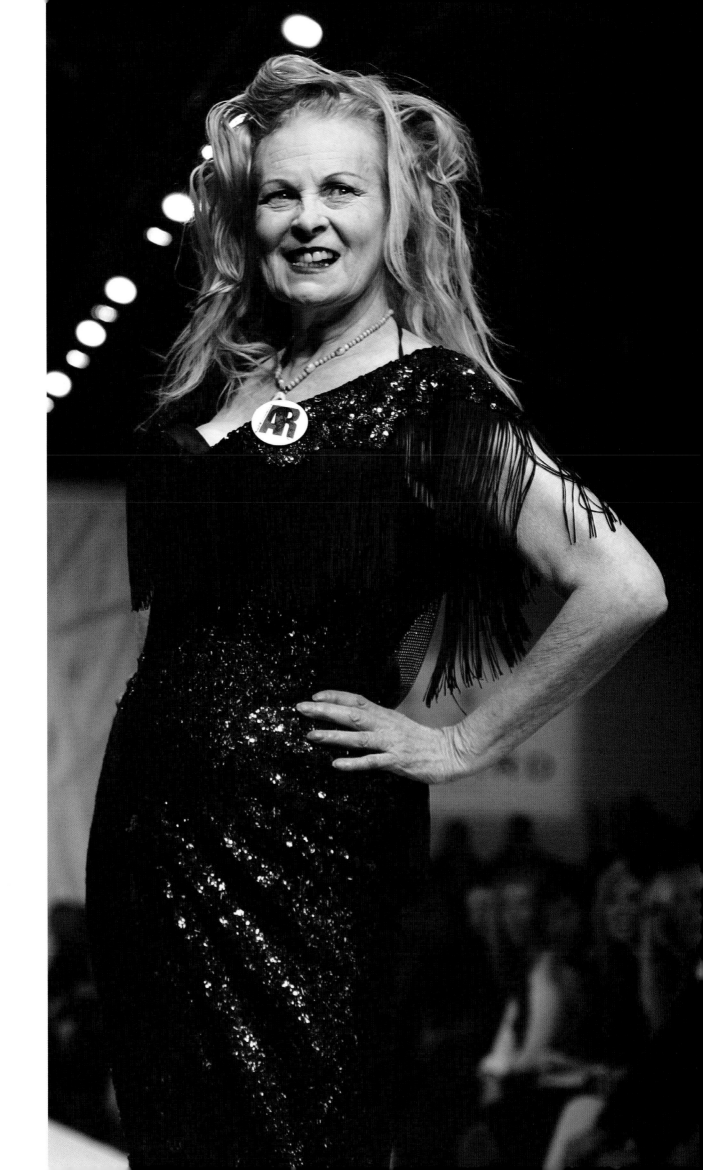

KATE MOSS (SECOND FROM RIGHT) WITH JADE JAGGER
(RIGHT) AND OTHER MODELS BEHIND
THE SCENES AT LONDON FASHION WEEK

1997

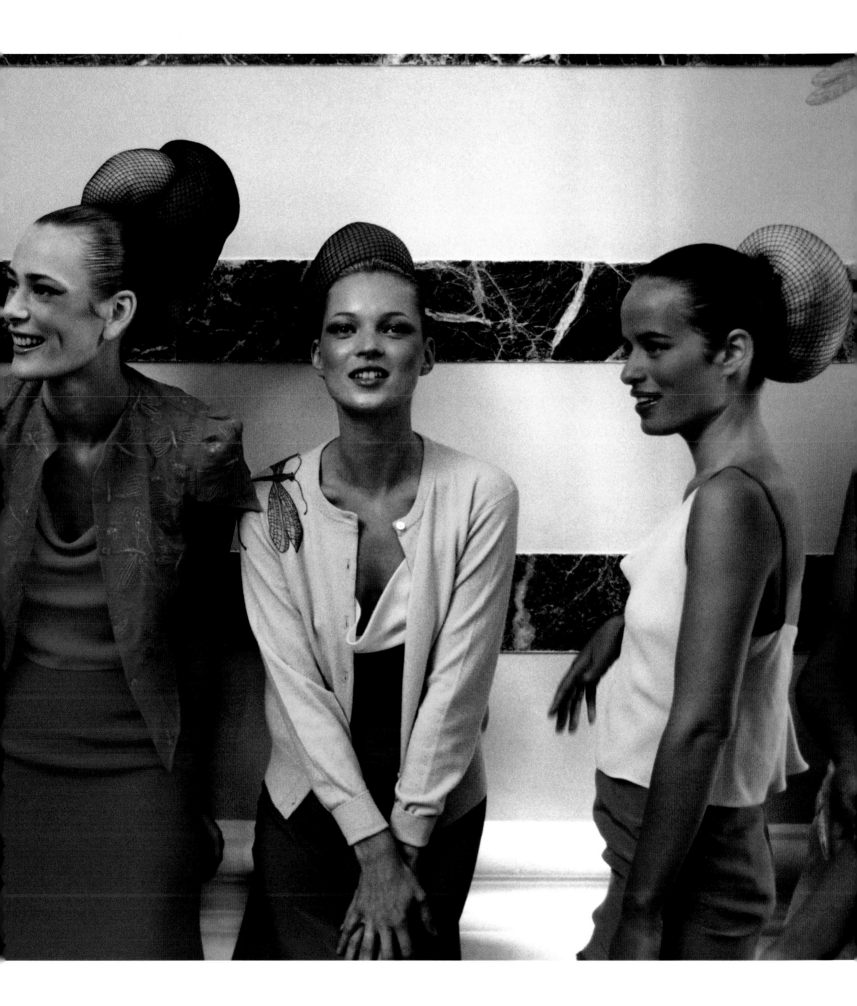

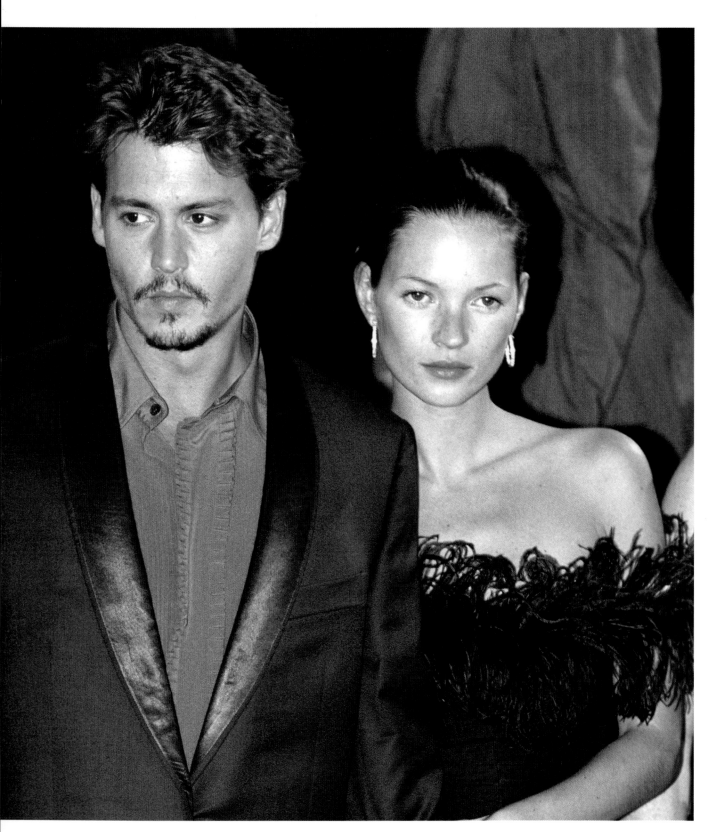

Kate Moss with Johnny Depp at the Cannes Film Festival

1998

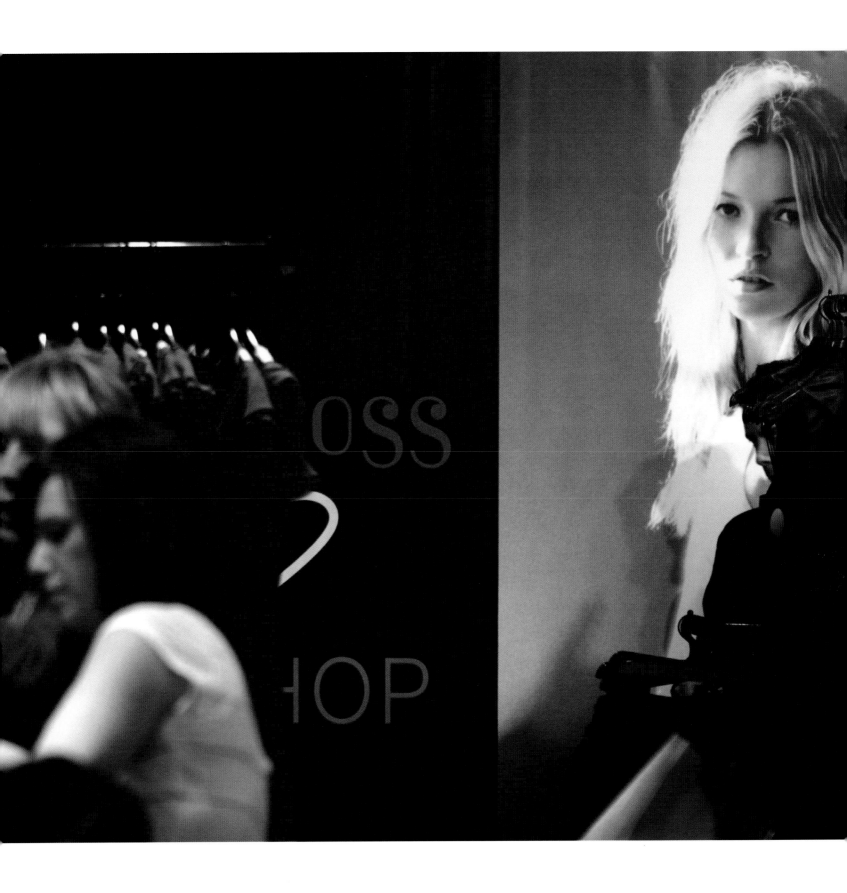

AN IMAGE OF KATE MOSS LOOKS ON AT THE LAUNCH OF HER NEW COLLECTION AT TOPSHOP, OXFORD STREET

2007

KATE MOSS WITH
BOYFRIEND JAMIE HINCE
2009

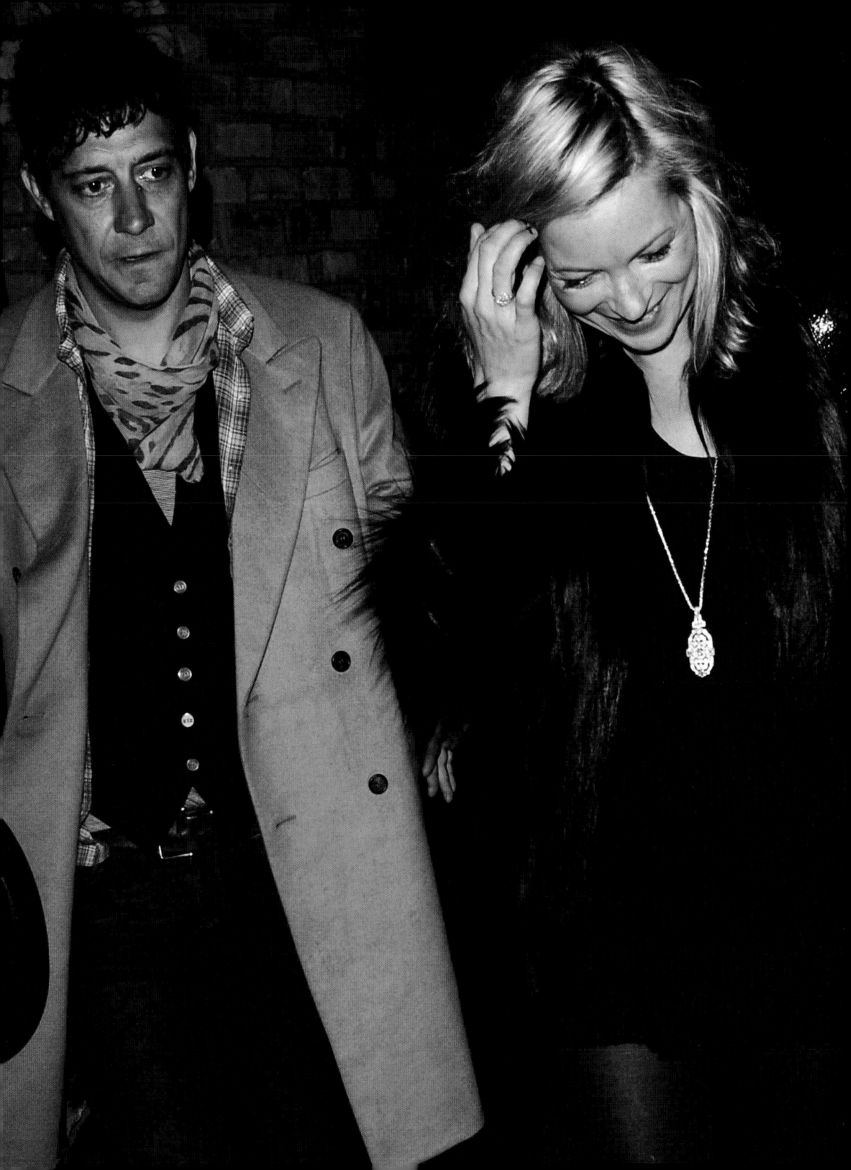

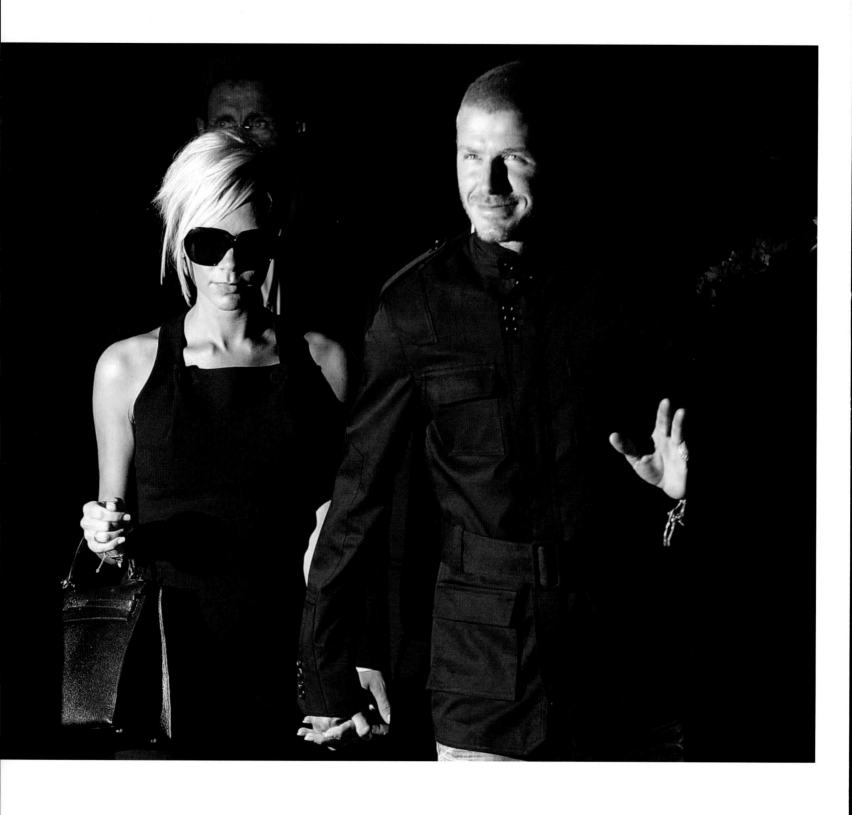

ABOVE: THE BECKHAMS ARRIVE IN LOS ANGELES

2007

RIGHT: VICTORIA BECKHAM AT HARVEY NICHOLS IN MANCHESTER
WHERE SHE LAUNCHED HER NEW FRAGRANCE 'SIGNATURE'

2008

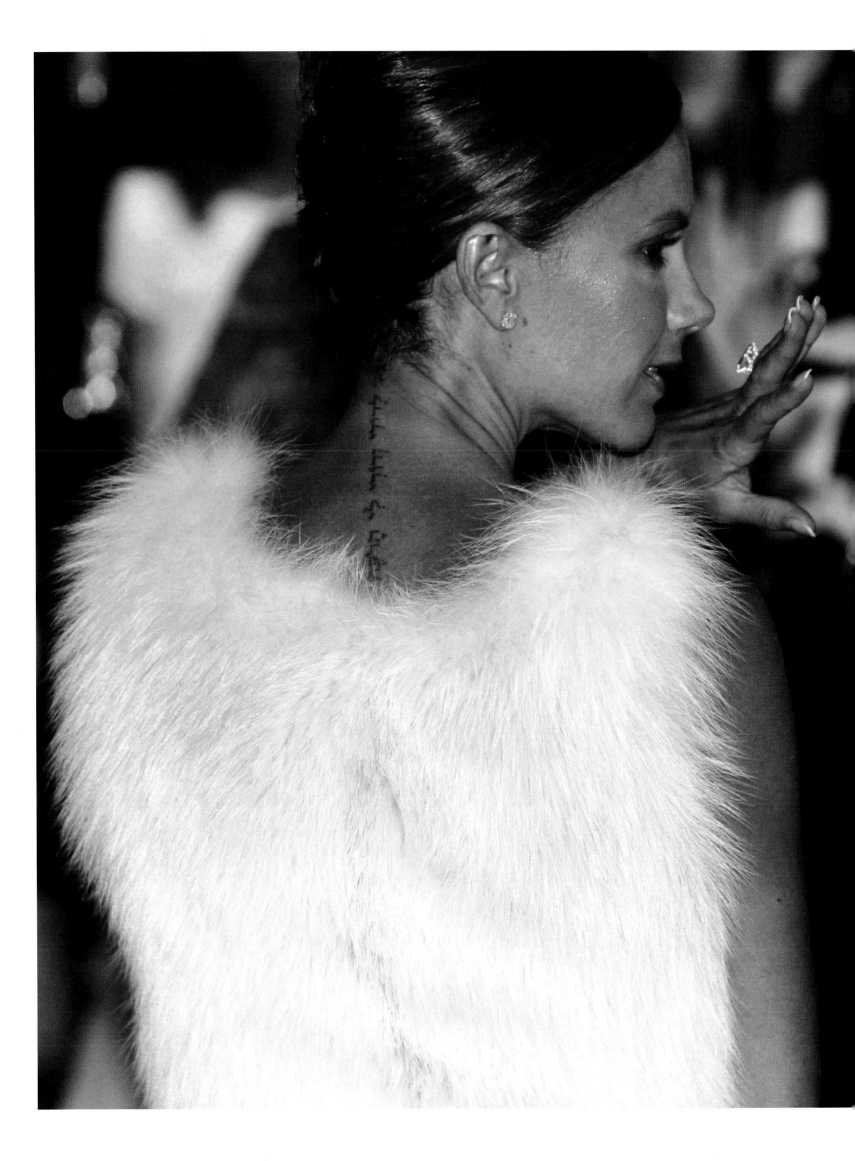

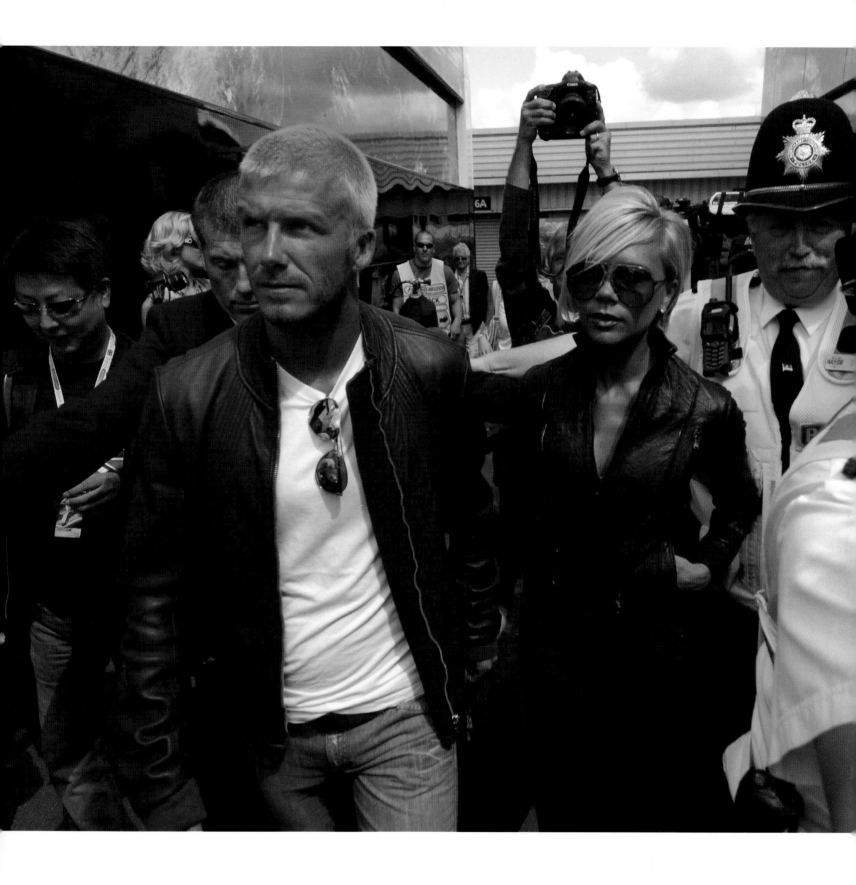

ABOVE: Victoria and David Beckham at Silverstone, Northamptonshire

2007

RIGHT: Victoria Beckham

2009

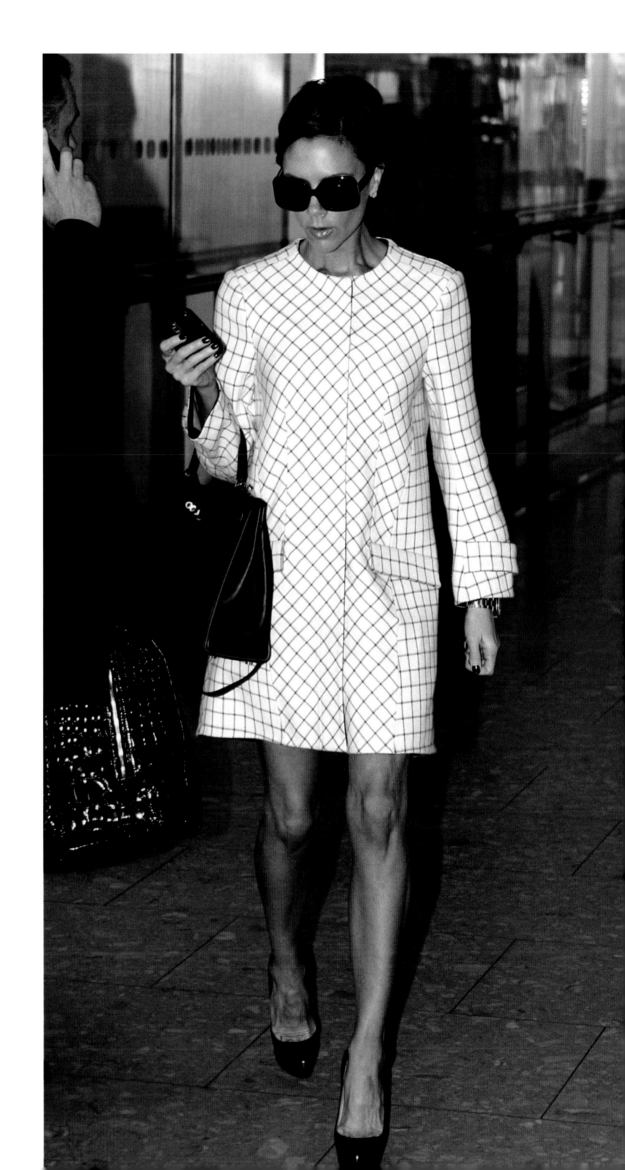

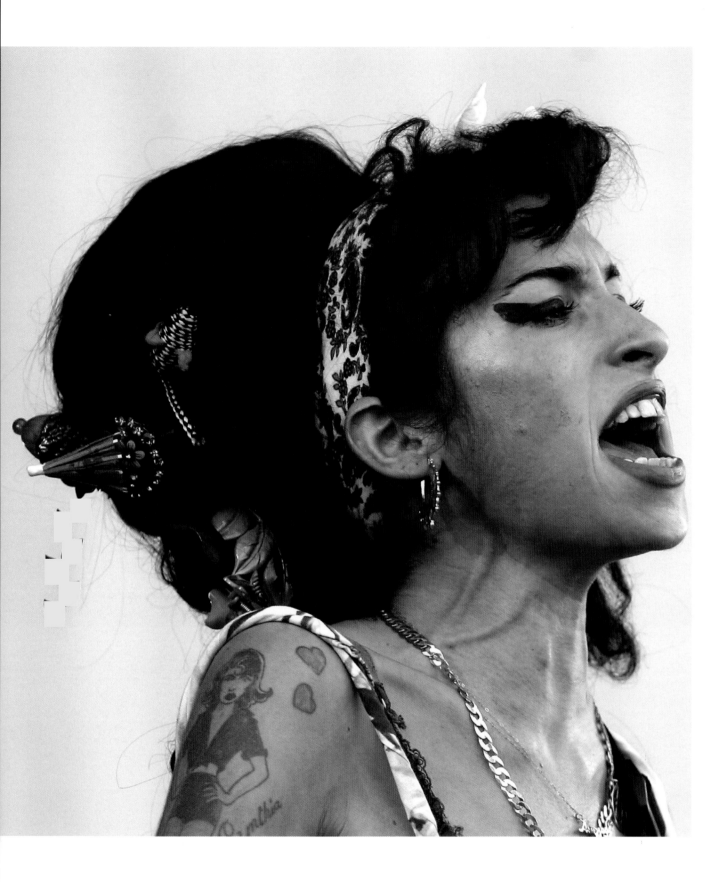

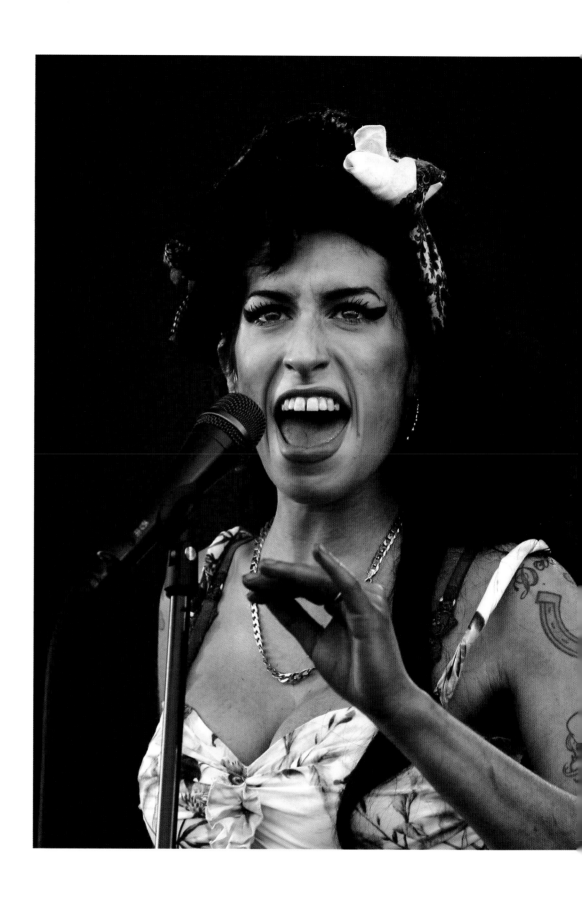

Amy Winehouse performs at the Oxegen music
festival in Co Kildare in Ireland

2008

CHAPTER

ON THE STREETS
AND IN THE SHOPS:
WHAT WE
REALLY WORE

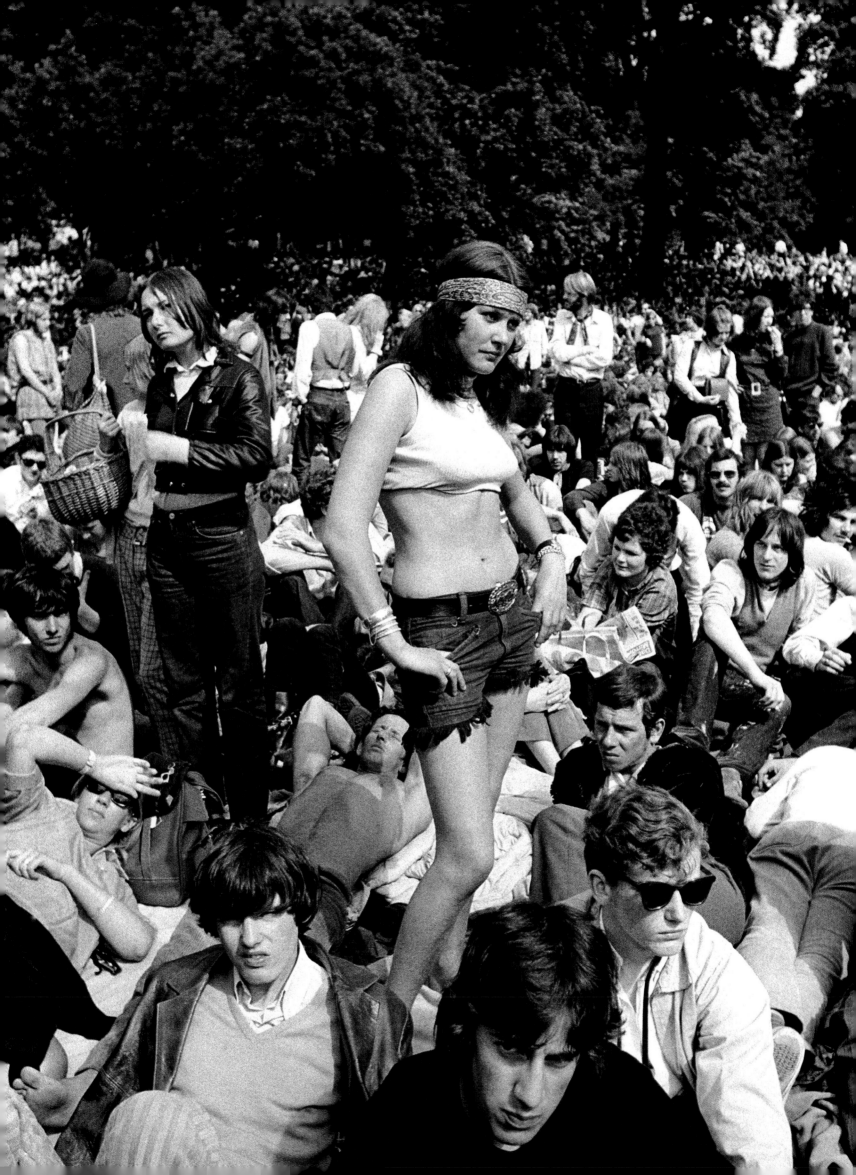

THE REALITY OF FASHION is part of our everyday lives. Even if we claim complete disinterest in it, it still affects us. The cut of a collar or the length of a skirt will be dictated by the fashion of the day and, unless we are wearing clothes 10 or 20 years old, we will discover that we have, however unwittingly, gone along with it – for if we buy clothes they will follow the styles of that era. On the other hand, we might find ourselves fascinated by fashion, looking out for new trends as soon as they come into the shops and discarding our old clothes as being 'out of date'.

This is of course nothing new. Madame Bovary, in Flaubert's novel of the mid-19th century, was undone by her desire for the latest fashion, and while she couldn't reach for her credit card she could borrow money from those who were willing to lend, but at a price. For most of us, designer clothes are beyond our means and, unlike Emma Bovary, we accept the fact and buy cheaper alternatives in the high-street shops. But these days the standard of design, if not the manufacture, of such clothes is on a par with the couture equivalent. London Fashion Week shows the Topshop range alongside Paul Smith and Vivienne Westwood, despite the disparity in their selling price.

But within this context we dress ourselves in the way we do for many different reasons – to conform or rebel, to express our individuality, to fit in with a group or simply for practical purposes. Our clothing often incorporates new technology, from the 'easy care' fabrics introduced in the late '50s to the high-tech sports clothing of today. We frequently look to the past for inspiration; the 2000s have seen a melding of fashions from different decades of the last century, mixed up with the new, to produce a 'postmodern' style of its own.

Looking back at past fashions can produce different emotions, from hilarity to nostalgia. We generally have a favourite era that we either lived through or would like to have lived through; the clothes of that time perhaps express something we would like to say about ourselves. Ultimately, our clothes are a message to the world; they tell those around us, if only superficially, where we fit in. They are a code that functions to entice, to warn, to empathise or to shock.

PAGE 196: A ROLLING STONES
CONCERT IN HYDE PARK
1969

THE WOMEN'S LEAGUE
OF HEALTH & BEAUTY
1947

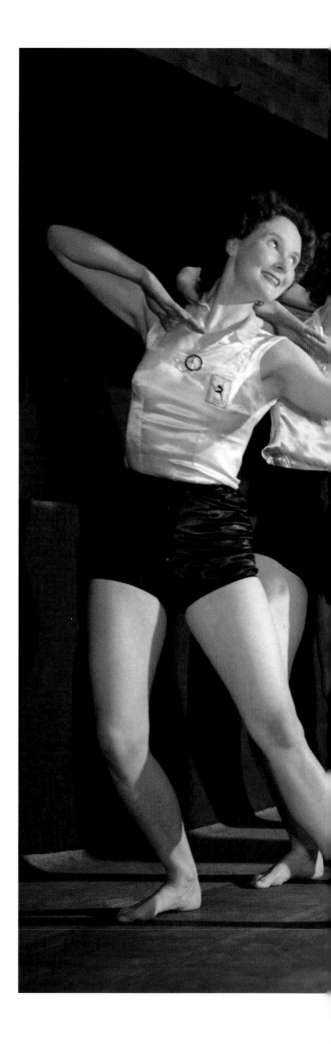

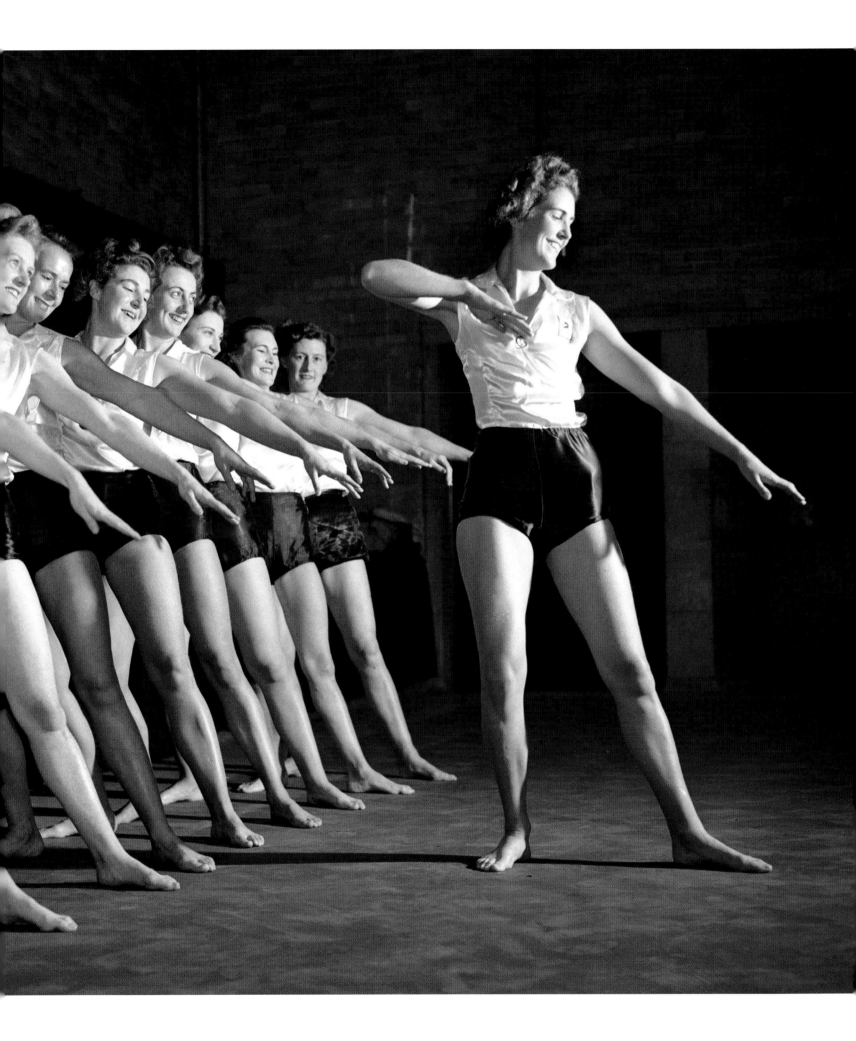

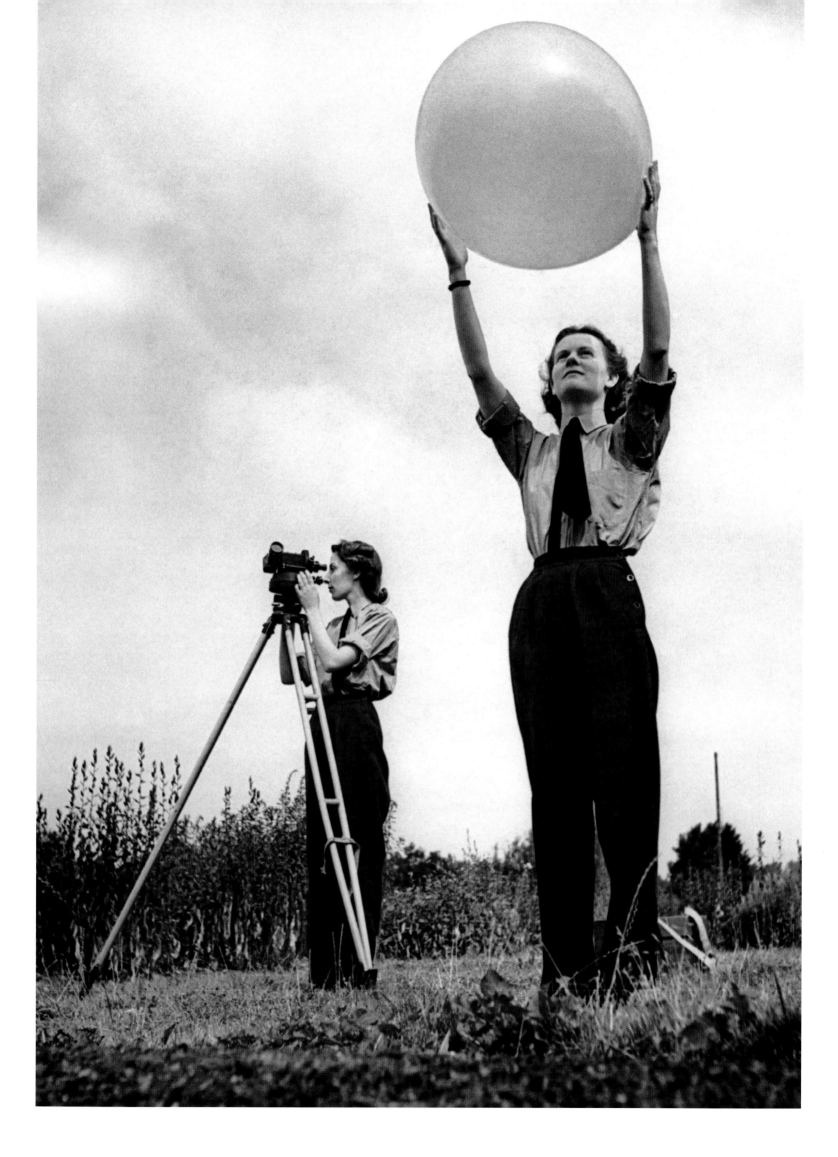

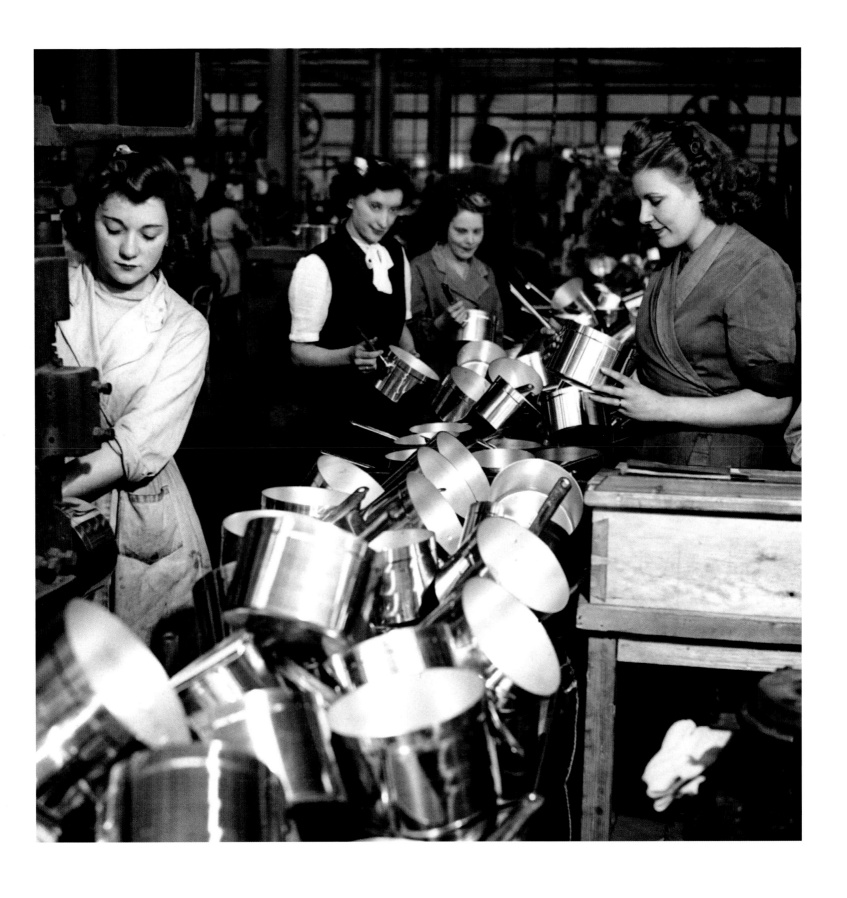

LEFT: RAF 'MET' GIRLS IN UNIFORM AT UXBRIDGE WEATHER STATION

1947

ABOVE: WOMEN WORKING IN A POTS AND PANS FACTORY

1947

A CROWD OUTSIDE BUCKINGHAM PALACE

1947

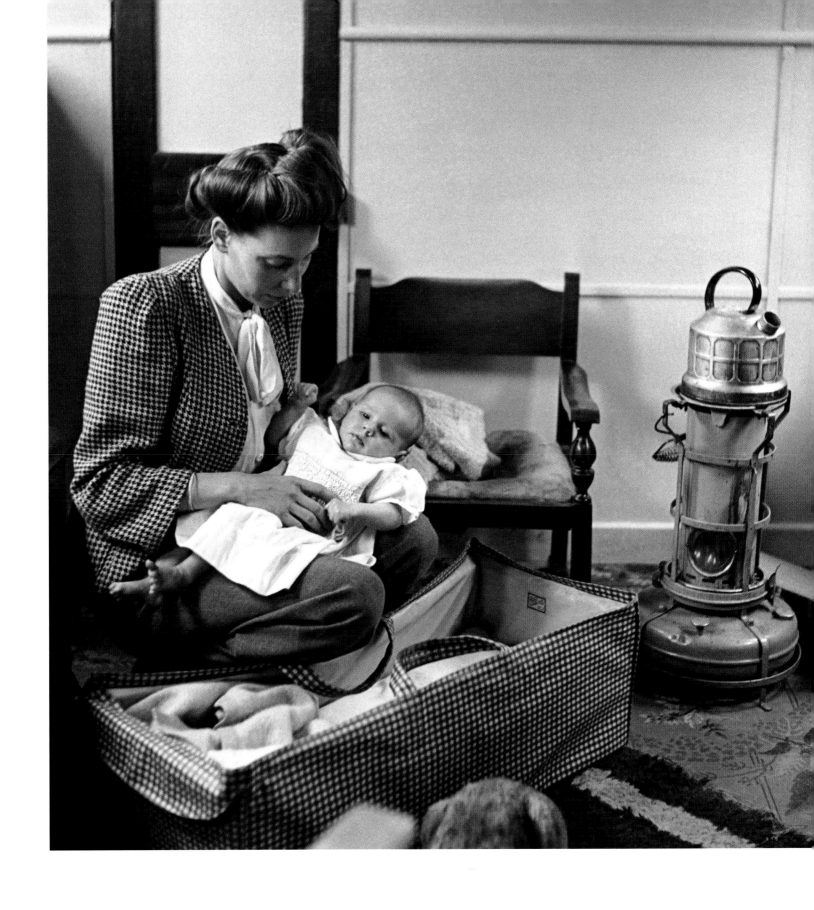

A WOMAN AND BABY ON A HOUSEBOAT IN WALTHAMSTOW

1947

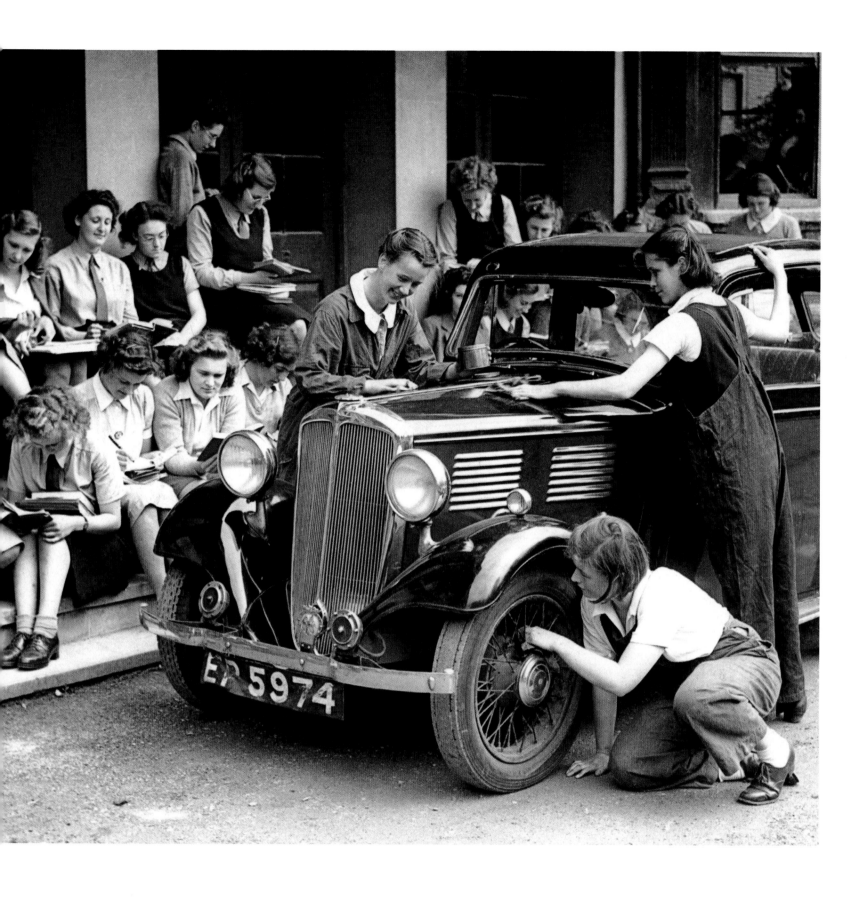

ABOVE: SCHOOLGIRLS RAISE MONEY FOR CHARITY BY CLEANING CARS

1947

RIGHT: TWO YOUNG WOMEN ON A BEACH IN SKEGNESS

1948

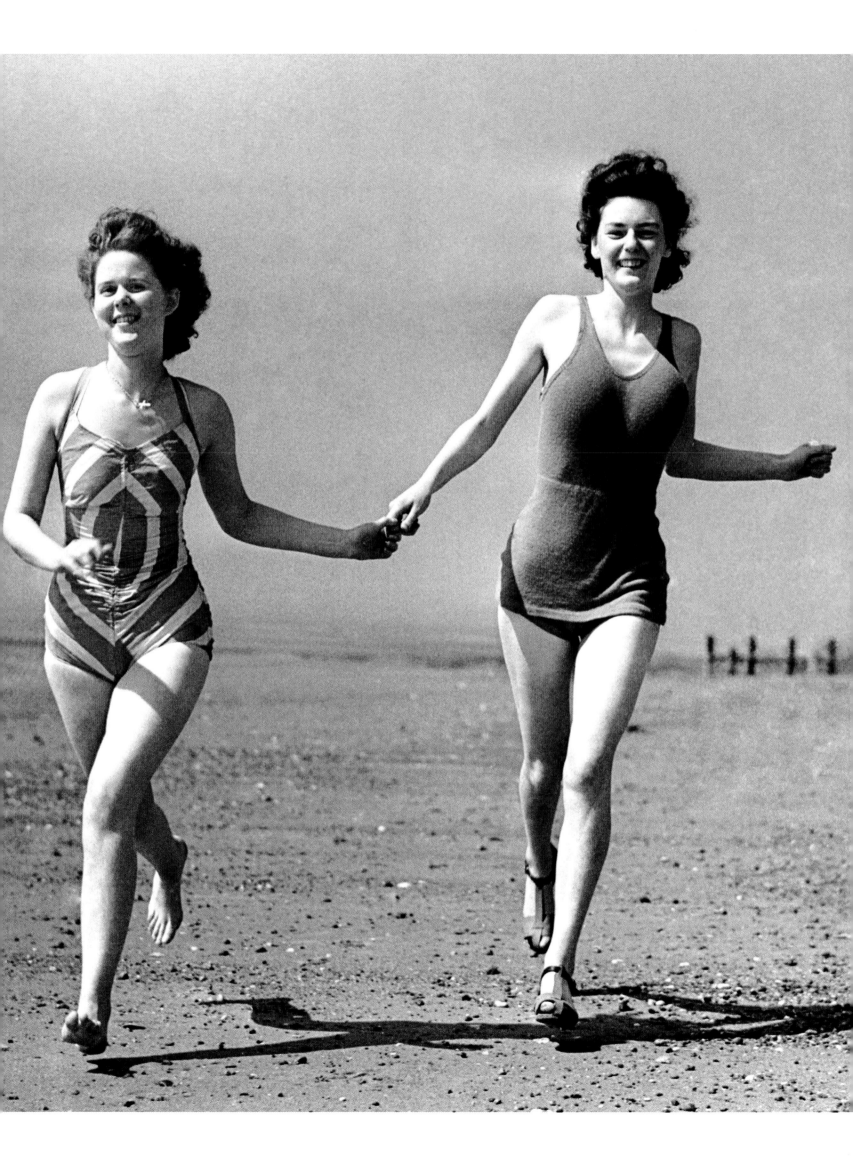

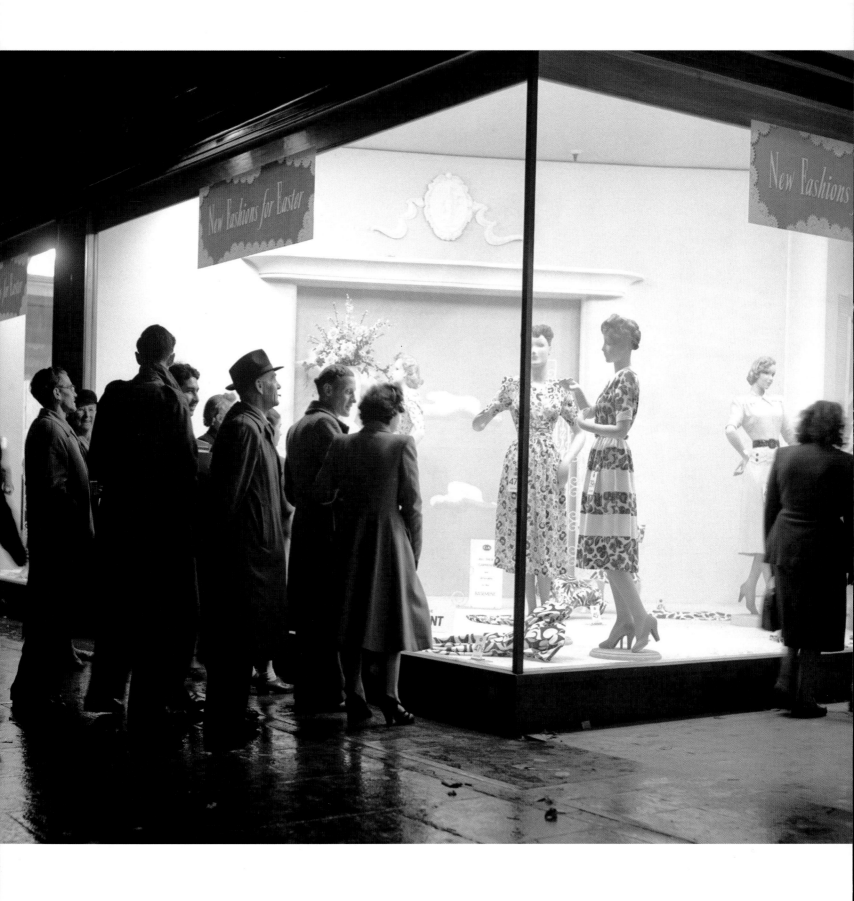

FOR THE FIRST TIME SINCE 1939 THERE ARE LIGHTS ON IN THE SHOPS AT NIGHT

1949

THE END OF CLOTHES RATIONING AT SELFRIDGES UNDERWEAR DEPARTMENT

1949

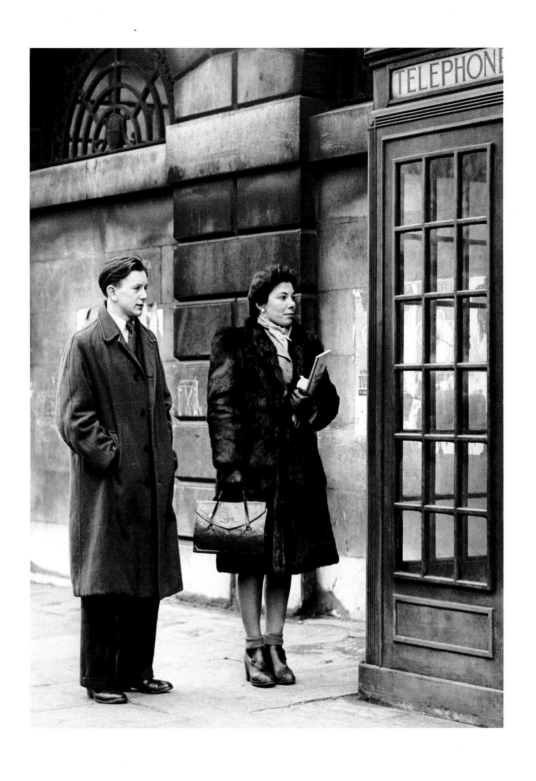

ABOVE: A YOUNG COUPLE WAIT OUTSIDE A TELEPHONE BOX

1950

RIGHT: A BOY SCOUT CLEANS A WOMAN'S SHOES

1951

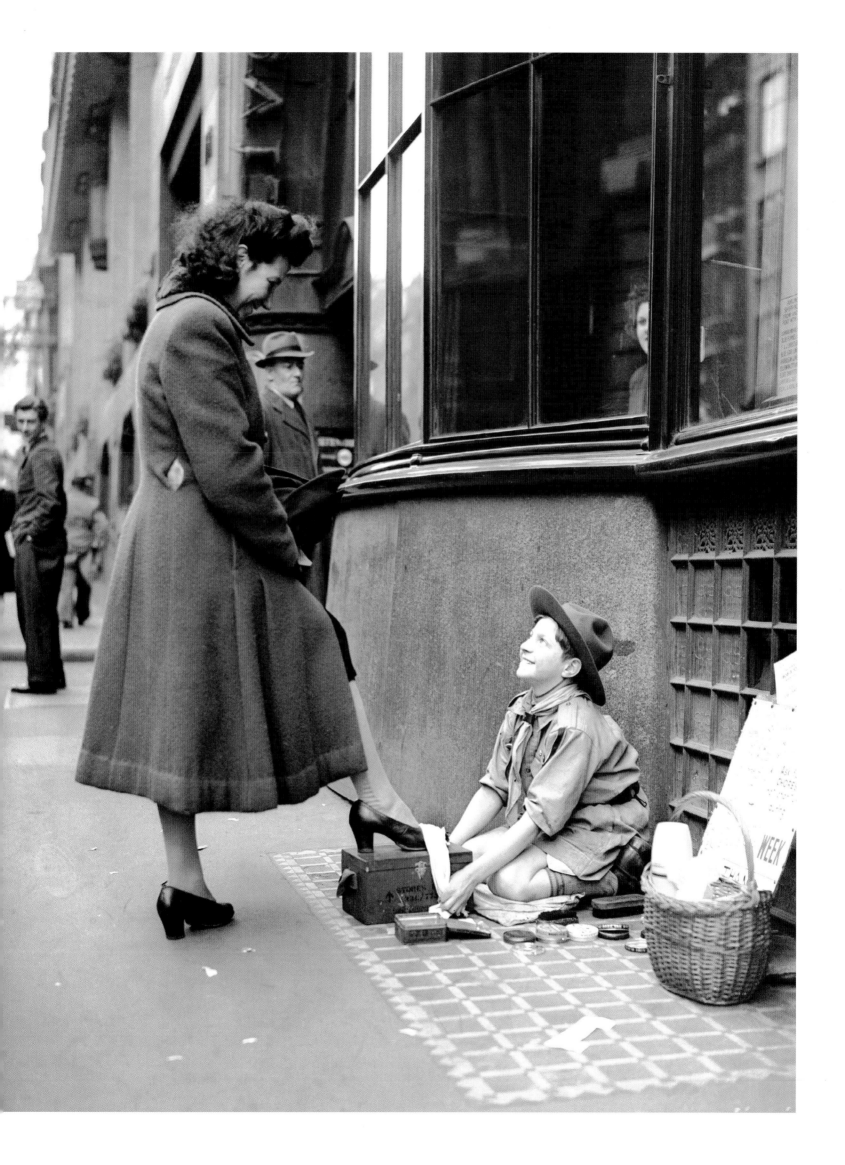

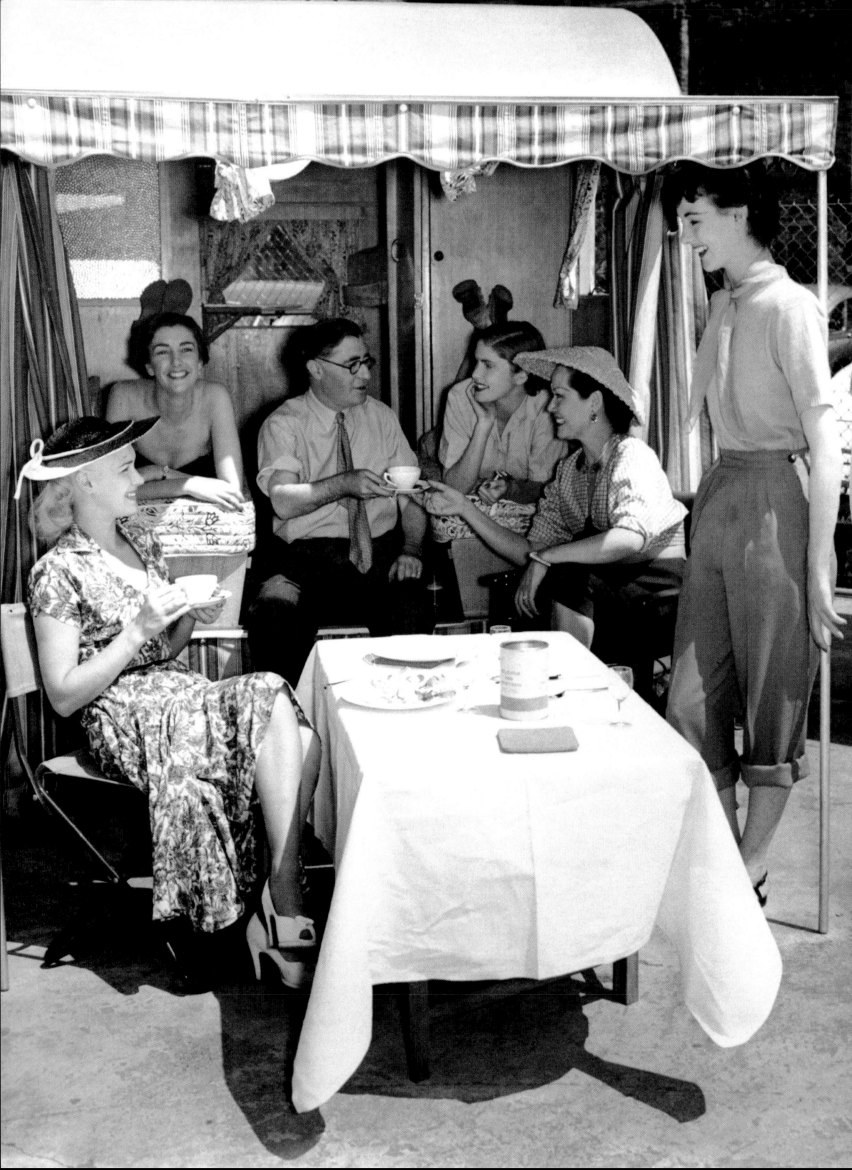

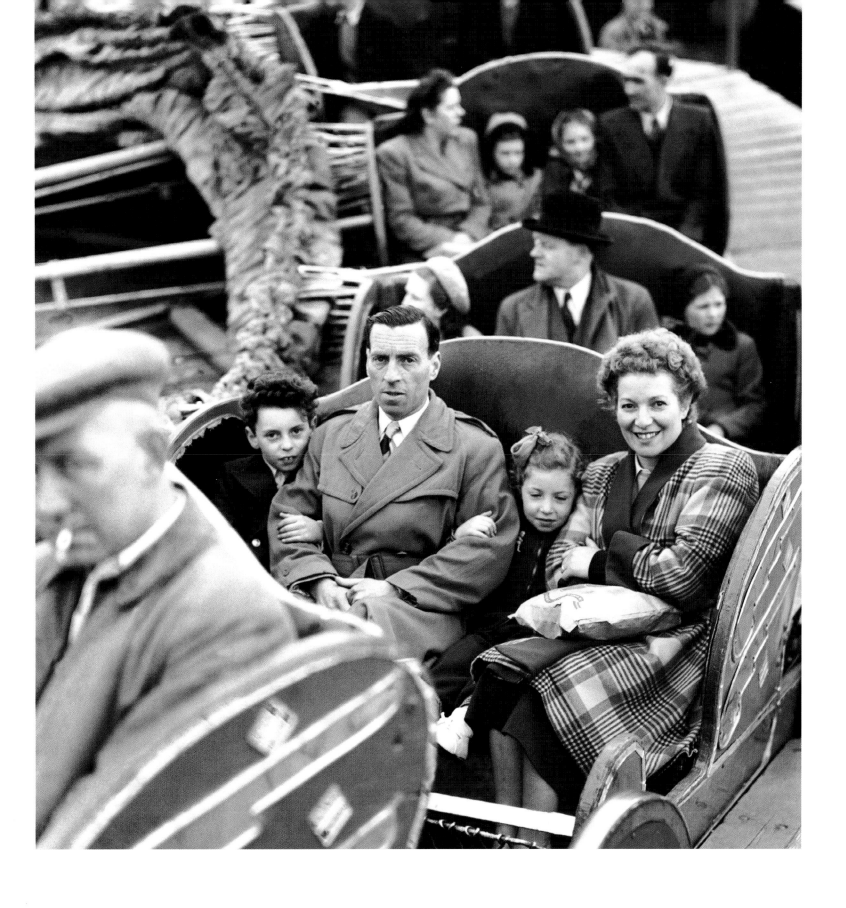

LEFT: AN EXHIBITION OF CARAVANS IN OXFORD STREET

1951

ABOVE: A 'CATERPILLAR' RIDE AT THE FESTIVAL OF BRITAIN FUN FAIR AT BATTERSEA PARK

1951

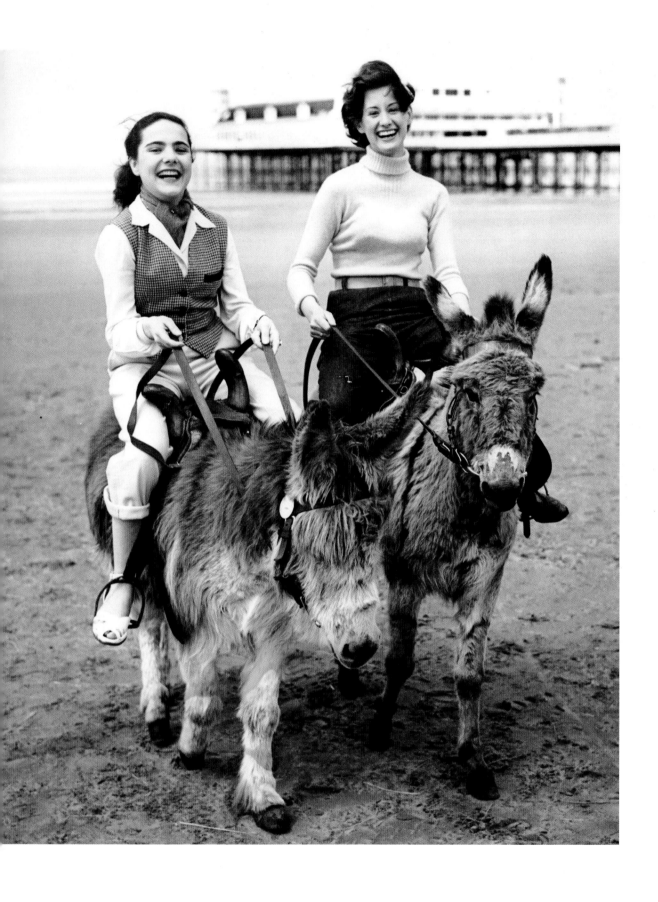

DONKEY RIDES ON THE BEACH AT WESTON-SUPER-MARE

1951

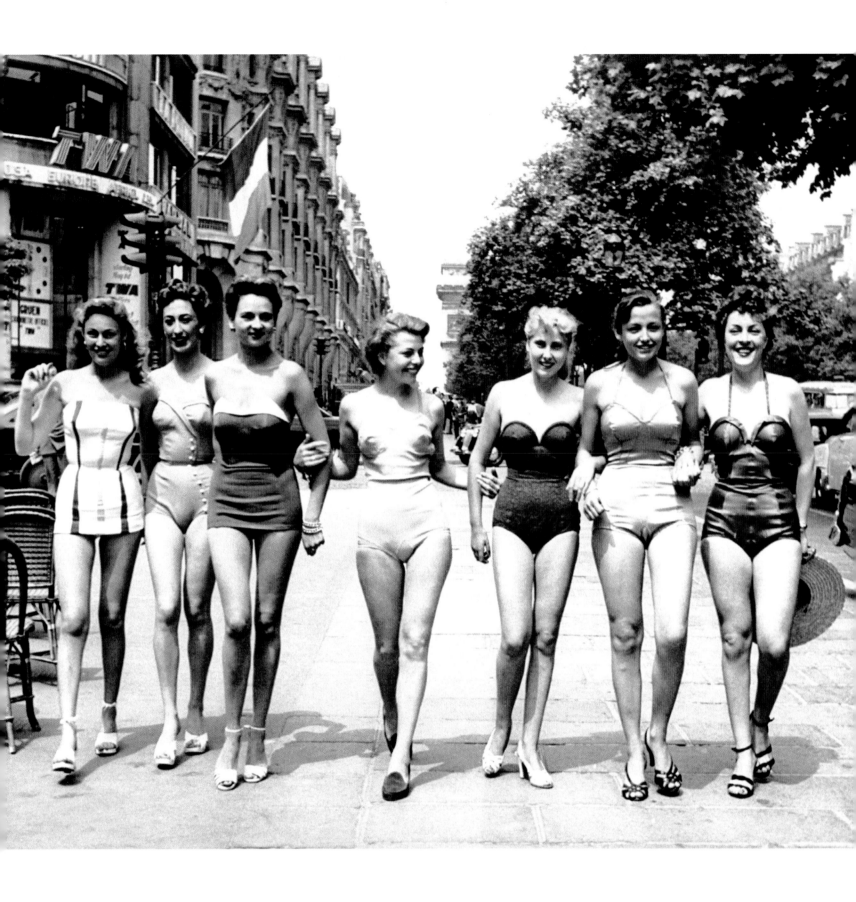

BEAUTY QUEEN FINALISTS IN PARIS

1952

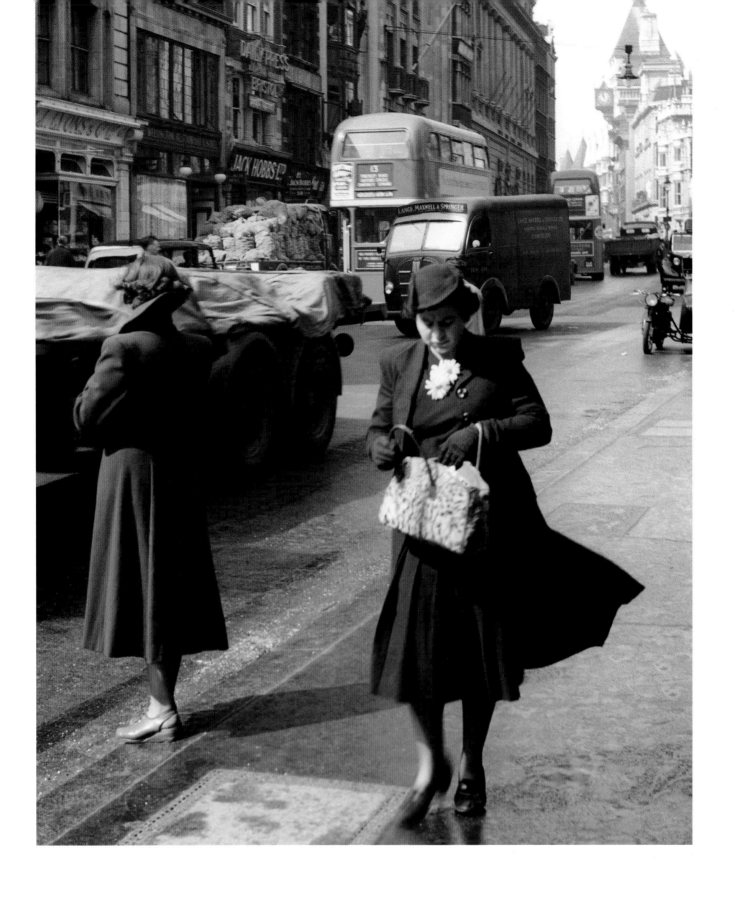

FLEET STREET, LONDON

1952

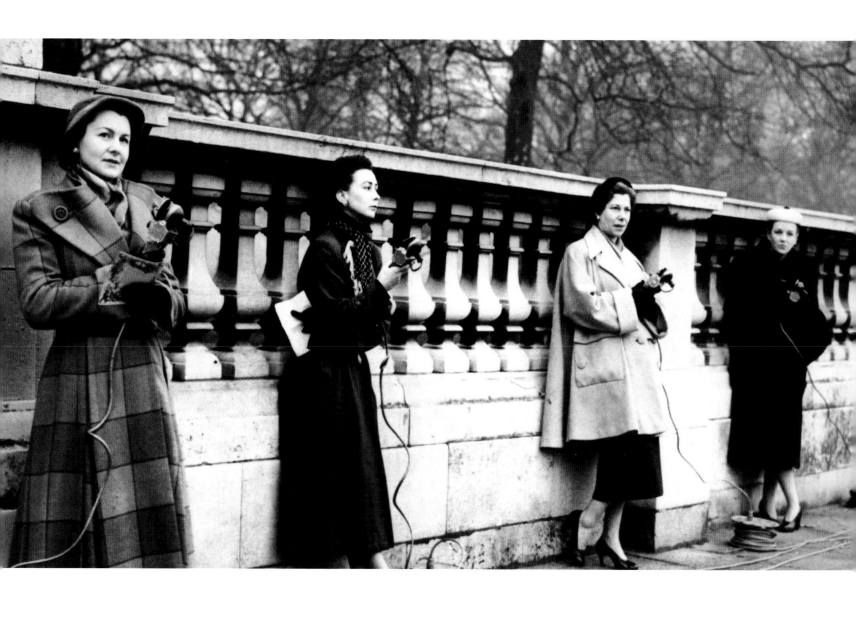

FOUR WOMEN AUDITIONING TO BE COMMENTATORS AT THE CORONATION FOR THE BBC

1953

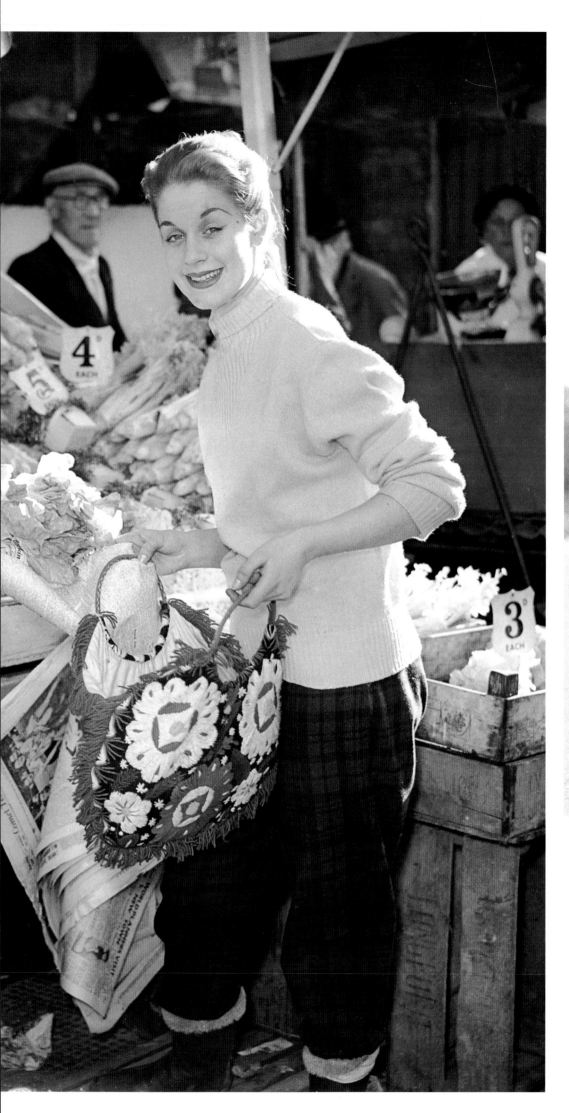

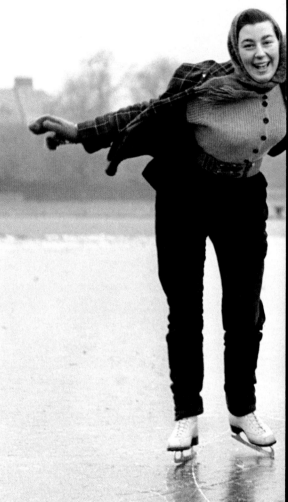

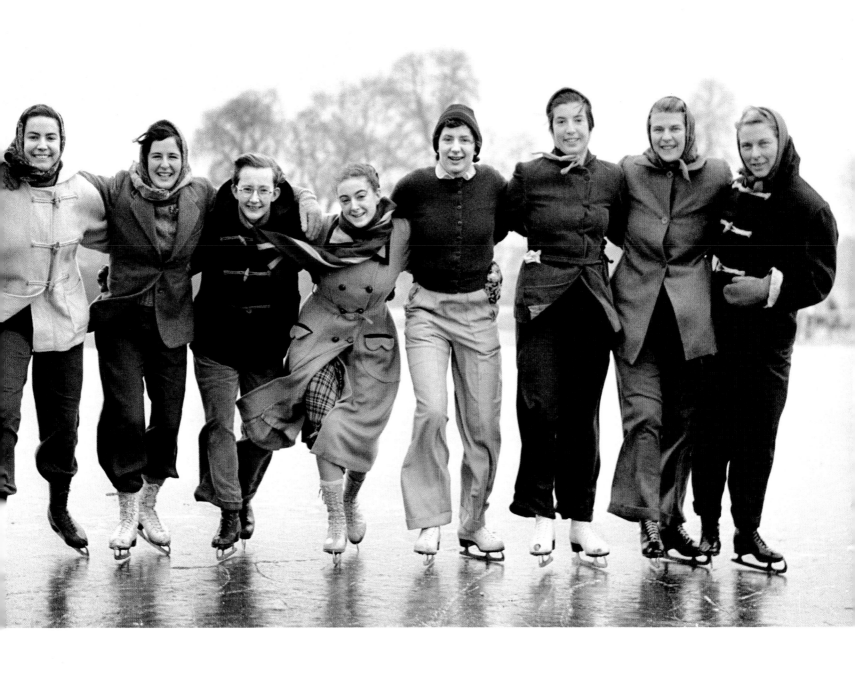

LEFT: A YOUNG WOMAN BUYING VEGETABLES AT HAMMERSMITH MARKET

1954

ABOVE: SKATING ON THE ROUND POND AT KENSINGTON GARDENS

1954

A YOUNG COUPLE IN
NOTTING HILL GATE
1958

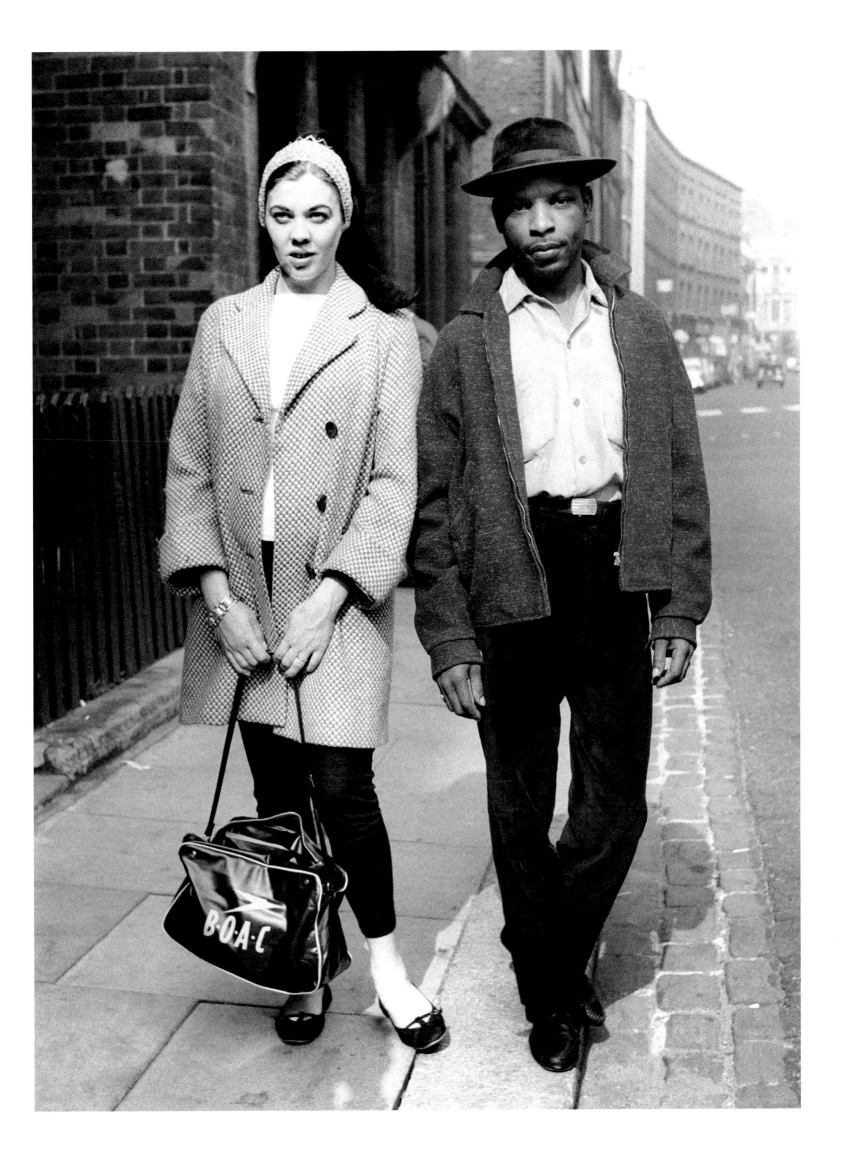

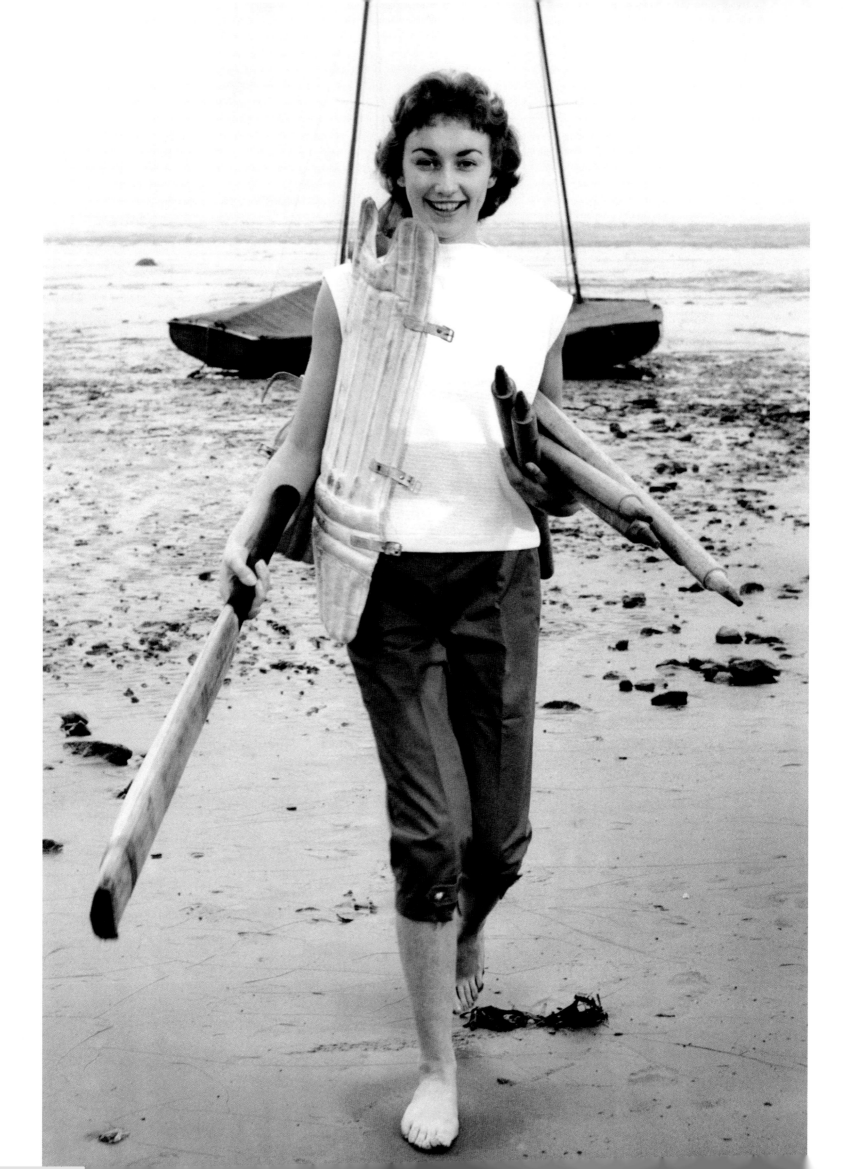

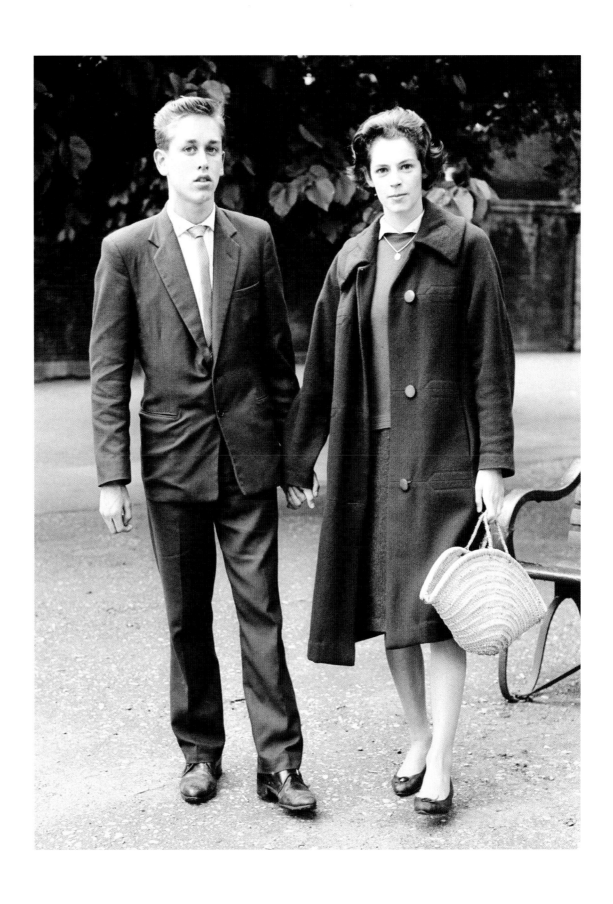

LEFT: A YOUNG WOMAN ABOUT TO PLAY CRICKET
ON THE BEACH AT WESTON-SUPER-MARE
1958

ABOVE: A STROLL IN THE PARK IN LONDON
1960

FANS AT A BEATLES CONCERT
IN MANCHESTER
1963

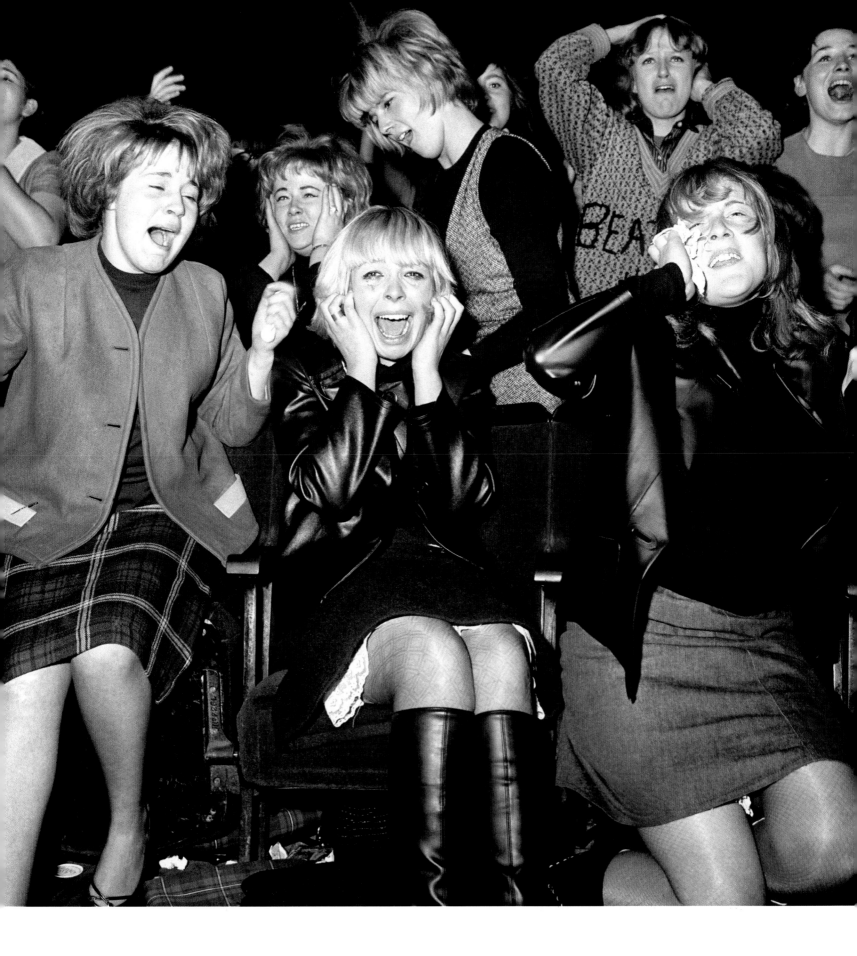

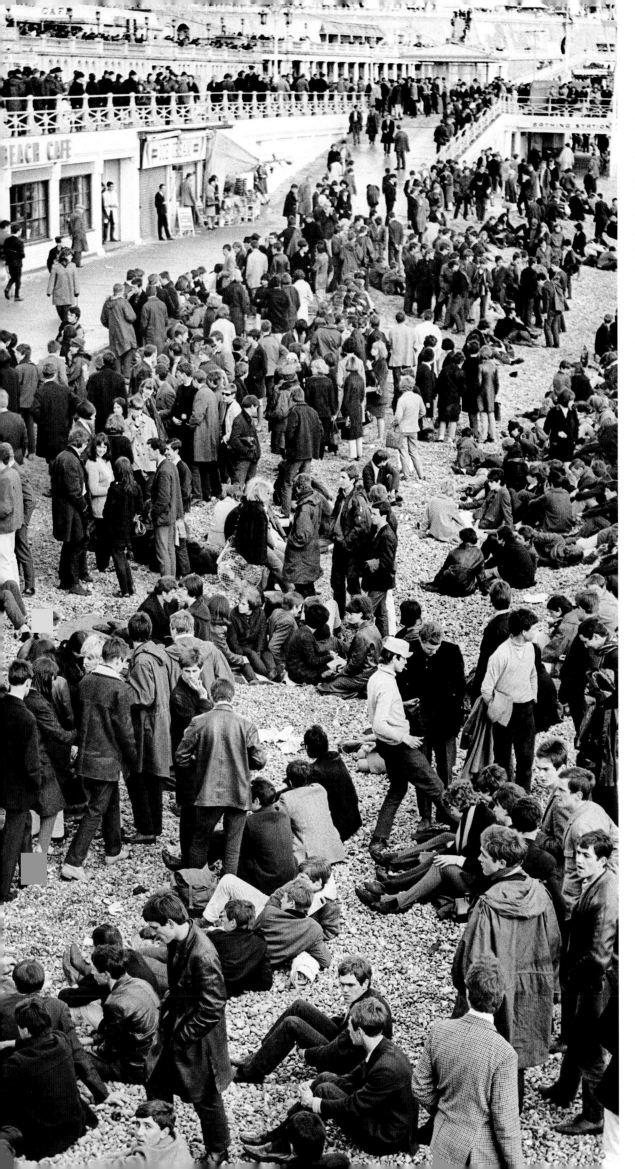
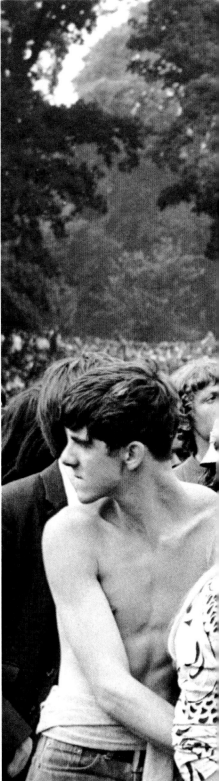

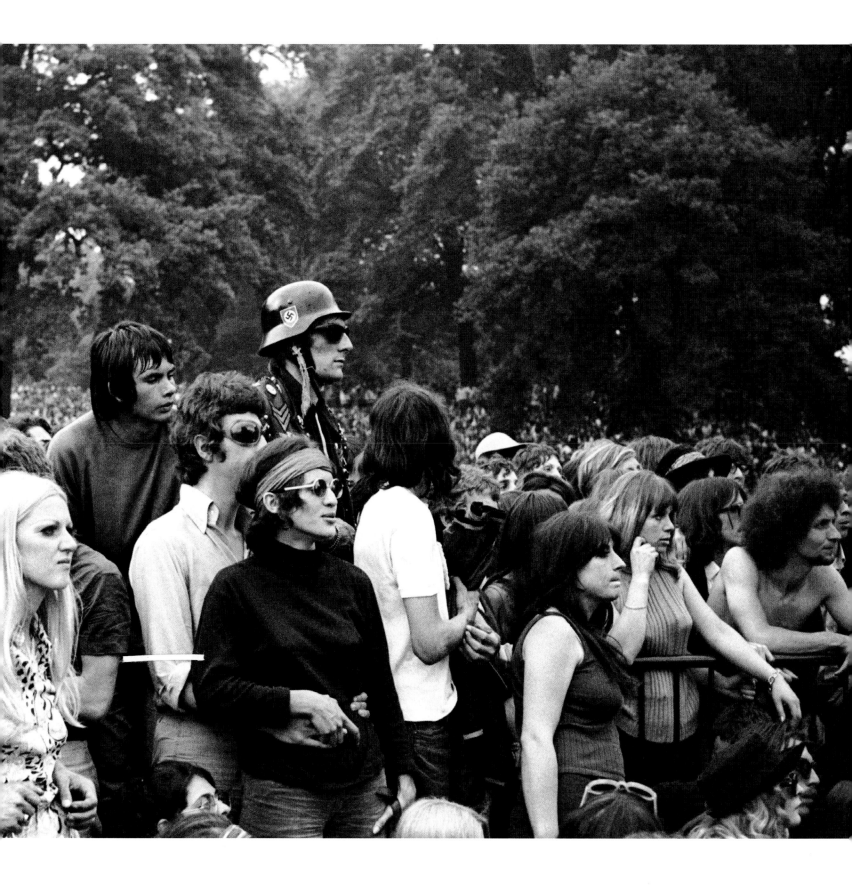

LEFT: MODS AND ROCKERS MEET ON THE BEACH IN BRIGHTON

1964

ABOVE: A ROLLING STONES CONCERT IN HYDE PARK

1969

THE HERE TOMORROW EXHIBITION OF PROTOTYPES AT THE DESIGN CENTRE IN LONDON

1970

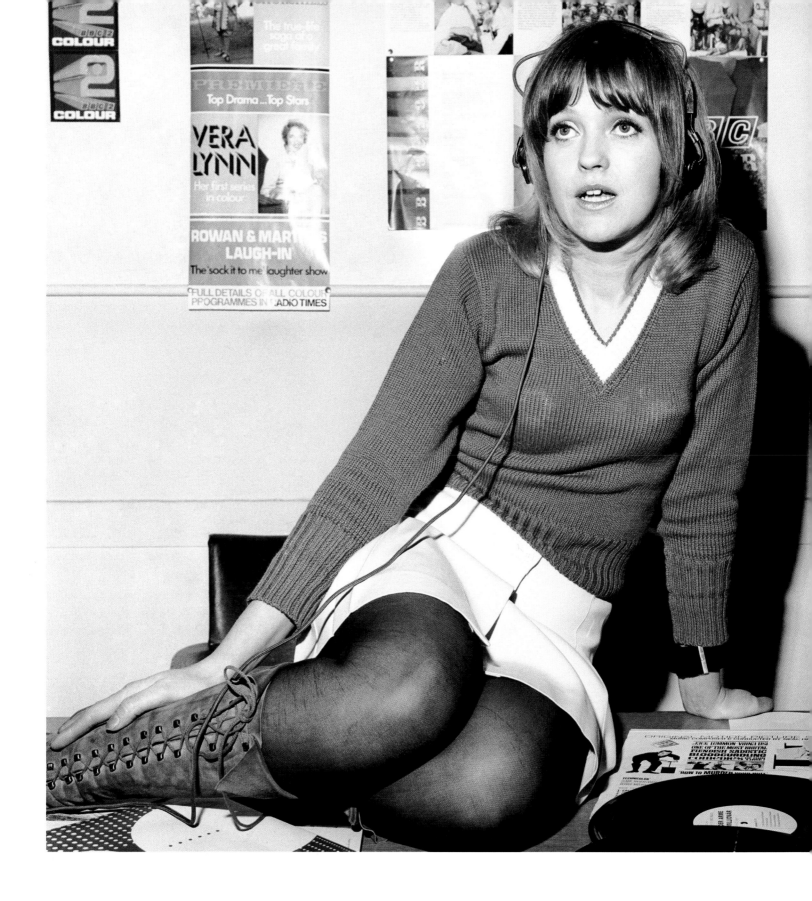

RADIO 1'S FIRST FEMALE DISC JOCKEY, ANNIE NIGHTINGALE

1970

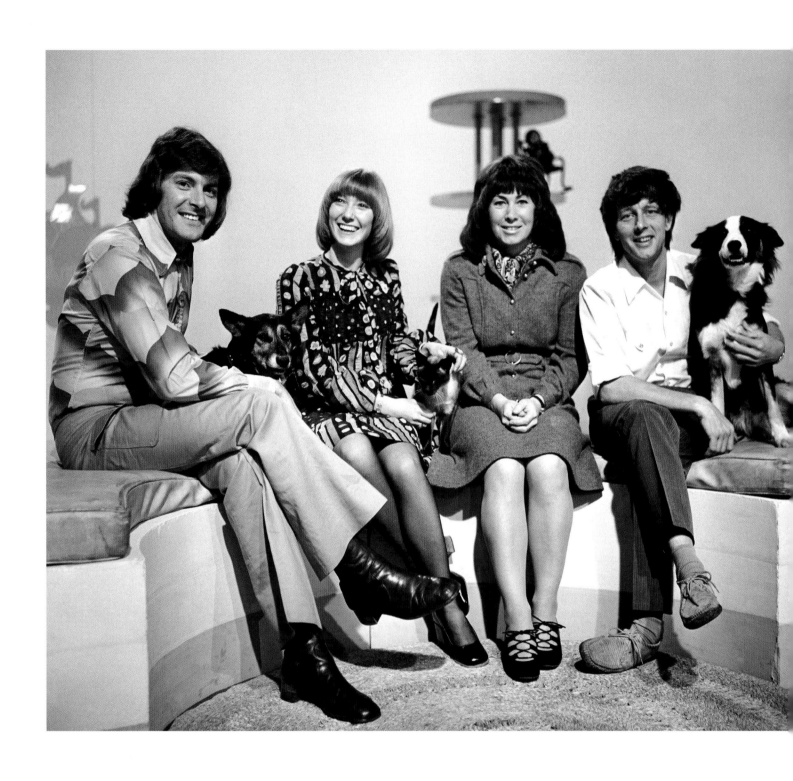

THE PRESENTERS OF THE CHILDREN'S TELEVISION PROGRAMME BLUE PETER

1972

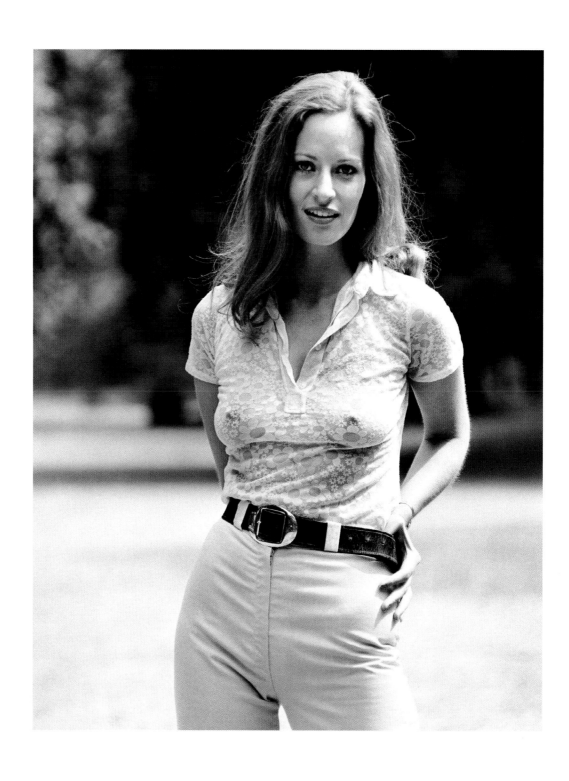

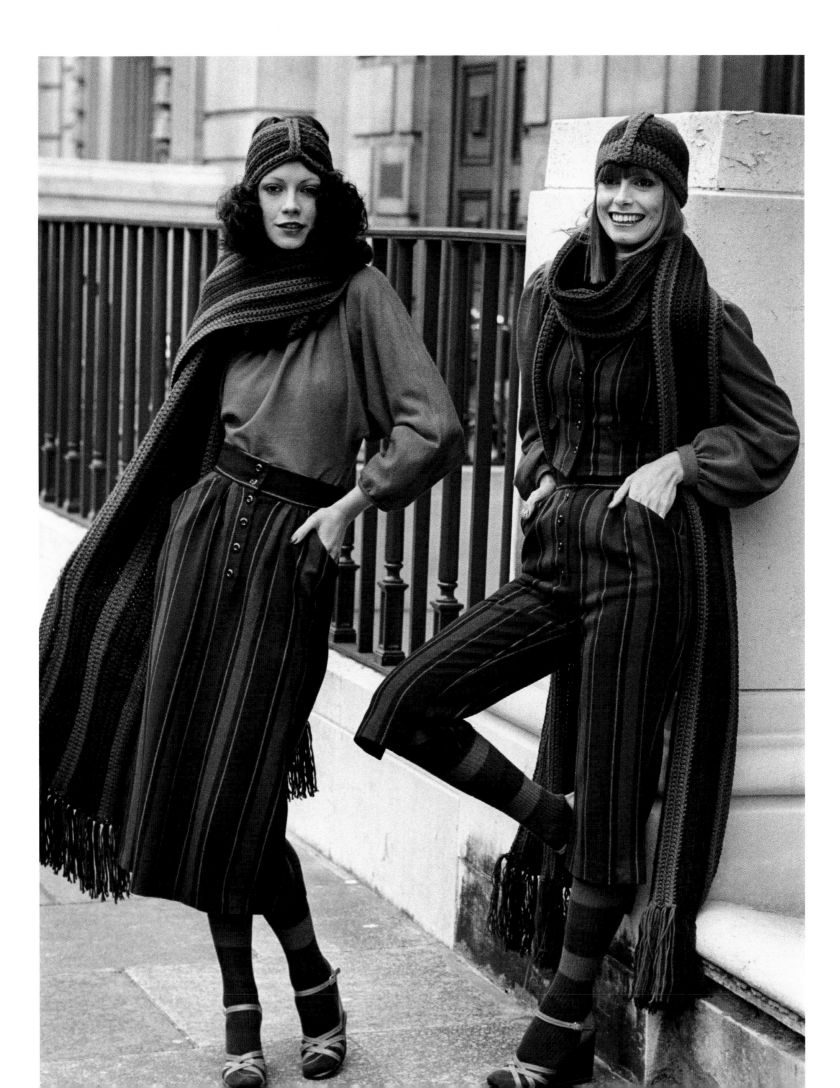

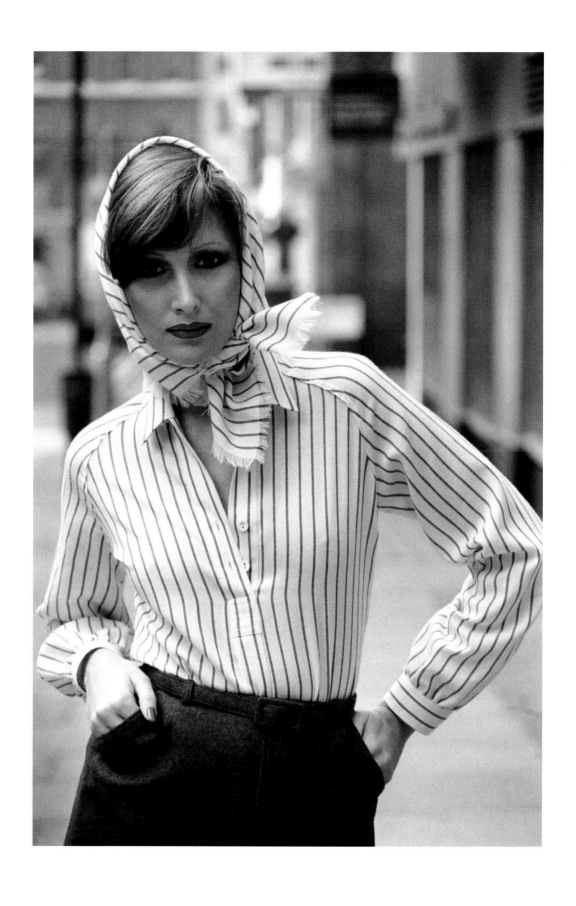

LEFT: Designs from the Mary Quant fashion show in London

1975

ABOVE: Shirt and matching headscarf by Mary Quant

1976

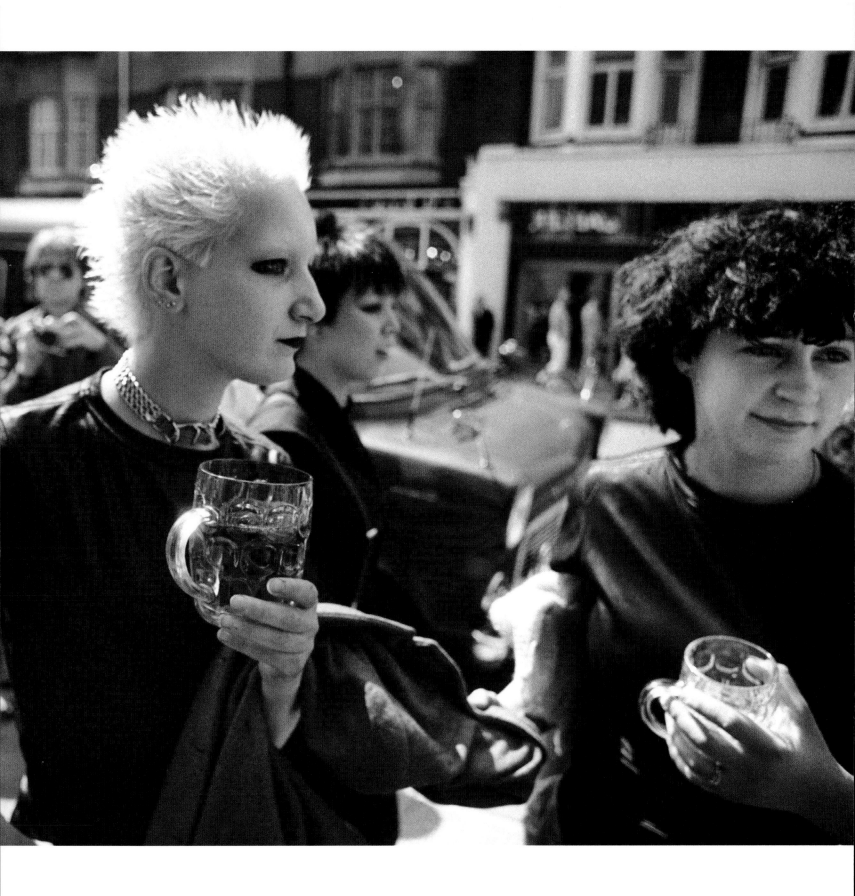

PUNKS ON THE KINGS ROAD, CHELSEA

1977

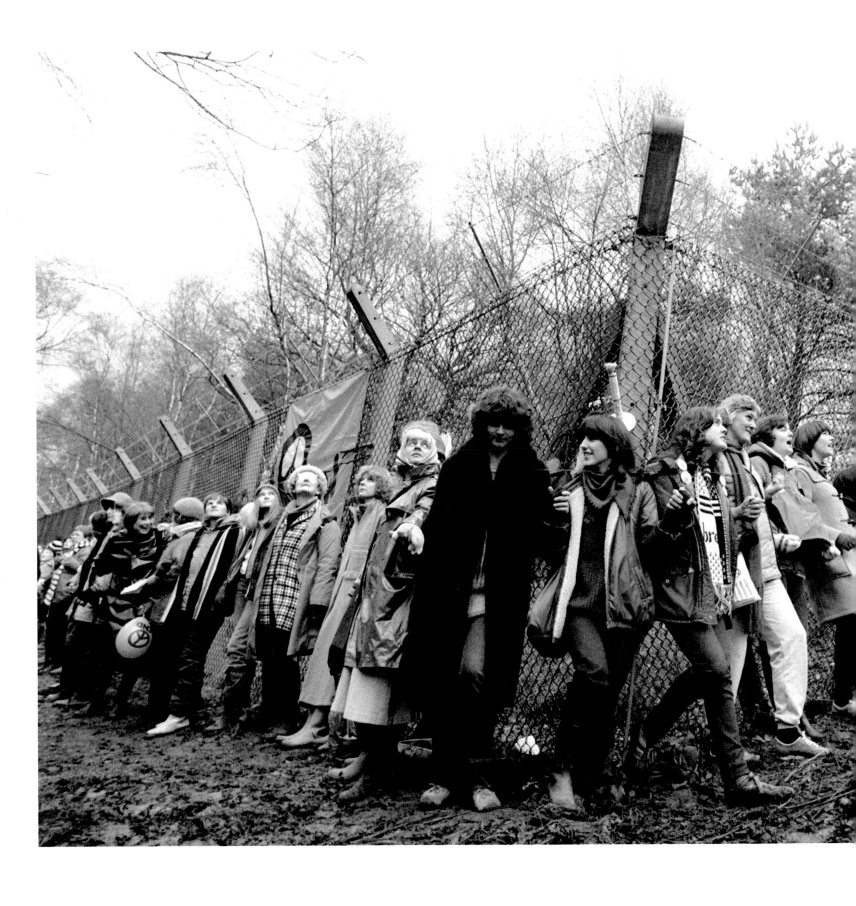

WOMEN'S PEACE PROTEST AT GREENHAM COMMON AIR BASE

1982

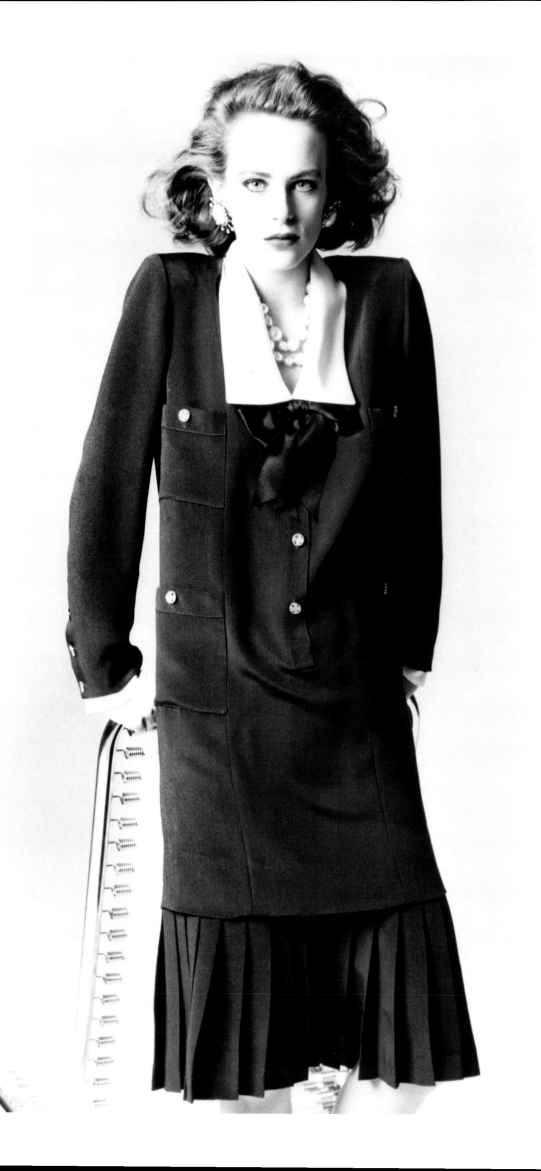

LEFT: PADDED SHOULDERS
ARE A KEY FEATURE
IN THE CHANEL
AUTUMN/WINTER COLLECTION
1983

RIGHT: FAIR ISLE KNITS
1986

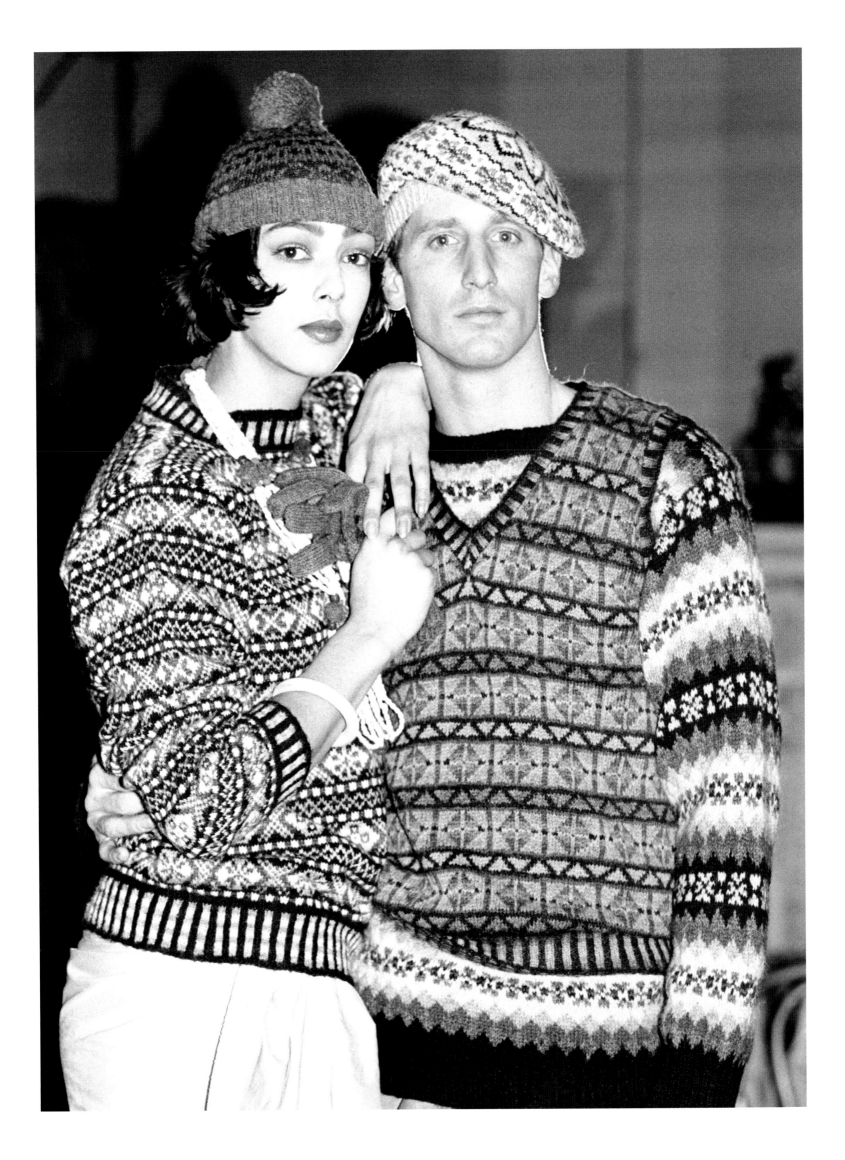

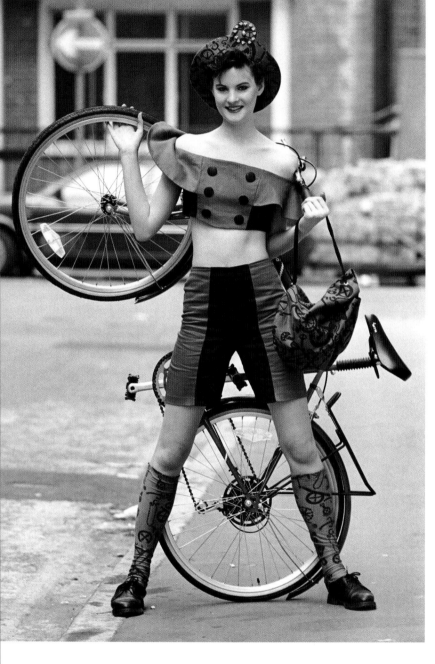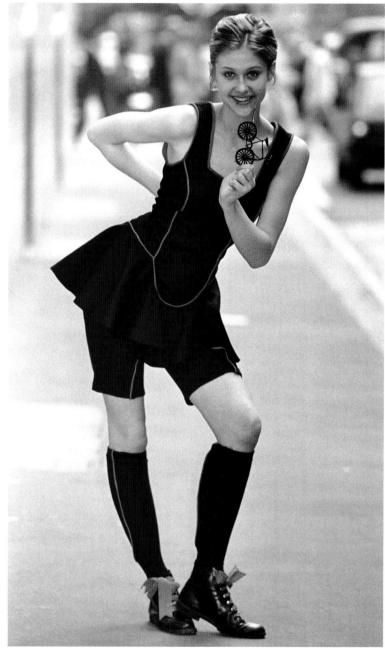

ABOVE: SPORTS WEAR DESIGNED BY STUDENTS FROM THE LONDON COLLEGE OF FASHION

1988

RIGHT: GERALD DURREL COATDRESS WITH SHAWL

1989

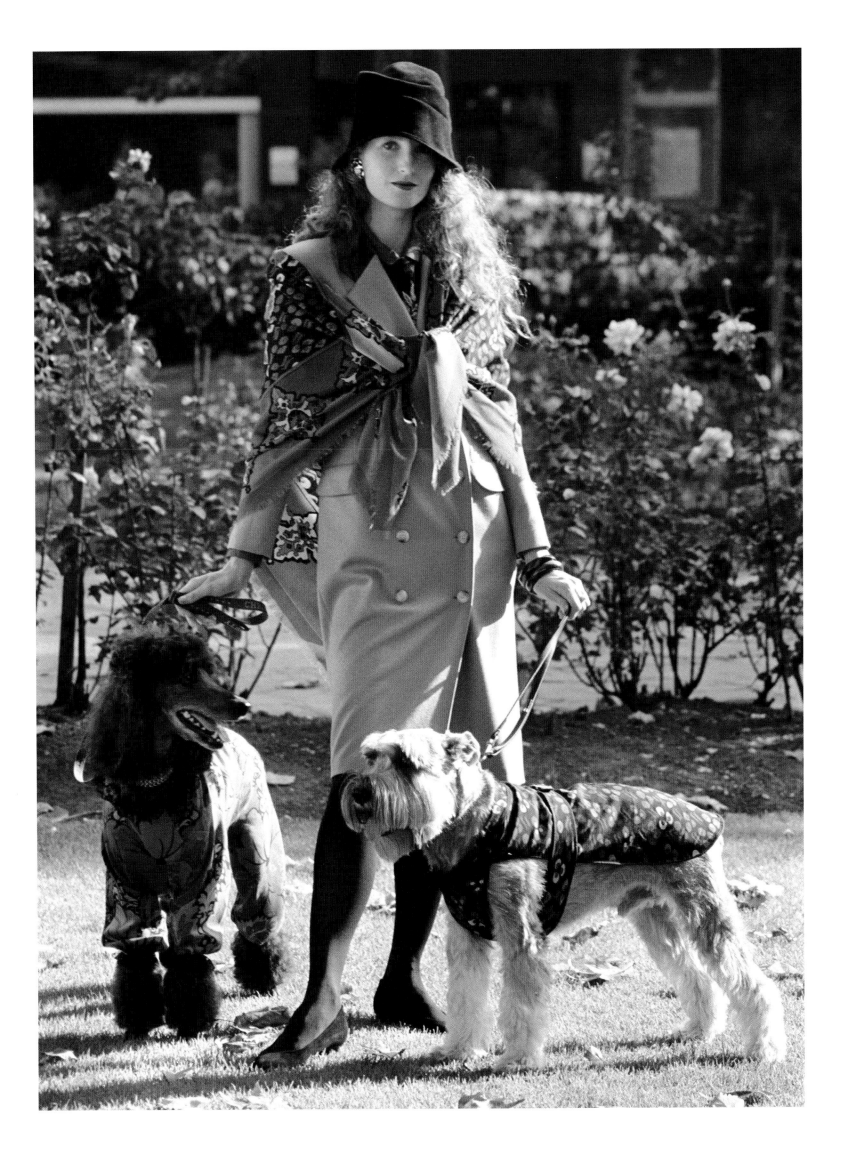

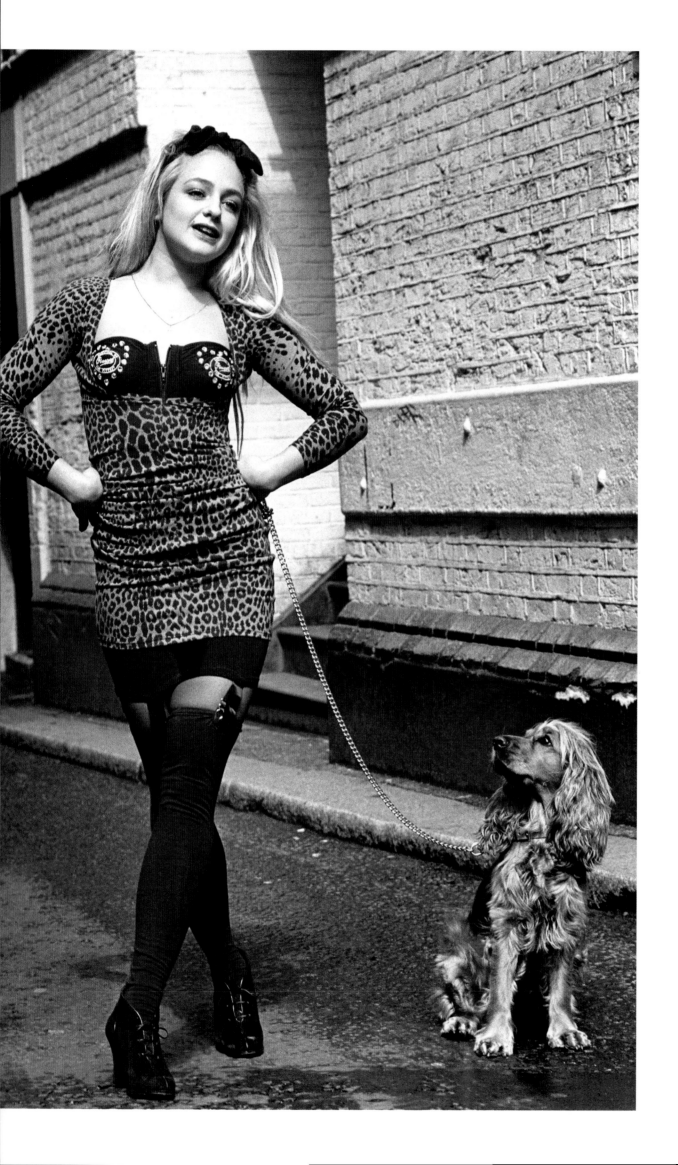

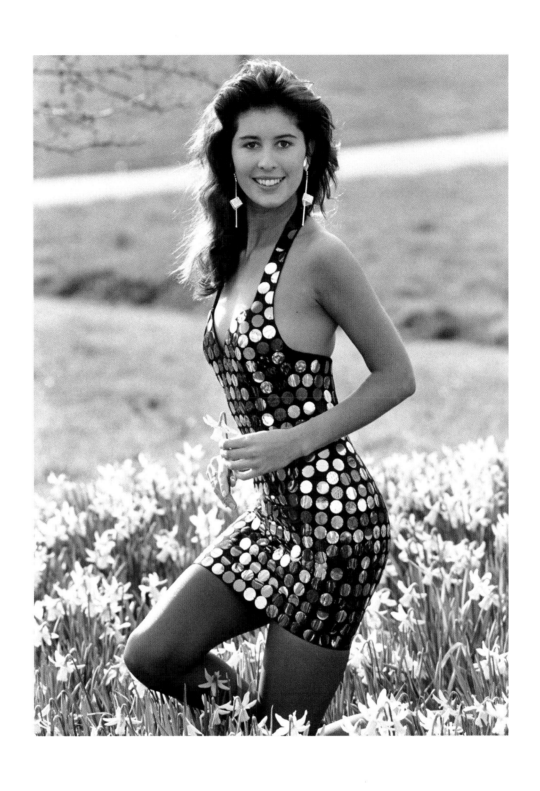

LEFT: DRESS BY PINEAPPLE

1989

ABOVE: DRESS BY JENNY PACKHAM

1989

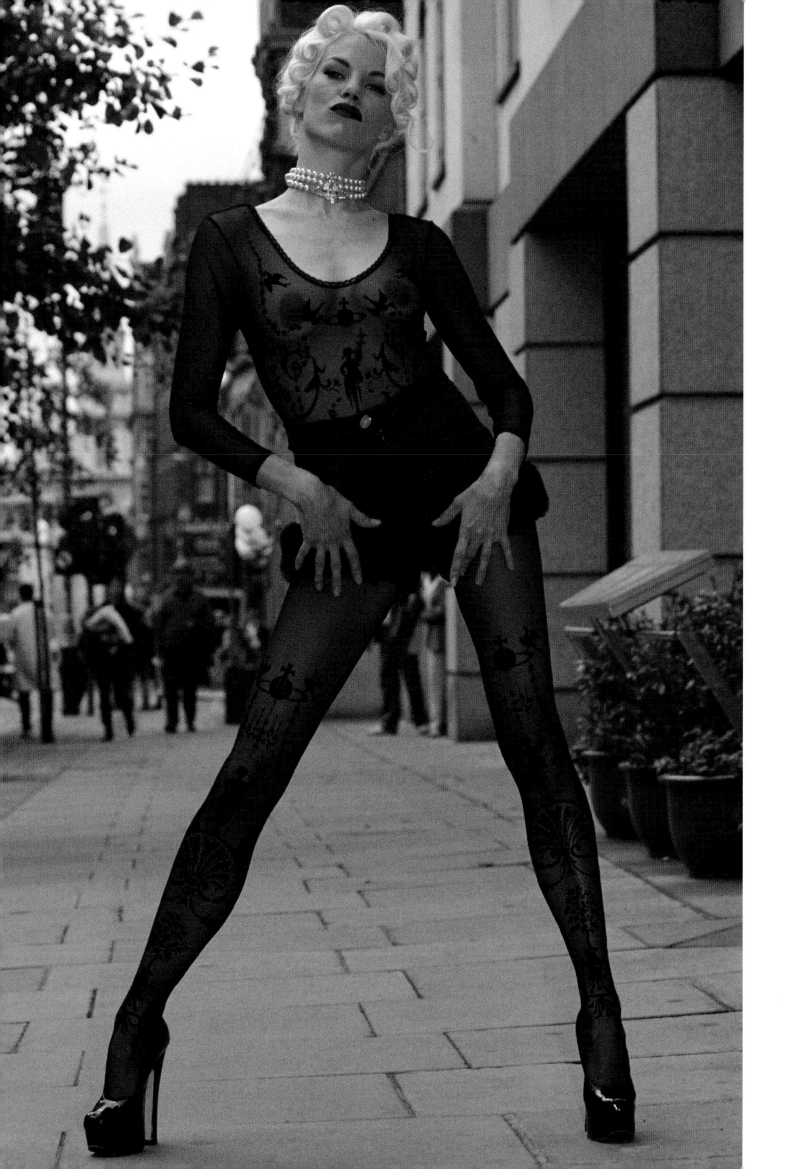

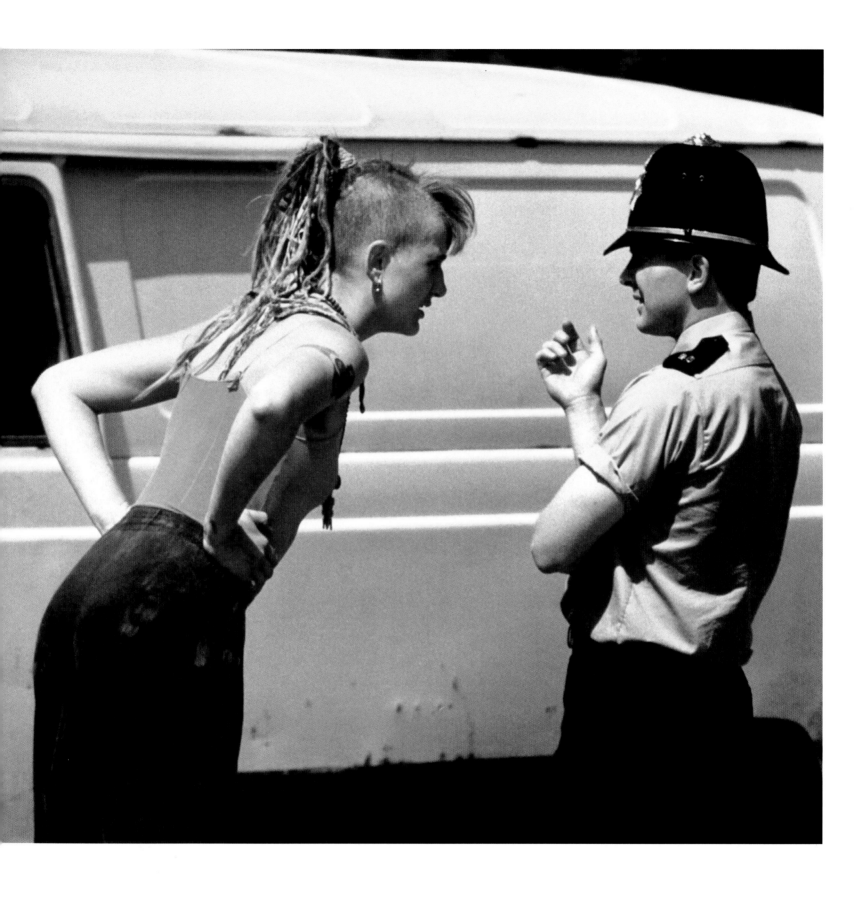

New Age traveller with a policeman in Kerry, mid Wales

1992

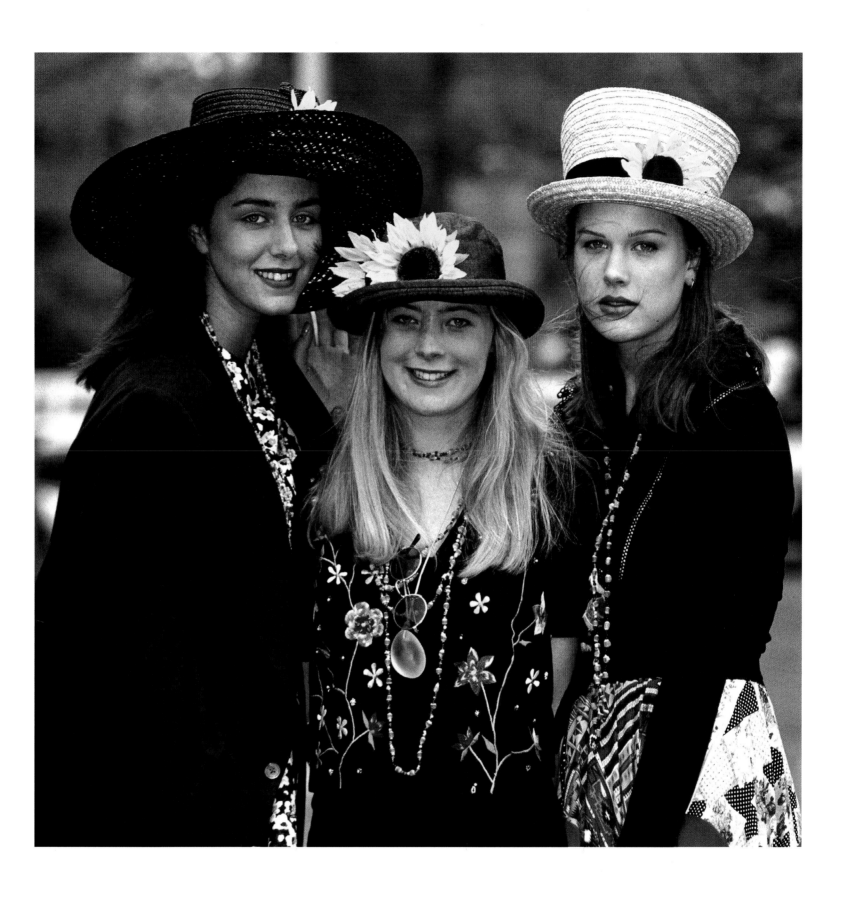

THREE YOUNG DEBUTANTES

1993

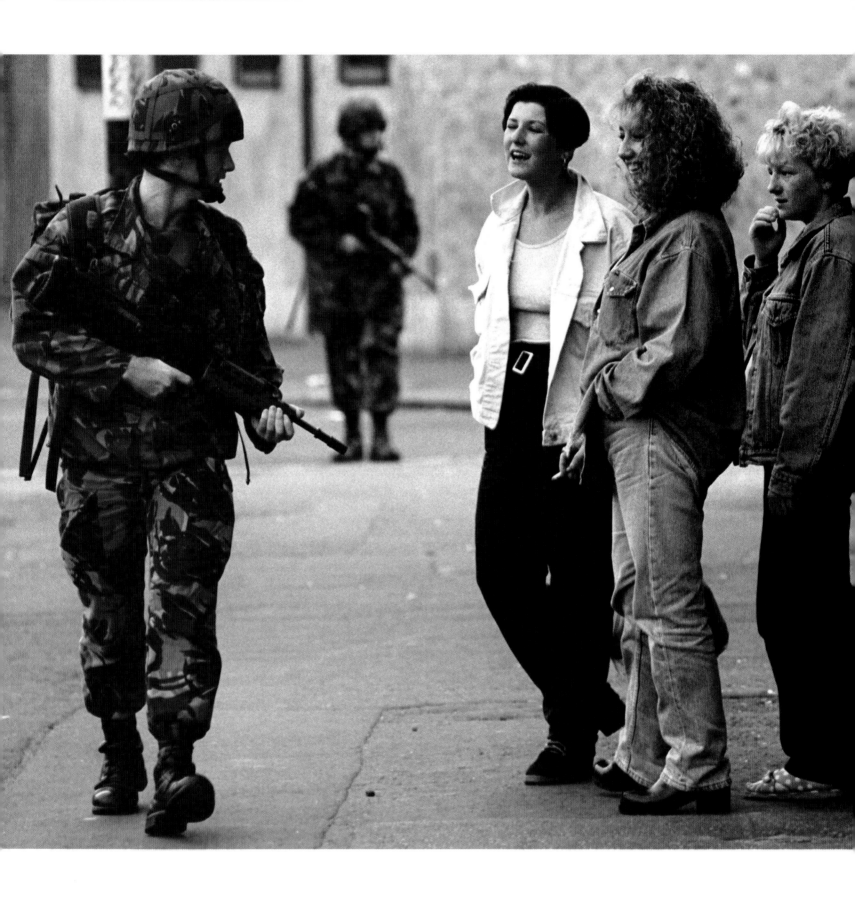

A soldier talks to passers-by in the Falls Road, Belfast

1994

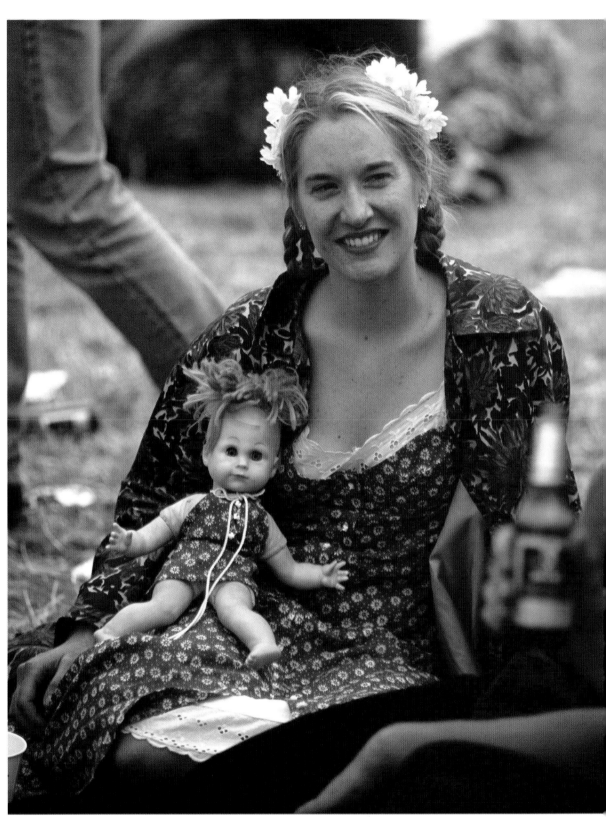

GLASTONBURY FESTIVAL

1994

RECYCLE REDRESS RETHINK AT ALTERNATIVE
FASHION WEEK IN LONDON
1996

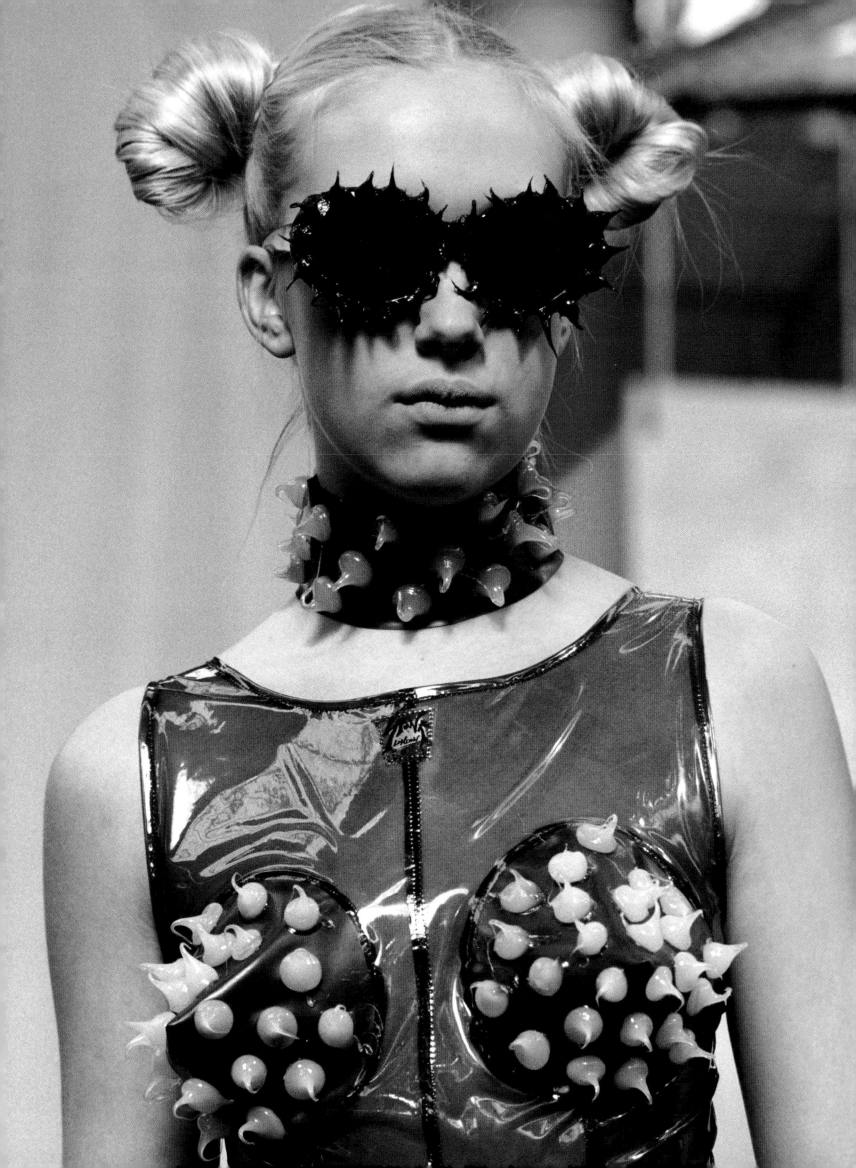

DRESS FROM THE SPRING/SUMMER
LITTLEWOODS CATALOGUE
1998

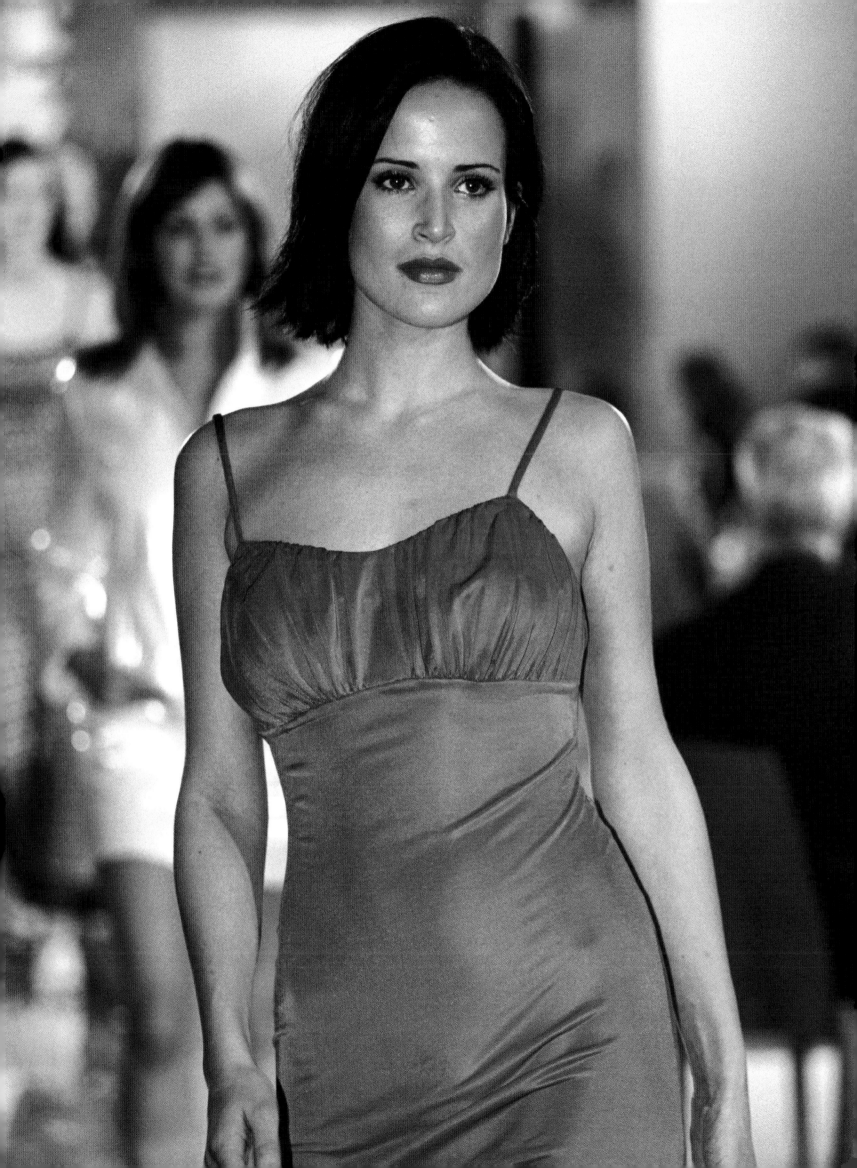

A FREE CONCERT IN REGENT'S PARK
2002

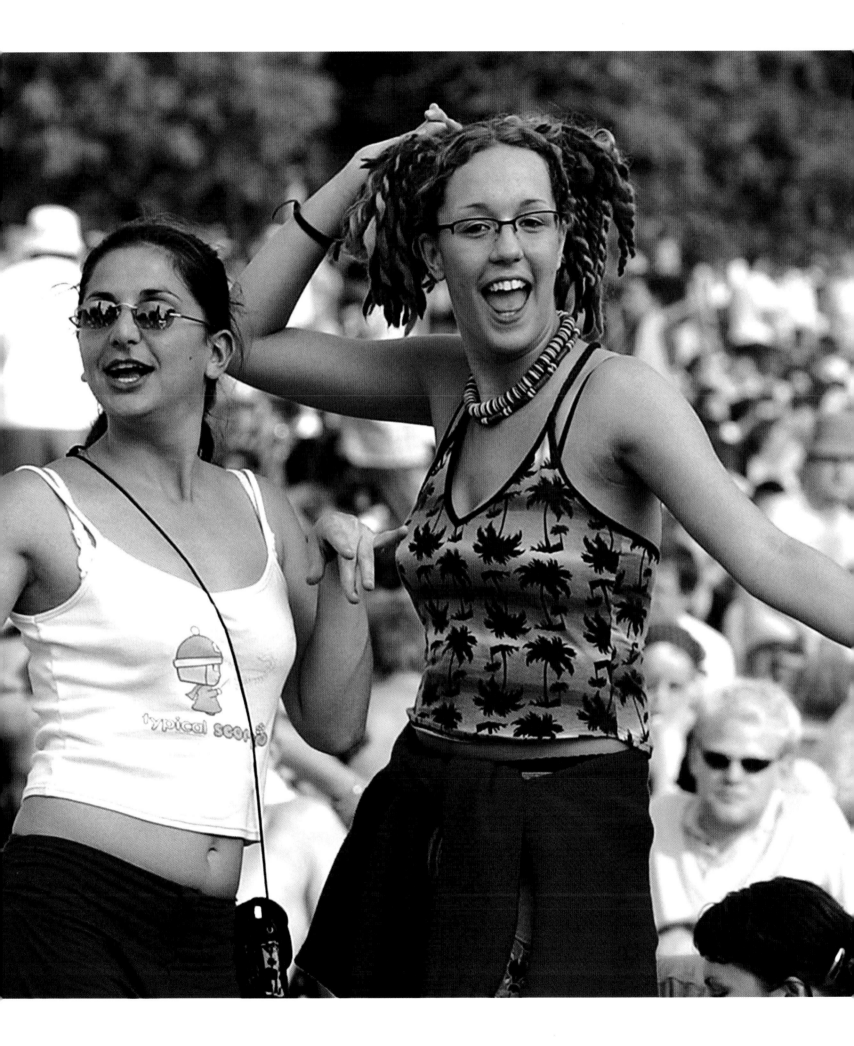

College student, Eleanor Mains

2003

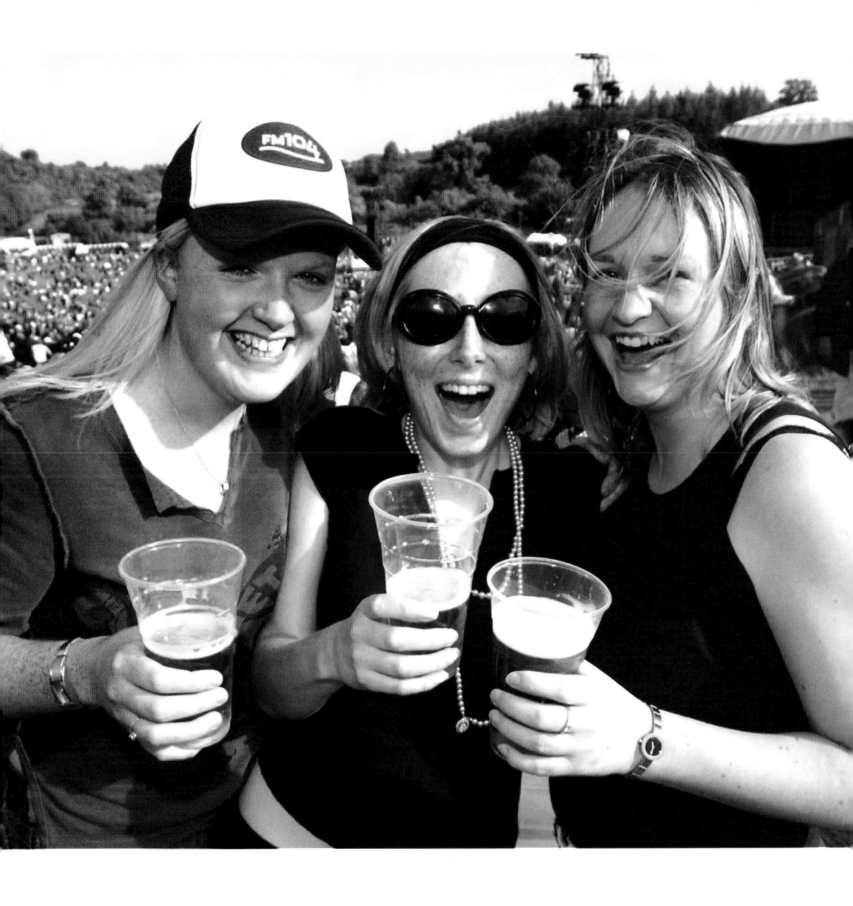

Fans at a Madonna concert at Slane Castle in Ireland

2004

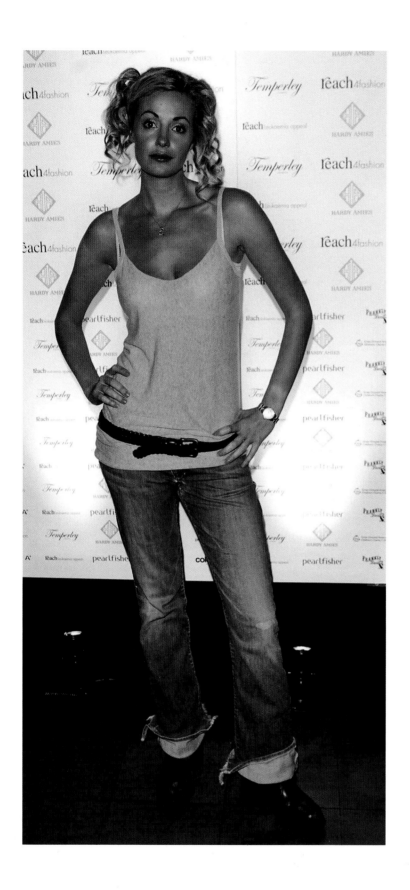

ABOVE: ACTRESS ELIZE DE TOIT ARRIVES FOR THE
REACH 4 FASHION CHARITY EVENT IN LONDON
2004

RIGHT: DESIGN BY ALICE TEMPERLEY
SHOWN AT REACH 4
2004

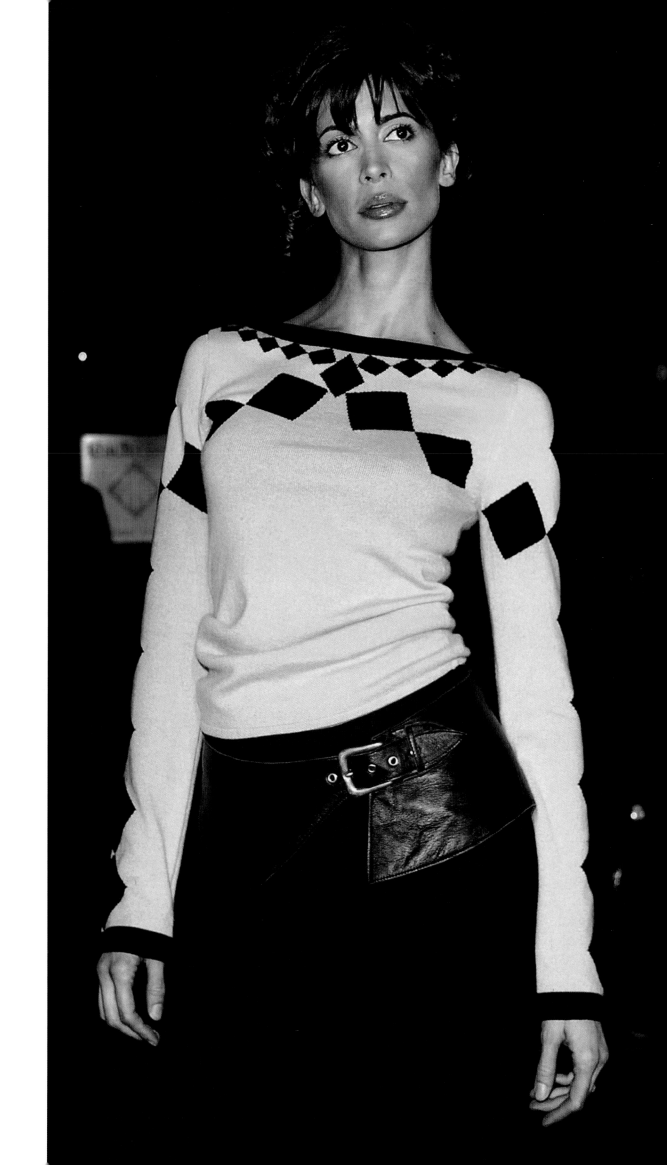

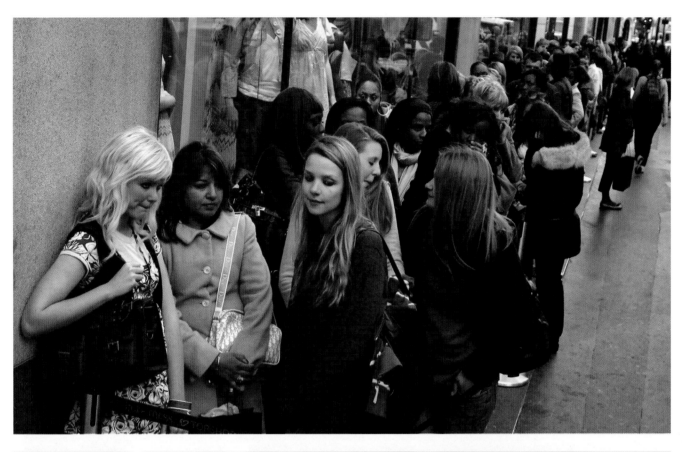

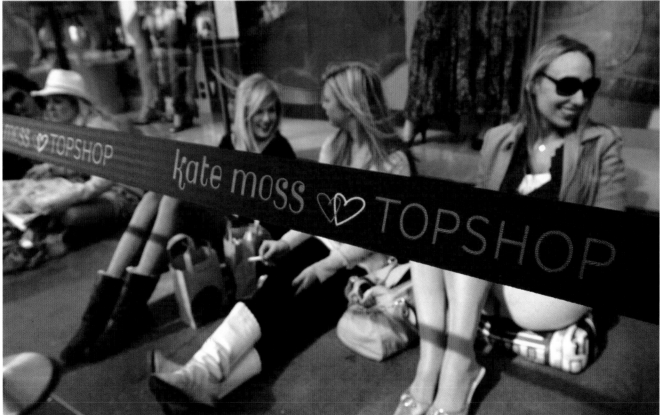

LEFT: QUEUES OUTSIDE
TOPSHOP IN OXFORD
STREET WAITING FOR THE
LAUNCH OF THE KATE
MOSS RANGE
2007

RIGHT: A YOUNG WOMAN
BUYING ITEMS FROM THE
KATE MOSS RANGE
2007

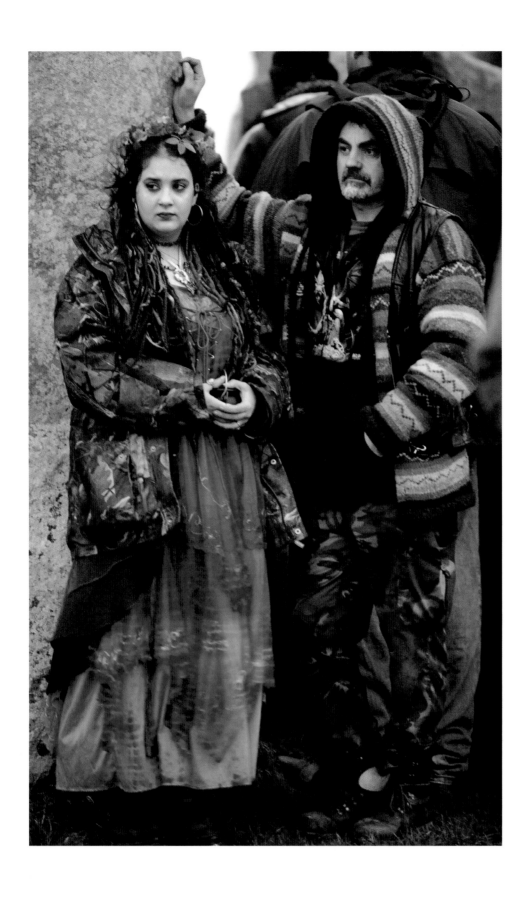

WINTER SOLSTICE AT STONEHENGE

2008

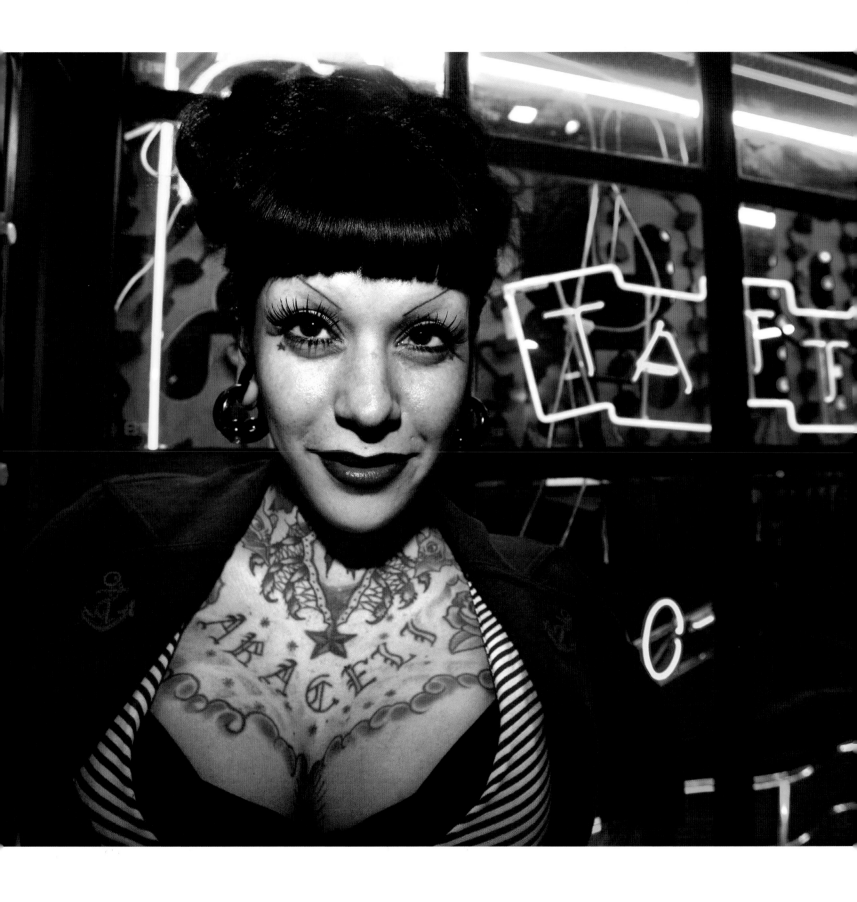

A young woman at the London Tattoo Convention

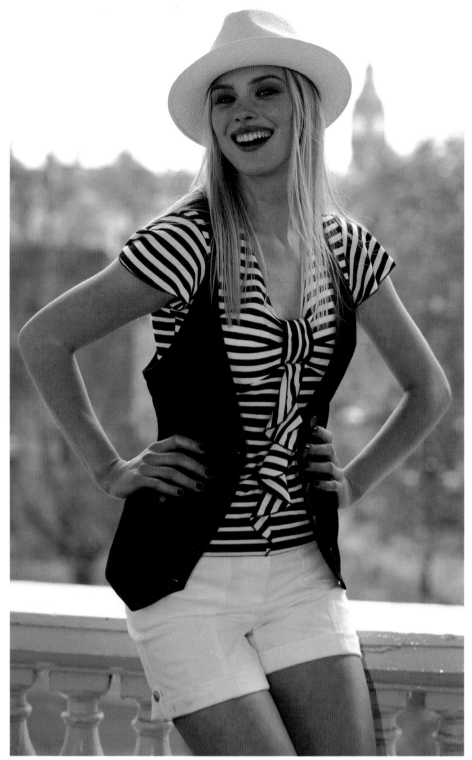

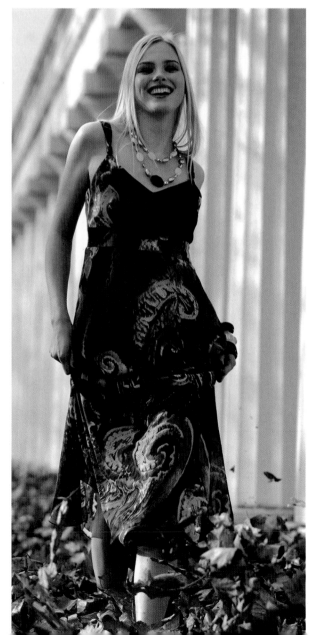

Designs from Marks and Spencer's spring range

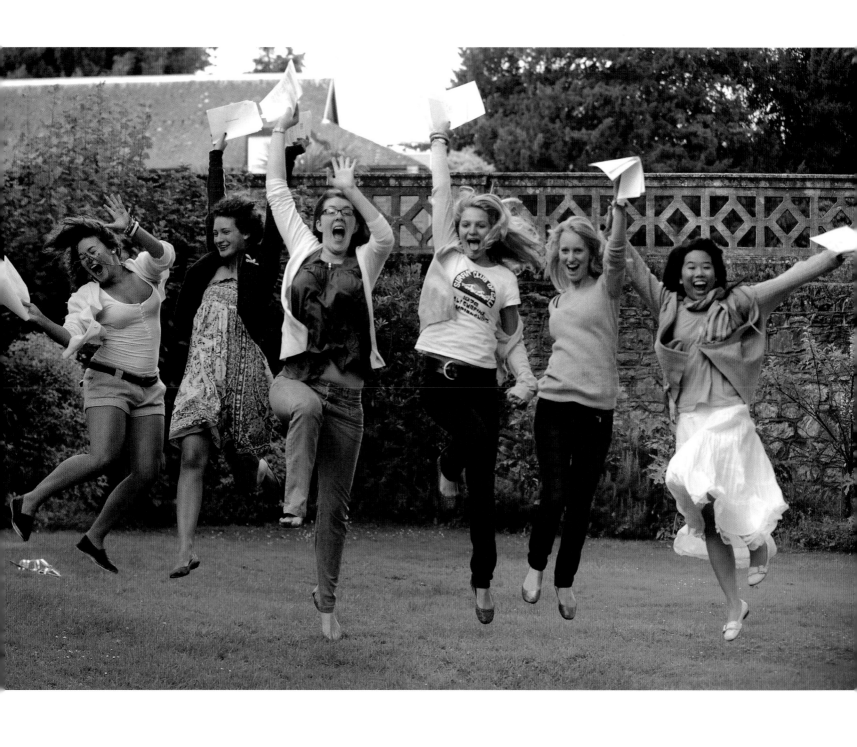

A-LEVEL STUDENTS

2008

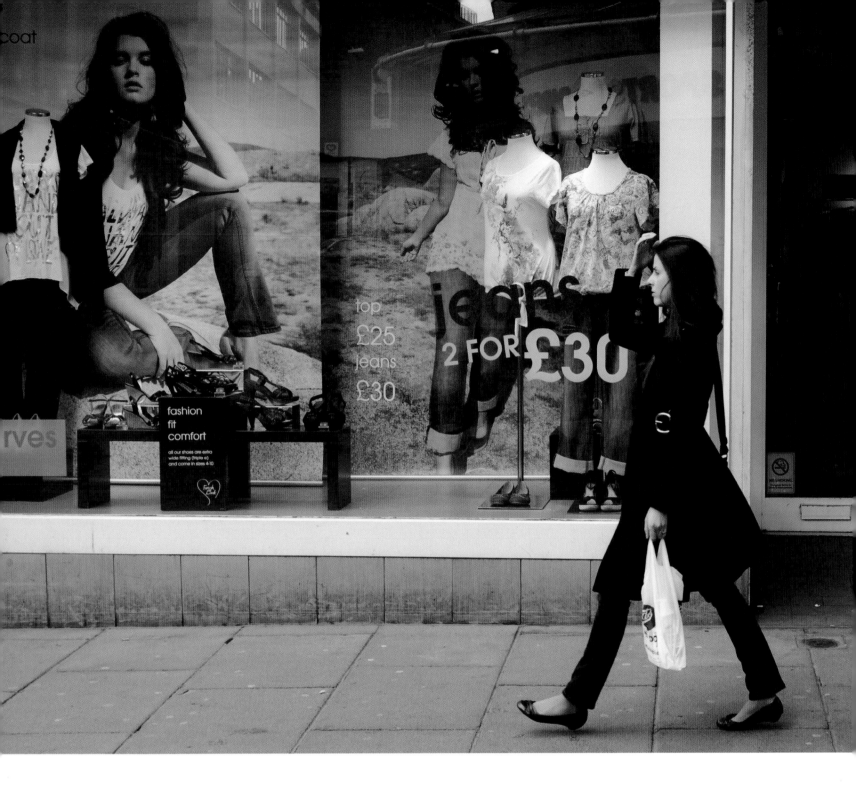

ABOVE AND RIGHT: NOTTINGHAM

2009

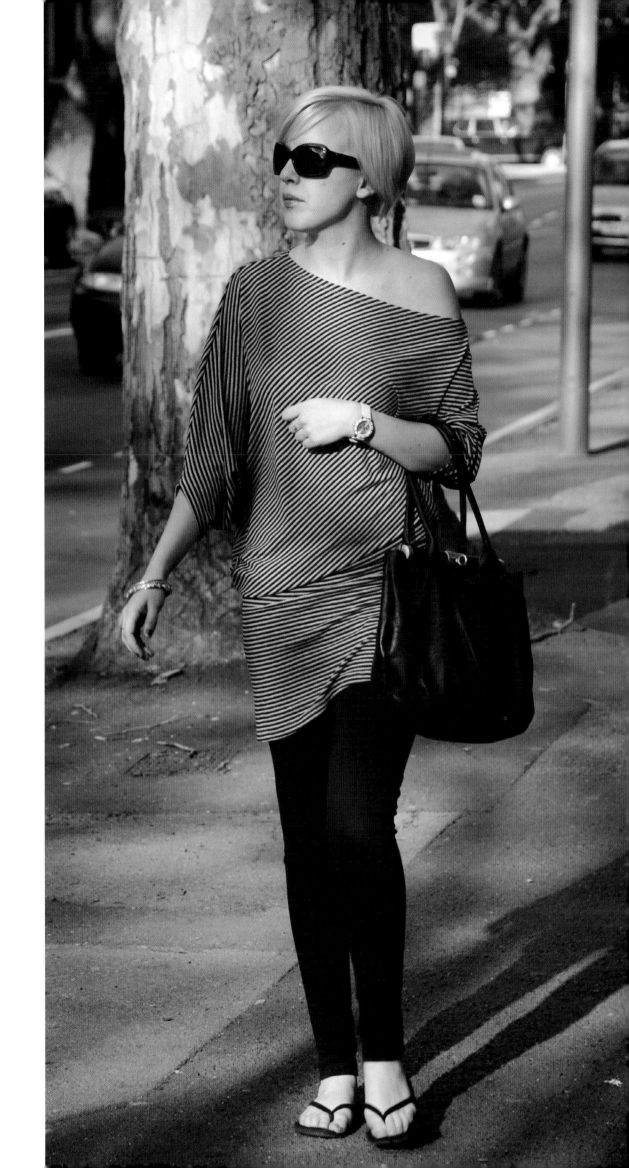

CHAPTER

5

FANTASY
AND REALITY:
LONDON
FASHION WEEK
2008–2009

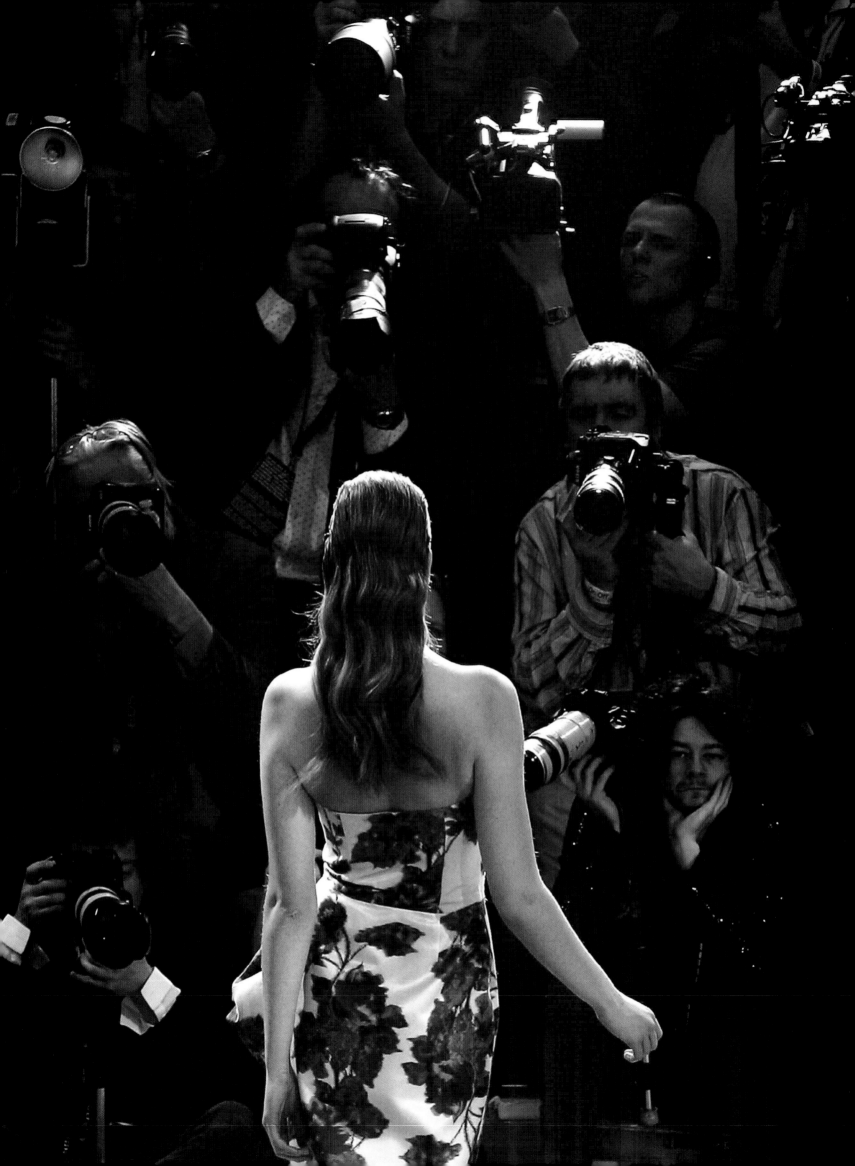

IT'S HERE THAT IT ALL STARTS – on the catwalk. It's the beginning of what will filter down and eventually – adapted, modified and transformed – end up in the high-street shops where most of us buy our clothes. But at this stage it is about enchantment and mystique; the unattainable. Here we see perfection in the woman and in the clothes she wears, both refined and modelled into a fantasy created by the designer – an extravaganza of beauty.

From here the word is disseminated through the media. Women's magazines from *Vogue* to *Easy Living* feature London Fashion Week as an important event for their readers who, in turn, take in the colours, the shapes and the underlying subtleties that fundamentally change fashion on its journey through the years.

The catwalk is about the future; clothes that are yet to be worn, yet to become reality. It is a place where magic is performed, a place of inspiration and aspiration. How many of us, as children, played at 'dressing up', entering a world of fantasy with an old net curtain and a discarded tablecloth, able to transform ourselves and the world around us. The experience of the catwalk is not dissimilar; it allows us to step out of the everyday. The role of the imagination, then, is not just the territory of the designer.

And yet, when it comes down to it, this is about clothes. Although we long ago abandoned the idea that they are worn simply to protect us from the elements, are we prepared to admit that they play such an important role in our imagination? The answer is probably yes. Most women would admit to being, if only moderately, interested in their appearance, and most are willing to spend a proportion of their income, to varying degrees, on clothes. It has long been so.

The catwalk is a springboard of innovation that fuels a highly complex – and profitable – industry, but we can also see it as fuelling part of our collective imagination. Our need to engage with a fantasy world is an important part of our psyche; fashion is one way we can enter it. Just as the child steps into the imaginary game, we can become transformed into whatever we want to be, if only temporarily. It isn't just about the clothes we wear.

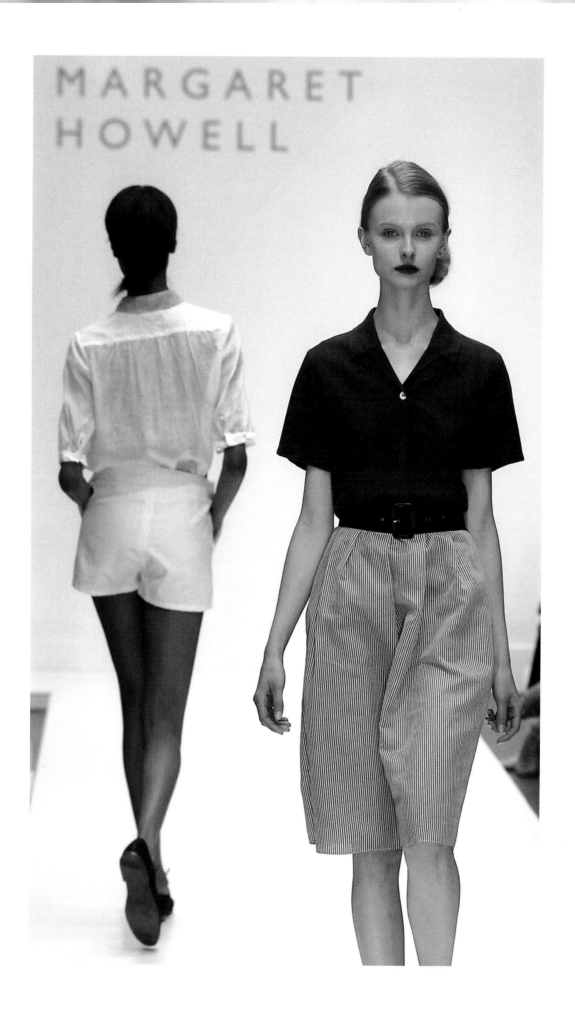

MARGARET
HOWELL

PAGE 266: A MODEL ON THE CATWALK DURING THE NICOLE FARHI SHOW
AT LONDON FASHION WEEK

2009

MARGARET HOWELL

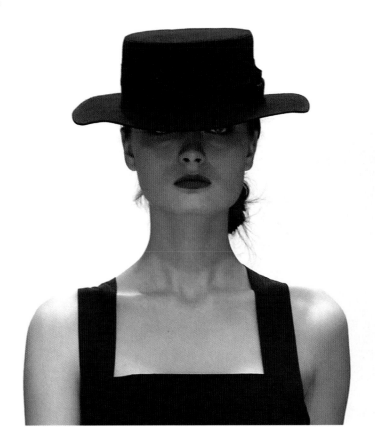

LEFT AND ABOVE: MARGARET HOWELL

2008

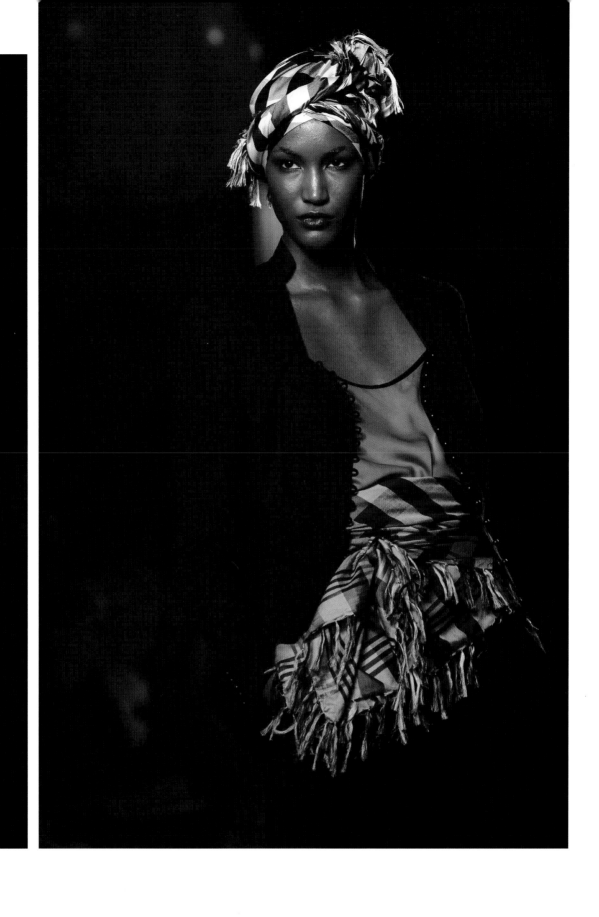

LEFT AND ABOVE: PAUL SMITH

2008

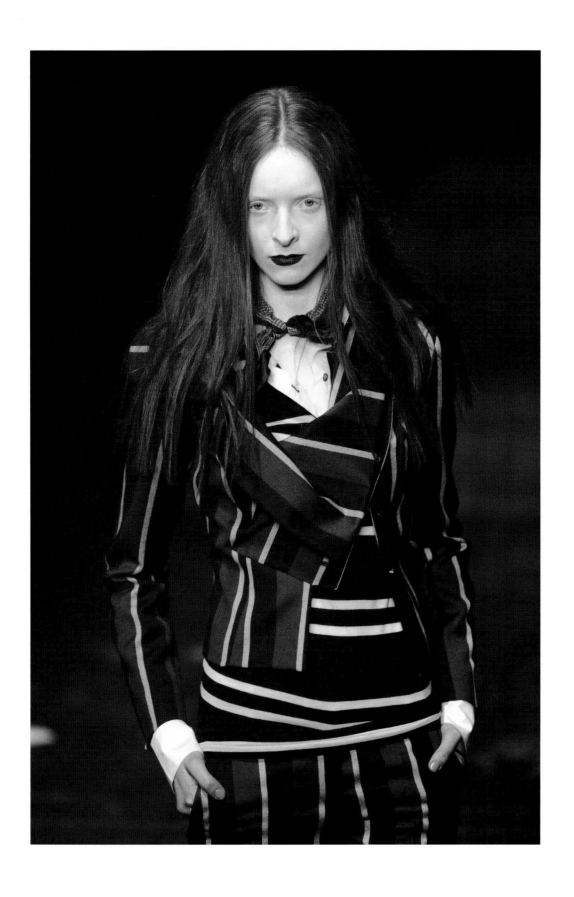

ABOVE AND RIGHT: VIVIENNE WESTWOOD
2009

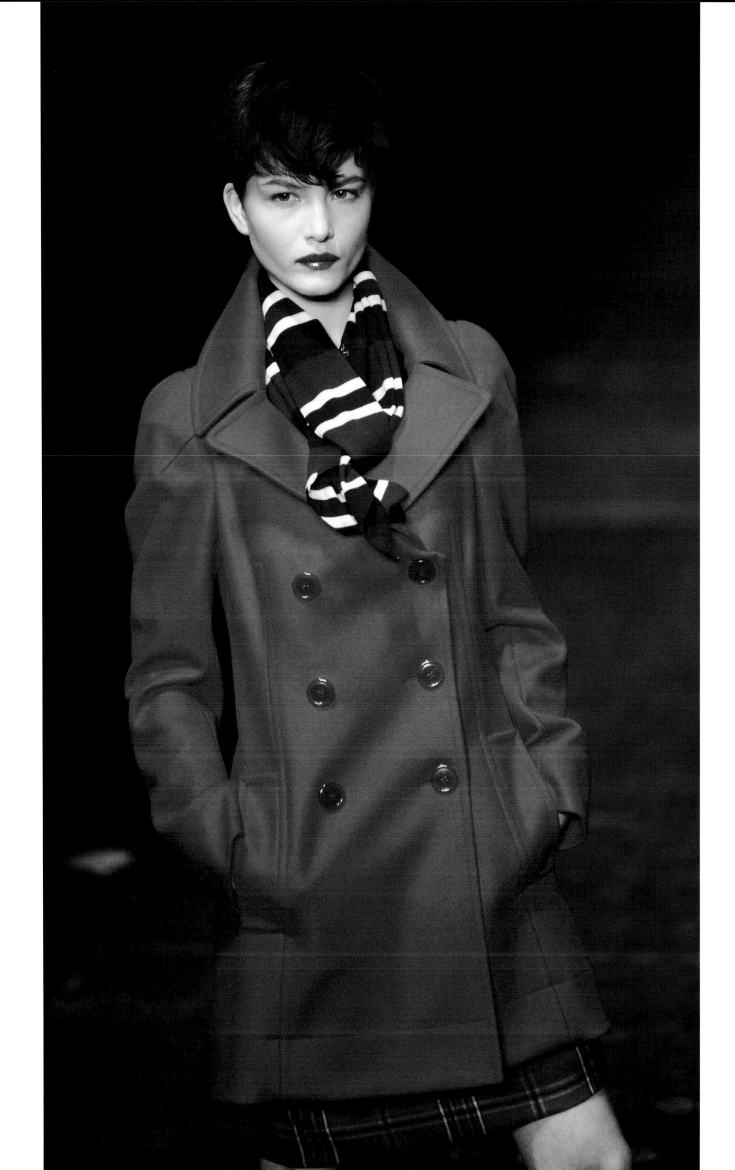

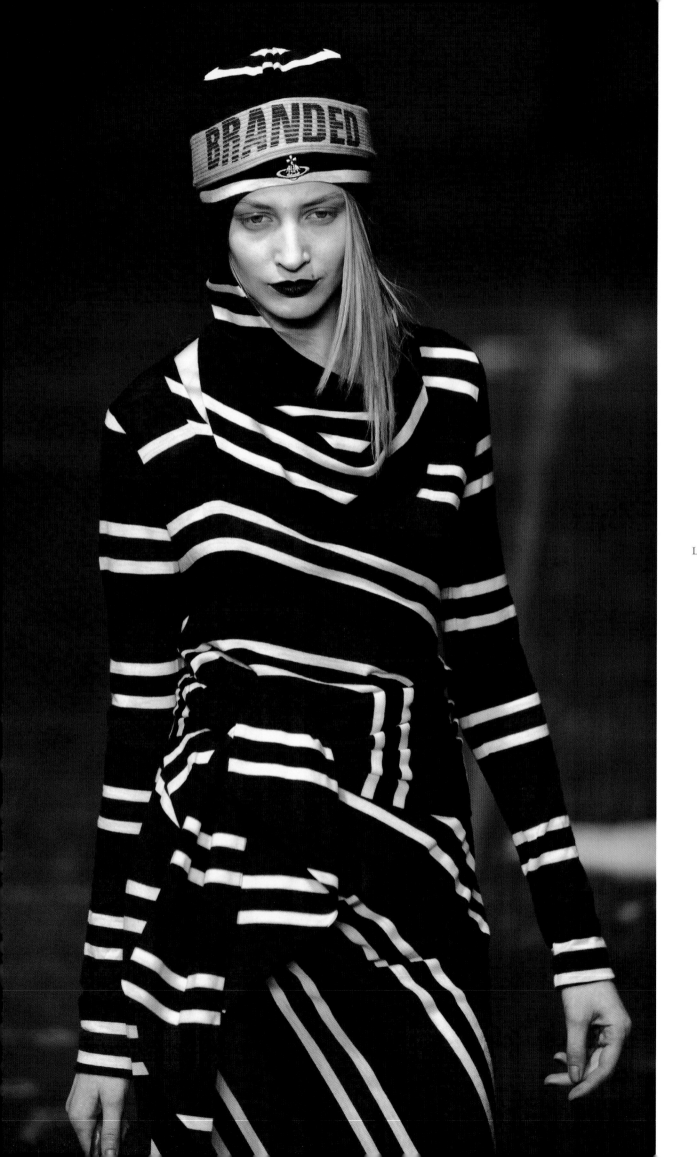

LEFT AND RIGHT:
VIVIENNE
WESTWOOD
2009

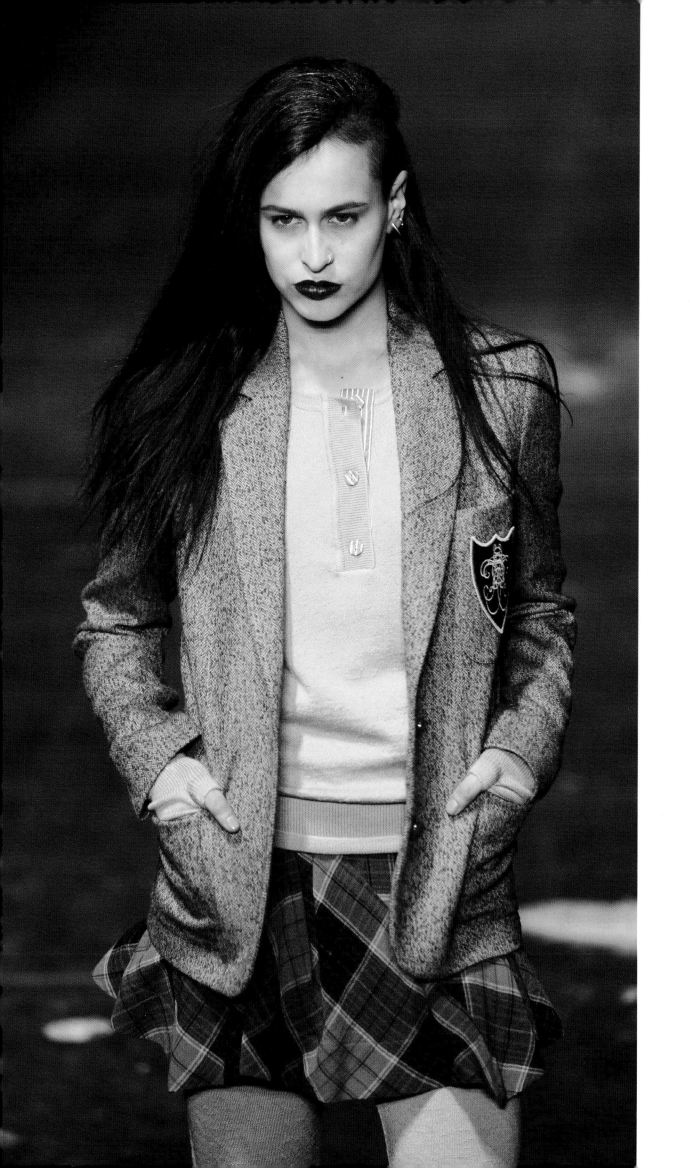

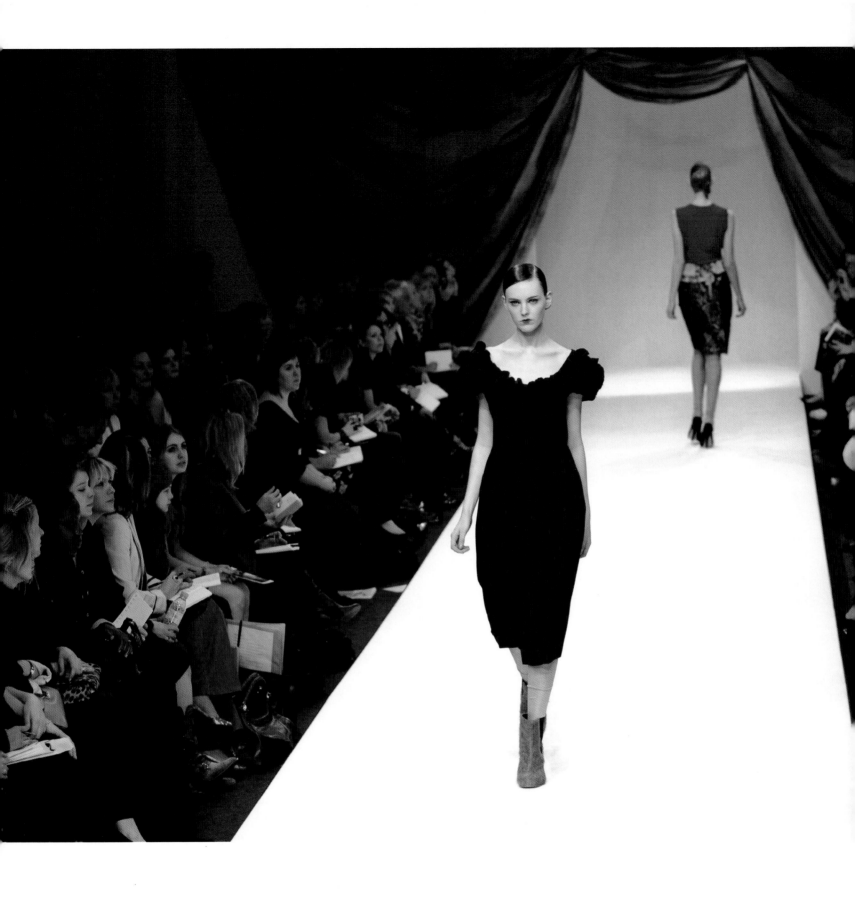

ABOVE AND RIGHT: BETTY JACKSON

2009

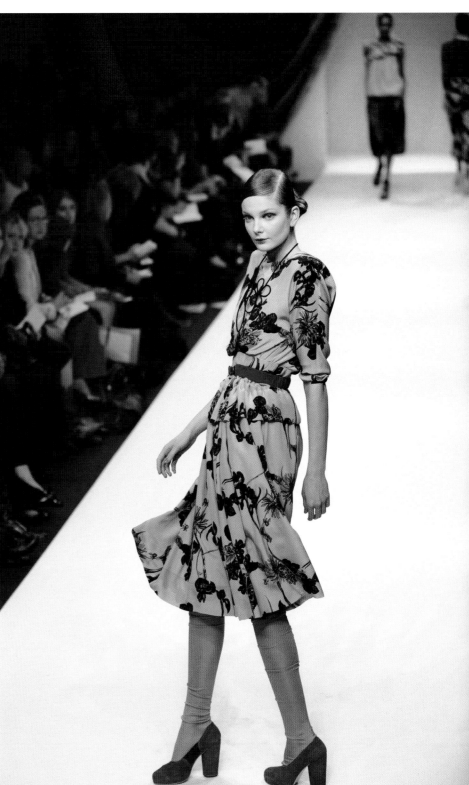

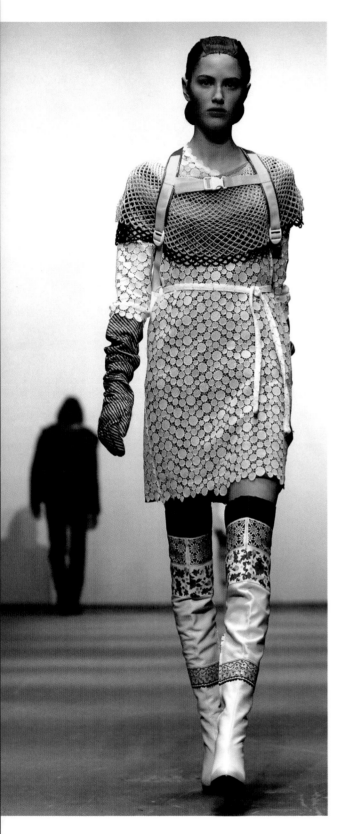

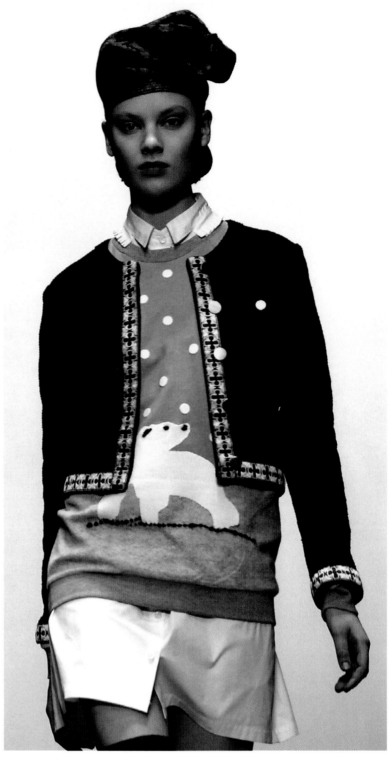

ABOVE AND RIGHT: PETER JENSEN

2009

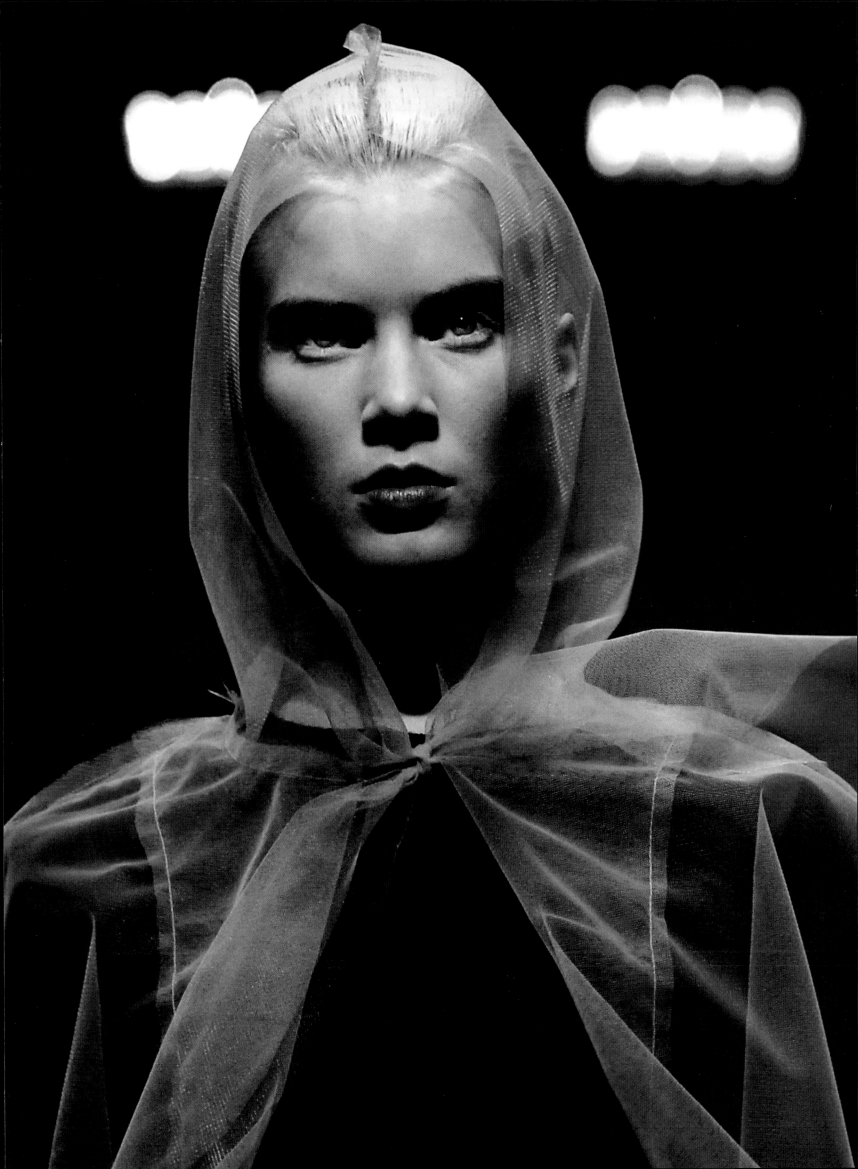

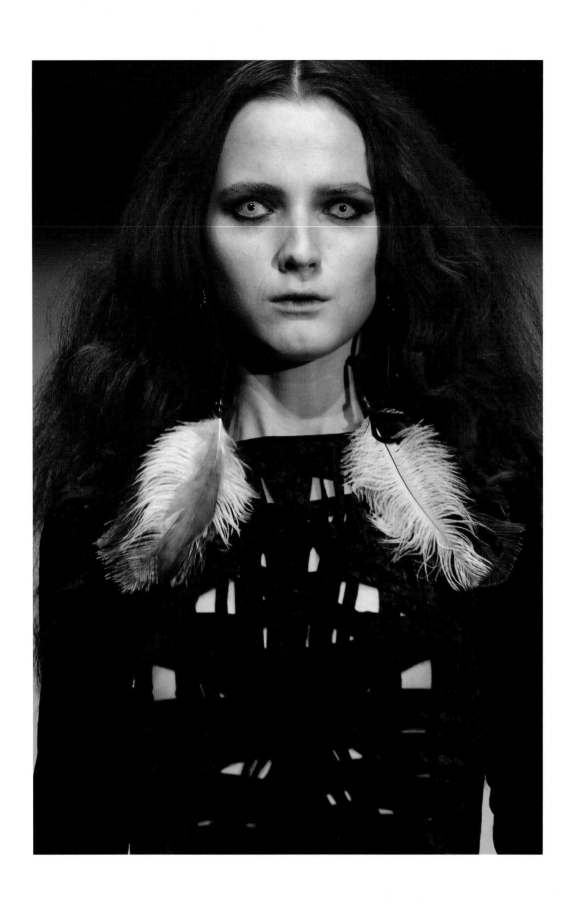

ABOVE AND RIGHT: ANNE SOPHIE BACK

2009

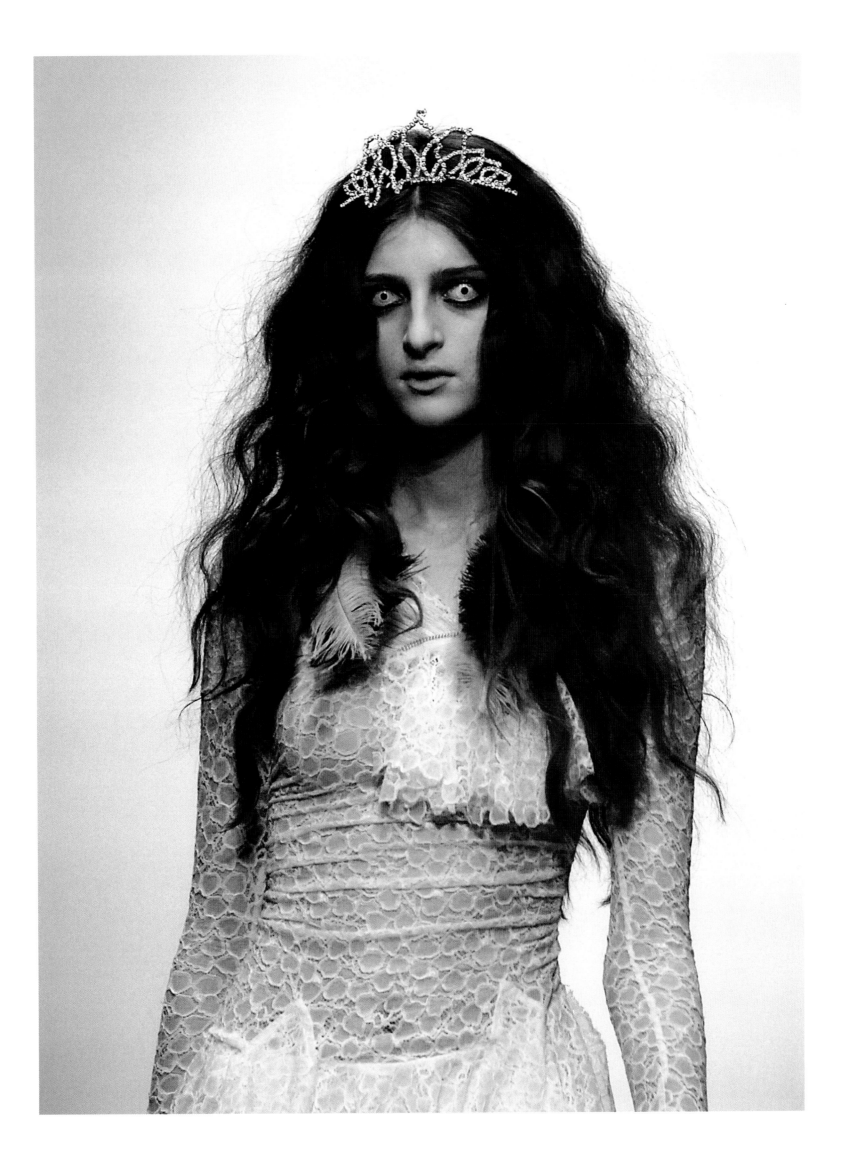

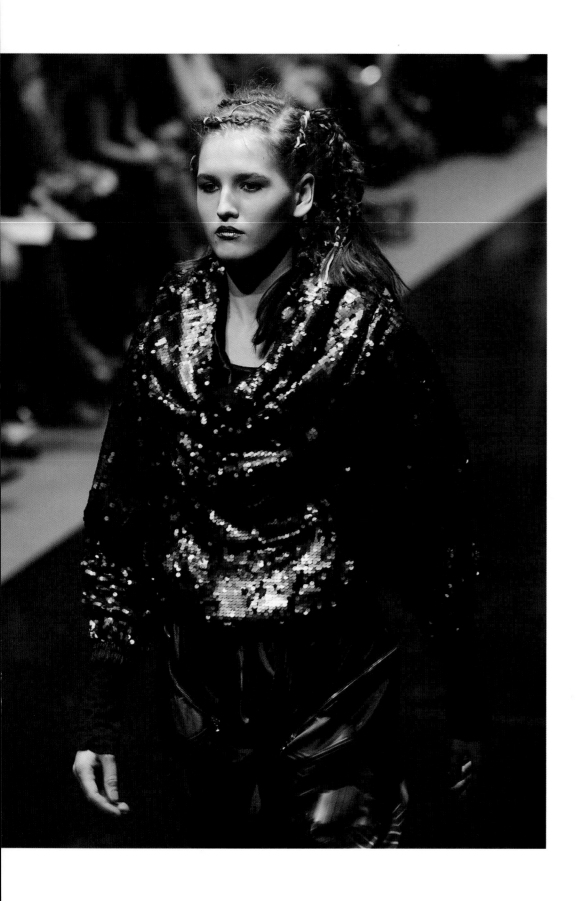

LEFT AND RIGHT:
Topshop Unique
2009

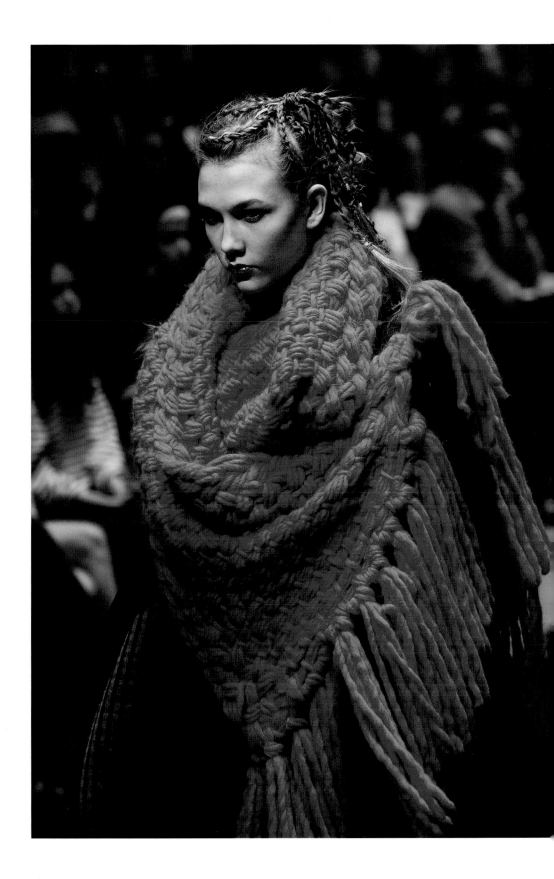

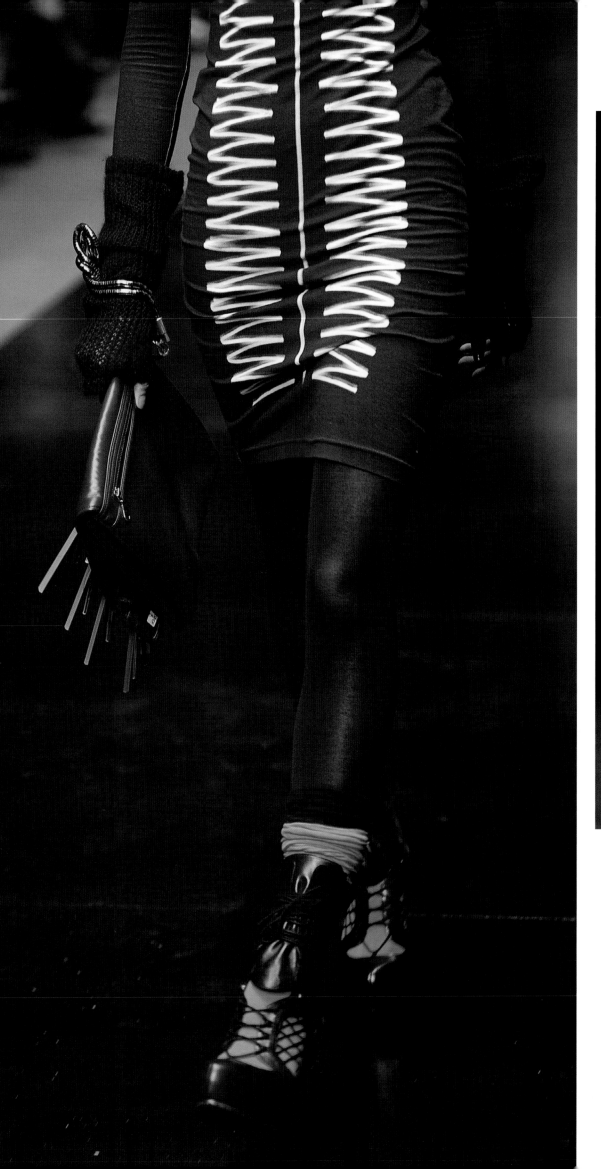

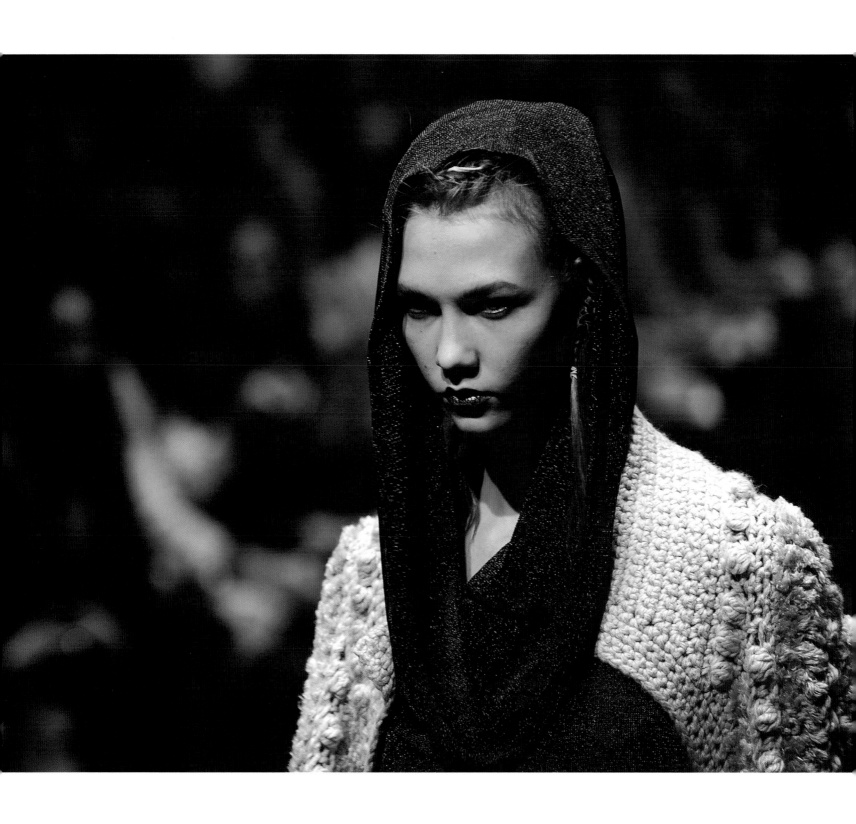

LEFT AND ABOVE: TOPSHOP UNIQUE

2009

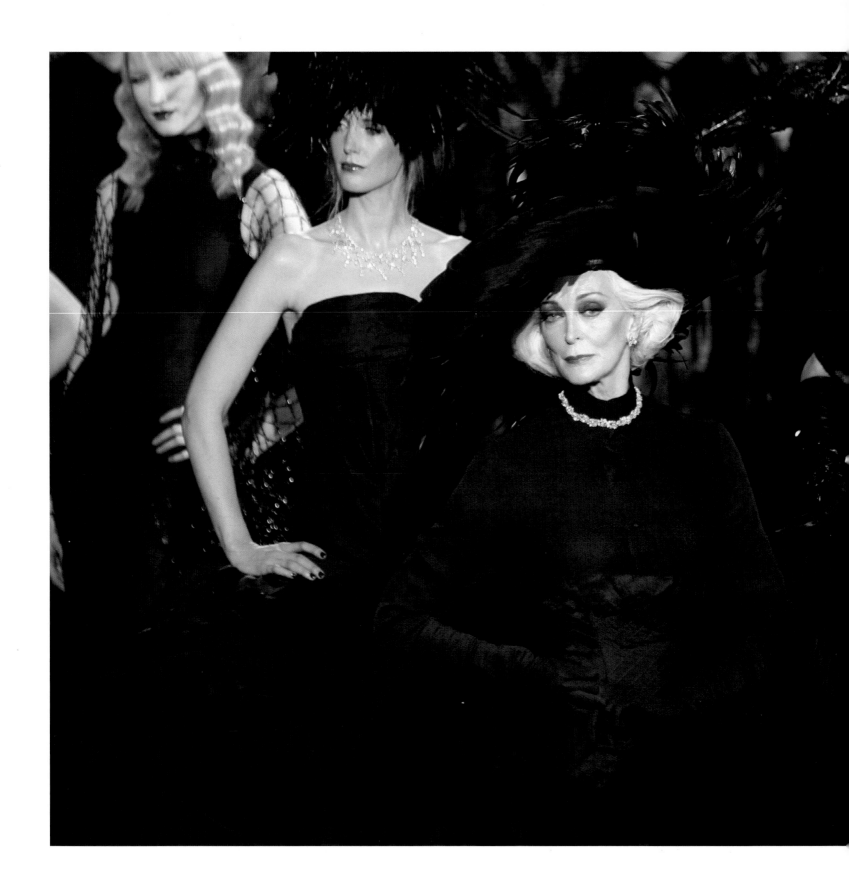

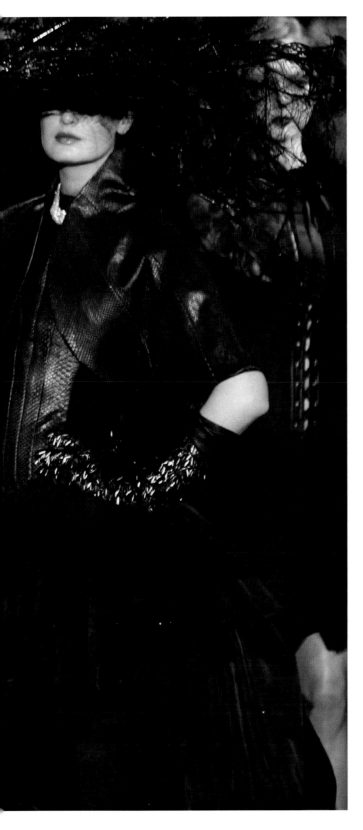

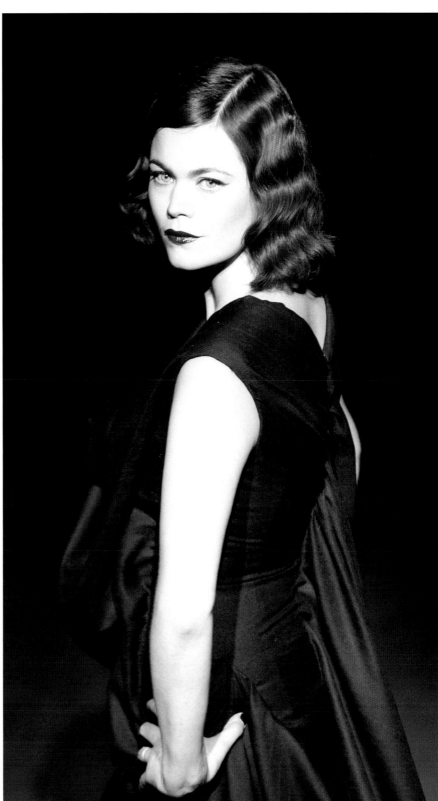

LEFT AND ABOVE: QASIMI

2009

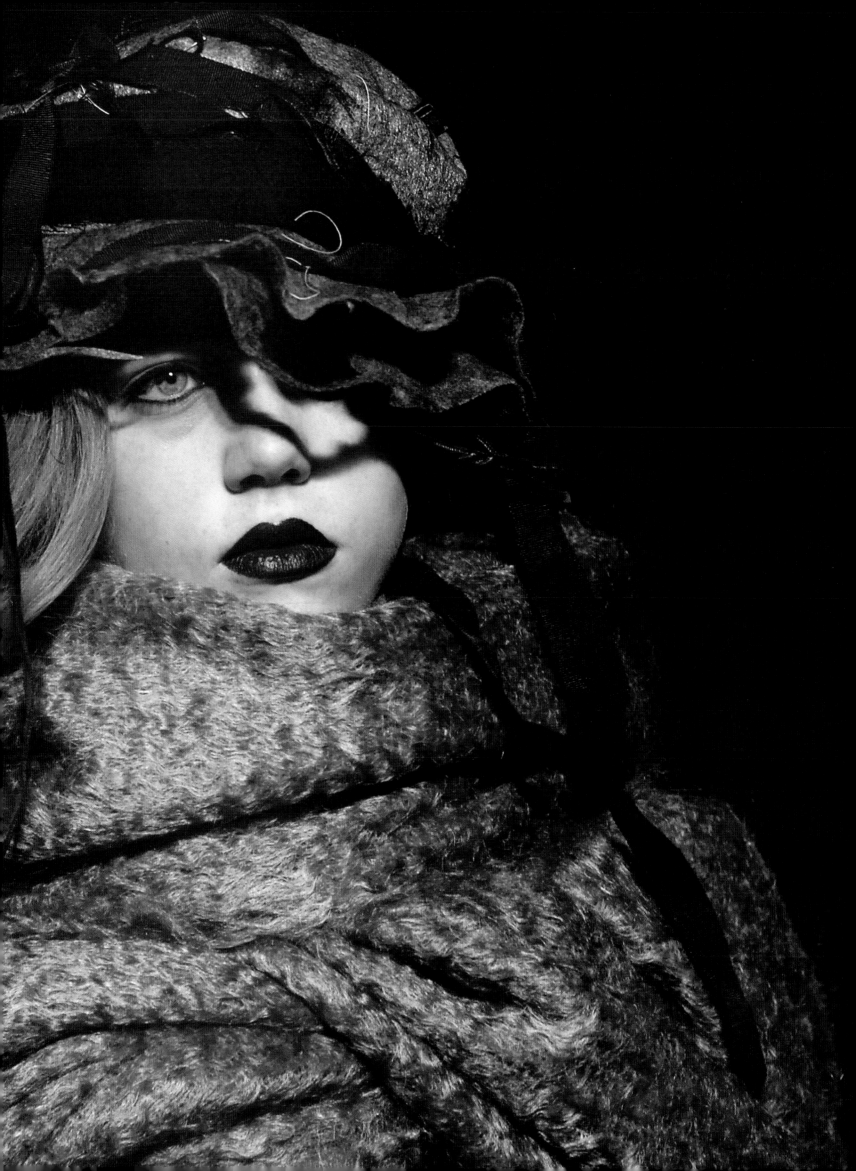

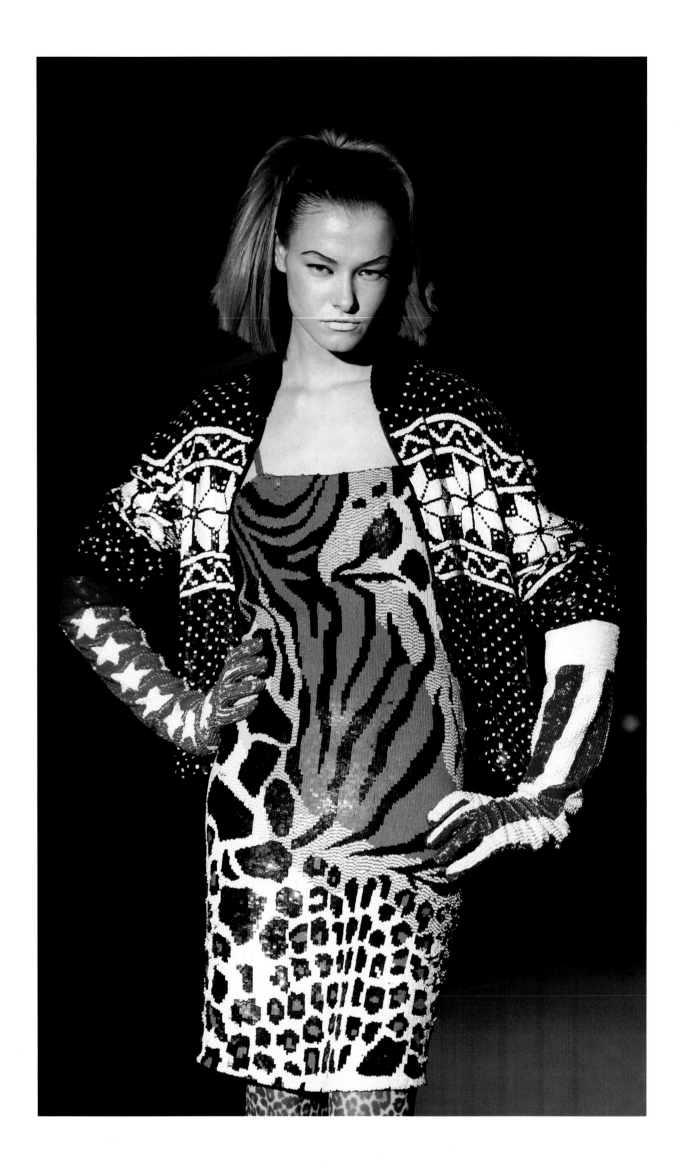

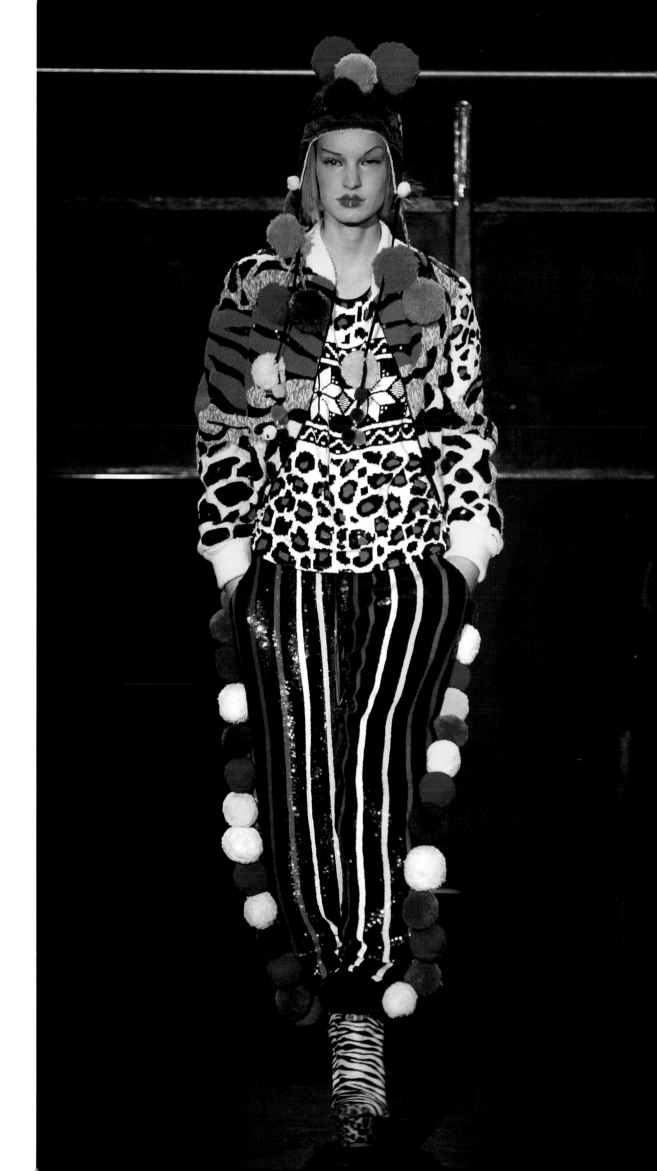

page 1

pages 2–3

pages 4–5

pages 6–7

pages 14–15

pages 16–17

pages 18–19

pages 20–21

pages 28–29

pages 30–31

pages 32–33

pages 34–35

pages 42–43

pages 44–45

pages 46–47

pages 48–49

pages 56–57

pages 58–59

pages 60–61

pages 62–63

pages 70–71

pages 72–73

pages 74–75

pages 76–77

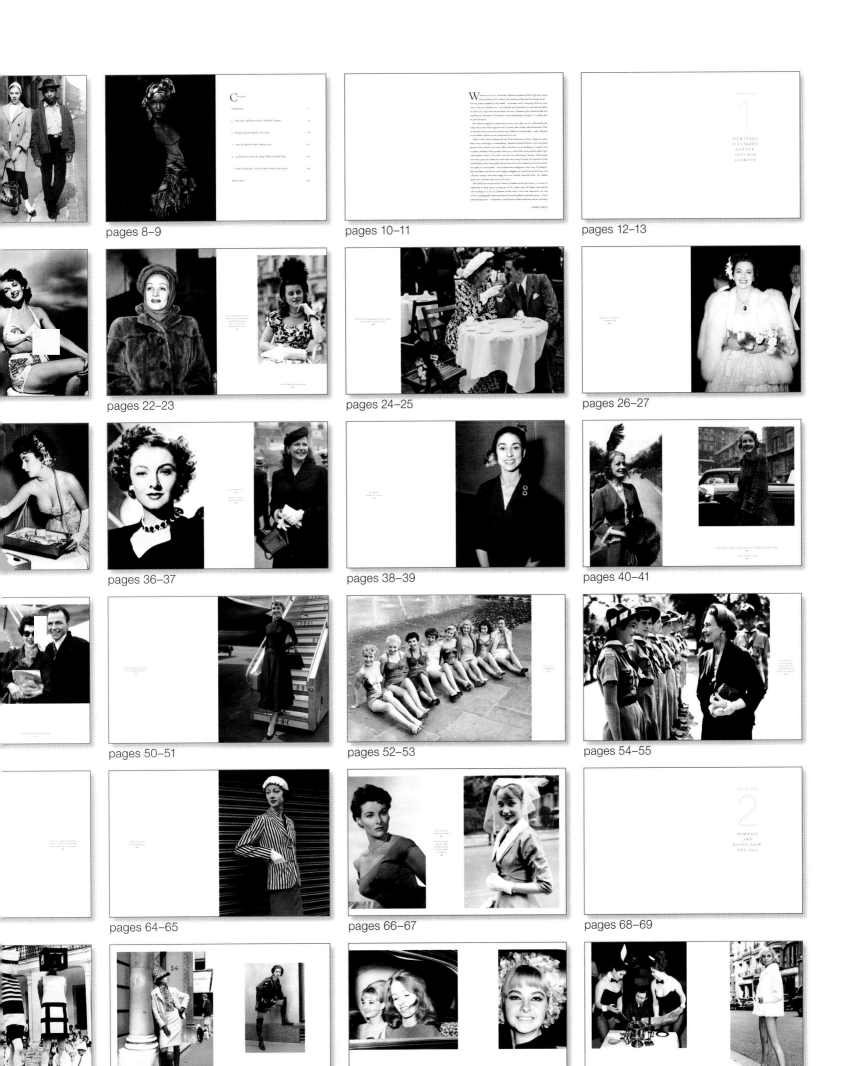

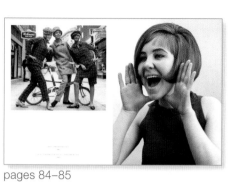

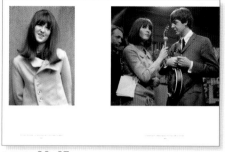

pages 86–87

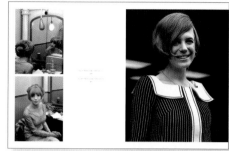

pages 88–89

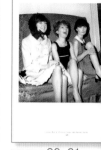

pages 90–91

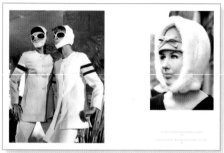

pages 98–99

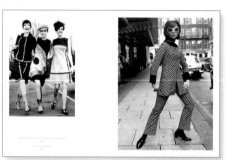

pages 100–101

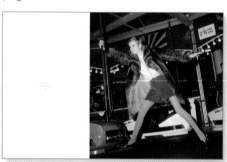

pages 102–103

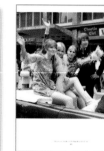

pages 104–105

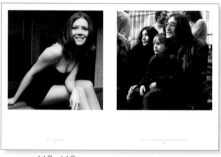

pages 112–113

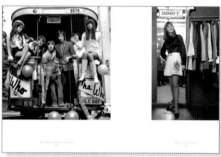

pages 114–115

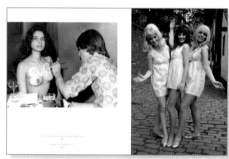

pages 116–117

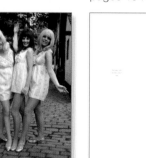

pages 118–119

pages 126–127

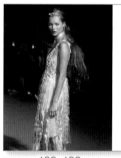

pages 128–129

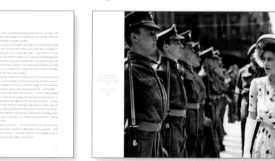

pages 130–131

pages 132–133

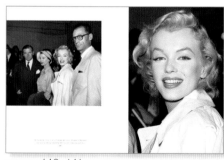

pages 140–141

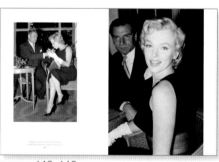

pages 142–143

pages 144–145

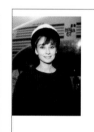

pages 146–147

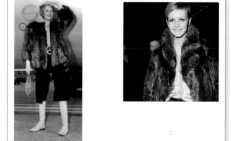

pages 154–155

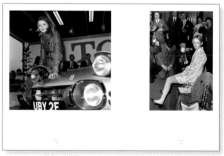

pages 156–157

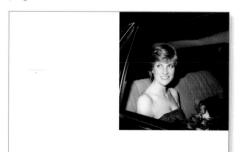

pages 158–159

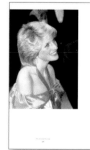

pages 160–161

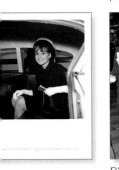

pages 92–93

pages 94–95

pages 96–97

pages 106–107

pages 108–109

pages 110–111

pages 120–121

pages 122–123

pages 124–125

pages 134–135

pages 136–137

pages 138–139

pages 148–149

pages 150–151

pages 152–153

pages 162–163

pages 164–165

pages 166–167

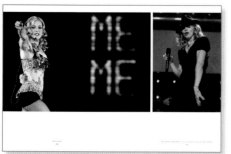

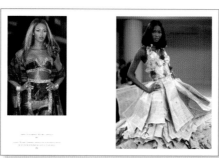

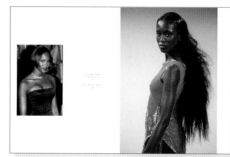

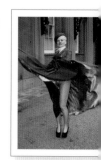

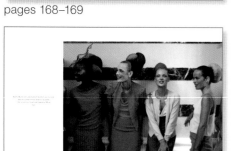

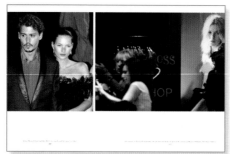

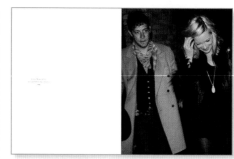

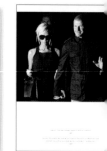

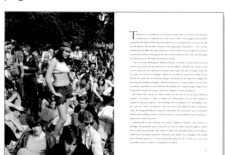

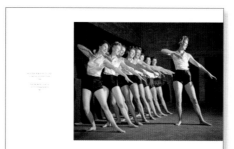

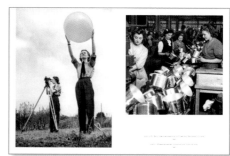

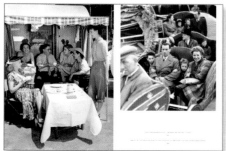

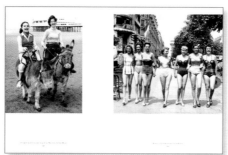

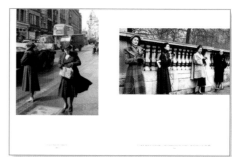

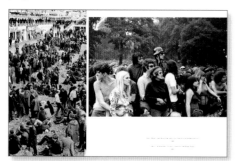

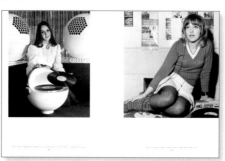

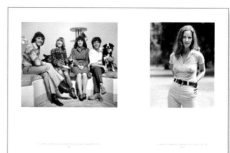

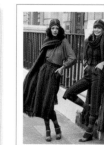

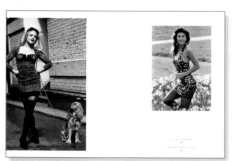

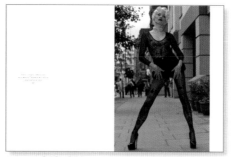

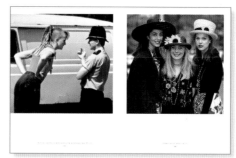

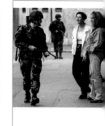

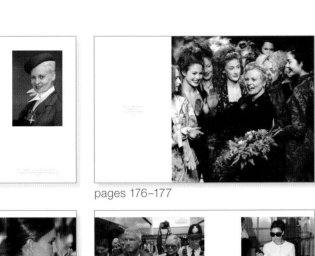
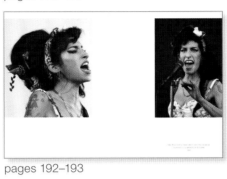

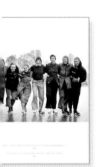
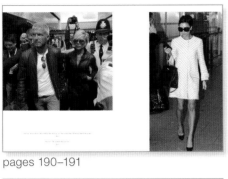

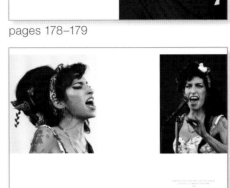

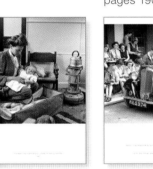
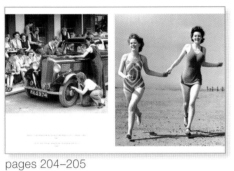
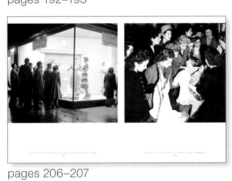
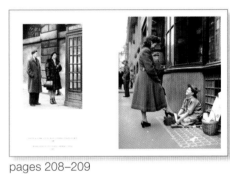

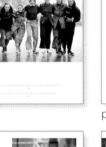
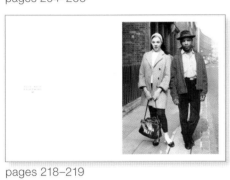
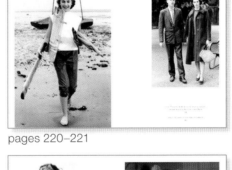
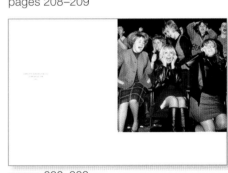

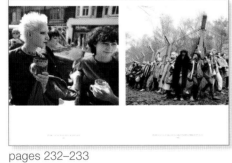
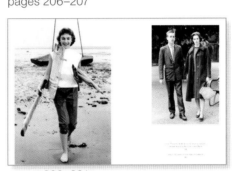
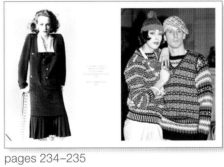
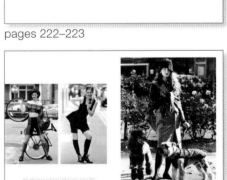
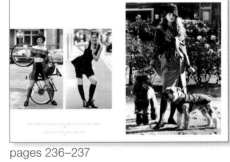

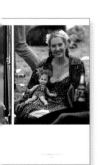
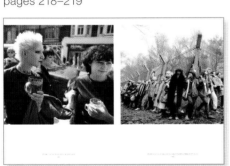
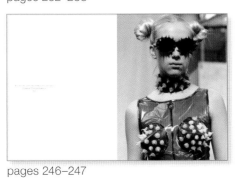
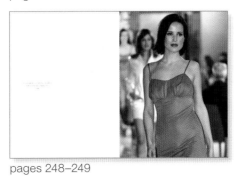
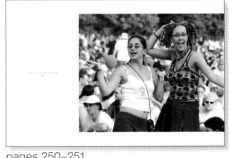

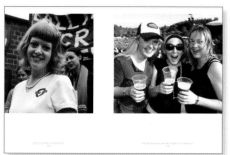

pages 252–253

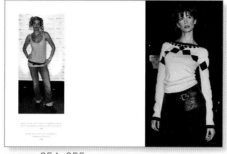

pages 254–255

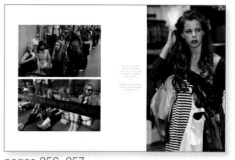

pages 256–257

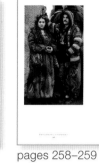

pages 258–259

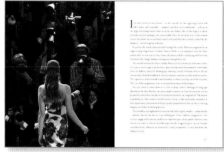

pages 266–267

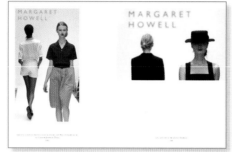

pages 268–269

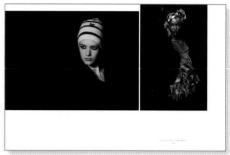

pages 270–271

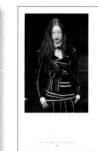

pages 272–273

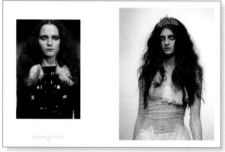

pages 280–281

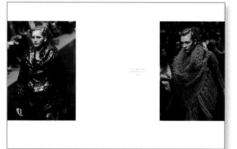

pages 282–283

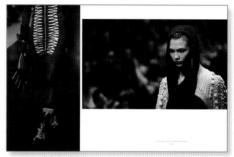

pages 284–285

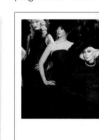

pages 286–287

pages 294–295

pages 296–297

pages 298–299

page 300

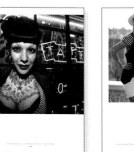
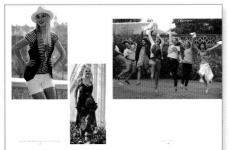

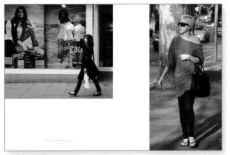

pages 260–261

pages 262–263

pages 264–265

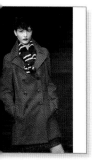
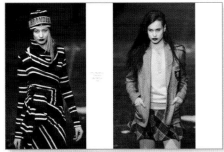
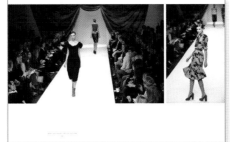
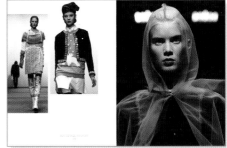

pages 274–275

pages 276–277

pages 278–279

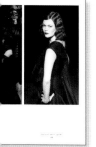
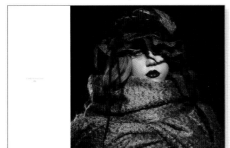
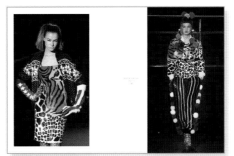

pages 288–289

pages 290–291

pages 292–293

The Publishers gratefully acknowledge Press Association Images, from whose extensive archive the photographs in this book have been selected. Personal copies of the photographs in this book, and many others, may be ordered online at www.prints.paphotos.com

For more information, please contact:

Ammonite Press

AE Publications Ltd. 166 High Street, Lewes, East Sussex, BN7 1XU, United Kingdom

Tel: 01273 488005 Fax: 01273 402866

www.ammonitepress.com